Van Gogh, Gauguin and the Impressionist Circle

Van Gogh, Gauguin and the Impressionist Circle

MARK ROSKILL

206 illustrations, 8 in colour

Thames and Hudson · London

The author has prepared a supporting catalogue to go with the present book, entitled *Van Gogh, Gauguin and French Painting of the 1880s: A Catalogue Raisonné of Key Works*. It is available in xerographed form from University Microfilms, Ann Arbor, Michigan 48106, USA.

FILMSET IN GREAT BRITAIN BY FILMTYPE SERVICES LTD, SCARBOROUGH
PRINTED IN SWITZERLAND BY BUCHDRUCKEREI WINTERTHUR AG
BOUND IN HOLLAND BY VAN RIJMENAM NV, THE HAGUE
ISBN 0 500 49001 5

CONTENTS

To Bob and Lisa

Preface

Picasso once said, according to Françoise Gilot, that when, beginning with van Gogh, 'they decided it was the painter's sensations and emotions that mattered, and every man could recreate painting as he understood it from any basis whatever, then. . . . there were only individuals.' He went on to say, however, '. . . even if you are against a movement, you're still part of it . . . you can't escape your own period. Whether you take sides for or against, you are always inside it.'

Picasso was surely right in taking the 1880s as the period when this dualism, so characteristic of modern art, comes out into the open. From van Gogh and Gauguin on, it becomes practically inevitable that the development and contribution of each artist should be talked about primarily in terms of its uniqueness. The second half of what Picasso said also holds good, in the sense that artists still form loose or temporary associations; and also in the sense that there is a certain climate within which, from phase to phase, the development of each artist runs its course. The problem then, from the late nineteenth century on, is to find a way of writing about the paintings of any one period which reconciles these two aspects of the modern situation.

The particular fruitfulness of re-studying the 1880s from this point of view lies not only in the fact that this decade ushers in the problem of approach which has just been defined. The fact is also that the documentation for this period has become reasonably complete. Though there is some sorting out still to be done, the paintings and drawings of the major artists, and the corresponding writings, are available and published in an organized form. The stage is therefore set for interpretation of a broader and more unifying kind.

Three main themes, accordingly, run through these pages: the parallels between impressionism after 1880 and the course of post-impressionism; links and parallels between the individual post-impressionist painters; and the general movement in the 1880s towards an allusive and suggestive art. And the common aim of these three themes is to show that, though the 1880s were a period of explicit experimentalism and also marked by a highly self-conscious pursuit of individuality, it is still possible

to study the art of the period as a reasonably integral fabric. I have concentrated a great deal on the subject of imagery, and on the way in which the artist structures and organizes his imagery. For I feel that it is helpful to detach these elements from the general discussion of style (which often amounts to little more than a discussion of technical handling) and to deal with them in their own right. There are in fact important connections and relationships, quite typical of the 1880s, which are purely and simply a matter of imagery, and have to be understood in that light.

The four middle chapters of the book have to do with parallels between the different artists which start with, but go far beyond, the known details of contact and exchange between one artist and another. The first and last chapters are concerned with threads of a more general kind which tie in artists with one another across the whole field of the 1880s. Three such threads will, I hope, emerge with particular clarity. There is the postimpressionists' use of works by their immediate predecessors as a springboard for personal invention. There is the making of references to earlier art, which is fundamental in twentieth-century painting. And there is the forging of a structural language which will accommodate or set up associations that are more than simply personal to the artist.

I have also devoted one special section, the Coda between Chapters 5 and 6, to the factual statements which the artists made in one particular connection, and to the question of what happens to these statements when they are interpreted in terms of their context, and critically collated with the evidence of character and motivation. This is a very important problem—indeed it was one of my starting points—and I plan to return to it afresh in a study of the theory of Cubism.

The whole study is meant, finally, as a contribution to the running debate today—among artists and critics as well as art-historians—as to what the term 'influence' implies: what artists get out of personal contact with one another, and how far the late nineteenth- and twentieth-century situation differs in this respect from the pattern of earlier periods.

This book has been ten years in the making and it has changed shape radically at least twice. A large number of people have helped me along the way, and I cannot thank all of them individually. I am, however, particularly grateful to John Rewald, who went very carefully over my initial documentary study of van Gogh's and Gauguin's relationship, making numerous corrections and suggestions. He also gave me access

to some of the important letters from Gauguin to the van Gogh brothers which he has collected in preparation for a new edition of Gauguin's correspondence, but has only published partially and in translation. And I owe my original knowledge of certain Gauguins to his photographic collection. Finally he has answered many queries about points of documentation arising from his books on impressionism and post-impressionism. And without those books themselves I should not have had a groundwork on which to build. They contain so much in the way of factual material, and are so skilfully put together, that I have used them absolutely constantly as a source of reference. I hope that my own book will serve as a complement to them.

I would also like to thank Merete Bodelsen, for many exchanges of information and ideas about Gauguin, and for her help and interest in my work since our first meeting; Douglas Cooper, Robert Goldwater, Annet Tellegen-Hoogendoorn, Richard Field, Wayne Andersen, Donald Gordon, and many others, for the time they have given to discussion with me of points arising out of my work; and all of my colleagues in the Department of Fine Arts at Harvard, especially Frederick Deknatel and Sydney Freedberg, for their support and the understanding hearing they have given to my ideas, and Seymour Slive, who went over the manuscript most carefully and made many helpful suggestions. My approach owes a great deal to Sydney Freedberg's book on the High Renaissance and to the late Nils Sandblad's book on Manet. And I have learnt much, in more indirect ways, from the field of literary criticism. It has sharpened and fortified my sense of what I was doing, in the tackling of comparable problems; and this has been of great benefit.

The preparation of this study has taken me to Paris several times and to Provence, to Holland and to Scandinavia, and I am very grateful to the museums, libraries and other institutions whose staffs have facilitated my looking and my research; especially the Stockholm Museum, the Kröller-Müller Museum and the Stedelijk Museum in Amsterdam. Then there are the private owners of paintings who have kindly let me see them and supplied me with photographs, and all those with whom I have corresponded about points of detail. John and Polly Coolidge lent us one summer their beautiful house on Eastern Point. By the nicest of coincidences it was built in 1888, the very year that I was working on at that time. And my parents have, in successive years, had us to stay in a villa in Provence and next door to them in England. Thanks to these kindnesses, I associate this book, in great part, with the places where it was composed.

All of the Harvard graduate students who took part in my 1962 seminar on van Gogh and Gauguin have contributed on the level of fruitful discussion and helped me towards a synthesis. There are many details in my text which they clarified or worked out with me. I have acknowledged specific findings of theirs wherever possible, and the particularly valuable papers are listed in my bibliography. Similarly the reports of a different set of students in my 1965 seminar on Symbolism have helped me to build up and organize the materials of my last chapter.

My wife has done far more than simply keeping me happy during the years of preparation. She undertook all of the early typing, and took down the final text in draft, contributing comments and improvements all along the way. Many of the points made about individual pictures, therefore, are there because of her perceptiveness and sense of what was important. And the two people to whom the book is dedicated have, in special ways, helped me to teach and write about modern art.

Research grants from Princeton University and Harvard University enabled me to travel to Europe in 1961 and 1963 and work on the catalogue which supports the present text during the summer of 1967. The Department funds at Harvard have covered many of my incidental expenses, and the text was written on a year's leave of absence provided by Harvard and the American Council of Learned Societies.

Amherst, Mass. M . R .
August, 1969

1 Impressionism:
A Reconsideration of its Relevance during the 1880s

The relationship between post-impressionism and impressionism is more complex than has usually been recognized. The idea of a complete contrast between the two works well enough, so long as there is a time-gap of a decade or more between the paintings chosen for comparison. Put together an impressionist work of the mid seventies, that is, and a post-impressionist work of the mid or later eighties, and one can certainly speak of differences of an absolute kind in colouring and brushwork, in the handling of contour and the organization of space. But this picture of a direct reaction against impressionism on the part of the younger generation skates over everything that happened between the dates in question. It hastens too quickly to make the post-impressionists into over-throwers and controverters of everything that impressionism stood for. Except as a convenient simplification, this will hardly do. For one thing, the impressionists themselves had moved on in the intervening years—in the same general direction as the post-impressionists would take in their turn, or were already taking. And for another, the post-impressionists all passed through impressionism (Cézanne had already done so in the early seventies); and its continuing legacy was of great importance to them.

We will begin, then, with the impressionists after 1880—in particular, with Monet and Renoir. In summary form, what happened in the early eighties, across the whole field of impressionism, was a bending back towards the original sources and premises of the movement. In a mood of doubt and self-questioning, each artist individually, within the space of some two to three years, called back into his work the type of subject-matter, with a handling to match, and type of pictorial mood, which had underlain and empowered his first impressionistic beginnings during the 1860s.

Starting in 1880, Monet went back to rough-sea subjects, which he had not painted since 1867-8; and the ruggedness of mood in his 1883 paintings of the coast at Etretat makes for an affinity with Courbet, which had not been present in his art

since about 1865. At the same time his colours moved towards becoming high-keyed and synthetic,[1] as they had been in his forest-subjects of 1866-7, but never in his lucid and serene out-door paintings of the seventies.

Renoir in 1880 did Oriental costume-pieces afresh. They had not figured in his art since 1872. His imagery now ran to broad and heavy female figures of a distinctly plebeian cast, and the rather lush sensuality of these figures is directly reminiscent of his Courbet-like nudes of the later sixties. His brushwork equally became flatter, with larger units of piquant or contrasting colour; and he consistently used such colour to play up the highlights of costume and make the details of facial expression more winsome. The example of Manet was clearly relevant here—as in the later 1860s, only now in a more general way.

Similarly, the peasant figures which Pissarro drew and painted in the early 1880s show him turning back very specifically to the example of Millet. Cézanne went back to the Louvre at this time, and the drawing which he did there of one of the nudes in Couture's *Romans of the Decadence* stresses the voluptuousness and sensuousness of the female body in a way which recalls his work of the later sixties. A stress on fleshy roundness is also found in his self-portraits of the time, like the one in the Reinhart collection; and the use there of blacks and greens and the way in which the paint is laid on are directly reminiscent of his early debt to Courbet and Manet. Again, the strange poses and stretchings of the body in Degas' series of pastels of this time of women washing and drying themselves relate back conceptually to the kind of thing this artist had done with the nude figure in his early historical paintings.

Simultaneously the impressionists were reforming their pictorial structure. Besides intensifying all his colours and bringing them up towards the surface, Monet began using thin, criss-cross strokes and a shallow impasto. He wove these strokes of his into a dense fabric, and increasingly ran a continuous, sharp-edged contour-line around each of the segments of landscape which were textured in this way. These segments, therefore, became in due course like detachable shapes, united only by juxtaposition. Variations of tone and texture within each shape, and the force of the surrounding contour, now served as the major indices of depth. And just because these shapes were so explicitly bounded, the brushwork inside them took on a free-floating, material character.

In Renoir's case the initial changes took the form of a greater sharpness and piquancy of detail, and of a harder, more enamel-like quality of surface used alembically in certain key parts of

the painting. The 1881 trip to Italy was therefore, from this point of view, a ratification of the artist's renewed concern for refinements of a classical kind. It also provided (in the tradition of the Grand Tour) a thorough-going confrontation with the High Renaissance and Baroque art of the museums. An old-master orientation was always deeply implanted in Renoir. Consequently, when he confronted the later art of Raphael and saw the lines of continuity running through from there to the Italian Baroque, the spirit of emulation led him to make his own figures comparably large, rounded and heavy. By 1883 he was doing this with renewed emphasis, as in the *Dancing at Bougival*. He now treated the setting to the rear of his main figures simply as a painted backdrop—thereby increasing the physical detachment of those figures and making them loom proportionately larger. And in 1884-6 he took to using, for his backdrops of this kind, the constructive brushwork which he had learnt from Cézanne at L'Estaque in 1882. The result was a firming up of the pictorial structure as a whole. The relationship between plane and mass became stronger, and also more balanced. Most important of all, an intellectual stiffening which had been missing from Renoir's art of the seventies crystallized during this period. In the seventies Renoir's work had been characteristically soft, in both of this word's common senses. The handling had been feathery and flocculent; the mood of the paintings had constantly verged towards the sweet and the sentimental. Now, on the other hand, these qualities were tempered by a new conceptual fibre. The Italian trip and Renoir's sustained rethinking of his premises were jointly responsible for this development.

Pissarro, during the same years, combined intimate description in the foreground of his paintings with vast, infinitely receding backgrounds. The seams between foreground and background, and between different areas of landscape, became forceful in their own right. His brushwork too became increasingly regular, to the point where it was made up of small, comma-like strokes throughout; and eventually he went over to pointillism, in the sense of using dots of a varying concentration within areas whose boundaries were still clearly marked out. Cézanne was concentrating his attention more and more on those objects which have well-defined outlines and are intrinsically highly stable: apples, houses and trees, the nude and the seated figure. He was progressively eliminating superfluous detail in his treatment of these forms, and at the same time strengthening his pictorial architecture. He was also increasingly making the lateral organization of his pictures assert

itself more strongly than their organization in depth. This is particularly evident in his *Avenue of Chestnut Trees at the Jas de Bouffan* of the mid eighties, where the trees provide a spaced-out series of intervals, or pockets, through which the rest of the landscape is seen. As for Degas, the intimately observed detail within his figures was now bounded and compressed by wire-like contours, which thrust into prominence certain key parts of the anatomy at the expense of the action as a whole, and asserted on the surface a compact unity of design.

The result of all these changes, then, is that there is a continuous series of parallels between the kind of organization which the impressionists had arrived at by the mid 1880s, and the structure of van Gogh's and Gauguin's paintings some three to four years later. Monet's *Rocks at Belle-Isle* of 1886 can be compared in this sense with van Gogh's *Ravine* of 1889, and Renoir's *Bathers* of 1884-7 with Gauguin's *Yellow Christ* of 1889.

Pl. 1
Pl. 2
Pls. 3, 4

In the Monet and the van Gogh—equally tempestuous, for all their differences of treatment—the tones consist predominantly of mauve, dark blue and grey. The movement of the eye is channelled, in both cases, along two major diagonal paths which run all the way across the canvas surface and intersect at the heart of the imagery. From bottom left to top right, bulges and twists of contour speed the eye along in a continuous, pulsating rhythm from one piece of rock to the next. What happens on the central axis is equally in key. There is a discharge down towards the bottom of the painting of the energy and thrust gathered up from either side; and there is a tilting up of the ground-plan behind the central motif, so that the distinction between foreground and middleground is eliminated, and the only major cue as to depth is the effect of a triangular wedge built upon the base of the painting, and extending almost as far as the framing edge at the top.

Correspondingly, in both the Renoir and the Gauguin the landscape background is like a continuous fabric hung parallel to the picture-plane. In the foreground, heavy figures in stylized, arrested poses join together in a common action—physically detached from one another, yet sharing a distinctive mood. Individual motifs in the landscape and the use of common colours there provide a ground for these figures, which interlocks with their rhythms and with the spaces between them, sharpening throughout their schematic yet supple geometry and intensifying their psychological separateness. In both cases, too, secondary figures of a smaller size serve, both in their position and in their activity, as a bridge between the main group and the setting.

These parallels should not, however, be taken to mean that van Gogh and Gauguin were dependent, in 1889, upon the impressionism of a few years earlier. In fact they had arrived at this kind of structure independently and individually, just as Monet and Renoir had. They had arrived at it, to be sure, after passing through impressionism. But the passage in question had taken place in their art, or completed itself there, some two to four years earlier. And the impressionism upon which they had depended then had been, characteristically, that of the seventies and very early eighties.

The hallmarks of this passage through impressionism— which Seurat and Toulouse-Lautrec also experienced—are borrowings and assimilations on two different fronts, either successively or simultaneously. First there was the adoption of impressionist handling and colour—of a certain way of laying on the paint, or working the forms, and of the tonal values associated with this brushwork. And then there was the taking over of characteristic impressionist motifs, and of the compositional syntax used to organize and shape these motifs.

In Seurat's case these two developments occurred in unison, the relevant years being 1882-4. Seurat's *Garden Scene with a Watering-Can*, which must date from around 1883, shows in some of its detail very much the same kind of handling and colour as Monet had used in his garden-scenes of 1872-3. At the same time the motifs of path, bushes and watering-can, and the way in which they are put together, recall Manet's garden-scenes of 1880-2. Similarly the *Baignade* of 1883-4 shows an assimilation of Monet's and Renoir's art of the mid seventies, both in the technical means used for rendering the fall of light and in the basic imagery of holiday-makers, boats and sun-struck water. The debt to impressionism on both of these scores is particularly clear in the final oil-study for the painting.

With Gauguin, the corresponding process of assimilation was spread over a longer time-span. Personal contact with Pissarro in the later 1870s had provided him with a basic language for the rendering of landscape. Thereafter, between 1879 and 1886, he drew unsystematically—there was never any continuous, single drift to his development—on the art of Manet and Monet, Degas and Cézanne. And it was characteristic with him that, whichever of these artists he was drawing on, he first took over particular traits of handling, and then, some two to three years later, moved over to borrowing motifs and corresponding structural devices. It is as if he needed to feel his way in, in terms of technique, before he could go on with security to the second type of borrowing.

To go into this point more specifically, artist by artist: a variant of the constructive brushwork which Cézanne had evolved in the later seventies is found in Gauguin's work as early as 1879. In his *Market Gardens of Vaugirard* of that year *Pl. 5* short, even brushstrokes are already arranged in parallel formations. The Cézanne of *Harvest* which later supplied Gauguin *Pl. 6* with motifs for a fan and a pot was probably the operative source here—on the assumption that he did indeed own that canvas, and had already acquired it by this date. Gauguin's first debt to Monet was equally a matter of handling. In the snow-scenes which he painted in Paris in 1879 and 1883, the scumbling of the snow areas and delicate treatment of the trees can be taken as technical borrowings from the paintings of snow and ice which Monet had done at Vétheuil in 1878 and the three succeeding winters. Gauguin was familiar with these winter landscapes of Monet's, because representative examples were included in the impressionist exhibitions of 1879 and 1882, and he showed himself on both of those occasions. Again, the first works of his which can be connected with the example of Degas and Manet are ones in which pastel is used in their kind of way. His study of a *Seated Model* in this medium, from 1882 *Pl. 7* or thereabouts, is a revealing case in point. It can be directly compared with the Degas pastel which he owned of a *Dancer adjusting her Shoe*—particularly in the treatment of the arms. *Pl. 8* Gauguin's early female portraits in pastel, such as the one of *Mlle Charlotte Flensborg*, which probably dates from 1882, are *Pl. 14* similarly related in handling to Manet's late works of this kind. They suggest this on their own account; it is simply a corroboration to know that one such Manet, the *Woman seated in a Garden* of 1879, was in Gauguin's own art-collection at the time.

The second stage of borrowing on Gauguin's part came, in each case, after an intervening space of time; and the works which he then drew on were correspondingly different in date and character. In 1881 he had the experience of working alongside Cézanne at Pontoise,[2] but he does not appear to have gained much from this encounter. Rather, it was his acquisition of several further canvases of Cézanne's in the early eighties which ushered in a new recognition of Cézanne's usefulness. It is in 1883-4 that this recognition shows itself in Gauguin's work. In the landscapes of those years, especially the ones done at Osny,[3] close-packed texturing is often used, as in the Cézanne which Gauguin owned of the *Château of Medan*. Buildings are elongated or pulled around, and there is a Cézannesque reliance on the higher registers of yellow and green as a scaffolding for the colour-scheme.

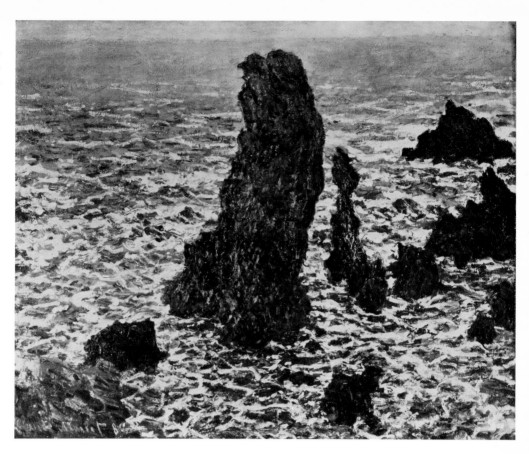

1 MONET
Rocks at Belle-Isle
1886

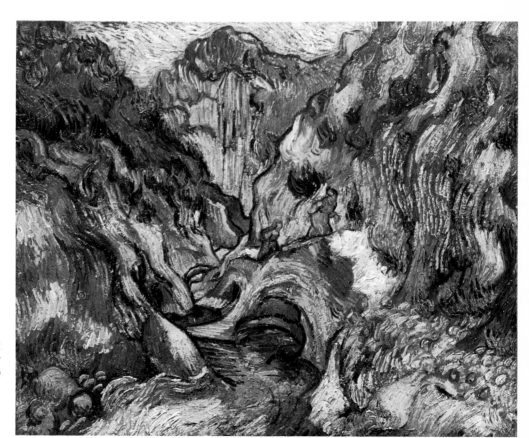

2 VAN GOGH
The Ravine
October 1889

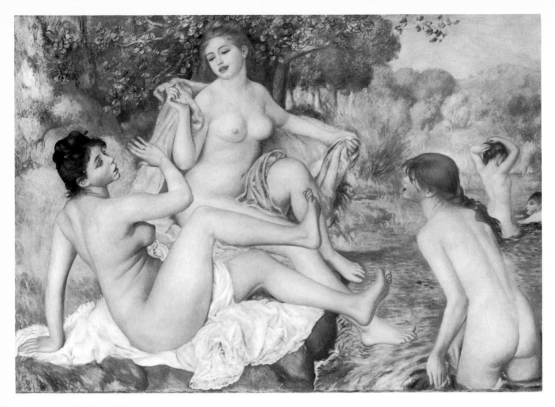

3 RENOIR *Bathers* 1884-7

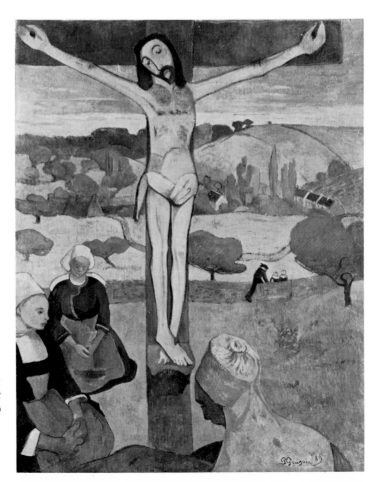

4 GAUGUIN
The Yellow Christ
1889

5 GAUGUIN
*Market Gardens
of Vaugirard*
1879

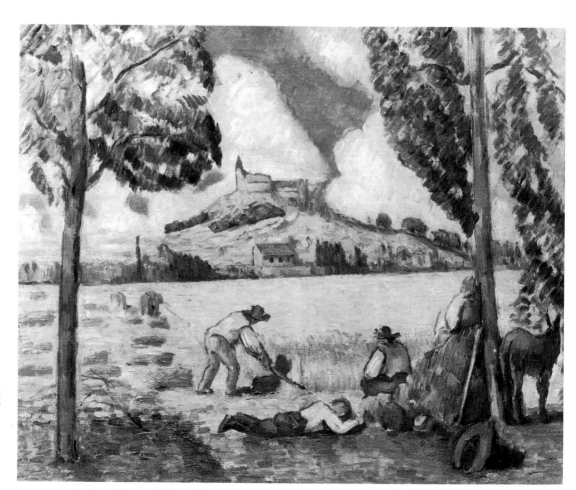

6 CÉZANNE
The Harvest
c. 1876.

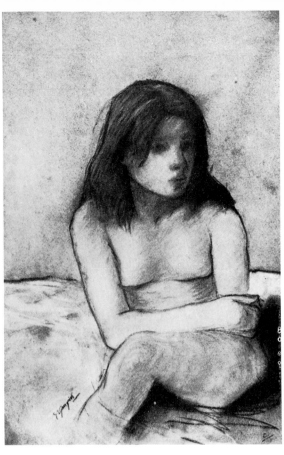

7 GAUGUIN *Seated Model* c. 1882

8 DEGAS *Dancer adjusting her Shoe* c. 1880-2

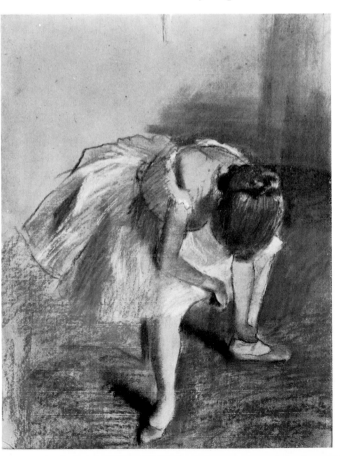

9 MONET *Sunflowers* 1881

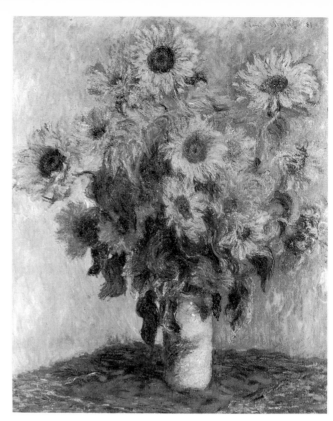

10 GAUGUIN *Basket of Flowers* c. 1884

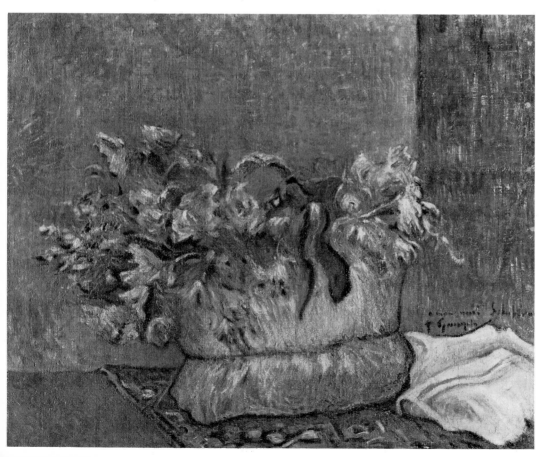

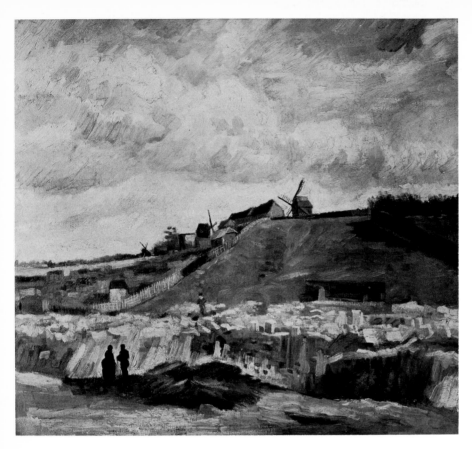

11 VAN GOGH *Quarry at Montmartre c.* 1886

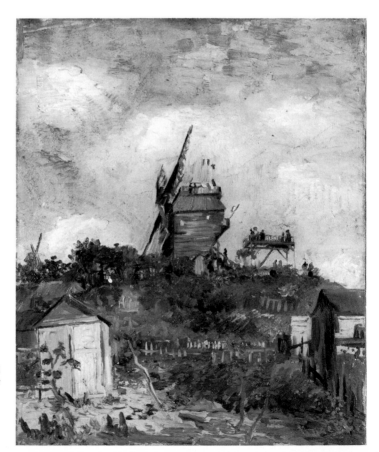

12 VAN GOGH
Moulin de la Galette c. 1887

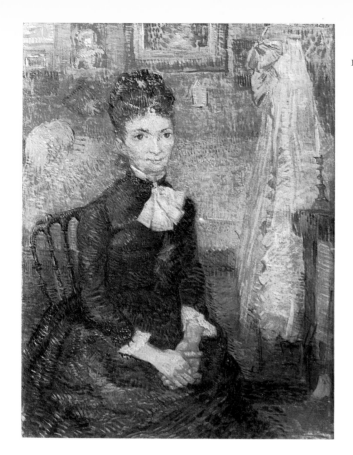

13 VAN GOGH *Lady at the Cradle* c. 1887

14 GAUGUIN
Mlle Charlotte Flensborg c. 1882

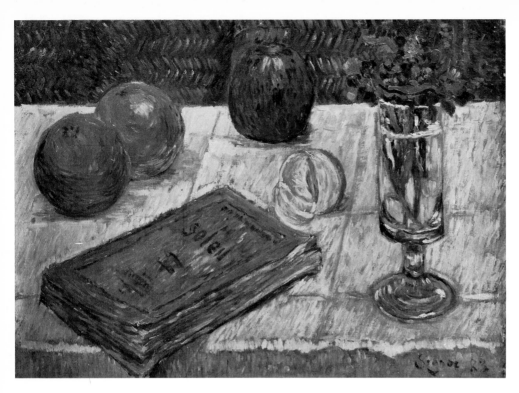

15 SIGNAC
Still–Life 1883

16 GAUGUIN *Breton Coast* 1886

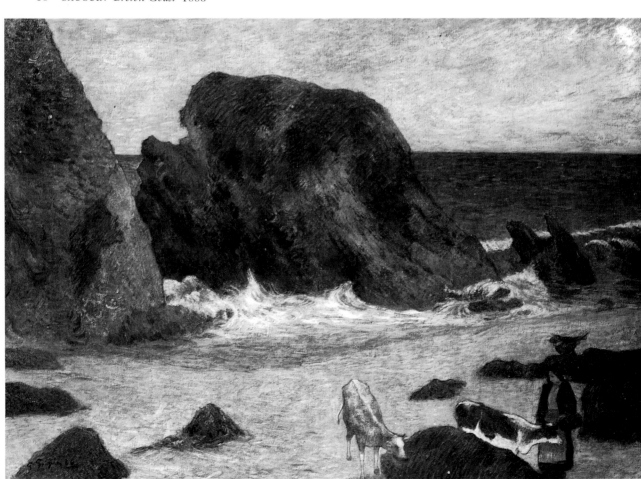

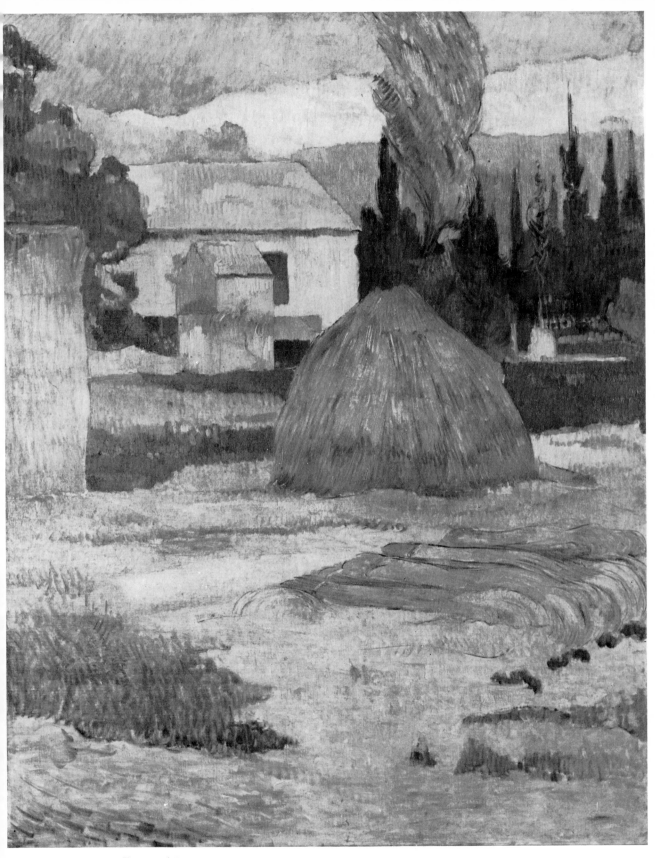

17 GAUGUIN *Farmyard Scene* c. 1889

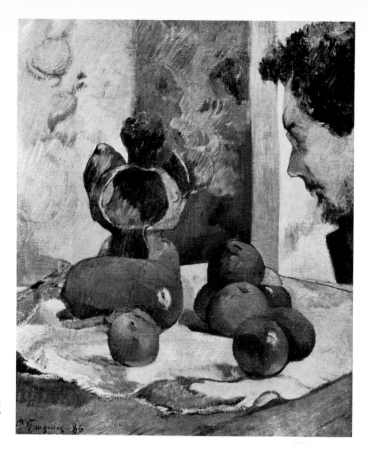

18 GAUGUIN
*Still-life with a
Portrait of Laval*
1886

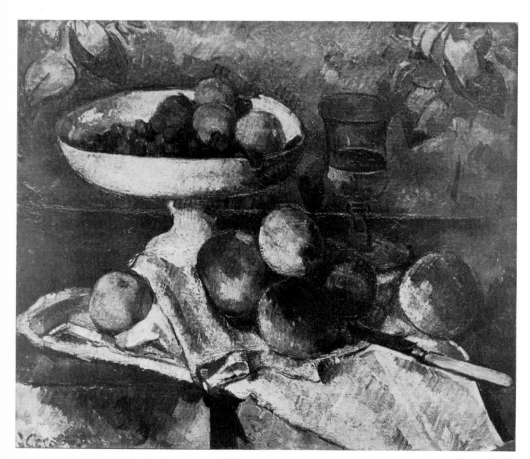

19 CÉZANNE
*Still-life with
Fruit Dish*
c. 1880

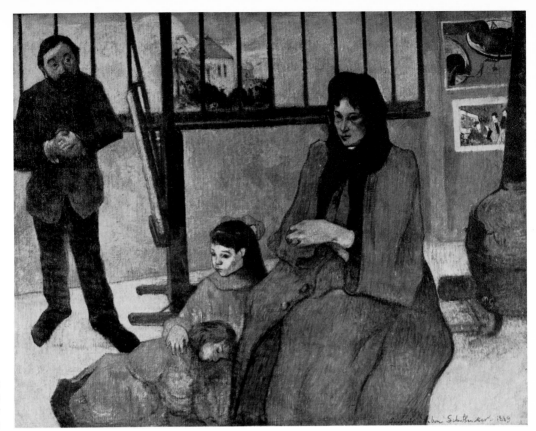

20 GAUGUIN
*Portrait of the
Schuffenecker
Family* 1889

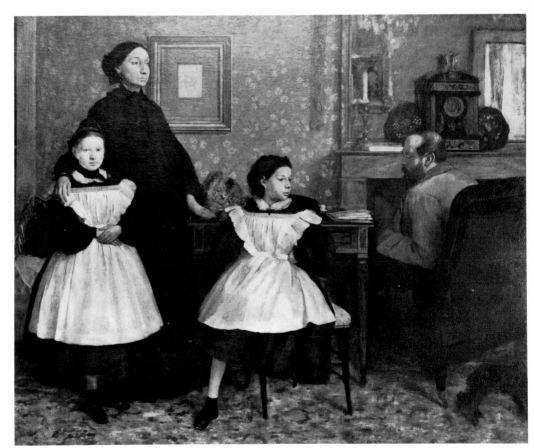

21 DEGAS
The Bellelli Family
1858-60

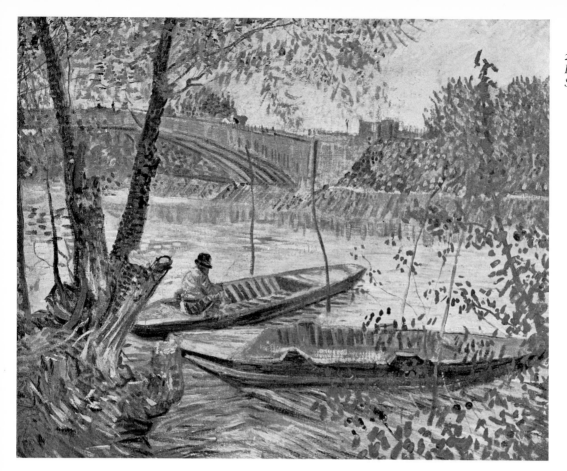

22 VAN GOGH
*Fishing in the
Spring* c. 1887

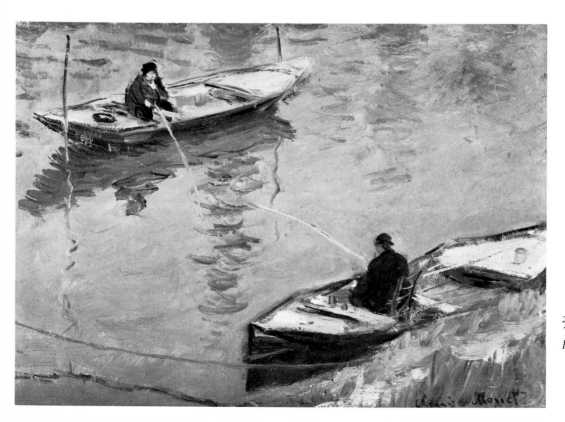

23 MONET
*Two Men
Fishing* 1882

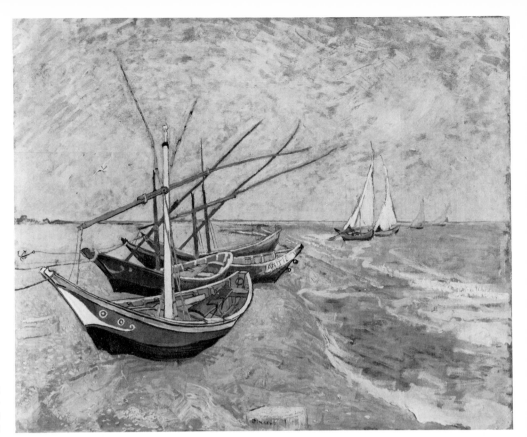

24 VAN GOGH
Boats at Saintes-
Maries
June 1888

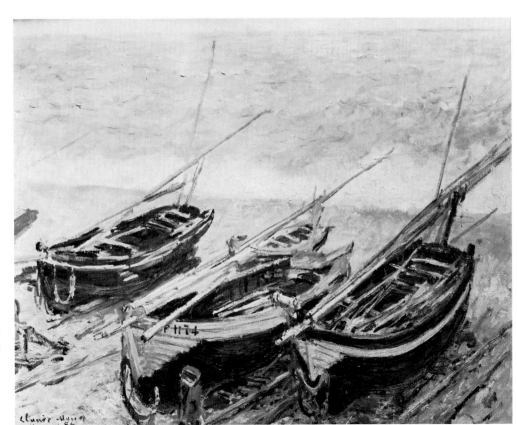

25 MONET
Boats at Etretat
1884

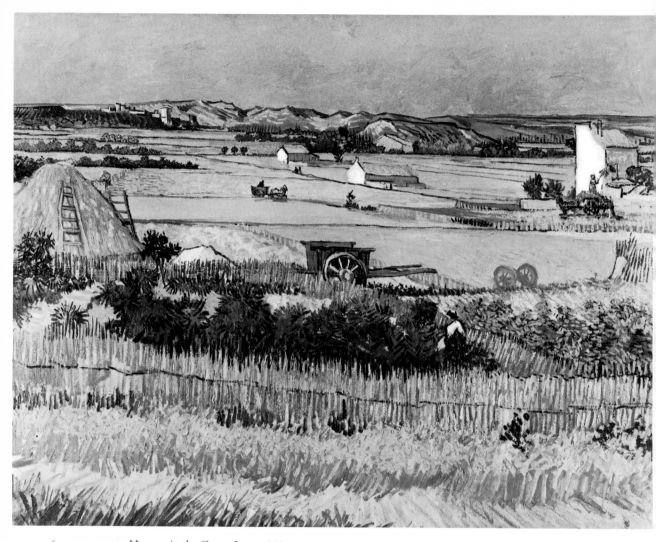

26 VAN GOGH *Harvest in the Crau.* June 1888

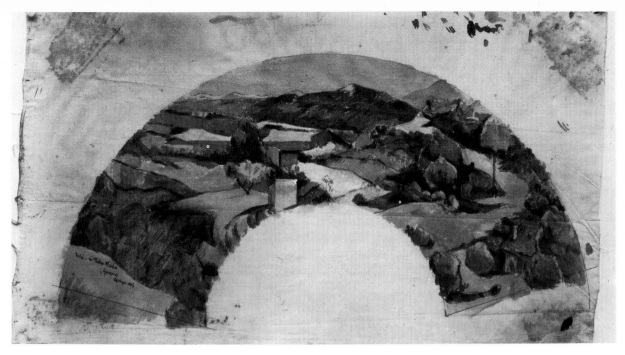

27 GAUGUIN *Fan-design* after Cézanne 1885

28 CÉZANNE *View of L'Estaque* c. 1882

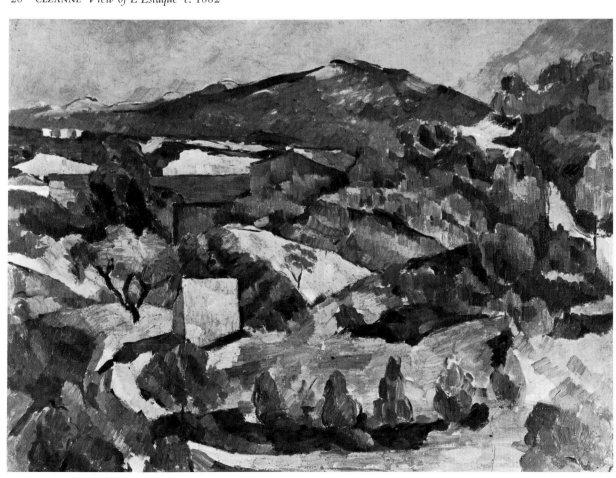

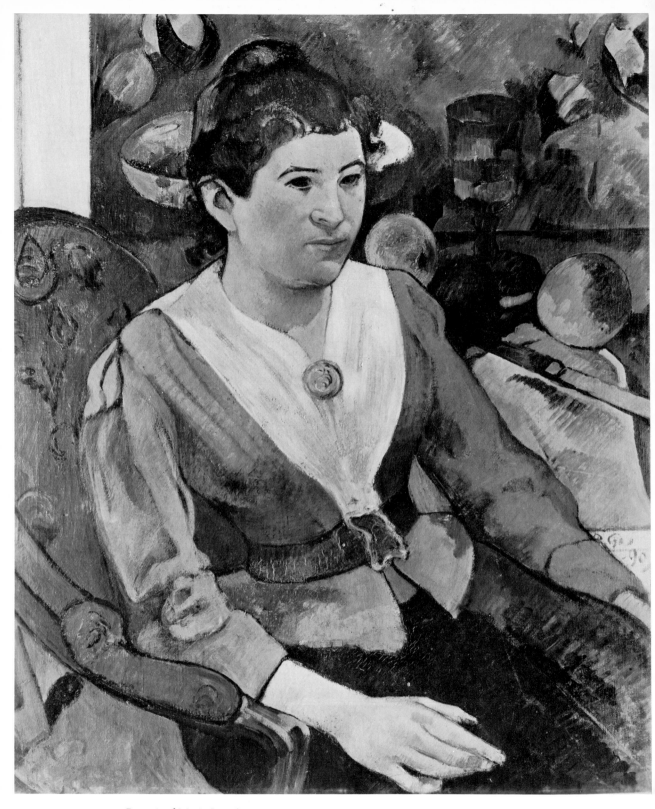

29 GAUGUIN *Portrait of Marie Lagadu* 1890

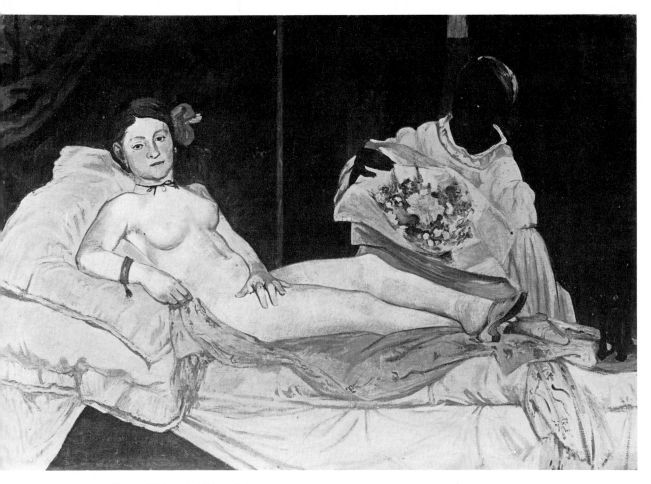

30 GAUGUIN *Copy of Manet's 'Olympia'* 1891

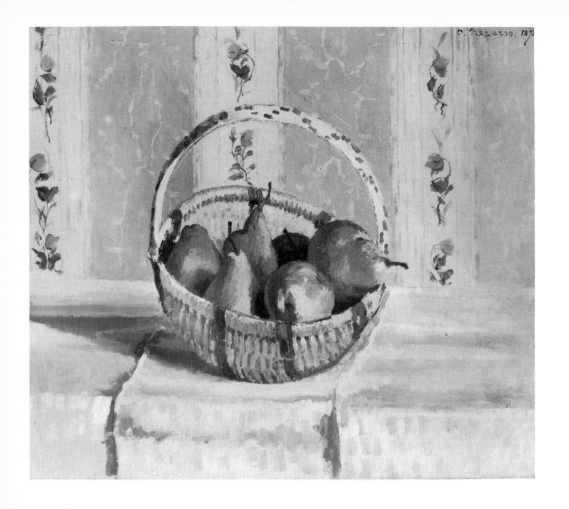

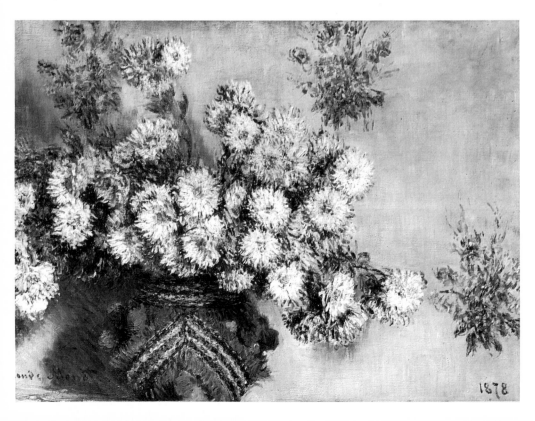

31 PISSARRO *Still-life, Basket of Pears* 1872

32 MONET *Chrysanthemums* 1878

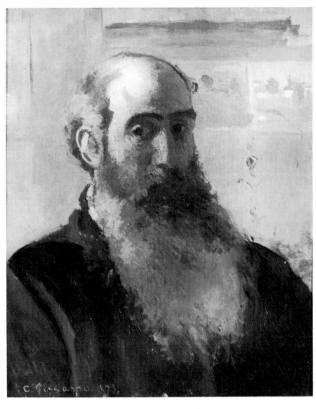

33 PISSARRO *Self-portrait* 1873

34 CÉZANNE *Portrait of Chocquet c.* 1877–80

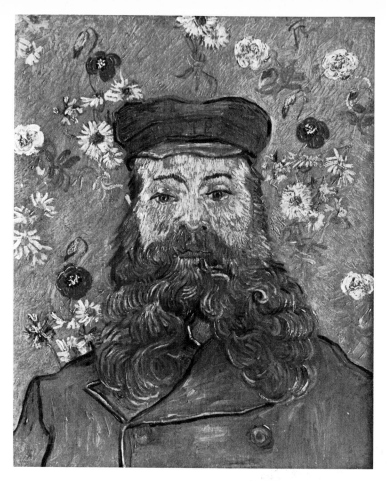

35 VAN GOGH
The Postman Roulin c. 1889

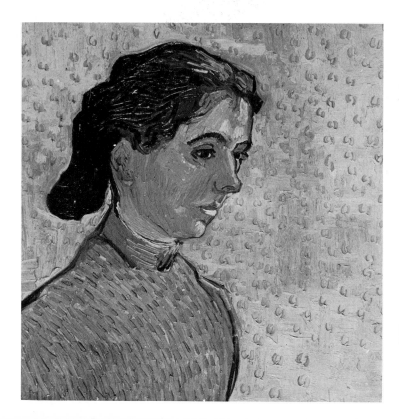

36 VAN GOGH
Portrait of a Young Girl c. 1890

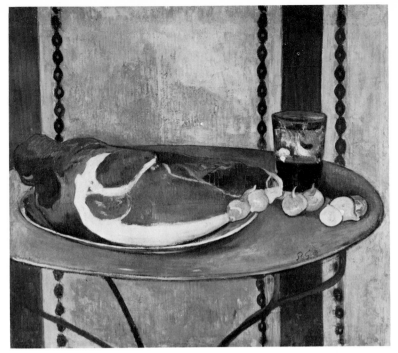

37 GAUGUIN *Ham* c. 1889

38 GAUGUIN *Self-portrait with the Yellow Christ* c. 1889

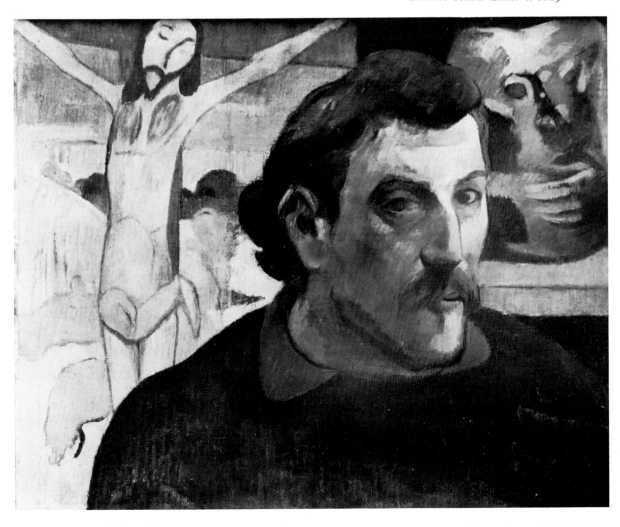

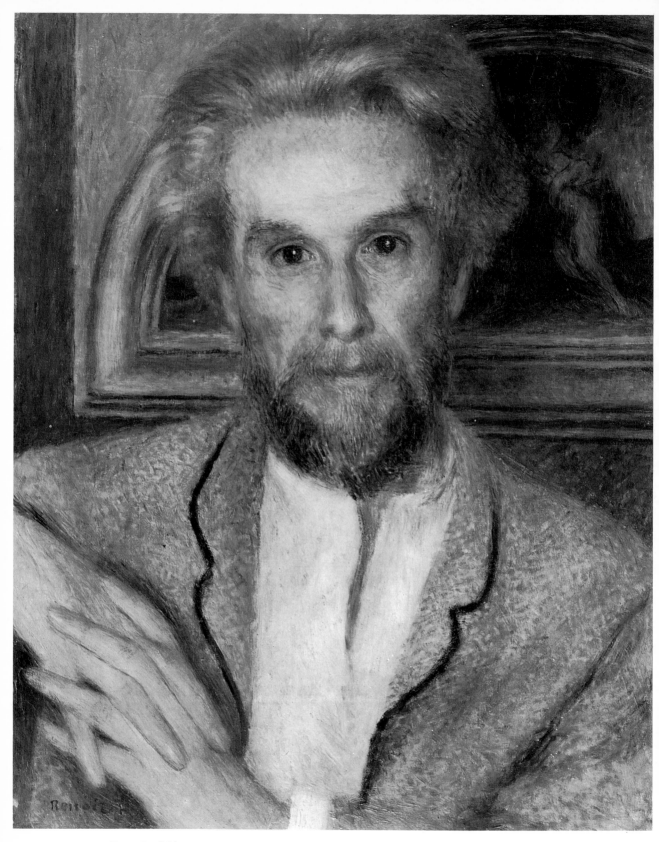

39 RENOIR *Portrait of Chocquet* *c.* 1875

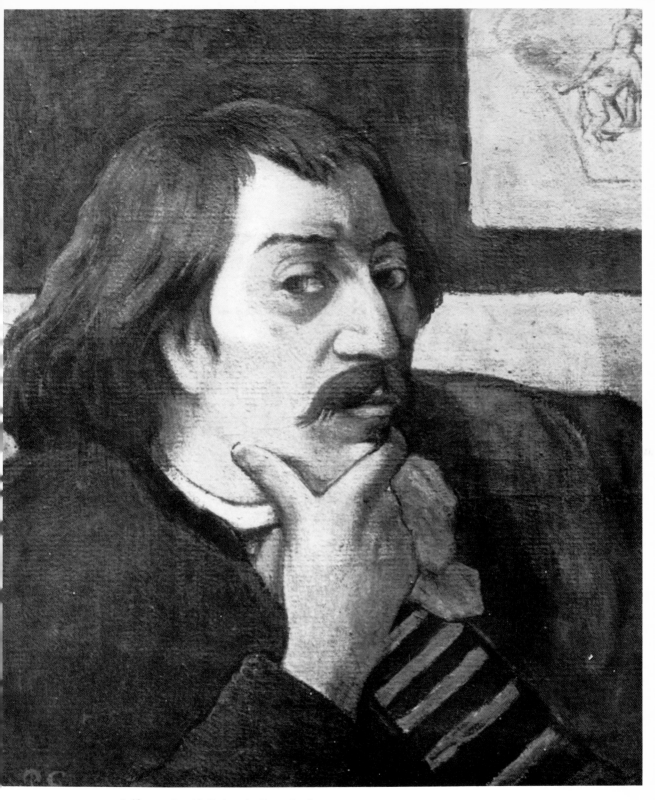

40 GAUGUIN *Self-portrait with Delacroix Reproduction c. 1890*

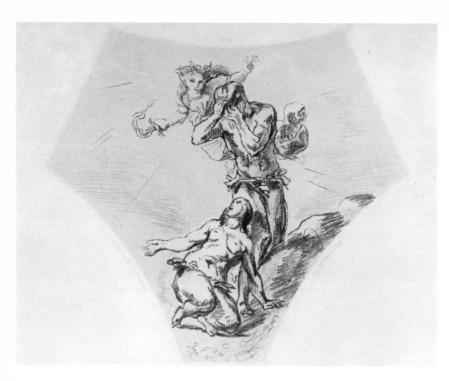

41 Facsimile reproduction (1864) of a Delacroix drawing: *Adam and Eve driven from Paradise*

42 GAUGUIN *Window open on the Sea c.* 1885-6

Gauguin's *Portrait of a Man* and *Still-life dedicated to Faure*, both of 1884, make the point even more clearly, because their backgrounds consist of a combination of textured strokes and a floral wallpaper motif undoubtedly suggested by a favourite *Pl. 19* Cézanne of Gauguin's, the *Still-life with Fruit Dish* of around 1880. Rather similarly, Gauguin had seen in the impressionist *Pl. 9* exhibition of 1882 Monet's *Sunflowers* of 1881. A remark made to van Gogh six years later shows that he remembered the *Pl. 10* picture clearly.[4] And his own *Basket of Flowers*, which probably dates from 1884, has the same kind of sinuous rhythms as are found in the Monet, and the same kind of textured background. Its ribbon-ends are even very close in character to the hanging leaves there. Again, Gauguin owned a second Manet —this time an oil-painting, the 1872 *View of Holland*. He lent this work to the 1884 Manet retrospective in Paris. On the reverse of his 1888 *Harvest in Brittany* there is a still-life, *Window Pl. 42 open on the Sea*, which is surely of earlier date; several different features, in fact, point to 1885 or 1886. The depiction and spatial arrangement of the boats on the water there can be compared directly with Manet's syntax in that marine of his. And finally there are the Degas-like features of Gauguin's 1886 canvas, *The Four Breton Women*. The light buoyancy of the figures, the supple poses, the fine delineation of the delicate profiles, are all very much in line with Degas' practice in his ballet-scenes of the mid seventies. And Gauguin must indeed have owned a photograph of one such ballet-scene, the 1874 *Rehearsal*, since he used three figures from it on a carved box of 1884.

Toulouse-Lautrec's assimilation of impressionism resembles Gauguin's, in the sense that it took a long time to complete itself, and also in the sense that the following of technical leads preceded and led up to dependence in terms of organization. Between 1883 and 1887, that is, Lautrec explored, quite gradually, the technical traits which made Manet's and Renoir's example fruitful, before going on in 1888 to render body movement on lines suggested by the work of Degas.

Van Gogh, on the other hand, did not acquire any knowledge of impressionism until as late as 1886-7;[5] and he then passed through the corresponding stages of assimilation so rapidly that the whole development compressed itself into the space of some six to nine months. Just because of this rapidity, it is difficult to pinpoint the exact sequence in which the different kinds of borrowing occurred, and to relate them to one another. It would appear, however—insofar as the evidence allows any conclusions—that technical borrowings and borrowings of syntax were pretty well interwoven in his case, as in the

case of Seurat. This is suggested by consideration of the
following five works, in the order in which they were pre-
sumably done: the *Quarry at Montmartre*, the version of the
Moulin de la Galette with sheds below, the *Self-portrait* in the
Kröller-Müller Museum, the *Lady at the Cradle* and the *Still-life*
with Plaster Statuette. The *Quarry*, that is, suggests the instruc-
tion of Camille Pissarro, both in the technique used to convey
fluidity of atmosphere and open up the space as a whole, and
in its low-keyed, predominantly grey-green scheme of tonal
harmonies. The *Moulin de la Galette* with sheds ties in with the
example of an early, impressionist landscape of Signac's, the
1884 *View of Montmartre*—there were presumably others like
it—not only in the loose, rather thick quality of the brushwork,
but also in the steep downward jump from the skyline to the
base of the hillside. The Kröller-Müller *Self-portrait* combines
quick, free strokes, which enliven the subdued blue-green
tonality of the background and give a sense of air around the
head, with touches of lighter colour. In the *Lady at the Cradle*
a fine stitch-pattern of strokes, with an effect of shimmer
reminiscent of Renoir's work of the seventies, is superim-
posed on a harmony of blues, light pinks and yellows which
recalls both Renoir's and Monet's indoor portraits of the early
seventies. As for the *Still-life with Plaster Statuette*, the dry, raffia-
like quality of the angled strokes as well as the tilting up of the
table-top and the placing of the books in relation to it can be
related to the example of a Signac *Still-life* of 1883. And this
sequence covers the whole of the relevant period, running as it
does from the winter of 1886, when van Gogh's palette first
began to grow consistently lighter, through to the summer of
1887, when he moved over to using a pointillistic technique.

So much for the passage through impressionism. The rele-
vance of impressionism to the post-impressionists does not,
however, end there. There are also two further stages to be
considered, which belong to the relative maturity of the post-
impressionists and whose character can be conveyed by the
terms 'transformation' and 'translation'. Transformation invol-
ves using a known work by another artist as a springboard or
point of reference, but making the resultant picture absolutely
and completely one's own. The affinity with the earlier work is
therefore confined to imagery, mood and behaviour in the
case of figures—without there being any sense on the artist's
part that he is falling in with precedent. And this is what tends
to distinguish the creative process in question from its counter-
parts in earlier periods.

Pls. 11–13

Pl. 15

Pl. 16 Gauguin's *Breton Coast* of 1886 is a transformation of a north-coast subject of Monet's. The motif of massive rocks stretching across the picture, with breaking waves or surf and a short strip of beach, is found specifically in some of the sea-scapes which Monet had painted at Etretat in 1884-5. A number of these paintings were shown at Georges Petit's in the middle of 1886. In all probability Gauguin saw that exhibition, which opened in May, before he went off to Pont-Aven that summer. He would then have used this imagery of Monet's, with its wildness of mood, as a point of departure when he came to paint a north-coast subject of his own that same year. The *Snow Scene* of 1888 equally calls for comparison with winter subjects of Monet's and Sisley's which Gauguin must have known, by virtue of its imagery of cottages, snow on the ground, bare trees and a winter sky. But it departs from that precedent in every other respect, thereby advertising the now consolidated differences between Gauguin and Monet.

Pl. 17 Another, more intricate case of transformation is Gauguin's *Farmyard Scene* in Indianapolis which probably dates from 1889. Gauguin, according to report, had a penchant at this time for starting work on a canvas with the words 'Let's make a Cézanne';[6] and it looks very much as if this picture were one of the works created in that spirit. It contains a whole array of Cézanne features. There is the imagery of rectilinear white buildings with orange-red roofs, directly reminiscent of Cézanne's Provençal landscapes, and the dominantly orange-green colour scheme. And then there is the merging and fading out of certain planes where they meet one another, and the long weave used for the hay with the white priming showing through. But at the same time the minutiae of technique and colour usage identify the picture absolutely as Gauguin's handiwork throughout. Furthermore, the Cézannesque features just enumerated are introduced and manipulated in a much more pointed and self-assured way than was true of the comparable elements in Gauguin's landscapes of 1884. The 1886 *Still-life* *Pl. 18* *with a Portrait of Laval*, with its apples grouped on the table-*Pl. 19* cloth almost exactly on the lines of the *Still-life* of Cézanne's which Gauguin owned, and its fracturing of the self-contained unity of this ensemble by the introduction of the head looking in, stands in between from this point of view. The relevance of Cézanne's syntax is accepted in the modelling of the fruit there, as in the treatment of the background; but it is rejected entirely, and almost made fun of, in the motif of the head. It is as if Gauguin were allowing the usefulness of Cézanne's example at this stage, and capitalizing on this usefulness where it suited him

to do so—while at the same time he saw Cézanne's art as limited, and limiting, in its uniformity.

The *Farmyard Scene*, seen in this light, all but amounts to an open parody of Cézanne.[7] For the respect and the reservations, instead of being expressed side by side, now apply to the picture as a whole. And parody, when it rises to this level, is a special form of transformation. Toulouse-Lautrec's 1884 parody of Puvis de Chavannes' *Sacred Wood*, and the caricature of Manet's *Olympia* which Gauguin did in his notebook in 1889 can be compared from this point of view. Just as Lautrec's version introduces a spearhead of Bohemian invaders breaking up the peace of the grove, and the flying figures overhead are made to carry a mirror instead of a harp, so Gauguin gave the attendant with the flowers a leering expression which is foreign to the original, and showed Olympia as propping herself up with one arm. While the basis for this sketch of Gauguin's is immediately recognizable, because of the nude's outward gaze and the presence of both cat and bouquet, the sense of the original grouping is wilfully disrupted—as it is also in the Lautrec.

Again, Lautrec's *Drinker* of 1889 is a transformation of Degas' *Absinthe* of 1876. The subject is essentially the same in both cases—the slouch and dejection associated with alcoholism —but Lautrec showed his figure in a close, profile view, with more strongly etched contour-lines and more acid colours. Analogously, Gauguin's *Portrait of the Schuffenecker Family*, from the very beginning of 1889, may be read as a transformation of Degas' *Bellelli Family* (1858-60). In both works a pair of daughters, though psychologically detached from their mother, are close to her and watched over by her, while the father in contrast is at some remove from the mother and has an occupation of his own. Furthermore, the cryptic quality of innuendo in the Gauguin about Schuffenecker's capacities as a man and as an artist gains an additional pointedness from this presumed reference to Degas. Schuffenecker, a small and rather awkward figure, stands to one side by his easel, looking on deferentially while his wife and children huddle together in their greatcoats. The clothes are humble, instead of proper; the room is bare, instead of well-furnished; and two unframed prints stand in for the oil-painting and the drawing of the artist's father in the Degas. A whole chain of further cases in which Gauguin appears to have drawn on Degas' imagery and transformed motifs of his will be discussed in later chapters. All of them come in the second half of 1888, so that they link up in date with the *Schuffenecker Family* and form a line leading up to it.[8]

Pl. 20

Pl. 21

Pl. 22 By the same tokens, van Gogh's *Fishing in the Spring* of 1887 moves towards being a transformation of a Monet subject. By the second half of 1886 van Gogh had seen some of Monet's landscapes and had admired them greatly.[9] No doubt he had been to the exhibition at George Petit's that summer, mentioned earlier as including Monets; and he may also have visited Durand-Ruel's gallery. In terms of imagery, his *Fishing* is to be

Pl. 23 compared with Monet's 1882 canvas of *Two Men Fishing*, which he could well have known. And the basic kinship of subject-matter here makes the differences, and those elements which are quite personal to van Gogh, all the more transparent.

While it bears no relation to the Monet in question, van Gogh's technique in this case could still be called impressionistic.

Pl. 24 This, however, is no longer true of his *Boats at Saintes-Maries* of June 1888. And here van Gogh presumably had in mind a Monet of four coloured boats on a beach which he had seen at his brother's gallery, for he mentioned it to his brother, in another connection, four months later.[10] The painting in

Pl. 25 question was most probably Monet's *Boats at Etretat* of 1884. It has a similar alignment of prows and criss-cross of masts and spars. So it could well have represented for van Gogh a standard in outdoor painting which he was matching in his own terms. And the line of connection here can be compared with line of connection between Seurat's *Cornfield* with poppies, of about 1885, and related subjects of Monet's of the early 1880s.

Pl. 6
Pl. 26 Again, van Gogh had in mind Cézanne's *Harvest* when he painted his *Harvest in the Crau* in the same month.[11] This was the same Cézanne, of the mid seventies, that Gauguin appears to have owned; and van Gogh had seen it at Portier's in Paris, where Gauguin had evidently left it when he went off to Martinique in 1887. The link between that *Harvest* and van Gogh's lies not in technique, syntax, or detailed imagery, but in the harshness of the sunlight in both cases and the pungency of the colours (unusual for Cézanne). Similarly, at Auvers two years later van Gogh saw the 1873 *View of Auvers* by Cézanne which was in Dr Gachet's collection. Indeed, it was amongst the pictures which he was shown by the doctor almost as soon as he arrived.[12] And he chose a broadly similar viewpoint for one of his own paintings of the village, the *House of Père Pilon*. Here again, then, van Gogh—whose appreciation of Cézanne seems to have been restricted to relatively early works—can be said to have been matching in his own terms an impressionist's choice of subject.

As for translations, these are cases where the artist bases himself on a given image or motif, in the same sense as a copyist

does, but brings into play his own language of colour and brushwork and his own expressive syntax. He changes the values of the imagery in the process, in terms of the phrasing of details, and often adds motifs of his own around or in the empty areas. Here the factors of homage and self-training may still play some part, as they did in earlier periods. But they tend to be quite secondary, as compared with the artist's assertion of his ability to remake the given image in his own personal fashion.

Translation was in fact van Gogh's own term for the painted versions which he did at Saint-Rémy of prints after Delacroix, Millet and others.[13] And Gauguin used an exactly analogous process to create a watercolour version of a Delacroix flower-piece in the 1890s. He used, that is, the black-and-white photo-lithograph of the Delacroix found in the 1878 sale catalogue of the Arosa collection, of which he had a copy with him; he invented appropriate colours; and he gave the whole transcription a fluidity, harmony and tonal freshness of his own. He pasted the work into the manuscript of his *Noa-Noa*, which also contains two graphic transcriptions, equally free, of Delacroix reproductions in that same catalogue.

Van Gogh never did a translation of an impressionist work. Presumably this was because he never had a suitable work available at an appropriate time; for he was not averse to using for exactly this purpose the drawing of an *Arlésienne* which Gauguin left behind at the end of their stay together. Gauguin, on the other hand, produced works which fill the gap. Already in 1885 he had adapted a landscape of Cézanne's which he owned, a *View of L'Estaque* dating from about 1882, to make a fan-design. This is not exactly a translation, for Gauguin's main interest here obviously lay in evolving a design which was effective in a decorative sense; and he added invented sections to the Cézanne simply in order to fill up the two outer-most segments. It does, however, embody one of the key features of translation in embryonic form, in the sense that the fan-shape forced Gauguin to slice away much of the falling landscape at the bottom of the Cézanne. This inevitably violated the painting's structural integrity, and Gauguin, in compensation, wove in a different kind of continuity by making the contour-lines of the fields and hills sharper and more cursively rhythmic. The same applies to the bending around and retailoring of the landscape at those points where it was originally adjacent to the framing edge.

Far more to the point, however, is the appearance of the *Still-life* of Cézanne's which Gauguin owned in the background of his 1890 *Portrait of Marie Lagadu*—especially since this

Pls. 118, 119

Pls. 27, 28

Pl. 19
Pls. IV, 29

post-dates the transformation of Cézanne in the *Farmyard Scene*. Gauguin dropped the hanging corner of the tablecloth here, changed the angle of the fruit-knife and tilted up the base of the glass, so that it seems at first sight as if the objects in question were on an actual table behind the sitter, with a wall-paper background behind that. This enlivenment of the visible parts of Cézanne's arrangement has the effect of bringing the physical environment around the sitter into key with the obviously Cézannesque character of her head and shoulders. But the structural integrity of the painting is again compromised in the process. And the violation is now more extreme. For the Cézanne is also made more ornamental in its colours and rhythms, to fit with its role as a decorative adjunct which sets off the figure of the sitter. In sum, whatever harmony there may be in the Gauguin between the different parts of the still-life, the sitter in front of it, and the framing edges is verifiably due, not to the real Cézanne, but to the qualities of Gauguin's translation. And the picture in its entirety serves as a demonstration of how, at the invitation of Cézanne, Gauguin could remake reality in appropriate yet personal terms.

An element of homage may well have been involved here, since the Cézanne *Still-life* was a 'pearl' in Gauguin's eyes.[14] And the large-scale copy of Manet's *Olympia* which Gauguin painted early in 1891 was undoubtedly an act of homage, since the *Olympia* had been recently acquired for the nation by subscription amongst Manet's admirers, and it had just been put on view in the Luxembourg Museum. This work, nevertheless, is equally a translation. The silvery-grey passages of shadow in the bedclothes and bouquet are rendered in blue; blue as well as green is used for the curtains to the rear; and touches of yellow and orange fill out the face of the Negro. Gauguin's own characteristic brushwork appears in this face, the curtains and the panel at the left; and a patch of red behind Olympia's left shoulder accentuates the jut of this shoulder. Olympia's head is somewhat tilted, and there is a change in the direction of her gaze which modifies its expressive character. The head of the attendant, whose frame is proportionately larger and broader, is swung to the right, with a corresponding change in the angle of gaze there as well. And finally the thin vertical strip between the background panels receives more emphasis, and the lines of direction running out from this axis towards the edges of the canvas are accentuated. The result of these changes, then, is that the translation reads into the Manet a juxtaposition of modelled areas and flat ones, and an extended rhythmic flow. These are both leading features of

Pl. 30

Gauguin's current work. The translation also highlights and detaches the relevance which the *Olympia* now had for Gauguin simply as an image of female captiousness. It is on this very front that the Manet would contribute to Gauguin's 1892 painting *The Spirit of the Dead Watches*.

The sense in which impressionism had a continuing relevance for the post-impressionists emerges even more clearly from a consideration of one special aspect of the art of both generations: the backgrounds used in still-life painting and indoor portraiture.

By a natural process of continuity and inheritance, the impressionists' way of making the section of wall behind the sitter or still-life implicitly go on beyond the framing edges passed on to van Gogh and Gauguin. The minimum requirement here (already explored earlier in the nineteenth century) is that, within the section shown, there should be some positive constancy: a constancy of colour, or of atmospheric texture, or a division of some kind running all the way across. The impressionists collectively introduced a variety of more specific elements: elements which made the section of wall representative of the character of the room as a whole, and also made it serve as a kind of sound-board in relation to the main image.

One of these elements was a background of wallpaper patterning. An early and typical example of its use is Pissarro's 1872 *Still-life* of a basket of pears. It is typical, first because of the *Pl. 31* emphasis on the self-repeating character of the design; and secondly because the design is tied in with painting's central subject in a variety of ways. It gives a sense of hollow space under the basket-handle, it points up the fine delicacy of the pear-stalks, it is light and fresh like the fruits themselves. It is notable, on the other hand, that even a minimum definition of the wallpaper's design could suffice for it to contribute to one's sense of the whole environment. This is the case in Pissarro's 1873 *Self-portrait*, and these two works of Pissarro's are indeed *Pl. 33* of great exploratory importance.[15] The vocabulary used in them makes for an impressionist equivalent to what is already found in Delacroix's portraits and Millet's still-lifes: backgrounds which are spatial, material and sensual correlates of the main image.

On occasion, one or other of the impressionists enlivened the basic character of the wallpaper design so that it tied in even more specifically with the character and handling of the figure or still-life in front of it. This happens in Cézanne's full length *Portrait of Chocquet*, from the late seventies. The lozenge- *Pl. 33* pattern there links up with Chocquet's pursed, rather feminine

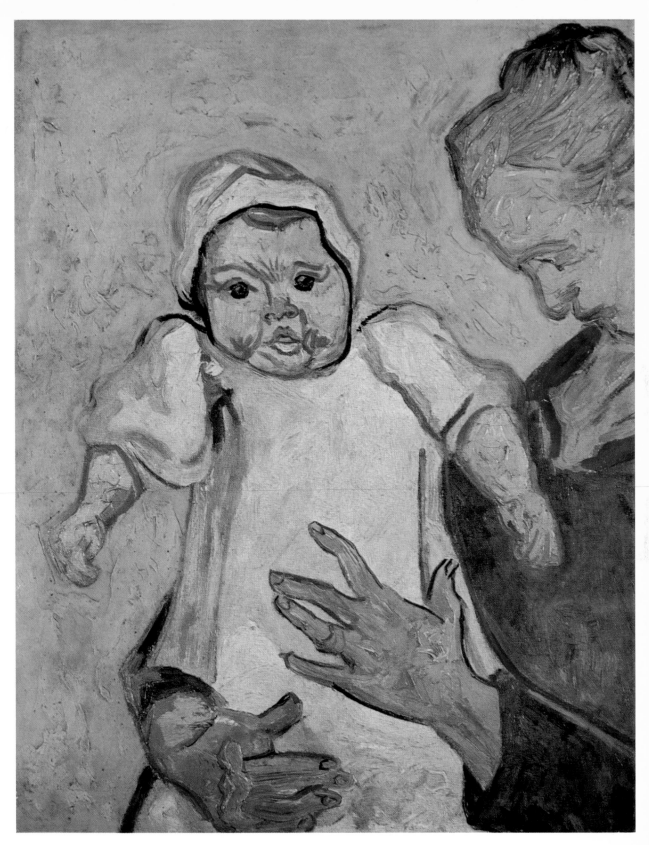

1 VAN GOGH *Mme Roulin and her Baby*. December 1888

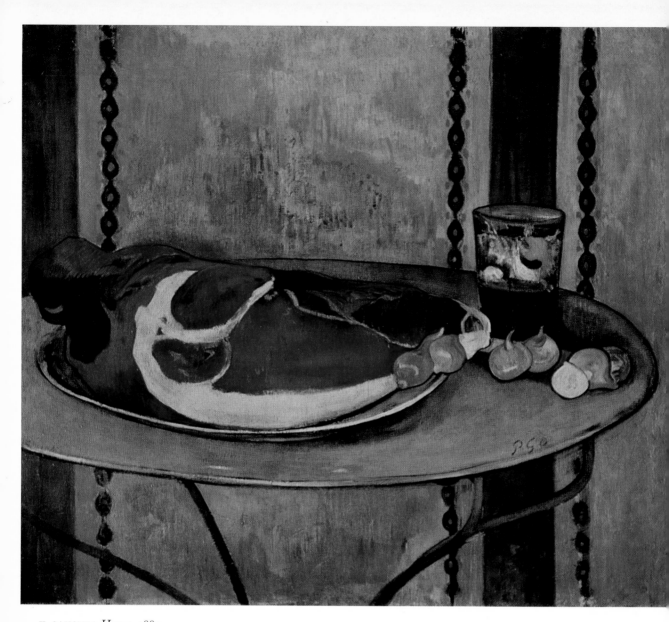

II GAUGUIN *Ham c.* 1889

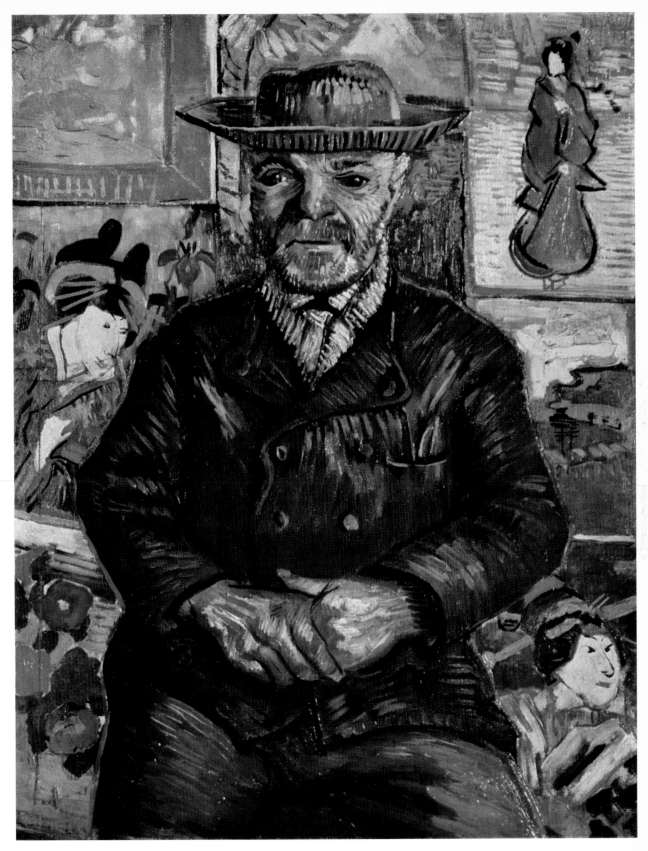

III VAN GOGH *Portrait of Père Tanguy* 1887

IV GAUGUIN *Portrait of Marie Lagadu* 1890

mouth in shape, in colouring and as a spaced-out sequence. It also happens in another work of about the same date, Monet's *Chrysanthemums* of 1878; and in Manet's *Autumn (Méry Laurent)* of 1882, where it creates an ambiguity as between the indoors and the outdoors.

Pl. 32
Pl. 45

Again, there is the way in which in impressionism, as in earlier portraiture—the tradition goes back to the Renaissance —a painting or group of paintings associated with the subject's professional or amateur interests is shown hanging on the background wall. Where this happens in Renoir's, Pissarro's and Cézanne's work of the seventies, an air of complete naturalness characteristically governs the association. The figure is completely at ease with the works which he has painted or owns. They also identify the setting as his studio or home. And finally there is once more a structural tie-in between figure and background, which amounts to a strong, and even rigid, binding of the two together.

Pls. 33, 34, 39

The relevance of all this to van Gogh and Gauguin is that impressionism provided a basic vocabulary here, which they in turn built upon and manipulated for special purposes.

Van Gogh's and Gauguin's portrait and still-life backgrounds of 1887-90 demonstrate the truth of this in a larger sense than their earlier works, marked by specific borrowings. Van Gogh's half-length portrait of the *Zouave* of June 1888, for example, has a background of red-brick wall which stands representatively for the whole setting in question. Gauguin had already used wallpaper backgrounds in the early and mid eighties, as described earlier; and he also used them afresh in the late eighties and subsequently, without their being in any particular way like those of Cézanne now. A case in point is his *Self-portrait for van Gogh* of September 1888. Wallpaper backgrounds are found that same year in van Gogh's *Old Woman of Arles* and *Woman rocking a Cradle*. A design of this kind is enlivened in one of van Gogh's later versions of *The Postman Roulin*, and in Gauguin's *Ham*, probably of 1889. For the blooms in that painting of Roulin have a kind of half-life—especially those which are bound up in bunches; and the chain-pattern in the *Ham* is playfully treated as if it were, in some sense, holding up the table-top. In Gauguin's *Mme Kohler* and van Gogh's *Père Tanguy*, head and work of art on the wall are bound together on the same basic principle as in Renoir's *Portrait of Chocquet*, of about 1875, and Degas' *Henri Rouart and his Daughter*, of about 1877. The juxtaposition of the artist and a work of his occurs in Gauguin's *Self-portrait* with the slightly open mouth, which probably belongs to the very end of 1888.

Pl. 79
Pls. 90, 164

Pl. 35
Pls. II, 37

Pl. 194
Pls. III, 58

Pl. 39

Pl. 159

And Gauguin's *Portrait of van Gogh* of the same date is, in one particular respect, in the tradition of Renoir's 1867 *Portrait of Bazille* and Manet's 1870 *Portrait of Eva Gonzales*. Bazille is shown working on a half-finished canvas, with a finished snowscape of Monet's on the wall behind him; Eva Gonzales is shown at work on a flower painting, with a peony on the floor demonstrating how Manet painted blooms himself, and a rolled-up print alongside with Manet's signature on it; and van Gogh is shown working under a landscape of Gauguin's. In all three cases, then, the picture within the picture suggests whose instruction it is that is being followed in the act of creation portrayed.

Equally, by an extension of the same premises, the background to van Gogh's *Portrait of a Young Girl* in profile, which *Pl. 36* consists of little broken circles of one colour, plays a role akin to that of wallpaper, because of the uniform size and regular spacing of the pattern. The work of art in the background of van Gogh's *Self-portrait with a Japanese Print* acts as an extension *Pl. 64* of the personality projected in the main image; and the one in Gauguin's *Portrait of Marie Lagadu* has a special appropriateness *Pls. IV, 29* to the treatment of the sitter. Again, the crescent moon and star in van Gogh's *Portrait of Milliet*—like the pictures on the wall in his Parisian *Portrait of Alexander Reid,* the art dealer— denote the sitter's profession. For they are the insignia of the lieutenant's regiment, transferred, as it were, from his shoulders to the background. And in Gauguin's *Self-portrait with the* *Pls. VIII, 38* *'Yellow Christ'*, the painting and pot to the rear both allude to the conflicting mixture of sensitivity and savagery in the artist's personality, and define the environment as his studio, with works which he has recently brought into being hanging on the wall and lying on a shelf. Gauguin is simply shown against this intensely lit background, rather than depicted at work or in an attitude of meditation, as in early nineteenth-century counterparts.

In these latter cases, both the continuities and the differences between impressionism and post-impressionism have to be considered side by side. The same applies to those backgrounds of van Gogh's which consist of a single, vibrant colour. In his *Mme Roulin and her Baby* of December 1888, for example, the *Pls. I, 156* golden-yellow background has the kind of atmosphericity and luminous clarity that one associates with Monet's landscapes. In some ways, indeed, it specifically suggests the outdoors rather than the wall of a room. But to say this is also to say that this background no longer denotes a specific environment, nor its lighting a specific time of day. Rather than being simply an ex-

tension of the sitter's personality, the background now becomes like an emanation from that personality, with a corresponding broadening of its implications.

A final comparison can be made, in the same sense, between a *Self-portrait* of Gauguin's which probably dates from 1890 and Renoir's *Portrait of Chocquet*. Similarities and differences stand out even more clearly here, by virtue of the fact that a work by Delacroix appears in the background in both cases. It is, indeed, the main feature of those backgrounds. In the Renoir the work in question—which Chocquet specially asked the artist to put in—is a study in oils for the Hôtel de Ville canvas of *Hercules delivering Hesione*. This is recognizable from the pose of the figure. And what one sees in the Gauguin is in fact a reproduction of a drawing by Delacroix for the Palais Bourbon fresco of *Adam and Eve driven from Paradise*. In both cases the work is so placed and presented that the key image within it is visible, isolated and clearly readable as far as focus is concerned. In the Renoir, that is, the figure of Hesione stands to one side of Chocquet's head, rather than in the section obscured by that head. In the Gauguin, Adam and the Angel are cut off by the framing edges, and the implications of relative distance affect the details of Eve's pose, but not its basic character. In both cases, too, the outer contours of the image are tied in with the build and physiognomy of the sitter himself. In the Renoir Chocquet's brushed-up crest of hair is linked up with the circular section of heavy frame, and his mouth is aligned with the straight section. In the Gauguin the two straight edges match the vertical axis of the artist's head and the nearly horizontal line of his right shoulder. Equally, some technical kinship is established in both cases between Delacroix's handling and the treatment of the sitter. In the Renoir this applies to the treatment of the beard and flesh and the tones of the body as a whole; in the Gauguin to the contours of the nose and hand. Beyond this point, however, the uses of Delacroix part company. In the Gauguin there is no space-defining frame, and no implication that the environment houses other, similar works. The Delacroix is, as it were, inserted in quotation marks, making for a more stringent and tendentious form of juxtaposition. The artist's gaze has a strongly disruptive effect on the viewer's relationship with the Delacroix. And the gesture and gaze of Eve seem correspondingly to be directed out at Gauguin himself.

There are really three sides, then, to the relationship between post-impressionism and impressionism. In passing through impressionism, the post-impressionists based themselves on

Pl. 40

Pl. 39

Pl. 41

55

what the impressionists had done between the late sixties and the very early eighties. Thereafter, they accepted the general lines of achievement of that phase as a *fait accompli*; or so it would seem from the fact that they never explicitly discussed them. They still, however, maintained their natural place in the line of succession, in the sense that they looked back to impressionist works which were relevant to their own endeavours, used one or another work as a point of departure, and built upon specific elements in the vocabulary passed on to them. And in doing this, they found that the impressionists had themselves struck out along new and refreshing paths during the course of the eighties. There were affinities now with their own advanced work, in terms of new structural departures. In so far as the politics and ambitions of the post-impressionists allowed, this was a further source for respect.

2 The Japanese Print and French Painting in the 1880s

Fundamental to this chapter will be the making of a distinction between *Japonaiserie* and *Japonisme*. Once the difference between the two has been clearly established, it can be used to clarify and interpret what happens in the 1880s.

The term 'Japonaiserie' is the equivalent, for Japan, of the better known term 'chinoiserie'. It means an interest in Japanese motifs because of their decorative, exotic or fantastic qualities. The kind of response which it aims to elicit is purely and simply a matter of imaginative or wishful association. 'Japonisme', on the other hand, means the incorporation into Western art of devices of structure and presentation which match those found in actual Japanese works. Abstracting such devices from Japanese works which he knows, the Western artist wills into being a parallel in his own art, bending to this end a theme or subject which remains basically in the European tradition.[1]

As is well known, a great wave of interest in things Japanese and the world of Japan—succeeding the earlier enthusiasms for England and Spain—struck France in the late 1850s and 1860s. The first firm date which documents the availability of Japanese prints to artists is the opening in Paris in 1862 of the 'Porte Chinoise'—a shop which sold Japanese wares.[2] In French painting, the corresponding changeover from Japonaiserie to Japonisme can be accurately dated to the mid 1860s, on the basis of the works themselves. It has been clearly shown that this is the case with Whistler; and the same point applies more generally to Whistler's major contemporaries on the French art-scene.

It is worth looking carefully in this connection at the features of Japanese art which were brought out by critics of the 1860s.[3] Half of these features were entering French art anyway between 1850 and 1870. The idea of a 'science of forms' was embodied in the legacy of Ingres. The treatment of silhouette so that it had a characterizing role in relation to the figure as a whole was to be found in the art of Ingres and Daumier alike. Compositional asymmetry is already found in Whistler's *Music Room* of 1860; a free grouping of the figures in the early work of Degas. The choice of unusual views is found both in Whistler

and in photography of the time. And contrasts of flat tones are to be seen both in Boudin's art and in the earliest work of Monet.

Another third of the features which the critics enumerated represent simply the overhang of Japonaiserie. Their constant reference to the diversity of a Japanese subject matter is a case in point. So are their comments on the piquant effrontery of this subject matter, its curiosity value and its fairy-like mood.

The remaining features which they isolated, however, are genuinely hallmarks of Japonisme. They amount to four in all. First, shifts in the direction and quality of contour. These shifts assimilate a frontal or three-quarter view of the figure to a profile view, laid out in complete parallelism with the picture plane. They flatten the spread of the figure and associate this flatness with the flatness of the canvas itself. Secondly, the chiselling of the features by means of brittle and delicate outline. In this way the expression becomes flattened and purified. Thirdly, the suppression of detail in the backdrop against which the figure is seen. The background thereby becomes secondary. It is there to support and intensify the figure's presence, or to throw some key part of the figure into additional relief, rather than as a setting which is as important in its own right as the figure itself. Such a figure-background relationship tends to reduce the total structure of the painting to a scheme of superimposed layers; at the same time, the background forces the figure forward towards the spectator. Lastly, the setting up of relationships between the cleanly geometric shape or format of Japanese art objects and the organization of shapes elsewhere in the composition.

Whistler's *Princess of the Land of Porcelain,* painted in 1863-4, serves as key example of all these latter qualities. In fact it is in this particular work that Whistler first moved over from Japonaiserie to Japonisme. And it is significant that an exactly contemporaneous change in the same direction is found in Manet's figure painting. In his *Street Singer* of 1862 only the geisha-girl-look is really Japanese; and it is in the category of Japonaiserie. The way contour is treated here really owes more to Ingres than it does to the Japanese print. Manet's *Zacharie Astruc* of 1864, on the other hand, does contain a certain quotient of Japonisme. It is mixed in with a continuing pattern of reference to the old masters (in this case reference to Titian); but it is there, nevertheless, in the schematic treatment of the hands, so that one tends to read them simply as shapes on the picture surface. It is there also in the painting of the secondary scene as if, in its light sketchiness, it were simply a section of screen behind the figure, and in the affinities of shape and colour

Pl. 43

which explicitly relate this figure to the volume of Japanese art on the table. Degas' portraits of the mid sixties, such as his *Edmond and Thérèse Morbilli* of about 1865, equally seem to contain a measure of Japonisme, in the treatment of the background and the pungency of facial expression. In the painting of seascapes, the move into Japonisme at this time is even more clear-cut. This can be seen by comparing Whistler's *Battersea Reach* of about 1864, and Manet's 1864 *Outlet of Boulogne Harbour*. Monet's *The Green Wave* of 1865, which was clearly influenced by Manet's seascapes of the previous year, falls into step too in the sense that boat and sail are comparably flattened and silhouetted there, while all detail is suppressed in the surrounding body of water.

The emergence of Japonisme in the mid 1860s (but not before that date) is therefore confirmed by a whole group of parallel developments, which coincide with a new type of appreciation of Japanese art on the part of critics and connoisseurs.

Our reason for taking the 1860s as our starting-point, even though the rest of this chapter will be about the influence of Japanese art in the 1880s, is first that the change-over from Japonaiserie to Japonisme would recur then; and secondly that the original Japonisme of the sixties was of direct concern to the impressionists when, in the early 1880s, they turned back to the initial sources and premises of their art.

To continue the story briefly from its starting point into the next decade, Whistler's Japonisme of the mid 1860s represents, in fact, a limited and circumscribed phase in his art. And the same is also true more generally. In Manet's *The Balcony* of 1868-9, there is a return to Japonaiserie. The geisha-girl-look here, the fan and the folding shutters are all, once more, motifs in that category. And the Japonisme here is certainly not more advanced than it was in the portrait of *Astruc*; if anything, it is less in evidence. The problem of access to Japanese art helps to explain this point. The Japanese prints available in Paris in the 1860s were generally cheap, commercial products of markedly poor quality—not the work of the leading Ukiyoè masters. In Manet's *Portrait of Zola* the print on the wall is not in fact by Utamaro, but by a later nineteenth-century follower of his, Kuniaki II. The general idea in Paris of Utamaro's art at that time was presumably based on this kind of derivative work. Also, the Japanese print only confirmed in the mid 1860s what was happening in painting anyway. Consequently, the Japonisme of around 1865 was fully absorbed and assimilated by the end of the decade. If the Japanese print is relevant to

Degas' *Mme Camus* of 1870, it is relevant only in the most broad and generic sense.

The continuing use of Japonaiserie in the 1870s is a matter of its introduction into isolated canvases, where the subject invited this. Degas' *Portrait of Hortense Valpinçon*, from about 1872, and Manet's *Lady with the Fans* of 1873-4 are both cases in point. An interest appears here in the charm of Oriental pattern, as found in a fabric or a fan. This interest is only a further extension of that Western appreciation for the pattern of Oriental carpeting already seen in Whistler's *Princess;* it is simply a special case of susceptibility to the exoticism and charm of Oriental decorations.

Equally, in Monet's *Camille in Japanese Costume* of 1876 the degree of Japonisme found in the treatment of the figure, and its relation to the space around it, is no further advanced than the Japonisme of the mid sixties. But there is also, of course, Japonaiserie here. Monet gives full rein to this; he makes capital out of the fancy-dress quality which Japanese artifacts assume in a European context. Furthermore, a more specialized kind of Japonaiserie prevails here. The key motif is not just Japanese costume in general, but a specific kind of costume with a samurai embroidered on it. A Japanese expert could pinpoint exactly the date and origin of this costume; the fan decorations are also specific enough for it to be theoretically possible to identify the actual ones which Monet used. Japanese artifacts, then, begin at this point to be treated as period costumes are treated when they are hung in a museum case with labels and dates. A second phase of Japonaiserie introduces itself here. In this connection there is a striking contrast between this Monet and Renoir's 1878 *Portrait of Mme Charpentier and her Children*. Renoir was not interested in Japonisme, and the Japanese objects in that particular work of his are brought in purely for their social connotations.

Whistler's *Nocturnes* are in fact one and all 'Japonaiseries' of the later and more advanced type which has now come into focus. Their specific source is the art of one particular Japanese landscape and seascape artist, namely Hiroshige. The kind of motifs and shapes which occur in Hiroshige's work are playfully attached to Whistler's London subject-matter, thereby giving this subject-matter an alien mood and an atmosphere of a strongly evocative kind.

Now in the 1880s the two possibilities, Japonaiserie and Japonisme, recur afresh, with the significant difference that the great Japanese artists are now known and appreciated individually. There were by now Western monographs pointing out

Van Gogh, Gauguin and the Impressionist Circle

Pl. 81
Pl. 44

43 MANET
Portrait of Zacharie Astruc 1864

44 MANET
The Lady with the Fans 1873-4

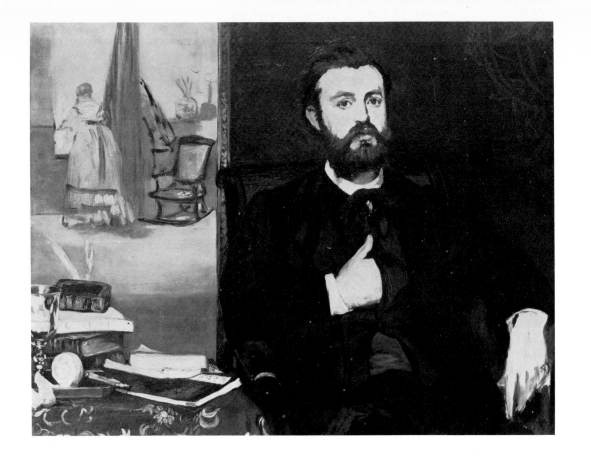

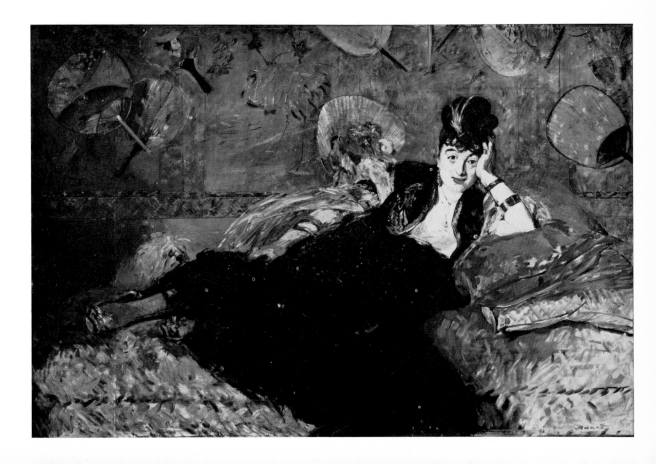

45 MANET *Autumn (Méry Laurent)* 1882

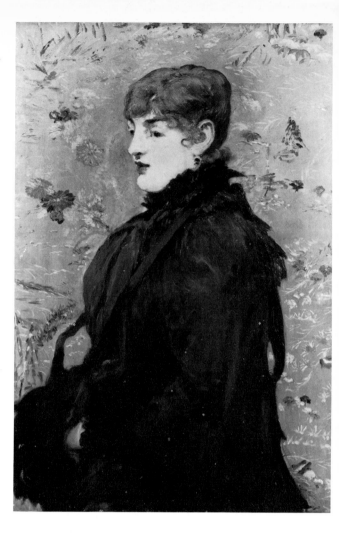

46 H. GUÉRARD
New Year Card 1884

47 STEVENS *The Japanese Dress* c. 1870-75

48 STEVENS *The Blue Dress* c. 1888

49 MONET
Juan les Pins 1888

50 HOKUSAI
Lake Siwa

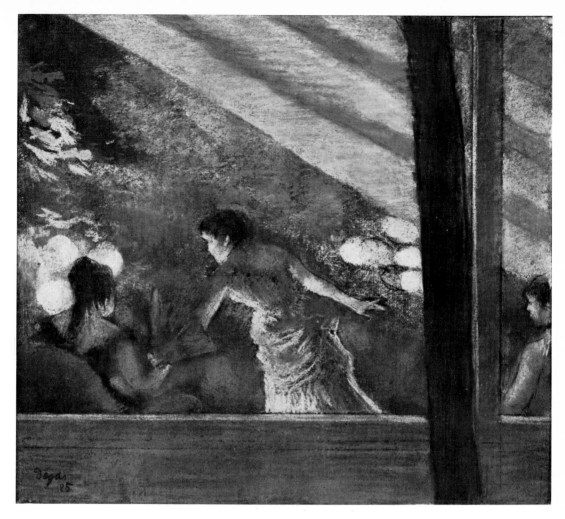

51 DEGAS
The Café Concert 1885

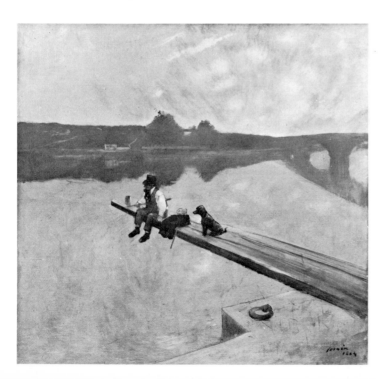

52 FORAIN
The Fisherman 1884

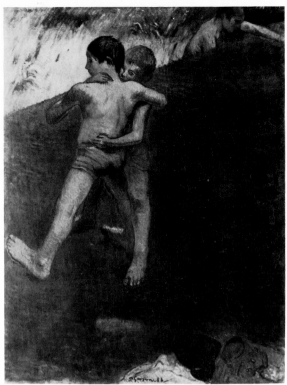

53 GAUGUIN *Young Boys Wrestling* 1888

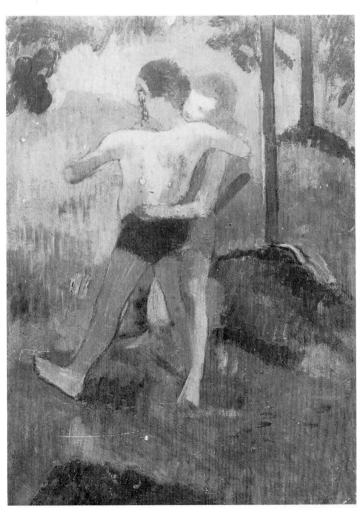

54 GAUGUIN *Young Boys Wrestling* 1888

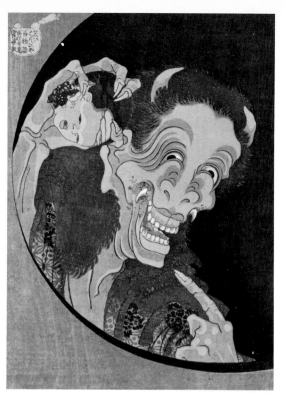

55 HOKUSAI *Laughing Hannya*

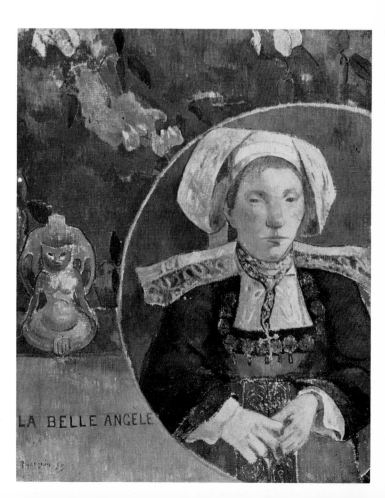

56 GAUGUIN *La Belle Angèle* 1889

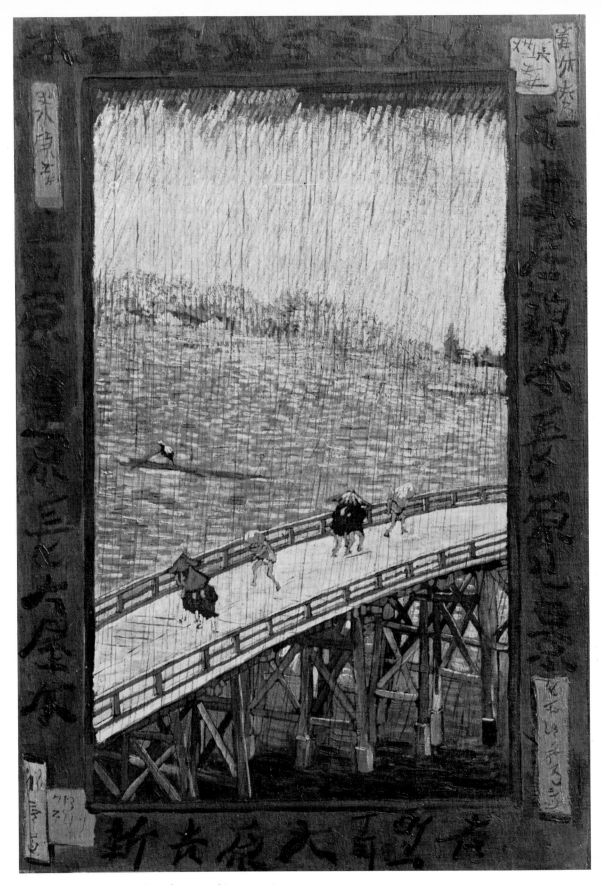

57 VAN GOGH *The Bridge* after Hiroshige *c.* 1887

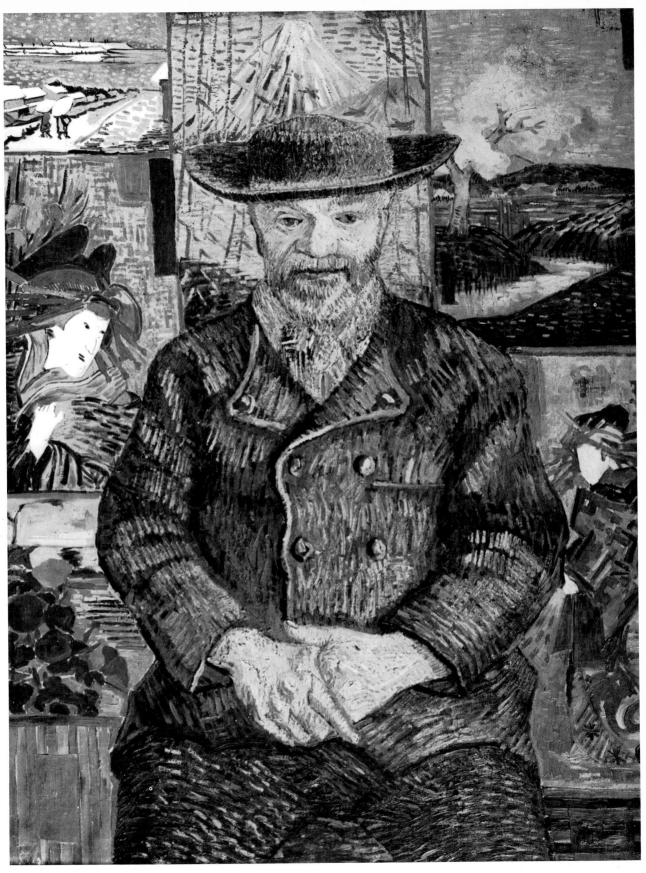

58 VAN GOGH *Portrait of Père Tanguy* c. 1887

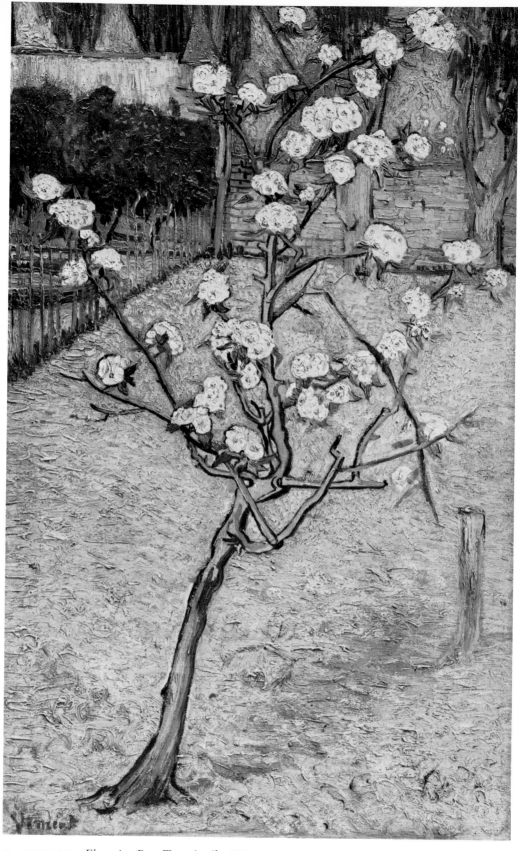

59 VAN GOGH *Flowering Pear Tree*. April 1888

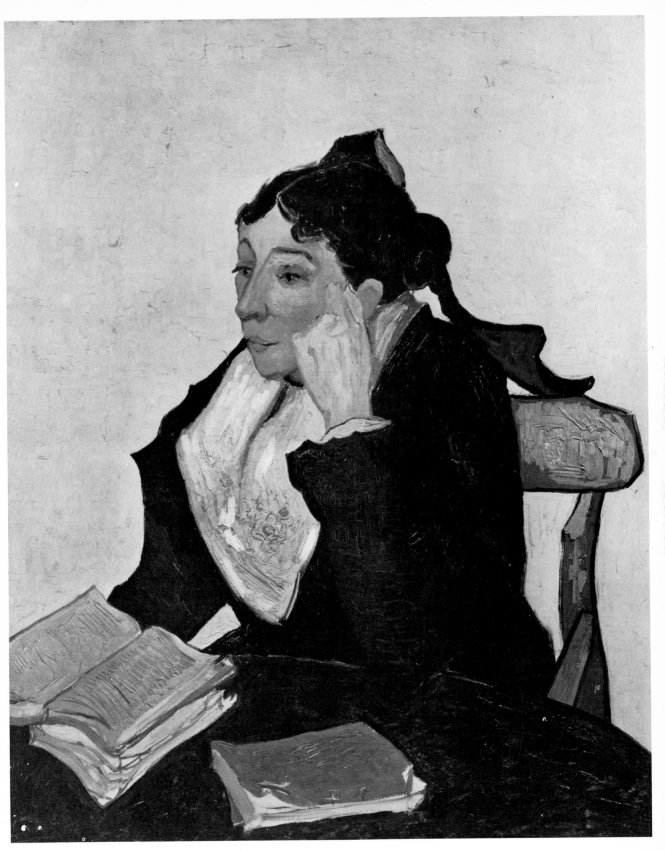

60 VAN GOGH *Arlésienne.* November 1888

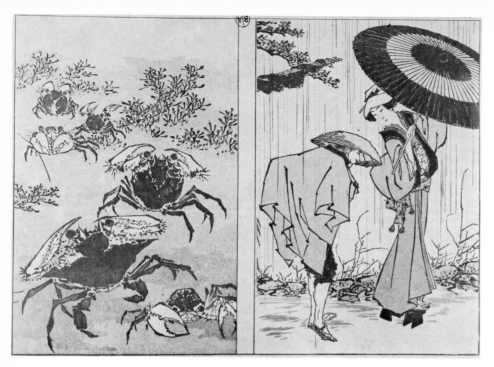

61 HOKUSAI *Crabs amongst Seaweed and People in a Shower*
from the *Gashiki* 1819

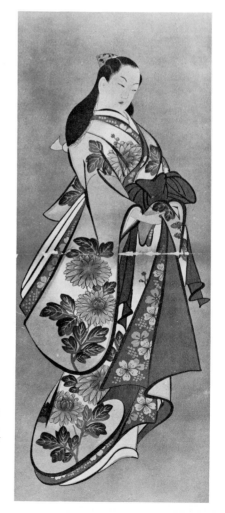

62 KAIGETSUDO
Kakemono ('Portrait of Usukumo').
Early eighteenth century

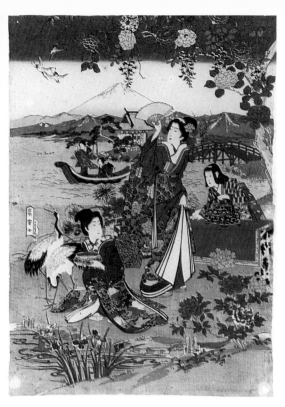

63 TAIYENSAI YOSHIMARU
Geishas in a Landscape c. 1870–80

64 VAN GOGH
Self-portrait with a Japanese Print
January 1889

65 UNKNOWN JAPANESE ARTIST
Study of Grasses 1845

66 'BUMPO' *Study of Pinks*
from an album of flowers *c.* 1800

67 VAN GOGH *Ears of Wheat*. June 1890

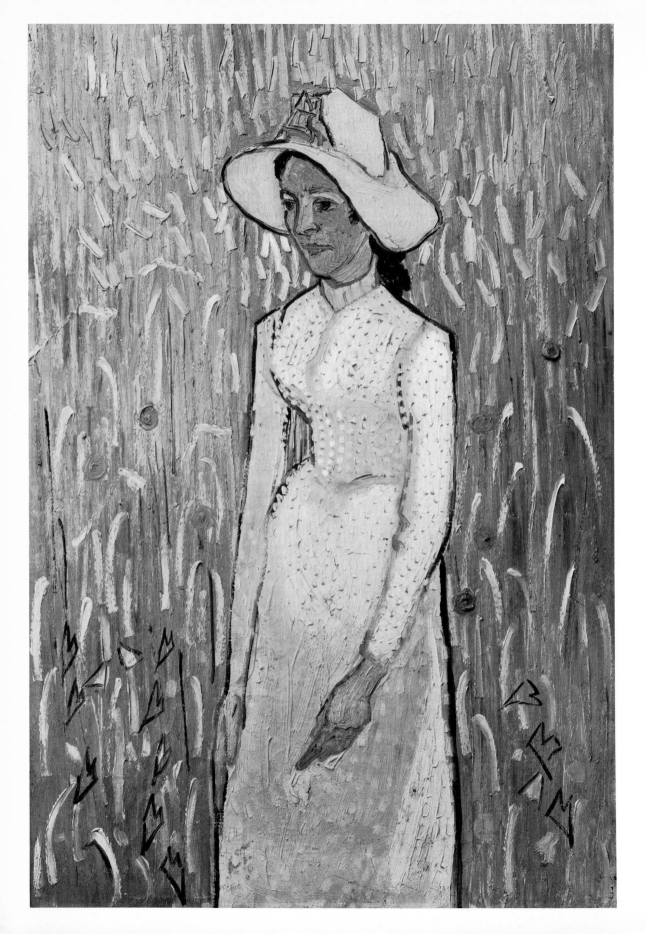

the hallmarks and the special qualities of each print-maker's work. Examples of the finest prints were now collected, as opposed to derivatives and imitations of poor quality; and reproductions were also being produced and circulated.[4]

The basic pattern of development of the sixties also recurs now, in the sense that Japonaiserie exists as a necessary antecedent of Japonisme—leading up to the latter and in due course giving place to it. Only in both cases the situation has moved one step forward. The second wave of Japonaiserie, that is, is a Japonaiserie based on specific models; it involved a recognition of the special or unique character of these models. And similarly the second wave of Japonisme was based on access to specific kinds of prints by the greatest Japanese masters, or on reproductions of such prints. It entailed an awareness of the special qualities of structure and presentation which were to be found in these particular prints.

The new Japonaiserie of the 1880s is rather well exemplified *Pl. 46* in a New Year card of 1884, signed H. Guérard, which belonged to Theo van Gogh. The Japanese heads here are based, in their diminutive and comical gnomishness, on the work of a certain follower of Hokusai. Similarly the treatment of grasses *Pl. 45* and flowers in the background of Manet's *Autumn (Méry Laurent)* of 1882 appears to have been suggested by Japanese screens. And then, to illustrate what Japonisme now meant, there is the low-level case of certain works by Alfred Stevens (just because this is a low-level case, the works in question *Pl. 47* have a representative value). In Stevens' *The Japanese Robe*, which presumably must date from the seventies, the Oriental costume is presented in careful detail, and this costume with its elaborate flower-patterns is associated with the young woman's dreaminess and the whole suggestion of romantic longing. In *Pl. 48* the same artist's *The Blue Dress*, on the other hand, which must date from around 1888, there are not only Japanese furnishings but also a counterpoint between the Japanese profile on the screen and that of the lady herself. Obviously the limited degree of Japonisme that one finds here was engineered to match the particular idiom of figure-painting which is seen represented on the Japanese screen to the rear.[5]

The work of at least two of the impressionists after 1880 involves Japonisme of the new kind. Monet and Degas are the artists in question. Each had passed through Japonaiserie in the seventies, in the sense that they had developed its potentials in one or two works apiece. Now the Japonisme in which they had briefly indulged in the mid sixties engaged their attention further.

68 VAN GOGH
Girl in White June–July 1890

Monet is known to have had a collection of Japanese prints of his own, which he had begun to form fifteen to twenty years earlier; and definite signs of Japonisme enter his work from about 1882 onwards. Almost as if he were picking up again where he had left off in 1865, colour, surface design, and the envelope around the image are now each and all developed more freely in their own right. Thus his works of 1882 like *The Cliff Walk* have a wiry, containing contour running around the larger shapes in the foreground. This contour is given a new force, a greater simplicity and purity of rhythm. The whole form is thereby brought up towards the surface; it becomes firmer and more geometric. Following on from this, his works of 1884-5 show an elimination of intermediate values and a spread of dominant colours, which are raised in themselves to a higher and more contrasting intensity. With this comes an even firmer and stronger segmentation of the landscape—as if it were made up of pieces welded together at the seams; and the whole of the foreground is tilted up towards the picture plane. By 1888 the foreground typically becomes like a screen extending itself parallel to the picture plane. This development represents the climax of Monet's Japonisme, in the sense that his landscapes are now extraordinarily close to actual prints by Hokusai, in structure and layout alike.

Pl. 182

Pl. 49

Pl. 50

For Degas, the 1883 exhibition of Japanese art at Georges Petit's seems to have been specially important.[6] It affected Forain too, to judge by his *Fisherman* of 1884. Perspective is manipulated there to produce a witty and striking ambiguity as regards the figure's relationship to the water surface on the one hand and the picture-plane on the other. Furthermore, the figure itself is very Degas-like. This suggests that Forain was in close touch at this moment with Degas' own preoccupations of the time. And Degas himself the following year in his pastel, *The Café Concert*—which represents a re-working of an etching of about eight years earlier—used sweeping, diagonal lines of perspective to very similar effect. The spatial position of the singer is made equally ambiguous there, as it had not been in the original etching.

Pl. 52

Pl. 51

To turn now to Gauguin and van Gogh, what happens with them testifies to the essential unity of French painting in the 1880s. They go through Japonaiserie first, some ten years later than the corresponding moment in Monet's and Degas' art. Since they were a generation younger, this is entirely appropriate. Their phase of Japonisme then begins about five years later than the corresponding phase in the development of the two older artists. Allowing, then, for the time-lag that one would

expect, impressionism and post-impressionism move in parallelism, as far as the Japanese print is concerned, during this decade. The direction of development was the same in both cases.

There is in fact only one example of Japonaiserie amongst Gauguin's early paintings—just as there was only one example in Monet's work of the seventies. About 1885 Gauguin did a *Still-life with Horse's Head* which includes a Japanese doll and two Oriental fans. It is as if the book on the table here opened to conjure up a world of fancy in which, as in a dream, the concrete objects are shown floating in an almost disembodied way.

The first signs of Japonisme then follow in certain of the Martinique landscapes which Gauguin did in 1887. The *Landscape* now in Edinburgh and the one with figures entitled *By the Seashore* are cases in point. What happens in them can be roughly equated with the kind of effects which Monet had arrived at two to three years earlier. In the first of these canvases, that is, the whole foreground is flattened and evenly textured to produce a tapestried effect; in the second the structuring of trees, figures and boats has a distinctly Japanese flavour. It is *Pls. 53, 54* only, however, in the canvases of *Young Boys Wrestling* which Gauguin did in Brittany early in 1888 that this artist's involvement with Japonisme becomes completely explicit. There are two different versions of this subject, the second of which is mentioned in a letter of July that year.[7] While the anatomical peculiarities in the earlier of the two versions are based on the Javanese reliefs from Barabudur, of which Gauguin already had photographs, the second and smaller version was presumably based on the *Wrestlers* in Hokusai's *Mangwa*. Gauguin is known to have owned one volume of this publication, and it would seem that he had other volumes in his possession as well. In any event these figures of Hokusai's were the source for the *Pl. 84* figures of Jacob and the Angel in the *Vision of the Sermon* of September 1888. So this preliminary use of the figures in question some three months earlier can be taken as marking Gauguin's first major step into Japonisme.

Pl. 56 The following year, 1889, in his *Belle Angèle* Gauguin again appears to have drawn on Hokusai. Theo van Gogh acutely detected Japanese influence in the way in which the head is placed and framed here;[8] and the specific source for the motif of the roundel would appear to have been the *Laughing Hannya* *Pl. 55* from Hokusai's *Hundred Tales*. There is Japonisme here, then, in Gauguin's cutting off and placing of the figure. But one can also speak of a move back into Japonaiserie, in the sense that a specific device of Hokusai's simply served as a stimulus to bizarre invention.

The two categories of Japanese influence are similarly bridged and compounded together in another work of 1889, the *Still-life with a Japanese Print*. The actual print there probably represents an actor-subject of about 1880. And the idea of making it seem as if the actor were glaring out fiercely at the left-hand pot from his place on the wall is again a fanciful piece of playfulness, based on the stimulating oddity and droleness of Japanese characterizations of this particular kind. It is the arrangement of the pots, however, which really sustains and amplifies the effect of humorous juxtaposition and incongruity communicated by the painting as a whole. And here Japonisme enters in, as it does also in the tilting up of the table-top and the treatment of the leaves in the foreground. What happens with space and form in these two latter cases can, in fact, be compared with the Japanese influence on Degas in 1885; and also with what happens in the bottom left-hand corner of Seurat's *Poseuses,* where the props are arranged in peculiarly ambiguous layers.[9]

Pl. 77

Gauguin's indulgence in pure Japonaiserie was brief, but van Gogh's corresponding phase was one of exuberant enthusiasm. He knew of Japanese prints as far back as his days in Nuenen, and had them pinned up in his studio in Antwerp.[10] But it was only during his time in Paris that they became a positive artistic stimulus. He organized an exhibition of them, and he and his brother together began building up a solid collection.[11]

In 1887 van Gogh actually made copies of three Japanese prints. Two of these, the *Bridge* and the *Flowering Plum Garden,* were done after one particular and major artist, Hiroshige, whose works were now well known. As far as the major motif is concerned, the *Plum Garden* was made by the use of a tracing, which was found amongst van Gogh's effects; and the same was presumably true in the other case. The third copy, the '*Oiran*', was taken from the cover of the special 1886 number of *Paris Illustré* devoted to Japan. Here, too, the tracing, squared for enlargement, survives. The frogs which appear in the border below come from a woodcut after Hokusai which belonged to Theo, while the cranes at the left were taken from a print which van Gogh would use again later.

Pl. 57

Pl. 63

Now in the first two cases van Gogh invented borders with Japanese characters, and his procedure here is worth discussion in itself. Enough can be made out to show that van Gogh used the inscriptions found on a series of *Eight Views of Yoshiwara* by another artist than Hiroshige. This title, the phrase 'the new Yoshiwara' and the name and address of the publishing house are all to be found, the last two in both cases. The remaining

characters in the *Plum Garden,* however, are either meaningless ones related to those taken from that source, or they have meaning individually, but are arranged in an arbitrary sequence; and they turn up afresh in the *Bridge,* sometimes several times over. The colophons, which should contain the artist's signature, are arbitrarily filled in that same way. It is certainly remarkable that van Gogh transcribed all of these Japanese characters in such a way that most of them can be read, without knowing anything about the way in which a Japanese word is structured. But the very fact that he did this indicates that these works are 'Japonaiseries', in very much the same sense as Whistler's *Nocturnes.* For the characters have no consistent meaning or connection with the image; they are introduced purely for their decorative and associative value.

Pls. III, 58

The 1887 portrait of *Père Tanguy* is equally a piece of Japonaiserie. The prints seen on the rear wall here include: at the bottom left *Morning Glories,* reminiscent of Hokusai; at the upper right the *Ishiyakushi* from Hiroshige's Tokaido series; at the bottom right the *Oiran* once more; and at the top centre a *View of Mount Fuji,* geographically akin to the *Hara* in the Tokaido series, but different in its details. The humorous device of making the mountain appear to grow out of Tanguy's hat evokes a personal connection between Tanguy and the prints. These prints are there, then, for their associative value; they give the idea of Tanguy as an honest bourgeois tradesman, living fraternally in nature, like the Japanese painters.[12] Tied in by colour, handling and placement, they frame him physically as the border of characters frames the *Bridge.* The whole work is therefore roughly on a par with Monet's *Camille in Japanese Costume* of eleven years earlier.

Pls. 114, 136

Much has been said about van Gogh's work of 1888 which implies a full-scale change-over to Japonisme in that year; but the works themselves do not really support this contention. In paintings like the *Pont de Langlois* series, only the motif is Japanese, and then purely by affinity. Very typically, there was a delayed stimulus here from motifs which van Gogh had observed in Japanese prints in Paris. He had come to think of them in the meantime as typifying the response of Japanese artists to the landscape in which they lived. In van Gogh's drawings of 1888, the forms are, to some extent, brought up towards the surface. Outlines are crisp and incisive, the whole technique is one suited to the rapid notation of nature. Where body-colour is used, the tones tend to be flat and clear and to stand out contrastingly against the white of the paper itself. But these traits do not really add up to a completely new excursion into

Japonisme on van Gogh's part. In the first place, they are present in embryo in Parisian drawings of his. And secondly, there is a close parallel between the bulk of these drawings and the kind of landscape studies which Millet had done in the mid 1860s, under the influence of Japanese prints (which he collected from about 1863).[13] Van Gogh had probably seen such studies of Millet's at his brother's gallery, and his own drawing-style of 1888 has a basic affinity in the handling of space and contour. If, then, there is a specific Japonisme in such works of van Gogh's, it amounts to no more than a recapitulation of the stage which Millet had gone through in the 1860s.

It may be added that van Gogh's statements about Japanese art represent, to a quite considerable degree, borrowed formulations. However personal they may appear, by virtue of the enthusiasm behind them and the force with which they are put forward, some of them at least are based directly on the published essays and analyses of Japanese art which van Gogh is known to have read, or must have read, at this time. Théodore Duret's 1884 essay, *L'Art Japonais* is one such source, and the critical comments on individual plates in the opening numbers of Samuel Bing's periodical, *Le Japon Artistique,* are certainly another.[14] Van Gogh's general view of Japan—making it a simple, primitive civilization—is similarly based on literature; most specifically, on Loti's novel *Madame Chrysanthème.*[15] Finally, Japanese imagery and Japonisme do not really go hand in hand in van Gogh's paintings of this time. One particular case where the two are combined is the painting of the *Flowering Pear Tree* which he did in the spring of 1888. A high viewpoint *Pl. 59* is used there, the silhouette of the tree is detached and brought up towards the picture plane and each separate cluster of blossom has its own surrounding contour. But these particular elements do not really cohere with the associations of lightness and freshness which the motif entails, since the tree seems to topple away backwards.

Up to the last months of 1888, van Gogh's path of development represents a furthering of his intrinsic resources and a special intensity in the application of new techniques to nature. The two together add up to a newly forceful interplay of elements which already existed, more independently, in his earlier art. Only towards the close of that year did Japanese art provide an essentially new kind of stimulus, affecting both presentation and structure. And even then, van Gogh extended himself only tentatively and experimentally in this direction.

The *Arlésienne,* painted in November after Gauguin's arrival, *Pl. 60* stands out first of all in this connection. It appears that what lies

behind it may have been Gauguin's challenging claim that he saw in the local Arlesian subject-matter a mixture of Puvis and Japan, whereas van Gogh saw only Daumier.[16] If van Gogh did in fact do the picture in direct response to that claim, as will be suggested in a later chapter, then the work can be labelled by this token an experimental departure. And certainly there is Japonisme present here in the crackling quality of the contour and its quick changes of direction. In confirmation of this point, a direct comparison can be made between the *Arlésienne* and the reproduction of a Kaigetsudo print included in the June number of *Le Japon Artistique*, which van Gogh had received from his brother in September.[17] This can be identified beyond any doubt as the plate of a *'mandarine'* by 'Monorobu' which van Gogh had pinned up in his room in May 1889.[18] For he called it 'a large plate from the Bing album', *mandarine* was clearly his French for a female mandarin, and it is equally clear that he arrived at the bastard name 'Monorobu' by getting slightly wrong the caption to the plate itself, which labelled the work 'Kakemono. School of Moronobou. End of seventeenth century.'

Pl. 62

Granted, then, that van Gogh already had this reproduction among his effects in the second half of 1888 and was keenly attentive to its qualities, the Japonisme of the *Arlésienne* can be related to this specific source. This, accordingly, is the first sure case of a specific Japanese masterwork influencing van Gogh's whole mode of presentation in an independent work of his own.

The only other work of the end of 1888 with a comparably Japanese structure is the version of the *Sower* painted early in December. This again was an experimental work, in the sense that it was done from memory. The features which most clearly contribute to the total impression of Japonisme here are the treatment of the tree-trunk, and the silhouette of the sower intersecting with the looming disc of the sun.

Pl. 147

In January 1889, in any case, in the wake of his first break-down, van Gogh reverted immediately to Japonaiserie. His painting of *Two Crabs,* which almost certainly represents one of the still-lifes he did while recovering, was very probably inspired, as far as subject-matter is concerned, by another of the plates in the second 1888 number of *Le Japon Artistique,* a reproduction of a Hokusai drawing of crabs and seaweed. And the *Self-portrait with the Japanese Print,* also from this time, makes the same point more obviously. The actual Japanese work which van Gogh used in this case is, as it happens, known. Rather than being a masterwork, it represents an eclectic com-

Pl. 61
Pl. 64

Pl. 63

bination of popular Japanese motifs. That is, it includes Mount Fuji, a boat and a bridge, flowers, irises, a pair of cranes and a standing 'mandarine' with a fan. To van Gogh these motifs were presumably a summation of all that he thought of as typifying the tenor of Japanese life. He actually placed the print to the right of his head, without reversing it, in such a way that only the motifs came into focus, not the style of the original. Presumably, then, he intended a specific contrast between this evocation of the world of Japan on one side of his head, and the canvas on the other side awaiting use on the easel. In other words the Japanese print was put in to conjure up by association the world of van Gogh's dreams, as against the world of reality.

After this step back into Japonaiserie, it was only at the very end of his life that van Gogh arrived at a stage of full—and one might say true—Japonisme. His achievement in this quarter was then both personal and highly original. The *Flowering Almond Tree* of February 1890 first signals what was to come. In this work of astonishing clarity and verve, the background of crystalline, magnetic blue works like a Japanese background, purifying and setting off the motif of white blossoms which now comes back once more. There is undoubtedly, in certain works of that spring and the succeeding summer, a debt to Hokusai's and Hiroshige's botanical pieces; again, that is, a debt to a Japanese source of a very specific kind. The drawing of *Hyacinth Stalks*, for example, which dates from that spring, is done as if van Gogh were down among the plants, observing them in close-up at their own level. Here a comparison can be made with the Japanese pen-sketch of grasses included in the *Pl. 65* May 1888 number of *Le Japon Artistique*, and also with the study of pinks reproduced in the June number as coming from an *Pl. 66* 'Album of Flowers by Boumpo (1800)'. Van Gogh had mentioned both of these reproductions with enthusiasm in September 1888, and again he had the one of grasses hanging in his room in May 1889.[19] The latter plate is in the nature of a botanical study, while the pinks seem to be growing up from roots which are cut off from view. These two works were surely the concrete inspiration for the painting of *Ears of Wheat* *Pl. 67* which van Gogh did at Auvers; two little sketches in a letter of June 1890[20] serve as an intermediate link. At the end of June van Gogh went on to do a painting of a *Girl in White* against *Pl. 68* a background of this kind. The girl herself is flattened here and crisply silhouetted. So there is Japonisme in this case in both halves of the imagery. The twin constituents, figure and grasses, are laid alongside one another to create a structure which coalesces completely with the Japanese spirit of the piece.

It is, perhaps, something of a cliché to say of an artist who dies early that certain key features in his work had just come to a peak at the time of his death. But in this particular work of van Gogh's, and related paintings of the same date, the point happens to be true. Instead of the tensions that one usually associates with van Gogh's art, the way in which the paint is applied here takes the form of an extraordinarily sensitive, intermittent calligraphy; and this is combined with a wonderfully delicate lyricism.

In fact, then, there is a chronological correspondence between van Gogh's Japonisme and Gauguin's. The Japonisme of both men, based on specific models in the available repertoire of prints, went through a tentative and experimental stage—followed a year or so later by a renewal and effective synthesis. In both cases the whole development was confined to the very end of the 1880s. Appropriately too, as already noted earlier, it came about half a decade later than the corresponding stage in the art of Monet and Degas.

Finally, given this framework for understanding what happens in the 1880s, one can look ahead with an equally clear-cut logic to the Japonisme of Bonnard and Mary Cassatt in the early nineties. Bonnard produced then such humorous pieces of Japonisme as his *Two Poodles* of 1891. They represent, in effect, the witty space- and contour- manipulation of Gauguin's 1889 *Still-life with a Japanese Print* carried a stage further. As for Cassatt, she began in the nineties doing a series of prints, such as the *Toilet,* in which handling and structure alike make for a completely Japanese spirit. These prints are Japonistic in the same coherent sense as van Gogh's *Girl in White.* And Toulouse-Lautrec around 1894 similarly did pen-drawings of birds which automatically label themselves as being in the manner of Hokusai.[21]

3 The Importance of Seurat and his Theory

In September 1888 van Gogh wrote to his brother about the recent works of his which were worthy of being shown to Seurat;[1] and in 1889, at Le Pouldu, Gauguin did a *Still-life* which establishes itself as an ironic parody of pointillism, first because the inscription itself is made up of little dots, and secondly because a whole series of little faces can be detected amidst the stippling. Both of these actions were, in their very different ways, acknowledgments of Seurat's authority and of the centrality of his art.

It was not simply that Seurat, in his lifetime, already commanded a considerable artistic following. Van Gogh and Gauguin both saw clearly that, in the hands of camp-followers, pointillism was in danger of degenerating into a mere technical system or recipe, applicable to any subject. But they were also able to make a clear-sighted distinction between the 'traffickers in little dots', with their dogmatic and ultimately academic temper of mind, and the originality of Seurat himself.[2]

From a modern historical standpoint, there are three separate reasons for Seurat's key position on the art scene of the 1880s. First, his theory and his whole stature as a man of ideas were bound up in a peculiarly intimate way with the Parisian climate of intellectual speculation. Paris at this time, with its overlapping café circles and its number of little magazines, was the nerve centre and the hub of all the newest trends in literature, poetry and philosophy. Already in July 1883 Camille Pissarro, who was leaving for the country, wrote regretfully to his son of how very useful it had been to him to have 'one foot in Paris'. 'It enabled me', he said 'to keep abreast of everything relevant to my art.'[3] And in the summer of 1888, writing to his sister from Arles, van Gogh acutely described the world of Paris as a 'hotbed of ideas'.[4] It was the feeling among artists at this time that Paris was in every sense the stronghold of modernity.

With the rise of independent galleries and the crystallization and recrystallization of politically-oriented groups or fronts, Paris was both an intensely stimulating and an intensely competitive milieu. Only there was it possible for the painter to find like-minded people in some kind of active and 'progressive' association with him; and only there could he hope to obtain

the kind of critical response to his work which would give a sympathetic boost to his endeavours and to his personal commitment. Seurat had the advantage of having as his spokesmen men of intellect and sensibility[5] who took an interest in his art and what he had to say about it while it was still, so to say, locked in the private world of his studio. He was, in short, an accepted leader of an ideological vanguard.

Then, secondly, Seurat's art was acutely contemporary in the sense that his major canvases embodied a sociological, rather than simply a social, insight into the whole character of metropolitan middle-class life at the time. His urban subject-matter recapitulates the entire development of that branch of imagery from Daumier and Guys through Degas to Lautrec, and, in his *Grande Jatte,* he brought out the whole temper of group behaviour on the island where the middle class spent its Sundays. Not only that, but also the attitude to fashion and the ethic of self-enjoyment which underlay that behaviour. There had been nothing in French art for two decades like this multi-figured composition, on a monumental scale, showing anonymous participants in a communal social activity.

Courbet in his *Hunt Picnic (The Hallali)* of 1858, had shown the meal after the rural stag-hunt as a social occasion. Disparate figures pose stiffly there, united by the costumes they wear and by the fact that they are sharing in a traditional ritual in one another's company. Similarly, in Monet's *Picnic* of 1865–6, it is the ease and reticence of the figures' behaviour which conveys the idea of a group of young people of like-minded interests, who are in natural and easy sympathy with one another. These two works are the nearest forerunners of the *Grand Jatte.* And just as the emphasis on costume and the character of the poses in these two cases suggests a parallel with contemporary fashion plates or photographs, and even the possibility that these latter kinds of 'popular art' may have served as a direct source, so with the Seurat in an updated way. It is absolutely crucial to the whole character and impact of the *Grande Jatte* that it instantly gives the impression of an up-to-the-minute modernity.

Finally, there is the compression of Seurat's career and his development. Between 1880 and his death in 1891, he moved all the way from an art based on the imagery of Millet and Daumier to works which are fully in the spirit of Art Nouveau, and anticipate all of its essential formal characteristics. All along the way, furthermore, Seurat concentrated on producing a small number of large and imposing canvases which showed in epitome, each time, both his exceptional sense of purpose and his extraordinary inventiveness.

Given, then, this centrality of Seurat's art, it follows that one can use it as a yardstick for measuring the general trends of the eighties and the way in which they took shape from year to year, much as developments in outlying cities can be compared, in the field of social or economic history, with what was happening in the capital or had already happened there at a somewhat earlier date. The work and thought of the other French painters of Seurat's generation can be aligned with his, with a view to seeing how they match up with one another. Sometimes there will be specific links between them and Seurat, or Seurat's world; and sometimes there will simply be parallels, where one of the other artists moved quite independently in a comparable direction, either contemporaneously or after some slight time-lag.

The *Grand Jatte* may again serve as a preliminary illustration of this point. There are three major aspects of this picture, begun in 1884 and finished in 1886, and each of them has a clear-cut parallel in the slightly later paths of development of the other post-impressionists. Thus the social side of the picture has a parallel in van Gogh's 1886 paintings *In the Bois de Boulogne* and *Terrace at the Tuileries*, where figures are shown strolling under the trees, individually or in couples. It also has a parallel in Emile Bernard's painting of 1888, *Breton Women in a Meadow*, in the shape of the two women there in fashionable contemporary dress. Bernard had adopted pointillism briefly in 1886,[6] and a further connecting link is provided by the group of watercolour drawings which he sent to van Gogh in September 1888. Two of these watercolours depicted groups of figures at ease on a river bank, who are similarly dressed in a fashionable way; and one, which includes trees and sails reflected in the water, is actually entitled *Idyll at Asnières*.

Pl. 69

Pl. 87

Pls. 70, 71

Then there is the witty playfulness of the *Grand Jatte,* which comes from the way in which the figures and props are organized in relation to one another. Gauguin would deal in a very similar kind of structural humour a few years later, as for example in his *Portrait of the Schuffenecker Family* of January 1889, where the separating distance between Schuffenecker himself and his wife and children suggests the idea of his inability to meet their needs.

Pl. 20

Finally, there is the sense in which Seurat's figures are independent plastic units, each one separately evolved as a product of formal research in its own right, and then combined with the others, so that the facial expressions seem blank and the gazes curiously unmotivated. This can be compared with Cézanne's treatment of a two-figure subject in his *Mardi Gras* of 1888. The

haughty aloofness of the Harlequin and the vacancy of the
Pierrot's expression there is connected with the preliminary
planning of each figure separately. One can also compare van

Pl. 98 Gogh's *Dance Hall* of 1888, which will be discussed later in
another connection. There too the faces have an almost wooden
character and the artist's main preoccupation lay with the force
of silhouette and the decorative character of costume.

Against this background the specific links and connections
between Gauguin and Seurat on the one hand and van Gogh
and Seurat on the other can now be considered in greater
detail. Irrespective of van Gogh's and Gauguin's personal feel-
ings about their Parisian contemporary, there is a sense in which
each of them moved in step with him during the later 1880s.

During his Paris period van Gogh had a great deal of contact
with Signac. It was Signac who helped him towards using a
variant of pointillism in a group of paintings, such as the

Pl. 75 *Corner in the Park*, which he produced between the summer of
1887 and February 1888. The strokes there tend to be arranged
like a magnetic field bearing off towards the top of the picture.
But the clean character of the silhouettes which are seen against
the sky and the linear character of the boundaries to areas like
paths and patches of grass are in line with the way in which

Pl. 73 Signac's canvases of 1886 are composed. As in those Signacs,
furthermore, dots and dashes of white, acting like granulation
in relation to the basic underlying colours, lighten the density
of the whole. It is probable that van Gogh had seen Seurat's
Grande Jatte when it was exhibited with the Indépendants in
August 1886. But Seurat had not used white there in that kind
of way, and van Gogh did not in fact meet Seurat for more
than a brief moment until the very eve of his departure from
Paris. The occasion for that meeting was a visit to Seurat's

Pl. 76 studio arranged by Theo van Gogh.[7] The *Parade*, which was
first completed in 1888 was in progress at that time. So van
Gogh almost certainly saw the preliminary study in oils for

Pl. 74 that work as a whole. Seven months later, at Arles, he created
Pl. 72 his *Night Café*. The treatment of the rays of light sent out by
the lamps here may well have been suggested by Seurat's treat-
ment of the gas jets in his oil-study. Indeed, the very idea which
van Gogh had that month of painting 'under a gas jet'[8] may
well have come from Seurat's use of gas lights as an ingredient
of his imagery. Van Gogh spoke of Seurat rather frequently in
his letters of this time, so it is indeed very possible that he was
drawing, in a typically retrospective way, on his memory of
pictures of Seurat's which he had admired in Paris.

Much more significant, however, is the extended parallel between Seurat's development as a theorist and the development of van Gogh's own ideas about colour and line. Apart from one rather brief expository letter of Seurat's, from near the end of his life, and the evidence of the paintings, knowledge as to this artist's theoretical principles, and the way in which they developed, comes primarily from friends and critics who knew him, and their reports on the subject. One of these critics provides in fact the best summary report on the whole question. In an article of 1891, Teodor de Wyzewa suggested, with great perceptiveness, that there were three distinct stages to Seurat's theory, and set out what each involved.[9] The first of these stages, the critic said, had to do purely and simply with the analysis of colour. In the second stage Seurat then turned to the expressive value of colours: 'he wanted to know why certain combinations of tones produced an impression of sadness, others an impression of gaiety; and he had put together, with this in mind, a sort of catalogue in which each nuance was linked up with the emotion which it suggested.' And the third and final stage was marked by a comparable concern for the expressive value of lines.

The sources which Seurat drew on in each of these stages, and their respective chronology, can in fact be put together from further documentary knowledge.[10] Briefly, the first stage lasted from about 1876 to about 1884. Its sources included Delacroix's didactic statements on the subject of colour and Charles Blanc's writings on the same topic. The second stage ran from about 1884 to 1887, and a fragment of a Turkish art treatise known to Gauguin as well, of which more will be said later, evidently played an important part at this juncture. Finally, from about 1886 on, Seurat paid close attention to the theoretical ideas of Charles Henry, and these ideas contributed in a major way to the third stage, which lasted from about 1887 up to the time of Seurat's death. The impact of Henry's ideas upon Seurat seems to have been particularly strong from 1887-8. Delacroix's theory seems also to have contributed afresh to this final stage in Seurat's thinking—this time in the shape of ideas about the concordance between colour and line.

Now it was in 1885, while still at Nuenen, that van Gogh first evolved something approaching a sustained theory of colour practice. In a letter of late October that year he wrote 'it is a fact that studying the laws of colour enables one to go from an instinctive belief in the great masters to an analysis of why one values them—what one values...'; and again '... one retains [that general harmony of the tones in nature] by re-

creating in a parallel colour scale, which may not be exactly like the model, and may even be very different from it.'[11]

These remarks come right after van Gogh's reading of Théophile Silvestre's 1864 publication on Delacroix and Charles Blanc's 1867 *Grammaire des Arts du Dessin*, which made a great deal of Delacroix's colour practice.[12] In other words, van Gogh's theory at this point was exactly akin to the first stage of Seurat's thinking, in terms of the major texts behind it. The only difference is that there was a time-lag of some four years in van Gogh's case, in that Seurat had taken notes on Delacroix's paintings as early as 1881 and had studied Blanc's observations on Delacroix even prior to this date.

Van Gogh then entered into a second stage of theoretical argument in the last months of 1888. He was now concerned with the 'suggestive' properties of colour and returned afresh to the analogies between it and music. In September and October that year, besides showing a marked interest in what Seurat was doing, he wrote intensively of his involvement in the study of colour and of how he hoped to express spiritual qualities and states of mind by the use of complementaries and by exploiting their special properties of vibration and radiation.[13] He wrote later in very much the same vein in letters of January, February and October 1889; but always in retrospective reference to paintings which he had originally embarked on, or first been concerned with, at the end of 1888.[14] So this stage of his thinking about colour certainly belongs, in essence, to the latter period; and the parallel with the second stage of Seurat's theory is obvious.

Now, as noted earlier, van Gogh met Seurat only once, in February 1888, and then briefly. He did say, in a letter of May 1890, that that visit of his to Seurat's studio had been 'a revelation of colour' for him.[15] But he can hardly have had time on that occasion to gain any strong idea of the nature of Seurat's theory; and he does not seem even to have heard of Charles Henry and his writings until April 1889, when Signac mentioned in a letter that he was engaged in preparing the plates for a publication of Henry's on the 'aesthetic of forms'.[16] There is evidence, however, that during his stay in Paris van Gogh had had some personal contact with both Félix Fénéon and Gustave Kahn, a pair of critics who were intensely involved at that time with Seurat's art, and also with his ideas. A drawing by Lucien Pissarro shows van Gogh and Fénéon sitting together in Paris; and van Gogh had apparently shown some of his paintings to Kahn.[17] Again, he had contact in Paris with Signac, who was probably aware of Henry's ideas by 1887. He

also knew Gauguin, who had his copy of the passage from the Turkish treatise at that time; and he painted with the young Bernard, who probably had some acquaintance already with the ideas of Henry and Seurat in 1887-8, to judge from the record that he was researching in the summer of 1888 into 'the properties of lines moving in opposite directions.'[18] Finally, van Gogh seems to have acquired in Paris at least some inkling of the drift of Wagner's ideas on the subject of synesthesia. These ideas had a great vogue amongst the intellectuals and critics of the symbolist movement in the later eighties. Presumably van Gogh must have heard them discussing the idea that Wagner's musical tones worked like colour tones; and he undertook further reading, which would extend his understanding of these Wagnerian concepts, in June and September 1888.[19] All of these points, then, provide a background to the second stage of van Gogh's theory and help to explain the continuing parallel with the ideas of Seurat. The time-lag in this case had shortened itself to a matter of one or two years—if van Gogh's Parisian experiences are counted as the foundation for the ideas which he went on to enunciate once he was settled at Arles.

It is interesting, too, that there was still a further stage in the cycle of van Gogh's thinking. The period to which the new ideas belong in this case is the second half of 1889. In letters of September that year he spoke of first catching the 'real and essential' on canvas. Once this had been done, it was possible to 'take up the study again after a time and arrange the brush strokes according to the lines of the object.' And again, he wrote that his paintings from the summer, of *Olive Trees* and the *Moonrise*, were 'exaggerations from the point of view of arrangement, the lines in them being bent around as they are in old wood.' Similarly, late in October 1889, he wrote of studies in the last batch of work he had sent to Theo which were 'drawn with great lines of such a knotty kind', and added that he felt that 'a form of drawing which seeks to express the entanglement of the masses' would go on being sought for by artists who worked on landscape subjects.[20]

Once again, then, the parallel between van Gogh's and Seurat's theory stands out very plainly. And again there was no direct line of communication between the two men. For it was not until March 1890 that van Gogh gained any idea of the last stage in Seurat's development. This can be gathered from the fact that in a letter that month Theo mentioned briefly, as up-to-date news from Paris, Seurat's attempt in his recent pictures to 'express things by means of the lines' direction.'[21]

It is also clear, on the other hand, that van Gogh had developed at this time an interest in Delacroix's use of line as well as colour, just as Seurat had done on his side in the final stage of his thinking. Already in June 1889 van Gogh had written that 'by going the way of Delacroix more than would appear, by the use of colour and a way of drawing which is freer than illusionistic fidelity of detail, the nature of the countryside can be expressed . . .' He also remarked in one of the September letters already quoted on the twistings of the body in the Delacroix *Pietà* which he had just copied, characterizing them as 'not exactly easy or simple'.[22] Furthermore, it would seem that the continuing stimulus of Gauguin's and Bernard's ideas contributed equally to this new concept of line. This is implied by the fact that van Gogh suggested three times over, first in June and then again in September and October 1889, that there was a parallel between this use of line on his part and what Gauguin and Bernard were doing themselves at the time.[23] It was only at the very end of the year, after receiving a visual record of Gauguin's and Bernard's recent canvases, which he had not actually seen up till then, that he turned on those two artists and mounted a strong attack on the character of what they had done.[24] Up until then he felt a definite sense of alliance between his work and theirs; and this helped just as a comparable feeling had helped to crystallize the second stage of his theory. Otherwise, however, he had arrived quite independently at an idea of the value of line which was akin to Seurat's. And the time-lag in this case, as with the second stage of his theory, was again only a matter of one to two years.

Gauguin, for his part, got to know Seurat in Paris during his stay there in 1885-6, and it was evidently at that time that the extract from a Turkish treatise mentioned above passed from one to the other. This treatise was, according to Gauguin, the work of the poet Sumbul-Záde Vehbi, a real figure in Ottoman literature who had died in 1809. It is not known for certain whether it was Gauguin who gave the extract in question to Seurat, or the other way round. All that is known is that each of them had a copy and Seurat underlined the sentences or phrases which enjoined the artist to give his figures static poses, to cultivate the use of silhouette, and to rely on memory and seek for pictorial harmony.[25] Gauguin and Seurat, then, evidently had a common interest at this time in a kind of pictorial organization which was clear-cut and pure in its temper; and in an art which reflected the painter's control of form and his technical command.

Now there is a text of Gauguin's own, almost certainly of earlier date,[26] in which he put forward theoretical ideas which have a good deal in common with some of those which were being discussed by Seurat and his intellectual circle in Paris at the time of the *Grande Jatte*. In this text, written in reply to certain critics and academics who brought prejudicial criteria to bear in their judgement of painting, Gauguin argued that painting was superior to all the other arts in its powers of synthesis. He compared art and music in this connection, saying that both worked on the soul through the intermediary of the senses, and that there was a correspondence in the scheme of harmonies proper to both. This idea of 'correspondences' closely parallels the Wagnerian ideas mentioned earlier as having penetrated to van Gogh, as a result of his stay in Paris in 1886-7 and his contact with symbolist thinkers then. Gauguin also advanced, in rather mystical terms, the idea that instrumental music had at its base a unity like that of numbers, but he asserted that painting was in fact superior to music (and all the other arts, including literature) because it had a unity impossible in music, where the sounds follow one another. He suggested that, in painting, a vibration took place between juxtaposed colours, and presented colour as more than a mere accessory to drawing. The two elements should go hand in hand and the colourist should be guided by the principles of natural harmony; study on these lines could lead to a whole science of harmony. Rather similar ideas about colour practice are found in the letters which Gauguin wrote to Pissarro in the spring of 1885, and one which he sent to Schuffenecker from Copenhagen in January 1885 contains a very similar mystical interpretation of the properties of numbers and geometric figures.[27] So the text just cited, Gauguin's first known venture into theory, was presumably written either in Rouen in 1884 or in Copenhagen in the winter of 1884-5. The critics in question would then be those, notably J. K. Huysmans, who had responded unfavourably to the Gauguins included in the impressionist exhibition of 1882.

The remarks in the text about harmony of colour and colour practice are also paralleled in a few rather brief sentences in the Turkish treatise. This, then, suggests that it was Gauguin rather than Seurat who first had the translated extract from this manual. In any case, Gauguin had certainly read and studied Charles Blanc's *Grammaire* at the time when he drafted the reply to his critics. The notebook which contains that draft also contains a colour-circle which is obviously of contemporary date and is based, note and all, on Blanc's own colour-

wheel. Similarly, the remarks about the emotional connotation of different kinds of lines in the letter of January 1885 mentioned above closely parallel a passage in the *Grammaire*; and there is a section there comparing architecture with music. Gauguin was also extremely interested around 1885 in the emotive power of Delacroix's art and the effective way in which the lines in it put across an underlying idea, for there is a letter of May that year in which he discussed the *Bark of Don Juan* at length from this point of view.[28] All in all, then, Gauguin seems to have arrived independently at a range of ideas analogous to those entertained by Seurat in the second stage of his theory; and in certain ways he may even have been in advance of Seurat, although he seems to have been much less systematic in the way in which he used his reading-matter.

When Gauguin and Seurat came together in Paris in the winter of 1885-6,[29] the ground was in any case prepared for a certain degree of theoretical interchange. According to the later evidence of the playwright Strindberg, much intellectual attention was being paid at that time to the art of Puvis de Chavannes, and Félix Fénéon already noted in June 1886 that Puvis might be accounted relevant to the character of the *Grande Jatte*.[30] In April 1887 Gustave Kahn used the adverb 'synthetically' to describe the way in which Seurat and his associates treated the human figure, comparing the result to the effect of ancient statues.[31] And then there is Seurat's interest in the art of Egypt as well as Greece, and his presumed interest in the frescoes of Piero della Francesca. In combination, these latter interests amounted to a profound commitment to an art which had an archaic kind of flavour and a corresponding purity and hieraticism of structure. While Gauguin on his side may have first studied the work of Puvis at this time, it did not become directly relevant to his own way of structuring a picture until the 1890s. It was Bernard who first drew, rather weakly and passively, on the character of Puvis' imagery, to judge from his 1888 painting of his sister with its combination of spaced-out trees and flat, flower-studded meadow.

Pl. 82

On the other hand, Gauguin had almost certainly arrived at the idea of 'synthesis' some time before this word was used by the members of Seurat's circle. The title of his reply to his critics was, significantly, *Notes Synthétiques*—in reference to the claims which he made there for painting's superior powers of synthesis. It is probable that, in Paris in 1885-6, or even earlier, Gauguin's understanding of the meaning of this word 'synthesis' extended itself to include a reference to the kind of vision found in primitive art. Already in 1860 Baudelaire had used the

word 'synthetic' to describe Constantin Guys' special kind of
vision, and had introduced primitive art as a parallel phenom-
enon which helped to explain the special qualities that he had in
mind here.[32] This would mean that the concept of synthesis
prevalent in Seurat's circle had something of a parallel on
Gauguin's side; and certainly, just as Seurat was interested in
archaic art, so Gauguin was interested in, or became interested
in, the Assyrian reliefs in the Louvre.[33]

Gauguin and Seurat had a serious quarrel later in 1886[34] and
the result of this was a political rift between the two men.
Gauguin, at least, took pains thereafter to present himself as
completely opposed to the interests of Seurat's adherents.[35]
But the community of ideas between the two men in 1886 had
a continuing efficacy which politics could not erase. Para-
doxically, in spite of the workings of enmity, there is a much
closer parallel between Gauguin's painting of the later eighties
and Seurat's than there is between van Gogh's and Seurat's.

Gauguin and Seurat were both interested during the later
eighties in the idea of a masterpiece of a definitive, constructed
kind. They were also both interested in combining empathy
with their subject-matter and a style of presentation which im-
plied ironic detachment. Both of them, indeed, made capital
out of the very tension between these two approaches. The
parallel is particularly clear when, for example, Seurat's
Poseuses of 1887-8 is compared with Gauguin's *Portrait of the
Schuffenecker Family*, which dates from the beginning of 1889. *Pl. 20*
In the Gauguin, a flat, picture-like view of buildings and trees
to the rear stands for the outdoor world outside the studio,
just as in the Seurat the artist's own *Grande Jatte*, shown hang-
ing on one of the studio walls, introduces sunlight and grass and
further figures, as if one were looking through a window. In
both cases small works of art elsewhere in the room help to
define the character of the environment. No figure in either
case is placed parallel to the rear wall, but instead there are
multi-directional twists to the relationship between figure and
space. And when it comes to the relationship between contour
and pose, both the upper and lower halves of the figure of
Schuffenecker can be compared with the central figure in the
Seurat. Similarly, in Gauguin's figure of Mme Schuffenecker
and in all of Seurat's figures a classical pose is combined with a
quite unclassical demeanour.

Again, Gauguin's *Still-life with a Japanese Print,* most *Pl. 77*
probably from the spring of 1889, can be compared with
Seurat's *Parade* of 1887-8. For all the differences of subject there *Pl. 76*
is a striking affinity of structure here. The stiff metallic leaves

in the foreground of the Gauguin are so lined up, and so aligned with both the table top and the picture plane simultaneously, that they introduce the spectator into the picture in very much the same way as the figures do along the base line of the *Parade*. Then the background consists of entirely flat, rectangular units, like the background in the Seurat. And the two vases on the table are arranged in such a way that they seem to confront one another and at the same time implicitly side-step one another. The relationship between the two key figures at the right in the Seurat is extremely similar in both respects. The wittiness of both paintings, furthermore, arises from precisely these devices of presentation and the psychological overtones which they introduce. Fénéon, Seurat's chief supporter, was therefore perfectly right when he wrote in 1889 that Gauguin was seeking 'an analogous goal (to Seurat's), but by other methods'.[36]

As far as theory is concerned, Gauguin was in fact held back in the later 1880s by lack of any direct contact with the thinkers of the Symbolist movement. Correspondingly, his statements at that time about his own paintings tend to be tame or to wear a borrowed air, except where he was giving a straightforward and forceful description of what his imagery entailed. Unlike van Gogh, he did not have strong intellectual resources of his own to fall back on when he was cut off from Paris. And there is one particular case in which he actually stole from van Gogh certain turns of phrase which he could apply to a recent and important painting of his. *Pl. 116* Describing the picture of the *Vineyard* which he did at Arles in November 1888, he used a stanza of de Musset's which van Gogh particularly admired. Van Gogh's free quotation 'a wretched person dressed in black came and sat by us and looked at us like a brother'[37] became, in Gauguin's borrowing, 'a woman dressed in black faces and looks at (the other) like a sister'. Gauguin then went on later in the same description to draw on van Gogh's ideas of that autumn about the suggestive quality of colours, speaking of a 'magnetic current of thought' and of 'various harmonies corresponding to the states of our soul'.[38] This was not his own way of writing.

It was only in the winter of 1890-1, immediately before his departure for Tahiti, that Gauguin came into direct contact with the Symbolists and absorbed their ideas at first hand. And the experience did indeed affect his whole capacity for arguing in theoretical terms. In the 1890s, that is, one finds him writing, much as van Gogh had done in 1889, about the harmony of lines and colours.[39] He was late by almost half a decade in catching up in the realm of theory; but he finally did draw parallel with Seurat and his circle in that respect as well.

4 Van Gogh, Gauguin and Emile Bernard

This chapter falls into two parts, both of them having to do with the year 1888. The first half consists of a reconsideration of the relationship between Gauguin and Bernard. An analysis then follows of the relationship between van Gogh and Bernard in that same year. This discussion will rest throughout on the works themselves, and show on that basis how the two topics hang together.

To begin, then, with Gauguin and Bernard. Bernard met Gauguin in Brittany in 1886. Two years later, he returned there and, after a period on the coast at Saint-Briac, he joined Gauguin at Pont-Aven in mid-August.[1] The two men worked together there until late October, when Gauguin moved off to join van Gogh at Arles. They painted related subjects. Gauguin was forty at the time, Bernard a young man of twenty. Bernard was a bright and voluble personality—one gathers this from van Gogh's letters to him (his to van Gogh are lost). He was full of aesthetic ideas and theories, and good at articulating them verbally. He was also, through his recently formed friendship with the poet-critic Aurier, a link with Symbolist circles in Paris. He was effectively co-opted into Gauguin's circle.

These are the basic facts underlying the Gauguin-Bernard problem. Around them a long standing controversy has been woven. The dispute is about what happened artistically between the two men. Did Bernard influence Gauguin—specifically, did he contribute to the creation of Gauguin's *Jacob and the Angel*? Or was the influence the other way round? Which man was fundamentally responsible for the creation of so-called 'synthetism'? The literature on the subject is very extensive; in every treatment of the period from biographies of Gauguin to general studies of Art Nouveau, it makes some kind of appearance.[2] In the annals of art history, indeed, only the Giorgione-Titian problem stands out as having provoked a comparable amount of writing, accompanied by an invariable taking of sides one way or the other.

Now the origins of the dispute go back in this case to Gauguin and Bernard themselves. They fell out towards the time of Gauguin's first departure for Tahiti in 1891.[3] Bernard, in Gauguin's view, was detracting from the credit due to him for his artistic innovations and leadership. In 1895 Bernard

Pl. 84

published his first polemical piece, claiming that, at the Café Volpini Exhibition of 1889, he had wrongly been accused of having plagiarized Gauguin's work. Gauguin composed a reply which was not published in his lifetime.[4] The episode made him very bitter and ironic, about both the behaviour of his fellow artists and the ignorance of critics. One sees this in certain letters of 1899 and 1902. Thus, when Maurice Denis proposed in 1899 that he participate in a Symbolist exhibition, featuring the same artists who had exhibited at the Café Volpini ten years earlier, he refused on the grounds that he would be shown up as the weak copyist he really was, and this would endanger the masters from whom he had borrowed.[5] He was writing tongue in cheek, of course. Similarly, he took the critic Fontainas to task in 1902 for misrepresenting in a critical article what he, Gauguin, owed to others.[6] In both of these cases he referred specifically to the false claims of Bernard. After Gauguin's death in 1903, Bernard returned to the attack again in an article published at the end of that year. This time Denis and another critic, Charles Morice, replied in Gauguin's stead. Unabashed, Bernard developed the same arguments further in his memoirs of 1907-9, and again in a series of writings composed between 1936 and his death in 1941.

The breach of 1891 was never healed, then; and already in Bernard's lifetime art historians were participating in the dispute.[7] More recently, a further dimension of complexity has been added to the problem. It has become clear that Bernard backdated many of his early paintings; that is, he put on retrospectively dates which were earlier than the true ones.[8] There are works of his purporting to be products of the later 1880s which are incompatible with one another, both formally and in terms of the script used for the signature and date. This was already a pointer towards the conclusion of backdating. And the existence of two identical impressions of a print of the *Nativity*, one dated 1885 and the other 1888, puts that conclusion beyond any reasonable doubt.

Quite obviously the process of backdating was psychologically bound up with the whole vehemence of Bernard's contention that he had played a leading role during the later eighties. Most probably he was so obsessed with this claim, and with the view that his priority had not been properly recognized, that, like Kirchner in a very similar situation, he simply lost track of the truth and reconstructed entirely, bit by bit, the pictorial character and chronology of his early development. In addition, he may also have revised some of his early canvases technically[9]—strengthening or adding to the surface qualities

of form from the vantage-point of hindsight, again exactly like Kirchner. This point, however, has not yet been firmly established.

The facts, in any case, speak for themselves as far as the question of chronology is concerned. In the present state of knowledge, that is, no date on a canvas or drawing of Bernard's can be accepted unless independent documentation exists in support of this date; or, at the least, unless internal formal evidence argues very strongly for the date's feasibility. Equally, Bernard's failure to abide by the truth in the matter of dates means that the factual details which he gave in his later accounts of what took place at Pont-Aven must themselves be treated with a comparable caution. It is always possible that a fact recorded there may be given in a misleading form, even where the framework of events appears to be reported accurately.

Accordingly, if the Gauguin-Bernard problem is to be reopened, a gleaning out of Bernard's securely dated works is absolutely mandatory. These works and only these must be compared on a strictly empirical basis with the related works of Gauguin. Gauguin's intricate line of development up to that time must be taken into account. And it is not simply the handling of line and colour which must be compared in the two cases, but also the whole way in which the imagery is presented and structured.

The relevant works of the two artists fall, as it happens, into three convenient pairs. First, there are their paintings of Emile's young sister, Madeleine Bernard. Bernard's canvas of *Madeleine at the Bois d'Amour* is documented by a van Gogh letter of December 1889, which contains a sketch of it (based on Gauguin's verbal description when he came to Arles) and refers to it as done the year before.[10] This work is symbolic in a heavy, literary sense; that is, a verbal statement of its symbolism can be made independently of the actual interplay between motifs and the way in which they are given pictorial life. Thematically, furthermore, the imagery here is directly in the tradition of late Romanticism. Comparison with Max Klinger's print of the late seventies, *Early Spring*, makes this abundantly clear. For the girl there has the same kind of pale face and long, languid body clothed in an ankle-length dress. She too lies on her back upon a carpet of grass. And the association there between spring and maidenhood is quite explicitly romantic. This print could have been the source on which Bernard drew for his imagery; and even if this was not the case, it certainly verifies the presence in the Bernard of an iconography having to do with springtime and virginity.

Pl. 82

Pl. 83

Pl. 80

Pls. 78, 79

Gauguin's portrait of Madeleine, on the other hand, is not overtly symbolic. It does embody certain associative references, but these are there simply to support the general mood of the work in a secondary, uninsistent way. Specifically, it contains references to the art of Degas which can be recognized and read in counterpoint with one another. The work of art on the wall to the rear, cut off so that only the legs of two dancers are visible, must be based on the Degas etchings which Gauguin is known to have had in his art collection at this period.[11] This is indicated by the white framing border and the fact that everything is in black and white rather than colour. It is not, however, an actual Degas; there is no print at all like this one, with one ballerina presumably watching another who is standing in a practice position. Rather, it is probably a Degas pastiche, an imaginary fragment made up by Gauguin himself. This prop behind the figure points up, in its turn, the fact that the pose of Madeleine herself also embodies a reference to Degas. The motif of a woman with one hand resting against the side of her face is found several times in early Degas portraits.[12] There is, to be sure, no stylistic influence from the early Degas here. The borrowing from this artist is purely a matter of imagery, and Gauguin actually gives the borrowed motif a new twist by making it go with an expression of self-assurance rather than one of timidity or anxiety. Even while he trades, then, on the recognizability of his allusion to Degas, Gauguin leads through it to a clear cut distinction between his view of Madeleine and Degas' conception of womanhood. The use of Degas serves now simply as a springboard for Gauguin's own brand of psychological characterization. The sense in which this portrait is symbolic is, therefore, basically different from the sense in which the Bernard is symbolic.

The second pair of works consists of the self-portraits painted at the end of September and sent to van Gogh early in October; their receipt and the impression each made are described in van Gogh's letters of the time.[13] Instead of painting portraits of one another, as was originally proposed, the two men did these self-portraits instead, and included in the background of each a self-portrait by the other man. That is, the work shown hanging on the rear wall in the Bernard evidently represents a transcription by Bernard of an actual Gauguin self-portrait of approximately contemporary date—rather than a portrait of Gauguin by Bernard as has usually been supposed; and similarly in the other case.

The most distinctive and imposing feature of the imagery in the Gauguin is the counterpoint between his fierce-eyed, full-

blooded countenance and the background of flowered wall-
paper. The blooms decorating the rear wall are so brought
forward and arranged that they serve as a kind of halo around
Gauguin's head. The whole interrelationship between head and
background, then, suggests fierceness and primitiveness of
character operating in a context of purity; and it fits with this
that the background should entail another reference to the art
of Degas. It seems likely, that is, that Gauguin had in mind
Degas' *Portrait of Hortense Valpinçon,* a work of the early
seventies in which there is a subtle suggestion that the young
girl, so delicate and finely bred, is at home in a context which
includes flowered wallpaper, and domestically in tune with that
particular setting.[14] If this reconstruction is right, then again
there was a twisting on Gauguin's part of the connotations of
the Degas motif. He used it as a way of pointing up all the more
emphatically the rude strain of anti-domesticity which he
portrayed here as dominant in his own character. Bernard's
pale and tranquil head to the rear is so placed and oriented that
it ties in implicitly with the associations carried by the blooms,
but makes absolutely no contact with the taut pulsation and
glare of Gauguin's own features at the left.

Pl. 81

There is no such counterpoint between images in the Bernard
Self-portrait. The most that can be said of the relationship
between Bernard's own features and the Gauguin self-portrait
centrally placed on the wall there is that the spectator is intro-
duced to this image of Gauguin in an implied spirit of respect
and deference on the part of Bernard himself. The inclusion of
the back of Bernard's easel at the bottom right adds nothing
further, apart from its being an obvious prop, completely
traditional in the iconography of self-portraiture. Basically this
is a much more timid picture than the Gauguin *Self-portrait.*
Particularly striking in this connection is the way in which, by
virtue of his position right over to one side, partially hidden by
the frame, Bernard literally seems to efface himself. He was in
fact preternaturally deferential in his attitude towards Gauguin
at the time, and much given to belittling himself by com-
parison; this is evident from van Gogh's reports to his brother
on the subject.[15] Furthermore, this work of his is governed in
every major respect by the conventions of naturalism. Just as
the view of the easel from behind implies that the whole
amalgam of figure and setting was fixed by the use of a mirror,
so there is no compression of space to force the figure forward
but rather a complete continuity of atmosphere around and
behind its bulk. Finally, while the colours here, blue and
orange-yellow, are in tune with the ones which Gauguin was

Pl. 78

using in his picture, they are paler throughout and produce a harmony of a purely decorative kind.

In these two cases, then, where Bernard's conception involved an explicit symbolism, Gauguin underscored the way in which he saw Madeleine by the use of a few allusive references of a very personal kind; and where Gauguin's conception involved a charged counterpoint between figure and background, Bernard's conception was primarily naturalistic.

Lastly there are the two men's treatments of Breton subjects. *Pl. 87* Bernard's canvas of *Breton Women* was given to Gauguin, who brought it to Arles, and van Gogh copied it there. Van Gogh mentioned the arrival of the work in two letters of the time, and described it to his sister in detail the following year. He called its subject 'Breton women strolling in a meadow'.[16] It was only in 1903 that Bernard connected the work with the Pardon of Pont-Aven (an annual religious celebration which he said had just taken place).[17] In reality there is nothing religious about the painting's imagery, apart from the presence of two clergymen and the fact that the women are dressed in the traditional costume which they put on for feast days. The subject matter as a whole, with its dogs and little children and its pattern of conversational exchanges, is purely genre in character. So Bernard clearly made that connection in order to give the work a religious reference which would bring it in step with the *Pl. 84* religious character of Gauguin's *Jacob and the Angel*. He was trying to make the works match one another in a way which has no real basis in what is actually depicted.

Again, there is only Bernard's 1903 authority for saying that this painting was done before the *Jacob and the Angel*. However, Bernard's statement should probably be accepted here. An August letter of van Gogh's, dating from before Bernard's move to Pont-Aven, shows that Bernard was already interested then in 'the properties of lines moving in opposite directions.'[18] The treatment of the space in between the figures in the *Breton Women* certainly appears in line with this interest. The areas in question, that is, are activated by the contours of the figures themselves. And the path of each outline seems primarily an aesthetic piece of contrivance. One can also compare the draw- *Pl. 97* ing of a *Lane in Brittany* sent to van Gogh from Saint-Briac in July. This is another certified work, since van Gogh gave a description of it;[19] and the treatment of the headdresses already matches there.

The priority of the Bernard, however, still does not mean that it influenced Gauguin's *Jacob and the Angel*. Van Gogh's *Pl. 88* copy is illuminating in this connection, since it shows what,

from van Gogh's point of view, Bernard had failed to achieve. Van Gogh turned the purely decorative rhythms of Bernard's surface into one continuous rhythm which weaves its way through space. He transformed the unintegrated mixture of curvilinear and rectilinear contours in the Bernard into a much more organic ensemble, by virtue of such changes as those which he made in the girl's head at the far left. And by making changes in the overlap between forms, he also created a different kind of interval. In other words, for all that Bernard had used a continuous background of green, he had not succeeded in making his composition anything more than an amalgam of isolated and independent figures. His painting remains, in this light, simply an additive gathering of genre motifs.

It remains to ask if Gauguin required the specific stimulus of Bernard's *Breton Women* in order to arrive at his *Jacob and the Angel*. It is true that this latter work—described to van Gogh in a letter of late September[20]—stands out as exceptional in Gauguin's output of 1888. It is exceptional in structure, in composition and in its basic experimentalism. But all this can in fact be accounted for by taking into consideration three contributory factors which have nothing to do with Bernard.

Pl. 84

First, there was the use of Hokusai's *Mangwa*; as in the second canvas of *Young Boys Wrestling* discussed in Chapter 2,[21] the struggling figures in *Jacob and the Angel* are based on the paired figures of wrestlers in that Japanese source-book. Then, secondly, Gauguin had been finding his way gradually during the preceding months towards a greater solidity, heaviness and dourness in his treatment of Breton peasant figures. He actually charted this path of development in a page of studies which he sent to Schuffenecker in August—showing there how he had put aside delicacy of expression and pose in favour of a sternness and rigidity which are certainly not found in the group of watercolours sent by Bernard to van Gogh in July. The treatment of the Breton women in Gauguin's *Jacob and the Angel* is clearly an extension of this new conception. It entails a sculptured quality of form and a woodenness of behaviour which are not found at all in Bernard's *Breton Women*.

Pl. 54

Pl. 85

Lastly, the interrelationship between the two halves of Gauguin's imagery stands out as requiring discussion in its own right. Gauguin's own title for the work was the *Vision of the Sermon*. On their way home from church the Breton women see enacted in a meadow the biblical story told by the curé from the pulpit. An imaginary incident in Breton life and its psychological basis are conjured up simultaneously in a variety of concrete ways. The suggestion seems to be that the

four legs and horns of a cow have been transformed by the peasant imagination into the shapes of the struggle itself. The flattening of the wrestling figures and the dividing element of the tree imply that the vision does indeed belong to a different order of reality from that of the women themselves; but at the same time, the fact that the struggle is shown taking place in the very field in which these women are standing, and the fact that the golden light in that part of the composition falls across on to one of the women's faces, endow the vision with the quality of being, in a peculiar sense, 'real'. There is, then, a very elaborate counterpoint here between illusion and reality. This is really the fundamental novelty of the work and the central key to its bold experimentalism. And it may be suggested that just as Degas' art contributed to the imagery in Gauguin's *Portrait of Madeleine* —or at least to the forging of that imagery—it contributed here. Gauguin could well have had in mind, that is, those theatre-pieces of Degas' of the late sixties and early seventies which show the orchestra or men in the front stalls, heavy and thoroughly corporeal, down below; and up above, the performers on stage, light and ethereal, like disembodied spirits caught for a moment in a light and a setting which create a peculiar reality. There is a passage in Gauguin's memoir *Avant et Après* which shows that he did indeed respond to this dualism of appearance and reality in Degas' treatment of ballet subjects.[22]

Pl. 86

If this reconstruction of the genesis of the *Jacob and the Angel* is accurate, then Bernard's *Breton Women in a Meadow* is, when it comes to the real essence of Gauguin's inventiveness at this point, almost a complete irrelevance. It is the lack of connection between the two works which is really striking at this level. The two artists split apart at this point, in the same way as in their paintings of Madeleine, only even more so. Gauguin did not need to know this particular Bernard in order to bring his *Jacob and the Angel* into being. He may have been interested in Bernard's talk about 'lines moving in opposite directions', and this talk may have helped him to create, soon after Bernard's arrival in August, a linear syntax which would enforce his new conception of the Breton woman— so leading in turn to the marvellously firm and strong contour-rhythms of his *Jacob and the Angel*. But those contour-rhythms are not in fact made up of a continuous network of black lines running all the way around the figures, as has often been claimed in supposed proof of Gauguin's dependence on Bernard. Again, Bernard's use in his *Breton Women* of a background of a single colour, green, modelled as it evidently was on the example of Japanese

prints, may have helped to canalize Gauguin's already existent interest in this kind of colour-spread. Possibly it was Bernard's preoccupation with Renaissance art[23] which gave Gauguin the idea of the two figures to the left and right in his *Jacob and the Angel*. For these figures lead the spectator into the vision in the same way as donors or saints in Renaissance altarpieces introduce the central Madonna. And Gauguin may also have been interested in one of Bernard's Breton heads—the one at the bottom right in the *Breton Women*—creating in due course a variation of his own in the *Still-life with Fruits* which is dated 1888 and the *Vineyard* of November that year; the chronology here is not yet entirely clear. But even if this were so, Gauguin still gave the motif or idea, in all of these cases, an entirely personal twist and connotation of his own. The curé at the far right in the *Jacob and the Angel*—the man who conjures up the vision—has Gauguin's own features; the pose of the key figure in the *Vineyard* refers back once more to the art of Degas.[24] None of the above points, in any case, amounts to dependence upon Bernard—to his influence, as the term is understood in earlier periods of art history. The truth is that in 1888 there was no real interaction between the two personalities. On this basis the Gauguin-Bernard controversy should finally be laid to rest.

Pl. 116

One special reason for saying this is that the long-standing emphasis on that particular problem has thrown into shade a much more important issue: namely, the contribution of Bernard to van Gogh's art during the same year, 1888.

To understand the framework within which this contribution took place, it is necessary to go back to 1887. In the course of that year van Gogh and Bernard had met one another for the first time, in Paris.[25] They painted together at Asnières, and started corresponding when van Gogh went off to Arles. There are no very informative letters from van Gogh's Paris period, so a reconstruction of what happened then must be built up on the basis of later remarks of his and factual information from elsewhere.

In 1887 Bernard had worked in close association with Louis Anquetin. He described this partnership in an article of 1934.[26] Naturally he discussed it to his own advantage; but he did also set out certain basic facts, which ring true. The association is confirmed, furthermore, by two remarks of van Gogh's of 1888: in June that year he wrote 'young Bernard has perhaps gone further in Japonaiserie than Anquetin', and in July, 'the exhibition of Japanese prints which I organized at the Tambourin influenced Bernard and Anquetin a good deal.'[27]

The activities of the partnership can also be deduced from an article which Edouard Dujardin published in March 1888, entitled 'Le Cloisonisme'.[28] Van Gogh gave this article a mention too, saying that he had only heard of it, not read it.[29] Dujardin limited himself to dealing with Anquetin's work, without bringing in Bernard's. But the label which he used to describe the character of this work had to do with the influence of the technique used in cloisonné vase decoration. Gauguin, in the memoir he wrote at the end of his life, associated this technique with Japan.[30] So this again fits with the stimulus of the Japanese prints which van Gogh had put on view.

There are, at the present time, only two known works by Anquetin dating from 1887. Two more are mentioned in van Gogh's letters,[31] a study of a peasant and a painting of a boat, but these have not so far been brought to light. One of the known works is the *Harvest*, which van Gogh also mentioned, in a letter to Bernard of June 1888,[32] the other is entitled
Pl. 94 *Avenue de Clichy, Evening*. The reason that van Gogh knew the *Peasant* study, *Boat* and *Harvest* was that he, Anquetin and Bernard had exhibited together in a hall on the Avenue de Clichy; he referred to Anquetin as a friend several times in his 1888 correspondence.[33] So there is every likelihood that he also knew the painting of the *Avenue*. This is a very engaging work, but in no sense a revolutionary one. The critic Fénéon had the measure of what Anquetin's art at this period amounted to when he wrote in 1889 of his unbroken contours and flat and intense tones. These elements, he said, might have influenced Gauguin—an idea which made Gauguin furious—but he added that, if so, it was a purely formal influence, 'for it does not appear that the smallest feeling circulates in these intelligent and decorative works.'[34] With its prettiness of pattern and its quality of looking a little bit like everyone else's work, the *Avenue* has indeed all the marks of a cultivated decorativeness.

So much for a particular element of van Gogh's experience of 1887. Now it was characteristic of him to draw on his artistic experiences in Paris and the works of art to which he had been exposed there only after he had left the metropolis and was on his own once more. That is, he would lodge in the back of his mind some characteristic motif or trait of a work of art seen in Paris, and then, in the course of his campaign of painting at Arles, he would recollect that motif and the way it was handled, and arrive at a parallel in his own work.[35] It was a special aspect of his visual memory and temperamental inclination that he was able to do this, and clearly a kind of delayed homage was involved. He now saw the special relevance of what the artist in

question had done. It was real and meaningful to him as it had not been at first exposure, and he could adapt that meaningfulness to fit with current interests of his own.

There is only one painting of Bernard's which is certified as a work of 1887 by van Gogh's later references to it. This is the portrait of the artist's grandmother in the Theo van Gogh collection. Though undated, it is indubitably one of the two portraits of this lady which are referred to in an 1888 letter from van Gogh to Bernard. Van Gogh described the painting in further detail in a letter of 1889 to his sister, mentioning the wall to the rear with chocolate-coloured wallpaper and a 'completely white bed'; and he wrote that he had exchanged it for a self-portrait of his.[36]

Pl. 89

This account of van Gogh's explains the identity of the white object at the back right in the portrait. It also explains what the object at the left is in the *Portrait of an Old Woman* which van Gogh himself painted in February 1888, soon after his arrival at Arles. Clearly van Gogh was recollecting here, retrospectively, the imagery in a work of Bernard's which he knew very well indeed, and was putting an equivalent motif into his own painting of an analogous subject. A similar case of recollection of Bernard's imagery on van Gogh's part may be the painting which van Gogh did in March of *Lovers on a Towpath*. He sent to Bernard that month, at the head of a letter, a pen sketch showing what this study in oils was like; and a fragment of the painting, which was evidently cut up, does in fact survive. The two together can be compared, as far as subject matter is concerned, with a painting of Bernard's of the *Bridge at Asnières*; this Bernard is dated 1887 and, though there is no firm support for this date, style and script together lend it a reasonable plausibility. It could quite well, furthermore, be one of the 'landscapes and figures of suburban Paris' which van Gogh told his sister that Bernard had done.[37]

Pl. 90

In the same letter to Bernard in which van Gogh spoke of the *Grandmother*, he also alluded to two still-lifes of Bernard's. He had already told Theo in a letter of April 1888 that there was a Bernard *Still-life* which he had seen unfinished and had admired.[38] Though there can be no certainty on the subject, it is highly likely that the *Still-life* now in the Musée d'Art Moderne, which is dated 1887, was one of the works in question. The inscription on the back of this *Still-life*, 'first essay in synthetism and simplification' must quite obviously have been added by Bernard later; it must be a retrospective assertion of the work's importance. But the colours here (blue and yellow as in the 1888 *Self-portrait*) and the handling of contour seem

Pl. 91

69　VAN GOGH　*Terrace at the Tuileries*　c. 1886

71　BERNARD　*Idyll at Asnières*　1888

70　BERNARD　*Figures on a River Bank*　1888

72 VAN GOGH
Night Café
September 1888

73 SIGNAC
Gas Tanks at Clic
1886

Opposite :

74 SEURAT
La Parade (Study)
c. 1887

75 VAN GOGH
Corner in the Park
c. 1887

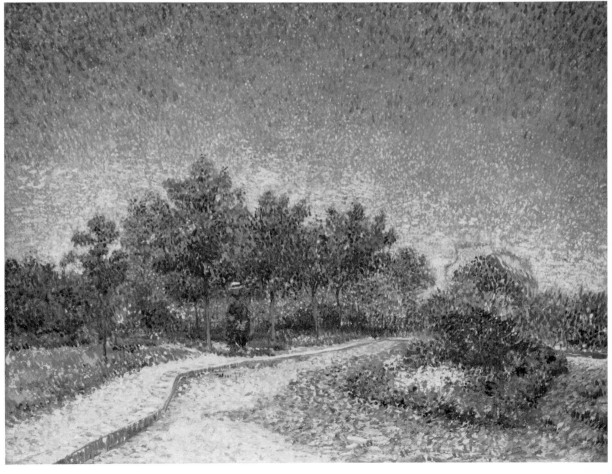

76 SEURAT *La Parade* 1886-8

77 GAUGUIN
Still-life with a Japanese Print
1889

78　BERNARD
Self-portrait for
Van Gogh
September 1888

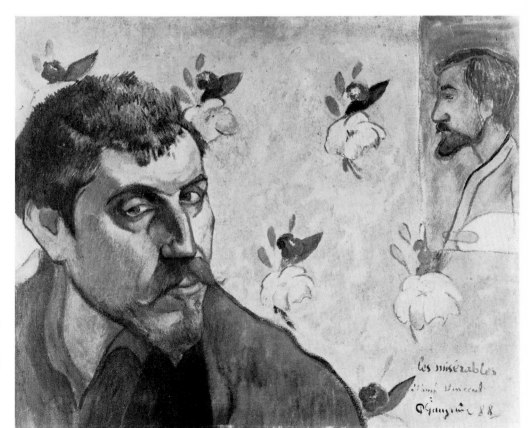

79　GAUGUIN
Self-portrait for
Van Gogh
September 1888

80 GAUGUIN
Portrait of Madeleine Bernard
September 1888

81 DEGAS *Portrait of Hortense Valpinçon c.* 1871-2

82 BERNARD
Madeleine at the Bois d'Amour. September 1888

83 KLINGER *Early Spring c.* 1877-9

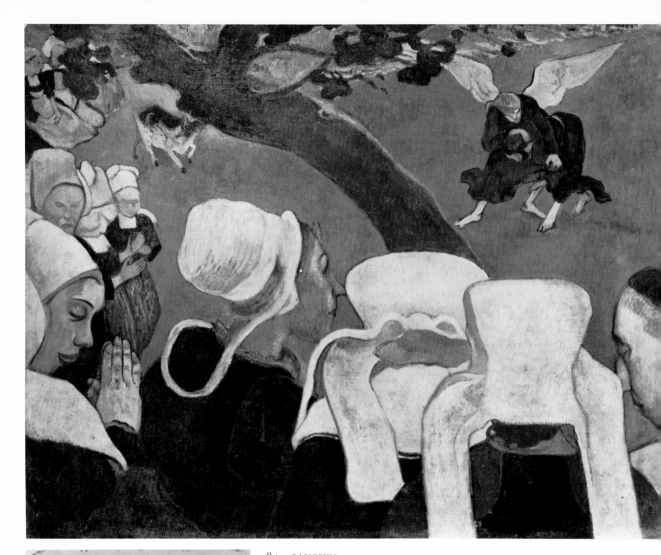

84 GAUGUIN
Vision of the Sermon (Jacob and the Angel)
September 1888

85 GAUGUIN
Page of drawings of *Breton Women*
August 1888

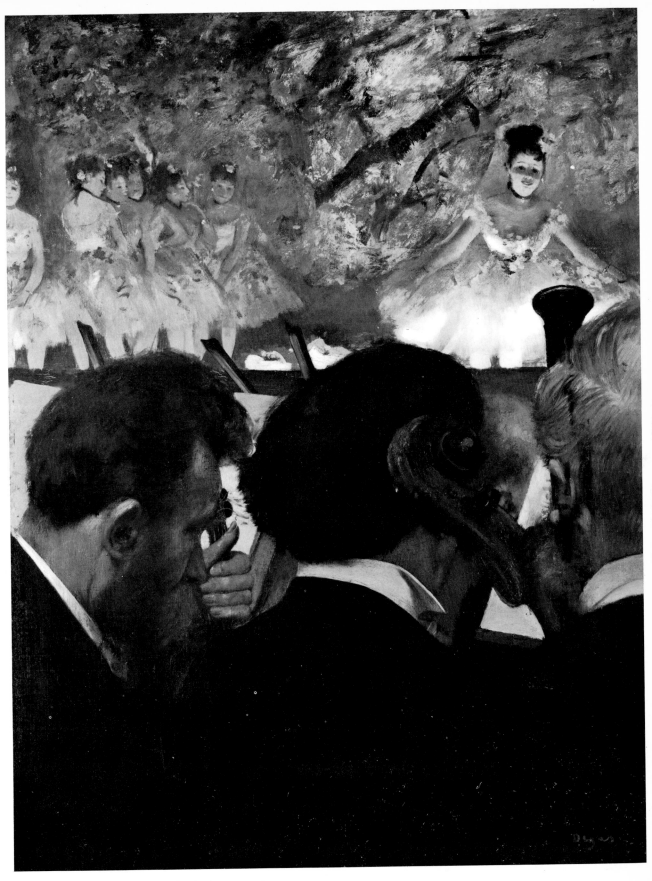

86 DEGAS *Musicians in the Orchestra* c. 1872

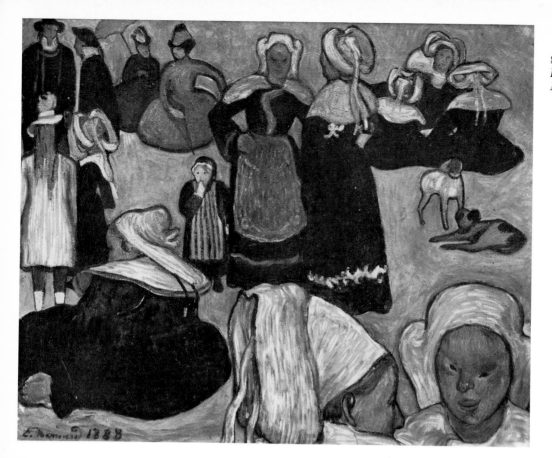

87 BERNARD
*Breton Women in a
Meadow* 1888

88 VAN GOGH
Copy of Bernard's
*Breton Women in a
Meadow* 1888

89 BERNARD *Portrait of the Artist's Grandmother* 1887

90 VAN GOGH *Portrait of an Old Woman*
February 1888

91 BERNARD
Still-life 1887

92 VAN GOCH
Still-life with Coffee Pot
May 1888

93 BERNARD
*Drawing of a Woman, inscribed
'Paris'*

95 VAN GOGH
Arena at Arles 1888

94 ANQUETIN *Avenue de Clichy, Evening* 1887

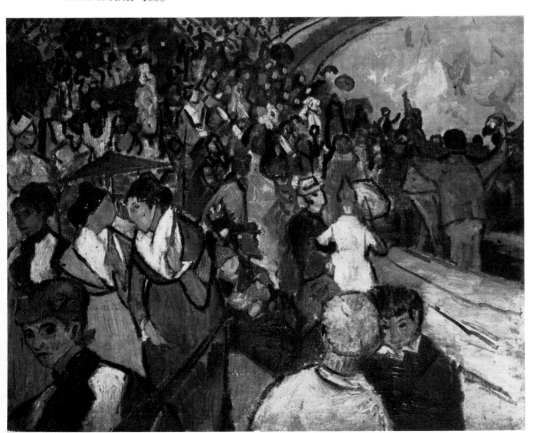

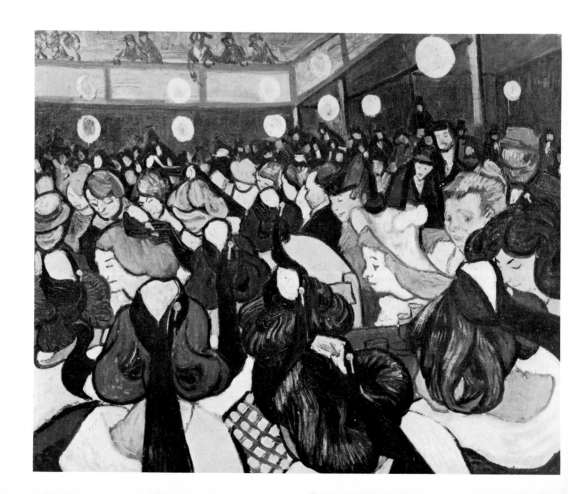

Opposite:

96 BERNARD *Brothel Scene* 1888

97 BERNARD *Lane in Brittany* 1888

98 VAN GOGH *Dance Hall* 1888

99 BERNARD *Brothel Scene* 1888

100 VAN GOGH
Brothel Scene. November 1888

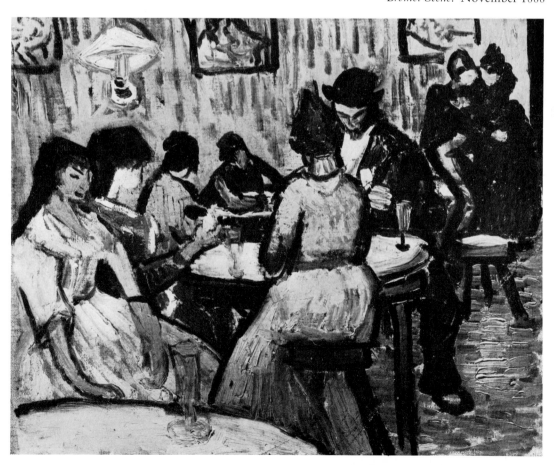

101 DEGAS
Portrait of Tissot c. 1866-7

102 VAN GOGH
Self-portrait for Gauguin
September 1888

Pl. 94

Pl. 92

Pl. 93

Pl. 94

Pl. 95

convincingly in step with Anquetin's 1887 style in the *Harvest* and *Avenue de Clichy*. So this painting, while it is not certified to the same firm degree as the *Grandmother*, has a much better claim to authenticity of date than most of Bernard's which purport to be of 1887.

Now, in the second half of May, van Gogh did a painting of a *Still-life with Coffee Pot*; and, as with the *Towpath*, he sent Bernard a sketch after the work. The tilting up of the table top there, and the contouring of the fruit compare very suggestively with the treatment of these same two features in the Bernard under discussion. This handling of fruit on van Gogh's part could in fact be called cloisonnistic. Between February and late May, then, van Gogh appears to have moved from drawing on Bernard's imagery to drawing on his pictorial syntax. What had brought about this change?

The answer is that in April Bernard had begun sending van Gogh sketches and drawings of his.[39] This was an extension of the correspondence between the two men and a fulfilment of van Gogh's idea of exchanges between himself and other artists—he sent back to Bernard drawings of his own.[40] All of the drawings which van Gogh received from Bernard during the year, and subsequently sent to his brother, are preserved today in the Theo van Gogh collection.[41] They can be sorted into groups and arranged chronologically on the basis of the descriptions of subject-matter found in van Gogh's letters. The first descriptive reference of this kind comes in a letter dating from the second half of May.[42] Van Gogh mentioned there a 'portrait of a woman' which he had received in Bernard's last letter but one—that is, in April. This 'portrait' was in all probability the drawing of a woman inscribed 'Paris'. Bernard was still in Paris at the time in question;[43] and what he did here is to be compared first with Anquetin's *Avenue*. The compositional scheme in these two cases is strikingly similar, and the similarity also extends to the imagery of figure and street-lamp. Obviously, then, this drawing provides a concrete explanation of van Gogh's remark in June that 'Bernard [had] gone further in Japonaiserie than Anquetin.'[44]

The painting by van Gogh of the *Arena at Arles* can now also be brought in for comparison. This is one of a small group of paintings from 1888 which are clearly outside the normal run of van Gogh's work at this time, and experimental in character. The *Arena* has usually been dated to the very end of the year, after Gauguin's arrival, and connected with his influence. But van Gogh described a visit to the bullfights in a letter of early April to his brother. He then returned to the same subject, in

more general terms, in his letter to Bernard of the end of April
—remarking on how magnificent the gaily-coloured crowd
had been, on the raised tiers surrounding the arena, and on the
effects of light and shadow created by the sunshine.[45] There is,
therefore, some documentary basis for supposing that the
painting in question, with its closely matching imagery, was
done around the date of that second letter. One can take the
argument a stage further by noting the strong similarity
between the figure at the bottom left and the one in the Bernard
drawing, and the further resemblance to Anquetin's *Avenue*
in the dense massing of the figures and the handling of contour
and facial expression. This double pointer, then, gives grounds
for supposing that the *Arena* was painted following receipt of
the Bernard drawing—the stimulus of which stirred up, in
turn, van Gogh's memory of the *Avenue* by Anquetin. The
whole character of the *Arena*, furthermore, suggests that it was
painted from memory, which was itself an experimental
departure for van Gogh. He was already at this time writing to
Bernard about the possibility of his choosing to work from
memory: 'I sometimes regret that I cannot make up my mind to
work to a large extent at home and on an imaginative basis.'[46]
Clearly, then, Bernard's advocacy of the use of imagination
was already pricking van Gogh—seven months before Gauguin
persuaded him into doing several works in this fashion.

After sending van Gogh a watercolour sketch of a brothel
scene late in June, Bernard then put together a consignment of *Pl. 96*
ten drawings at the end of July.[47] One of these was the *Lane in
Brittany* which is described, in unmistakable terms, in van Gogh's *Pl. 97*
letter acknowledging receipt of the batch, as 'the alley of plane
trees . . . with two women conversing in the foreground and
some people out walking.'[48] There is a painting by van Gogh
of a *Dance Hall* which is again experimental; this is indicated by *Pl. 98*
the use of strong blacks and a pungent yellow. Again, this is a
picture which has been dated to the end of the year, but in a
letter of mid-September van Gogh referred to paintings of
'cabarets' which he had done.[49] One of these so-called 'cabarets'
was the *Night Café* of early September, and there is a strong *Pl. 72*
argument that the *Dance Hall* was the second work included
under this heading. This, then, would date the *Dance Hall* to
the period when van Gogh was digesting the drawings received
from Bernard at the end of July. And again a direct com-
parison with the *Lane in Brittany* can be made, especially in the *Pl. 97*
emphatic use of contour and in the treatment of the headdresses,
which become in van Gogh's case a combination of coif and
coiffure.

Late in September Bernard sent six further drawings. Van Gogh mentioned 'two sketches of prostitutes' included in this batch, saying that he liked them particularly.[50] He was presumably referring here to a single sheet which has two drawings of prostitutes on one side and a third scene on the reverse showing a group of figures around a table in a brothel. And when, early in October, he received still another consignment from Bernard, which took the form of a suite of twelve sketches of brothel subjects, he now reacted in two ways. First, he corrected afresh Bernard's mistaken supposition that his *Night Café* depicted a brothel. Indeed, he was now quite vehement in his insistence that this was not so.[51] So he was obviously very sensitive to the fact that he had not so far painted a real brothel subject himself. And secondly he now sent (or at least promised to send) to Bernard a small canvas which he had done from memory in the meantime. Based on a scene which he had witnessed in the Night Café, it showed, as he put it, 'a pimp and prostitute making up after a row'. 'The woman was putting on an act of haughty indifference,' he went on, 'the man was cajoling.'[52] Clearly, then, this study piece represented a tentative answer on van Gogh's part to the challenge of Bernard's brothel subjects. As for the actual character of the work, this canvas of early October must be presumed lost. But the description just cited shows that it was, in its way, related to the drawing of figures round a table which Bernard had sent down. And some idea of what it was like in handling can also be gained from the rough oil-sketch of a brothel which van Gogh did in the second half of November, after Gauguin had joined him. This latter study belongs among the group of works which van Gogh did from memory, at Gauguin's instigation.[53] But the thick black contours there are not something that van Gogh could find in Gauguin's contemporary work. Rather they relate back once more to that same September drawing of Bernard's.

On 23 October Gauguin arrived at Arles,[54] bringing with him Bernard's canvas of *Breton Women*, which, as was mentioned above, was then copied by van Gogh in watercolour and gouache. Another of the paintings which van Gogh did from memory late in November, the *Novel Reader in a Library*, has the same sort of rhythmic, smooth-flowing contours as are found in his transcription of the *Breton Women*. Indeed the figure here has a certain amount in common with the two ladies of society included in that canvas. The colours in this van Gogh, furthermore, are pale yellow, black and dark green, a combination which significantly parallels Bernard's kind of colour

Pl. 99

Pl. 100

Pl. 87
Pl. 88

Pl. 126

usage. Imagery and colour together here, in fact, produce an effect of aestheticism. This aestheticism—out of line with the usual directness and humanism of van Gogh's figure paintings—can be compared with the aestheticism which so dominates Bernard's whole production of 1888, and his *Breton Women* in particular.

So even when van Gogh was working directly at Gauguin's instigation and suggestion, his experimental efforts were still more in line with Bernard's work than with Gauguin's. They were in line with the experimental paintings he had done earlier in the year, the *Arena* and the *Dance Hall,* in colouring and treatment of form. His approach in those two cases had simply become updated, technically and structurally, on the basis of the more recent works of Bernard's which he had seen since that time.

This point can be confirmed by contrasting the major work which Gauguin did towards the end of his stay at Arles: his *Portrait of Van Gogh painting Sunflowers.* Here, it may be suggested, Gauguin again took a cue from an early work of Degas'—just as he had done in his *Portrait of Madeleine Bernard.* The specific Degas which is relevant in this case is the *Portrait of Tissot* of about 1866-7. The painting across the rear wall there, with its upper part cut off, relates to Tissot's Japanese enthusiasm of the time; and correspondingly there is a cut-off landscape of Gauguin's at the back of the Gauguin portrait, under the shadow of which van Gogh works. Similarly, there is a division of interest, a split attention on the part of the sitter, which is communicated in both cases. In the Degas, Tissot, looking out at the spectator, seems divided between his preoccupation as a man of fashion and his connection with the paintings on the walls and in progress around him; one is almost surprised that this man is an artist. The idea of a split interest is also present in the Gauguin. But he characteristically gives this idea a new twist by suggesting a division of interest on van Gogh's part between the canvas on which he is painting, with his eyes almost hooded over, and the actual sunflowers which he is transcribing. There seems to be a further link between the two works in the fact that the eye is similarly, in the Gauguin, directed across from the figure to the contents of the studio. And just as Tissot's dandyism is set into key with his interest in the world of Japan, so van Gogh's behaviour is set into key with his interest in following Gauguin's example. If this suggestion about the stimulus of a particular Degas is correct, then this portrait of Gauguin's relates back, just as much as van Gogh's contemporary 'abstractions' do, to concerns which were at

Pl. 163

Pl. 101

work before the two men came together. The dissimilarities in the two men's work proceeding from this fact, among others, will be studied in detail in the next chapter. All that needs to be said here is that Gauguin's interests at Arles never really intersected with van Gogh's continuing response to the stimulus provided by Bernard.

To sum up, therefore, on van Gogh's side: the works which Bernard sent down to Arles were indeed of some importance to van Gogh in 1888. It would be wrong to imply that they added up to a strong and continuous artistic influence; van Gogh was already much too firmly set on his own path for that. But they were nevertheless a recurring stimulus to experiment.

It may seem curious and even disconcerting that van Gogh should have reacted with such enthusiasm and honest approval to works which did not have anything like the quality of his own creations. But it was always part and parcel of van Gogh's mentality to be impressed by second- as well as first-rate artists. One must also remember that van Gogh was incapable of taking a friendship lightly, when it provided a link with both Gauguin and the world of Paris. And the force of the intellectual ideas expressed in Bernard's letters must equally be borne in mind as an explanatory factory. Bernard's main forte indeed lay in the forceful way in which he could talk and write about art.

The general effect on van Gogh of works and ideas together can be gauged by considering the character of his own *Self-portrait* dedicated to Gauguin. This work was painted quite a while before Gauguin's arrival at Arles, and van Gogh had finished it well before the date when he received Gauguin's *Self-portrait with a Portrait of Bernard*. Supposing for the sake of argument that there was no word of van Gogh's to show that this was a symbolic portrait,[55] it could still be said that the close-shaven head, silhouetted against a green background, suggested monasticism. So does the monkish brown of the coat, and so does the clasp at the top of the shirt; for its relation to the lines of the collar brings up the idea of an emblem of faith. These individual motifs, then, and the cross-relationship between them, introduce special associations into the portrait image. Obviously, there is a connecting thread here between this kind of interest on van Gogh's part and Gauguin's contemporary procedure in works like the *Portrait of Madeleine*. But at the time when he did this *Self-portrait*, van Gogh had not yet seen any recent work of Gauguin's.[56] It was the intercommunication between him and Bernard which sparked off the special form which this *Self-portrait* took.

Pls. VII, 102

Pl. 79

Pl. 80

Already in September that same pattern of intercommunication had led van Gogh to attempt a *Portrait of a 'Poet'* with a starry sky behind, and to depict *Lieutenant Milliet* with the arms of his regiment superimposed on the background. In the succeeding *Self-portrait* it led to a temporary parallelism with Gauguin. That is the ultimate measure of Bernard's importance for van Gogh. And it is a very real importance, much greater than the importance of Bernard's work for Gauguin.

5 Van Gogh and Gauguin at Arles

When van Gogh and Gauguin met at Arles at the end of 1888, it was after a long period of negotiation on Vincent's part, through his brother Theo, for Gauguin to come down and join him. Basically, Vincent was lonely. He had invested so much, emotionally, in his own move south in February 1888, that he needed someone else with him, for support and involvement in exploration of the region, to make it all seem worthwhile. Gauguin, recently back from his disastrous expedition to Martinique of 1887, and now sick in Brittany and in financial straits, recommended himself for these personal reasons; it being part of the van Gogh brothers' philosophy of participation in the art-scene to help other artists in need. And Gauguin also recommended himself as having emerged, during the summer of 1888, as the leader and even the teacher of the small group of artists that he had gathered round him in Brittany. As Vincent's ideas expanded, in the swell of his hopes, Gauguin was to be head of the 'studio of the South', centred on Arles—a future place of refuge for other fellow-artists who needed respite from Paris. This was a role that Gauguin, independent, opportunistic and difficult in character as he was, was inherently unlikely to be able to fulfil. But he came finally, when his financial situation made this desirable, with a certain amount of good grace. And Vincent naturally welcomed him with open arms, eager to show him the virtues of the house and studio he had set up and its surroundings, and anxious—over-anxious—that he should be contented in his work there. Such was the background to the familiar personal tragedy of alienation and inner disturbance, bringing on Vincent's first mental breakdown and his cutting of his ear, just two months after Gauguin had settled in.

At the time of their meeting at Arles, both Gauguin and van Gogh were on the further side of a major breakthrough in their painting. It was little more than a month since Gauguin had *Pl. 84* executed his *Vision of the Sermon*; and that work actually detaches itself very strongly from the main drift of Gauguin's development during 1888. It is unique amongst his paintings of that year both in terms of its religious subject matter and in terms of its structural innovations, which were of an intensely

willed and schematic kind. And while Gauguin would take up afresh the following year, in his *Yellow Christ*, the idea of a monumental painting embodying what may be called an outsider's view of the psychology of religious belief, it was not until the opening year of his first stay in Tahiti that he would turn back to the structure of the *Vision* and exploit its potentials afresh.[1] At the end of 1888, then, he had just passed an experimental peak and was unable for the moment to push on directly from that point. He had also reached an imaginative peak in that single canvas of his. It is probably no coincidence that the image of Jacob and the Angel wrestling together had been used in Zola's *L'Œuvre* (1885-6) as a metaphor for the artist's rebellious struggle in the act of creation.[2] And Gauguin was the kind of person who, rather than face up to the consequences of his radicalism in advance, waited until they bore down on him of their own accord. It is, indeed, as if he could not see for himself any too clearly, for the time being, how exactly he could carry on and forward from what he had done in the *Vision*.

As for van Gogh, his whole excited reaction to the landscape and sunshine of Provence had propelled him forward into an extended series of paintings of seasonal subjects. But in coming to terms with the fact that he was an exile from his native Holland and from family life, he simultaneously used memories of the Dutch landscape and of the masters he had revered in early life as a guide in his new endeavours. This applies particularly to his choice of human subject matter, and to the way in which he organized his paintings around or in terms of these subjects. Furthermore, despite the strength and heartfelt purposefulness of his attack on his new environment, he was still ready and willing to turn aside momentarily during the year and produce experimental works along the lines recommended by Emile Bernard; this point has been brought out in the preceding chapter.

These qualifications about the character of the 1888 breakthrough in the work of both men underline very strongly the pattern of experimentalism which is so very characteristic of the 1880s. Even at a mature stage of development, both men were still capable of diverging from their main track, in terms of imagery and creative procedure. And that is exactly the effect which van Gogh and Gauguin had on one another during their time together.

Lastly, both men had been extremely productive during the earlier months of 1888, in terms of the number of canvases which they successively turned out. And, despite the personal difficulties in their relationship with one another, this high rate

of productivity would in fact continue throughout, or almost throughout, the eight weeks which they spent in one another's company.[3]

Pl. 145
Pl. 103

Between the time of Gauguin's arrival and the end of October, van Gogh produced a new canvas on the theme of the *Sower*, and one which he described as showing 'a ploughed field, with the stump of an old yew tree'.[4] These two works are in line, both in imagery and in structure, with works that he had done during the previous months. In June, that is, he had done a canvas of a sower crossing a ploughed field which harks back directly, in the figure's pose and placement, to the copies of Millet's *Sower* which he had done in 1880-1. The October canvas also refers back to that same original model but the figure is now turned in the opposite direction and follows a diagonal rather than a strictly horizontal path.

Again, the lumpiness of the earth in the foreground of this new canvas matches rather closely the way in which van Gogh had depicted the earth in the painting of September 1888 which he called 'the ploughed fields'.[5] Not only does ploughed earth appear in the other canvas of late October; the June *Sower* had also been framed as a pendant to a study of an *Oak on a Rock*. So there was a direct precedent for the idea of combining together ploughed earth and a single isolated tree. And the two canvases of late October hang together in their imagery in a further sense as well. Just as the figure of the sower, with heavy stride and outstretched arm, came to van Gogh out of Millet's late Romantic art of three decades earlier, so the idea of new growth coming out of an old, gnarled tree-trunk was ulti-mately a Romantic concept. And the solidity and centrality of the tree seem in fact to make it, like the sower, a personification of fundamental values—an island of strength amid the chang-ing world of nature.

The October *Sower* and *Ploughed Field* also have one very significant structural feature in common. Whereas the field to the rear lies flat and even, with a pronounced regularity of sur-face pattern, this changes altogether as one moves out in front of the major, central image. In the foreground, that is, the sur-face of the field shelves down very sharply towards the bottom of the canvas, and only the rootedness of the tree and the sower seems to keep them from toppling in the same direction. This precariousness in the relationship between the twin con-stituents of the painting, and this use of the one to shore up, as it were, a threat of engulfment emanating from the other, had first emerged in van Gogh's canvases of the preceding

summer.[6] And the direct carry-over now, late in October, shows that van Gogh was following a reasonably set way of dealing with nature at the time when Gauguin joined him.

The outline of the tree trunk is handled in much the same way as the clods in the *Sower*: in short, strong, crisp strokes of pure paint, which are characteristically set in angular relationships to one another. This incipient sketchiness and purity of technique are not found in any previous painting of 1888; but this is a difference of degree rather than one of kind, and merely indicates van Gogh's increasing capacity for spontaneous improvisation with the brush.

The works which Gauguin did at the end of October relate back, in an even more dependent sense, to earlier concerns of his. He remarked at the end of his life, apropos of his move to Arles, that it always took him time to find his bearings in a new environment.[7] And the works in question bear this out. According to van Gogh's report, his first essays were a study of some kind of a 'negress' and a 'large landscape of [the] region'.[8] The *Negress* (if it was ever finished), is lost without trace; but one can deduce, from the title alone, that Gauguin was harking back in his imagery here to his stay in Martinique and his first involvement with exotic subject matter. As for the 'landscape', the work which in all probability corresponds to this reference is the so-called *Landscape with Farm Buildings*. Its *Pl. 104* technique consists of short, soft strokes which are arranged in feathery patterns throughout most of the picture with the primed canvas showing in between. This technique, far from being a novelty, is found in certain Breton canvases of 1888 which can, from their subject matter, be assigned to the spring of that year. Furthermore, the motif of two young women conversing together in a pocket in the landscape is already found in a Breton landscape of 1888. Colour and handling in this latter *Pl. 106* canvas strongly imply that it postdates the *Vision of the Sermon*. This means, then, that it must have been one of the last canvases that Gauguin did before his departure for Arles. And a study in the sketchbook which Gauguin used at Arles shows *Pl. 105* that, in returning to the motif there, he simply changed the costume to conform to local custom.

The relation between the sketchbook pages in question and the *Landscape with Farm Buildings* actually offers a paradigm of Gauguin's creative procedure during his time at Arles. Besides the study for the costume of the right-hand girl, there is a study for the farm buildings themselves on the facing page. The *Pl. 105* contour of the foreground slope and the position of the foreground trees are both lightly sketched in there. In other words

Gauguin went out, armed with his sketchbook, into his new environment, and drew directly from nature both figurative and architectural motifs. Probably he aimed to build up, in graphic form, a whole stock of such motifs. His method of drawing was schematic, however. It took the form of a very personal redaction, without any reference whatever to such ephemeral data as movement or shadows. The motifs which he gleaned in this way then became the basis for his painting, in the sense that he grouped them together in an appropriate and associative relationship. But everything from then on seems to have consisted entirely of imaginative filling-in around and between these motifs. The ups and downs of the landscape, its vegetation and its spatial development were all in this sense improvised—partly on the basis of memory of the corresponding *Pl. 106* *Breton Landscape.* The study of a farmhouse also shows that, when Gauguin was confronting nature, he attended most specifically to the interrelationships between external contours. All of these graphic relationships are preserved in the final painting; but at the same time doors and windows are added, of which no track had been kept in the preliminary sketch.

All in all, then, Gauguin's procedure at this time had a great deal in common with the procedure which Manet had used in creating his *Beach at Boulogne* in 1869. There was the desire to give his work a certain flavour which was recognizably Provençal, even while the general character of his landscape imagery did not differ too notably from the works of the same type which he had been doing in Brittany. From now on, too, all of the major works which Gauguin did at Arles were to be on canvases of exactly the same dimensions.[9] So it looks as if, from the very first, he had in mind to work consistently on an ambitious scale.

In the first half of November van Gogh did four paintings of the Alyscamps Avenue: that is, of the avenue at Arles lined on both sides with poplar trees, Roman tombs and intermediate *Pl. 107, 108* benches. Two of the canvases in question show one small section of the avenue, seen from a high diagonal viewpoint, with autumn leaves falling and carpeting the ground. In both cases figures are shown walking along the path. There is a close precedent for this imagery of avenue and strolling figures in a *Pl. 69* painting of the *Terrace of the Tuileries* which van Gogh had done while in Paris. Again, the motif of the pair of lovers, alone by themselves in the centre of one version, is to be found already in many of the outdoor subjects dating from the summer and autumn of 1888. Most particularly it had been

used in the pair of *Gardens* painted in October for Gauguin's room.

The version with three strolling figures is probably the later of the two mentioned so far, because the figures there are seen from an even higher viewpoint, with a consequènt decrease in scale, and the movement of the avenue's perspective out towards the spectator is more formally controlled. The effect in this case is also emphatically more decorative. The gait and behaviour of the figures and the gay colouring of their costumes suggest that the Alyscamps was a place for social promenading. This, indeed, is the closest that van Gogh ever came to the kind of Seuratian subject matter and colouristic decorativeness found in Bernard's *Breton Women in a Meadow*. Cast shadows are completely suppressed, as there.[10]

It is certainly very much to the point that Gauguin had brought that canvas of Bernard's down with him to Arles. There is no direct evidence as to when exactly van Gogh made his copy of it in watercolour; and he may in fact have done this piece of copying at the earliest possible moment. This would then fit in chronologically with the point made in the preceding chapter about the stimulus of Bernard's canvas.

There are also two upright canvases painted from a spot close to the gates of the Alyscamps, looking down the avenue so that the whole of its length is shown. Only one of these versions is referred to in the *Letters*—the one which shows the buildings at the further end. This canvas was most probably the later and more definitive version. Here van Gogh made the Romanesque arch at the far end into a Gothic arch, presumably so that it tied in with the upward movement of the poplars and with the pointed shapes elsewhere in the composition. He also swivelled round two of the tombs so that, contrary to fact, they project out into the avenue at right angles to the trees. While the first upright version comes closest of all to the Parisian painting of the *Tuileries* in the size and number of the figures and the way in which they are painted—so that it may well have been done even before the two horizontal versions—the second upright version again has a man and women paired together, alone by themselves in the middle of the composition. And most interestingly of all, a group of factory buildings and chimneys is now introduced beyond the rise on the left. In fact beyond that rise there is, and was then (since Gauguin painted it), a narrow canal. Factory buildings are still to be seen in the vicinity today, on the same side of the avenue; but they lie much further down towards the entrance, so that they can only be seen from a point outside the avenue itself. Evidently, there-

Pl. 108

Pl. 87

Pl. 88

Pls. 109, 110

Pl. 110

Pl. 109
Pl. 69

fore, van Gogh was improvising here in a way that he had not done in the other vertical version. He must have wanted a contrast between the world of modern industry and the peace of the tombs, which were a permanent, undisturbed relic of Roman civilization.[11] The whole cathedral-like presentation of the avenue adds up, in this light, to the implicit suggestion of

Pl. 103
a timeless sanctuary. And here again, as in the *Old Tree*, van Gogh was drawing on a staple Romantic antithesis involving the old and the new. He had in fact depicted factory buildings in their own right in The Hague and during his Paris years, and again at Arles earlier in 1888. And the background to his canvas of *Cornshocks* which dates from the summer of 1888, shows, beyond the spreading cornfields, a view of Arles which includes the smoke of industry and a factory chimney. In introducing the factory into his canvas of the *Alyscamps*, van Gogh was simply bringing to the fore, more explicitly than hitherto, a metaphorical thread which had special meaning for him.

He was, as yet, completely untouched by the stimulus of Gauguin's creative procedure. For in so far as he himself was improvising, he was doing so in exactly the manner he had outlined to Bernard early in October 1888: 'I exaggerate, I sometimes make a change in the motif; but I don't after all make up the picture in its entirety.'[12]

It is commonly maintained that Gauguin painted the avenue at the same time as van Gogh. But there is no documentary evidence to show that the two men worked simultaneously on this, or any other outdoor motif. Nor is there any evidence that Gauguin ever chose to do his painting in front of nature. Furthermore, there is some considerable likelihood that

Pls. 111, 113
Gauguin's two canvases of the Alyscamps were among the landscapes of his which were reported by van Gogh to be in progress early in December. If this is right, there would then have been three to four weeks between van Gogh's own paintings of the avenue and those of Gauguin. And any relationship there might be between the two sets of paintings would work in van Gogh's favour.

It is possible, on the other hand, that Gauguin made graphic notes of a preliminary kind at the time when van Gogh was working on the spot. And one specific point about the canvas

Pl. 111
of Gauguin's which shows the canal on the left of the avenue suggests that this was in fact so. The implied viewpoint in that painting is the very edge of the canal, and the top of the ruined Saint-Honorat chapel appears beyond the further trees. From the edge of the canal, however, the chapel in question is in fact

completely invisible, being away to the right. Furthermore, Gauguin substituted a single tier of apertures for the double tier of the actual chapel tower. What does correspond very closely to actuality in his painting, on the other hand, is the relationship of scale and distance between the tower itself and the roof lines to the left of it. There is some reason to think, *Pl. 112* then—on the analogy of the studies for the *Landscape with* *Pl. 105* *Farm Buildings* and the way in which these were used—that Gauguin did a sketch or two of the chapel and its tower, based explicitly on the contour-lines of the various architectural parts. He may also have done a separate drawing of the canal, and ended by combining the two in his actual painting.

The imagery in this same canvas of Gauguin's also suggests a direct borrowing from an earlier work of van Gogh's. Three diminutive figures in Provençal costume appear together, as here, in one of the canvases of the *Pont de Langlois* which van *Pl. 114* Gogh had painted in the spring. Possibly Gauguin simply took over the motif from that source. He may also have derived the idea of rendering the poplars in uniform flaming orange from van Gogh's second upright version of the Alyscamps. In both of *Pl. 110* these cases he would simply have been using motifs which were to hand in van Gogh's work, in order to fill out what he had available in the way of sketches from nature.

Gauguin also did a second painting of the Alyscamps, *Pl. 113* focusing this time, in relatively close-up view, on the chapel gate at the end of the avenue and the buildings and tombs immediately to the right of it. Here again, the lack of close correspondence to actuality in the internal details of the *Pl. 112* architecture suggests the use of preliminary contour drawings, and an improvisatory filling out when it came to the actual painting. The strongly tapestried effect in both versions would again suggest an early December date—by analogy with the *Washerwomen*, which will be discussed later on. The internal *Pls. 134,135* detail of both architecture and figures is subsumed to this effect, creating a veritable sense of a tapestry curtain coinciding with the picture plane.

Van Gogh's *Red Vineyard* and Gauguin's *Vineyard* (which the *Pls. 115, 116* artist called *Human Miseries*) were painted more or less con-temporaneously during the first half of November. But whereas there is (in a letter to Theo) van Gogh's explicit testimony to the effect that the Gauguin was composed entirely from memory, van Gogh's own picture was clearly based on direct experience. In the same letter, van Gogh described the sight of a red vineyard with the sun going down behind it which he had enjoyed the previous Sunday,[13] and it

was obviously this sight which inspired this picture. It shows, correspondingly, a large number of figures at work in the fields, the foremost ones in bending positions. The colour scheme consists of reds, yellows and blues, and the arc of the figures' activity runs back deep into space in a wider version of the arc of the river. The Gauguin, on the other hand, shows only four figures, one seated, one standing, and two smaller ones bending over side by side to the rear. Gauguin told Bernard that he had seen such a vineyard at Arles—presumably the same one that van Gogh saw—but had chosen to make his figures Breton rather than Arlesian women.[14] He was presumably referring here to their costume, a specifically Breton combination of headdresses, aprons and clogs, and also to the dour facial types and heaviness of build, which can be regarded as a direct carry-over from his Breton work of the previous summer and autumn.

In this canvas of Gauguin's, the feathery textures of the *Landscape with Farm Buildings* are now abruptly put aside. Instead, the paint is applied in thick layers, with the use of a palette-knife. The graining of the coarse canvas shows very pronouncedly through the paint. The contours, too, become less rhythmically flowing and more directly expressive in correspondence with this technique. This is especially evident in the jutting right shoulder of the seated girl and the activity of the two bending figures. The large units of figure and landscape similarly take on afresh the sort of heaviness and rigidity they had in the *Jacob and the Angel*, so that they give the appearance of solid sculptural blocks. Van Gogh's work does not show any comparable novelties of technique or changes in the handling of form. Rather the opposite in fact. In particular, the handling and placing of the farm cart in relation to the landscape harks straight back to his *Harvest* of the previous summer.

The motif of the two bending women with their heads right down was probably suggested to Gauguin by the central figure in the van Gogh, and since his picture was put together indoors —this goes with the use of memory—it is highly likely that his colour scheme of red and violet was also suggested by van Gogh's picture. But whereas van Gogh's figures are interspersed through the landscape, Gauguin's are hung upon it. And the difference in the effect of colour between the two works is even more extreme. Whereas van Gogh gave his evening scene the luminous and uplifting colours of stained glass windows seen against the setting sun, Gauguin's colouring is sombre in character, and this sombreness of mood is picked up and reflected in the mood of the figures themselves.

Pl. 104

Pl. 84

Pl. 26

The pose of Gauguin's central figure, which was certainly not derived from van Gogh's imagery of the grape harvest, appears to involve a reference to the art of Degas—in other words, the same kind of reference which was already, in the preceding chapter, detected in the *Portrait of Madeleine Bernard* and the *Self-portrait* painted for van Gogh. In the mid 1880s Degas had done a number of drawings which show a ballet dancer seated with her head in her hands. It seems very likely that Gauguin had this motif of Degas' in mind in the present instance, and that he used it in order to give his key figure the connotation of rest and respite from work of an oppressively repetitive kind. He departed, however, from the example of Degas in conveying very positively, in connection with this pose, an emotional state of depression and resignation. The severe triangularity of the girl's body, picked up in the triangular shape of the vineyard itself to the rear, implies a physical condition of complete isolation and a psychological condition of withdrawal into the self. The gazes of this girl and her companion, instead of being related to the labour in hand, as they are in van Gogh's *Vineyard*, are directed off-stage, so to speak. This too has a suggestive effect, which is in line with the title *Human Miseries*. And the patterns of behaviour of all of the figures is disconnected to the highest possible degree.

This was probably, in sum, the first instance in which Gauguin resorted to specific borrowings from van Gogh's imagery. But van Gogh's *Vineyard* represents the last straightforward work in this artist's presentation of the cycle of seasonal labour. It touches the emotions in the sense that the subject conveys, as it originally did for the artist, the mellow twilight end of the outdoor year in Provence.

Gauguin's *Vineyard*, on the other hand, is an entirely imaginative vision of what the limited life of the peasant and its unvarying toil can do to the human spirit. The mood of the work as a whole, and of the central figure in particular, operates at a newly concentrated level of intensity. In this sense the work is a direct bridge between the *Jacob and the Angel* and the 1889 *Yellow Christ*, and is Gauguin's major canvas between those two highpoints.

The two men's portrayals of Mme Ginoux also belong to early November. Evidently this lady agreed to pose on several separate occasions, beginning at the end of October. Van Gogh's painting of her seated at a table with novels on it was blocked in very rapidly some time early in November, in the space of a single hour. Writing to his brother on the subject, van Gogh said that he had 'an Arlésienne at last',[15] and this suggests

Pls. 80, 79

Pl. 117

Pl. 115

Pls. 84, 4

Pl. 60

several earlier attempts on his part to achieve a portrait of the lady. Now Gauguin's Arles notebook contains, quite near the beginning, a rapid charcoal drawing of a lady which almost certainly represents the same sitter. She has a very similar hair arrangement, she seems to be seated, and the shape of her face is also very similar. She wears a fichu round her shoulders which could be part of the same costume as one sees in van Gogh's portrait; but it is more probably part of a slightly different attire. Presumably, then, Gauguin did this drawing at one of the earlier sittings. And in fact van Gogh was probably referring to it when he wrote at the end of October that Gauguin had already 'all but found his Arlésienne' (whereas he was having more success with the landscape).[16]

Whereas the Gauguin sketch is little more than a brief note concerned with the fixing of a type, van Gogh focussed in his oil painting on what might be called the lady's aesthetic qualities. There is a rather unusual slimness and delicacy of form here, especially in the treatment of the face and hands. Feminine distinction, taste and a certain sensitivity of mind are all implicitly suggested; the motif of the yellow novels on the dark green table bears this out. As was pointed out in an earlier chapter,[17] the treatment of contour and the flatness of certain shapes here hang together as elements deriving from a specific Japanese print which van Gogh had available at the time. As for the imagery, van Gogh had written to Bernard in August of two portraits of Puvis de Chavannes' which he specially liked. One of them included, in the way of props, a yellow-backed novel and a glass of water with a rose in it—motifs which both possess strong aesthetic connotations. The other depicted what van Gogh called 'a lady of fashion, such as the de Goncourts [had] portrayed'.[18] Probably, therefore, recollection of these two portraits on van Gogh's part supplied the special flavour which he gave to his interpretation of Mme Ginoux. In that portrait, accordingly, he was effectively combining Puvis de Chavannes and Japan. This was exactly the mixture which Gauguin claimed was suggested to him by the local subject matter during his first week at Arles.[19] Van Gogh could very well have taken this view of Gauguin's about the potentials of what was to be seen at Arles as a direct challenge to his own sensibility, and have conceived his *Arlésienne* as a response to that challenge. Here, in other words, there is the possibility of a cross-influence from Gauguin to van Gogh, on the first occasion when they used the same model. It was, however, at the most an influence of an indirect kind, having to do with fruitful aesthetic premises. There is no question of van Gogh's having

141

modelled his treatment on any specific piece of work of
Gauguin's.

The large and finished drawing, which became known to
van Gogh as Gauguin's *Arlésienne*, clearly served as a preliminary
study for the lady in Gauguin's *Night Café*, since compositional
notes appear at the top right of the sheet. The *Night Café* itself
was already in progress early in November, so this drawing
must have been done around the beginning of that month. Pre-
sumably, then, it was done after the sketchbook drawing and
represented a new, quite independent study of the subject in
question, created with the painting specifically in mind. It may
even have been a free adaptation suggested by the van Gogh,
since costume and facial features are again somewhat different.

Certainly, by comparison with van Gogh's *Arlésienne*,
Gauguin's has a much greater breadth and solidity. Where van
Gogh's contours are angular, those in the Gauguin are pre-
dominantly curvilinear. The round drum of the neck is accented.
And while the treatment of the eyes introduces a suggestion of
dreaminess and psychological distance, the expression as a
whole has a caustic flavour which differentiates it entirely from
the facial expression in the van Gogh. The pose with the hand
resting against the side of the face is a further variant of the
Degas-like pose in the *Portrait of Madeleine Bernard*, and
Gauguin may well have been concerned, in the thinking out of
this work as a whole, with the way in which a sexually attractive,
proletarian face could be made sculpturally firm and con-
crete in the manner of Degas.[20]

Gauguin's painting of the *Night Café*, with the same Arlésienne
in the foreground, was evidently completed within the month
of November. In a letter to his brother van Gogh said that it
represented 'the same night café' that he had painted.[21] He was
referring here to his September canvas with this title, which
was still at Arles at the time. It is evident that here again
Gauguin took over motifs from van Gogh and adapted them
to his own purposes. For three separate pieces of imagery
recur in his treatment: the billiard table with three balls out
on the cloth, the soda-water syphon with two glasses opposite
it, and the mirror on one of the walls.

Gauguin also seems to have resorted, in certain key respects,
to a kind of open and caustic parody of the van Gogh canvas.
For two of the male figures seen to the rear in his treatment are
recognizably favourite subjects and personal friends of van
Gogh's, namely the Zouave and Roulin the postman. Further-
more, the three women seated together were, by Gauguin's
own account, prostitutes. Gauguin was evidently well aware of

Pl. 118
Pl. 120

Pl. 60

Pl. 80

Pl. 120

Pl. 72

the fact that there was no sign of prostitution taking place in van Gogh's rendering of the café. He was also well aware that van Gogh felt the need to defend himself on the subject of this deficiency.[22] So it becomes clear, against this background, why he chose to show Roulin sitting with the prostitutes, and why he gave his Arlésienne a seductive look directed at the spectator. The combination of the motif of a cat with this lady suggests that he had in mind both Manet's *Olympia* and Japanese art, and that he gave the lady, with this in mind, something of the look of a geisha-girl. The eyes are appropriately narrowed and the whole expression now has a leering quality. In all of these respects, then, Gauguin seems to have been making a critical demonstration, as it were, of what was wrong with van Gogh's *Night Café* from the point of view of sexuality, and of the way in which he had the talent and experience necessary to produce an intrinsically superior treatment. It is of particular interest that when, after Gauguin's departure, van Gogh came to copy in paint the drawing of the Arlésienne, he followed the original even to the strokes on the right of the head. But he turned the image back, quite specifically, into one of a lady of society with novels on the table in front of her.

Pl. 119

Whereas the central figure in white in van Gogh's *Night Café* seems to be raised from the floor by some strange act of levitation, Gauguin's main figure is as solid and heavy as she was in the preliminary drawing. The space surrounding van Gogh's figure seems at once too large and too small for it, for despite the man's stature the heavy billiard table seems to press him back against the tables and wall immediately behind him. The viewpoint used for the scene as a whole is extremely high and the lines of the floorboards rush out towards the bottom right. This gives the chairs and tables and the occupants seated at them the effect of being centrifugally pushed out towards the walls of the room. The same applies, in fact, to all the items of furniture except the billiard table, which casts an ominously irregular pattern of shadow and seems, as it were, to dig in its feet, like one of van Gogh's lumbering peasants, in order to prevent itself from sliding precipitously down towards the spectator. Gauguin's main figure, on the other hand, is displaced off to the right, with her head and upper body tilted towards the right-hand framing edge. The space of his room is structured in shallow horizontal layers parallel to the picture plane, and extended horizontal lines mark the points of transition between each of these layers and the next. The subsidiary figures are aligned in two distinct groups within the furthest layer of space, so that they too form a continuous horizontal back-

Pl. 72

ground. There is no question, then, of Gauguin's picture owing anything to van Gogh's, apart from the specific borrowings of imagery which were referred to earlier.

In the second half of November Gauguin worked on his *Woman in the Hay with Pigs*, and he had it finished by the beginning of December at the latest. Here, once again, a reference can be presumed to the art of Degas. At the beginning of 1888 Degas had exhibited at Theo van Gogh's gallery some of his recent pastels of *Women Bathing*. Gauguin had seen that exhibition and had made small-scale graphic notes of five of the compositions in his current notebook. One of these diminutive drawings shows a naked woman seen from the rear, with her right arm raised, holding up a towel, and her left arm bent back to the nape of her neck. Gauguin's woman in the hay is correspondingly naked and seen from behind; the right arm in her case is bent back so that her head rests upon the forearm, and the left arm is extended upwards over the surface of the hay, in the act of gripping a grappling-hook. Granted, then, the reversal in the position of the arms, the two poses broadly match one another; and this suggests that, once again, Gauguin was using one of Degas' images of womanhood as a point of reference and departure. In his version of the pose, peasant labour on the part of a woman seems to be specifically associated with an imprisoned state of existence, and the destruction or repression of feminine sexuality. The mounds of hay are like confining walls hemming the figure in. The woman's back is dirty and musculated like that of a man, and the fallen apron exposes the sunken breast to the coarse squalidity of the farmyard. Gauguin may also have had in mind the central female figure in Delacroix's *Death of Sardanapalus*, whose sexuality turns on the fact that she is a captive slave to the last. In any case the grubbing pigs introduce a note of sexual degradation, as the woman's only companions in her nudity and abasement.

Structurally and technically, as well as in theme, this painting closely parallels Gauguin's *Vineyard*. The further mound of hay picks up in its rhythms those of the woman's body. Again there is a formal severity and heaviness complementing the whole resigned mood of the figure's behaviour; and again there is a corresponding use of a heavy impasto upon a coarse canvas. The colours here have a powdery quality, which contributes by itself the suggestion of a sombre and dense atmosphere. The texturing is harsh, but relieved by the relatively soft contrasts between passages of light and shadow.

Pl. 123

Pl. 124

Pl. 122

Pl. 116

Pl. 126

Pl. 100

Pl. 116

Pl. 127

In addition, there is a note of whimsical humour in the way in which key parts of the two pigs are cut off, and in the treatment of the further pig's tail.

Van Gogh painted his *Novel Reader in a Library* at this time. It was begun in the second half of November and completed before the end of the month, when he sent a description and sketch of the work to his sister.[23] It is one of the works done from memory, at the express suggestion of Gauguin, when the advent of bad weather made outdoor painting impossible. Van Gogh later called these works his 'abstractions', and he explicitly listed the *Novel Reader* as one of the works in question.[24] The imagery of concentration here was probably suggested by Meissonier's *Reader*, for van Gogh had a Jacquemart etching of this Meissonier hanging in his room at the time. As was brought out in Chapter 4, the handling here follows on from the technique experimentally adopted in the November *Brothel Scene*, and the colour scheme as a whole is also related to the example of Bernard. Structurally, the key feature of the work is the placing of the woman's figure close up to the picture plane and in complete parallelism with it. The figure is also completely static and self-absorbed. In this sense, and only in this sense, there is a certain parallelism with the structure of Gauguin's *Vineyard*.

Van Gogh also painted late in November, exactly contemporaneously with the *Novel Reader*, his *Memory of the Garden at Etten*. This too was an 'abstraction', as the word *Memory* implies. To paraphrase van Gogh's own words,[25] it shows an older and a younger lady out on a walk together, the younger one holding a parasol. The maidservant following behind them bends down to arrange some plants. The setting consists of cedar shrubs, cypresses and dahlias in the foreground and a large bed of cabbages to the rear, with a sandy path winding to the right of it. To the right of the path there are two pots of geraniums, and another bed of plants in which the servant is standing. The subject, as the title indicates, was based on the garden owned and cultivated by van Gogh's family when they were living at Etten. In this sense there is a certain relationship to the portrait of his mother which van Gogh had done from memory about a month and a half before; he even wrote to his sister that the two women depicted in the garden might be she and his mother together. For the portrait, however, van Gogh had drawn assistance from a photograph. Here, on the other hand, he depended purely on memory.

The *Garden at Etten* is certainly the most explicitly Gauguinesque of all van Gogh's works of the period under review. For

this reason, and also because the two works have certain elements of imagery in common, it is appropriate to make a direct comparison between the van Gogh and Gauguin's *Women of Arles*. There too, women are shown walking through a formal garden. This canvas of Gauguin's may in fact have been painted either at exactly the same time as the van Gogh or just a little later. In any event, the two works can be taken to have been done in something of a competitive spirit, if not in direct rivalry.

Pl. 128

In the van Gogh all three figures are cut off by the framing edges at the left and right. This cutting off is especially extreme in the case of the two main figures. Furthermore, these same two figures are united together formally into something approaching a single configuration of a broad and heavy kind. They are positioned at an oblique angle to the spectator, in an almost arbitrary way as far as the total rationale of space is concerned. There seems to be a combination of two different points of sight, one central and relatively high, the other oblique and low down at the left.

The relationship between structure and mood can be directly compared with the relationship between these same two elements in Gauguin's *Vineyard*. Here the withdrawal and inward passivity of the two main figures unites them emotionally as well as formally. And a secondary figure, like the two harvesters to the rear of Gauguin's picture, is presented exclusively in terms of the pattern of activity of stooping body and labouring hands. The contours of the main figures resemble in character those of the *Novel Reader*, and their effect is similar, in that they detach the figure from its environment both formally and psychologically, and give its behaviour a completely inward orientation.

Pl. 116

Pl. 126

Furthermore, the younger woman's head is strongly Gauguinesque in several key respects. The forms are appreciably heavier and more severe than they were in van Gogh's comparable *Arlésienne* of early November. The structure of the face is built up by a combined use of modelling and outline, and its expression has a caustic flavour, like that in the painted version of Gauguin's *Arlésienne*. Again, the background of the picture is dominated by continuous and melodic circular rhythms which reach out to complete themselves beyond the place where they are cut off by the framing edges. This is another Gauguinesque feature; and so also is the way in which the handling of space endows these rhythms with a two-dimensional rather than a three-dimensional value. The plane of the further garden is steeply tilted up towards the picture plane,

Pl. 60

Pl. 120

and the existence of a middle ground is almost completely suppressed. In so far as the sense of a middle ground is given at all, this is specifically due to the size and position of the maid-servant whom van Gogh himself described, in a turn of phrase apposite to the structure of Gauguin's most recent paintings, as standing 'in the second plane' midway between the dahlias and the geranium beds.[26]

For all of these reasons, then, one has the feeling that van Gogh painted this canvas with Gauguin more or less looking over his shoulder while he worked, providing tutorial instruction. One feature of the van Gogh, however—apart from the natural carry-over of his own personal phrasing—does not fit in with this pattern. The feature in question is the use of pointillistic dots of paint in the rendering of the costume, and of correspondingly short strokes in the treatment of the trees and path. Van Gogh may have been seeking here an explicit equivalent to the richness of Gauguin's most recent colour-schemes. But in any case he went back for this purpose to a technique which he had hardly used at all since he first adopted it in Paris in the course of 1887. At the time of his stay with van Gogh, the use of 'little dots' by Seurat's followers was absolute anathema to Gauguin.[27] So there was obviously an element of resistance to Gauguin's judgment in the expedient which van Gogh adopted here. And this in turn is probably the reason why, in his late-life memoir, Gauguin unkindly and quite unjustly charged van Gogh with having been 'immersed in the neo-impressionist school' at the time of his own arrival at Arles.[28]

In fact, while van Gogh introduced into his *Garden* a heavy dourness such as Gauguin had used to great effect in his *Vineyard*, Gauguin for his part chose to be comparatively whimsical and to stress the sheer picturesque oddity of the costumes in his corresponding canvas. His notebook shows that a whole series of separate graphic notes went to the making of this canvas. There are studies for the bench, for the fountain and the cone-shapes in front of it, for the horned headdresses native to the region and, above all, for the various strolling Arlesian women. In his painting, the bench appears in the background at the left, cut off and tilted up so that it seems like some kind of insect. The twin horns become a rather facetious element, added three times over to heads which did not carry them in the original sketch-notes. And, most whimsically of all, Gauguin's own features appear, looking satirically outwards, in the prominent bush right in the foreground. Gauguin had used this humorous device of a hidden head before. But it had not figured so far in any of his Arles canvases, and his use of the device in his

Pl. 116

Pls. 129, 130, 131, 133

Women of Arles clearly represented an assertion of his mocking wit and his psychological superiority.

On a more serious level, Gauguin's canvas does, in the natural order of things, embody some of the particular traits to which van Gogh had paid such serious and deferential attention. The women, for instance, are linked together formally in such a way that the degree of pictorial fusion between their shapes and costumes is even greater than in van Gogh's *Garden*. The contours are of a geometric or sinuously undulating kind. And the leading head is modelled in such a way that contour almost by itself, without assistance from shading, builds the kind of effect which van Gogh had sought in the head of his younger woman. The main structural difference between the two works lies in the fact that, in the Gauguin, the fence and the upright cones act as controlling and stabilizing vertical accents. In the van Gogh there are really no such accents. More generally, one of van Gogh's foremost achievements early in 1888 had been to endow genre subjects with strong emotional overtones. Gauguin, working with a comparable subject here, did give the whole conception a comparable emotional keynote. But whereas the feeling in van Gogh's case had invariably been strongly sympathetic in character, the sole note of feeling which this canvas of Gauguin's distills is one of caustic detachment.

At the end of November or beginning of December Gauguin retouched the hand on the far left in a canvas painted in the preceding summer, the *Ring of Breton Girls*. This canvas was sent down to Arles by Theo van Gogh, out of Gauguin's current one-man show at Theo's gallery, so that the hand in question could be changed to satisfy a prospective buyer. Gauguin quickly accomplished the necessary alteration, shifting the hand a little further away from the left hand border.

Pl. 132

Gauguin also did a still-life at this time which comprised, according to van Gogh's description,[29] a white linen table cloth, an orange pumpkin and apples set out on this cloth, and a yellow foreground and background. There is no trace of this work today and its character can only be guessed at. But the colour scheme, as van Gogh described it, does have a certain significance. In his memoir, Gauguin implied that, as a result of the enlightenment which his presence at Arles had brought, van Gogh had produced his *Poet* and his series of *Sunflowers*.[30] The *Poet* has, as Gauguin observed at some length, a colour-scheme of several different yellows; and the same applies to at least one of the 1888 *Sunflowers*.[31] However, all of these canvases which Gauguin chose to mention had in fact been painted well before

his arrival. In the *Novel Reader* of November, van Gogh used a yellow paler than usual, as was noted above. He did this, however, more in response to the nature of Bernard's colour than to the nature of Gauguin's. Gauguin did use a comparatively pale yellow himself, in his *Landscape with Blue Trees*.

Pl. 138

But this was more a matter of parallelism than of direct interaction with van Gogh. Gauguin was right, then, at least to some extent, in claiming that, as a result of his presence at Arles, van Gogh's use of yellow had become somewhat like his own; but he was quite wrong in maintaining that this was the result of his influence. And the lost *Still-life* not only confirms this point, by virtue of its December date; it also suggests that the idea of using multiple yellows may in fact have been one which Gauguin took from van Gogh, rather than the other way round.

One of Gauguin's two canvases of *Washerwomen* was in progress early in December, according to letters of van Gogh's.[32] And the other version was evidently done at the same time, since the two canvases are jointly listed in Gauguin's notebook among works which, in December, were in hand or recently

Pl. 134

finished.[33] The version in the Paley Collection shows five washerwomen, four kneeling at the water and one standing, and the heads of a boy and girl together in the left foreground.

Pl. 135

The other version shows only two washerwomen, one kneeling and one standing, and has a grazing goat in the right foreground. Gauguin had made sketches of a kneeling washerwoman at work and one walking away in his Breton notebook of 1886, and he had put a related pair of figures into a landscape of that year. He may now have remembered that earlier painting of his. But the costumes here are specifically Arlesian ones. In keeping with this, Gauguin's Arles notebook contains a

Pl. 137

study of costume which is clearly preliminary to the two canvases under discussion. It seems in fact to have been used three times over when it came to the creation of those canvases; for the first and third women in the Paley version and the standing woman in the other version all reflect its character.

Granted this procedure on Gauguin's part when it came to using his costume-study from the life, it is no surprise to find that a borrowing from van Gogh also went into the making of Gauguin's imagery here. A specific source for the imagery of the Paley version can be found in van Gogh's work of the first half of 1888. In the spring, van Gogh had done several treatments of the *Pont de Langlois* showing washerwomen at work

Pl. 136

on the river bank; and the version which is now in the Kröller-

Müller Museum shows figures whose patterns of action are closely matched by those in the Paley canvas. Specifically, that version includes four women kneeling at the river's edge and a further standing figure in a pose which is unmistakably matched by that of the standing lady on the far left in the Gauguin. The costume is also extremely similar. The Kröller-Müller painting and two other related versions were sent away by van Gogh, so that it has to be assumed that Gauguin had access to a drawing which had remained in van Gogh's hands at Arles, and did his borrowing from this.

Both versions of the *Washerwomen* involve the same sort of attention to costume as was seen in the *Women of Arles*, and the *Pl. 128* same use of costume to give flavour to a gathering of genre motifs. Shadow is used in both versions much as it was in the *Woman in the Hay*, and the quality of the paint-surface is also a *Pl. 123* feature in common with that work. Both canvases also show the beginning of a suggestive play with the motif of water. In particular, the shadows on the river surface are rendered as finger-like shapes, reaching out towards the women.

In the second letter of early December in which the *Still-life* and the *Washerwomen* are referred to, van Gogh also mentioned that Gauguin had 'some landscapes' in progress.[34] Besides the two canvases of the *Alyscamps* which have been dis- *Pls. 111, 113* cussed already, this group of paintings probably also included the *Landscape with Blue Trees* and the *Landscape with Farm* *Pls. 138, 139* *Buildings and Cypresses*. The *Blue Trees* allies itself with the *Washerwomen* in the sense that it contains a figure of a woman *Pls. 134, 135* in Arlesian costume. It is listed in the same corner of Gauguin's Arles notebook as the *Women of Arles*, the *Washerwomen* and the *Alyscamps*, and a section of it appears in the background of Gauguin's December *Portrait of Mme Roulin*. As for the *Pl. 150* *Landscape with Farm Buildings and Cypresses*, it must be one of the two canvases of farm buildings which figured in the list just mentioned.

The treatment of the buildings up on the hill in the *Blue Trees* much resembles the treatment of the chapel gateway in *Pl. 138* the canvas of the end of the Alyscamps. The trees themselves *Pl. 114* are blue, as in the second of van Gogh's horizontal paintings of the Alyscamps; the sky is a pale but warm yellow. The slope of the intermediate hill, radically flattened and painted very loosely indeed, is treated as a sort of fill-in between foreground and background. The trees, rhythmically aligned across the foreground, act like bars through which the rest of the landscape is seen and also lead the eye straight up the picture plane.

Pls. 139, 111

Pls. 140,141

Pl. 142

Pl. 125

Pl. 126

Pl. 88

Pls. 143, V, 144

The fieriness of colour in the *Landscape with Farm Buildings and Cypresses* makes for a strong affinity between it and Gauguin's painting of the Alyscamps canal. The handling of space is also markedly similar in these two works. There are studies in Gauguin's notebook for two specific motifs in this landscape, the dog lying down and the little girl skipping, further back. The rest of the imagery was probably suggested by a specific composition of van Gogh's, the *Small Landscape with a Farmhouse and Cypress*, for this painting of the spring of 1888 also shows a country road winding back from the foreground, a small white farmhouse with dark cypress trees to one side of it and another farm building on the opposite side of the road. Both this and the one related drawing known were sent away to Theo; but there may very well have been another lost drawing which remained at Arles.

Van Gogh's free version of the *French Novels* piled on a table can be assigned to the end of November or the beginning of December. It represents a considerably later adaptation of the *French Novels* painted in Paris in the summer of 1887—a canvas which van Gogh had given to his sister as a birthday present in the spring of 1888. Van Gogh had remarked to his brother in October that his *Bedroom* was something like that Parisian canvas;[35] and it fits that he should now have done a new version from memory. This, then, puts the canvas amongst van Gogh's 'abstractions'.

In the *French Novels*, the same kind of yellow as appeared in the *Novel Reader* is found in the background and some of the book covers. The other colours—pink, red, blue, dark green and pale green—all have a synthetic hardness and brightness. The freedom of recollection and adaptation which went to the making of this canvas is such that the imagery is characterized by a loose, almost disorderly grouping of the books and by an elimination of all secondary detail, so that the heavy solidity of the volumes and their centripetal arrangement both come strongly into focus. Much the same kind of circular grouping is found in van Gogh's copy of Bernard's *Breton Women*, which is also in this sense an adaptation, although a much less free one. If this copy was not made late in October, it is likeliest that it was done now, in van Gogh's new situation of having no outdoor subjects that he could tackle, because of the coming of winter.

It was at the beginning of December that van Gogh began his paintings of his own *Chair* and the *Chair of Gauguin*. It is very important to recognize that the *Chair of Gauguin* is to be counted amongst van Gogh's 'abstractions'. There are two

151

yellow books on that chair, and individual colours are almost all exactly the same as those in the *French Novels*. As in that case, furthermore, there is no explicit light source; or rather the burning gas-lamp to the rear is mysteriously treated as if it cast only purple shadows and an arc of darker colouring on the floor. Van Gogh's *Chair*, in contrast, completed as it was only in January 1889, after his breakdown, has the colouring of direct daylight experience. The line of the floor which serves as a kind of horizon-line in both cases is lower here in relation to the chair itself, and the props are homely ones. Just as the two treatments, pendants to one another, bring out the opposite personal qualities of the men whose chairs these were, so the *Chair* of van Gogh marks van Gogh's explicit reversion to being his natural, isolated self, devoid of any further desire to traffick in the process of working from imagination. That divorce from Gauguin, and from his advice as to method, was, however, yet to come.

Pls. V, 143

At the same time as he began work on the *Chairs*, van Gogh also made a new version of the *Sower*. In this case he began by doing a preliminary study in oils, and then went on to do a more finished version—something which he had failed to achieve with his November brothel subject. The tree trunk is thinner and the upper part of the composition taller in the final version. The ball of the sun is also very slightly above the horizon-level, and centred more directly behind the sower's head.

Pl. 146
Pl. 147
Pl. 100

Unlike the October *Sower*, this one certainly belongs in the cycle of van Gogh's 'abstractions'. Blue and yellow predominate in its colouring. The sower himself and the disc of the sun have much greater prominence than in the October canvas. Sower and tree, furthermore, are brought up against the picture plane so that their respective silhouettes detach themselves completely from the field and sky. There is now a strong diagonal movement of perspective in the left hand part of the field. This movement runs straight back to the horizon-line and contrasts with the flatness of the rest of the landscape. Again, there is no expression on the blank face of the sower, and the seeds group themselves in patterned formation around his looming, outstretched hand. In this way the image is not of sowing as a seasonal human activity, but rather as a link between man and the land.

Pl. 145

Between the beginning of December and the final catastrophe of 23 December, the two men were forced completely indoors by the weather conditions.[36] During this final phase,

they appear to have concentrated equally on portraiture. Certainly, on occasions, they used the same model, and worked from that model side by side in their shared studio.

Early in December van Gogh painted the whole Roulin family in sequence, one after the other, using for this purpose a series of canvases of identical size. From the specification found in his letters as to the size of canvas used, it is possible to pin down precisely which portraits of the Roulins are the ones from this particular period.

Van Gogh had already portrayed the postman himself twice in August, doing one half-length version of the man seated, and a full-size portrait of his head alone. The December *Pl. 148* version again shows the head and shoulders only, against a yellow ground, and again portrays the postman in his hat and uniform. There are two portraits of the elder son Armand, aged seventeen. Both can be assumed to be of the same date. One *Pl. 151* shows him full face, wearing a yellow coat; in the other he *Pl. 152* appears in an oblique view, wearing a blue-black coat. This latter version seems the more finished of the two. It was therefore probably executed after the other one.

In all three cases, there is a carry-over of what van Gogh had learned from Gauguin during his painting of the *Garden at Etten*. The lesson, or lessons, assimilated during the making of that picture were now applied by van Gogh to the task of working from a living model. One finds, that is, a greater heaviness and chunkiness of form than is usual with van Gogh. The paintwork itself is correspondingly more solid in character, and the total colour scheme broader, with the result that the individual colours become spatial planes in themselves. The contours, too, now have a longer and more evenly rhythmic character. All these points are particularly evident in the treatment of Roulin's beard, as compared with the August version. As for the mood of these portraits, there is a somewhat greater equipoise now between the evocation of the sitter's character and the creation of an aesthetic conformity between the different paintings in *Pl. 151* the series. In the second version of *Armand*, particularly, there is a distilled tranquillity, and even a kind of sadness, which cuts across the spectator's rapport with the young man and makes him seem philosophical in the same sense as his father.

Pl. 153 Van Gogh painted the second son, Camille (aged eleven) in a blue smock and a soldier's hat; and he showed the baby, *Pls. I, 156* Marcelle (aged about four months) in the arms of her mother. In clear contrast to the characterizations of father and elder son, both these portraits indicate very strongly the unformed qualities of body and character which are associated with boy-

153

hood and infancy. In both cases the mouth is open, the eyes
are wide and staring, and hat and smock fit the body only in a
loose and baggy way. The awkwardness of the arm movements
and the very construction of the faces convey a physiognomy
which has not yet attained any lasting, stable mould. The forms
seem to slip away from one's optical grasp; and just as the
chair-back makes Camille's arm seem insubstantial by com-
parison, so the grasp of the mother's hands in the other picture
seems altogether insufficient to control the baby's jerkiness.

There are two studies of the same baby in Gauguin's note-
book which were probably done at exactly the same time. *Pl. 154*
The emphasis there is on the baby's chubby corpulence and her
first tentative explorations of her environment. The keynote of
these sketches is, in fact, clever and humorous observation. So
they sound a very different note from van Gogh's suggestion of
growing emotional awareness on the baby's part.

Mme Roulin was painted by both van Gogh and Gauguin,
seated in a similar-looking chair. Her costume, however, *Pls. 149, 150*
differs slightly between the two versions, so they probably had
her as a joint model over a number of sittings. A section of
the *Landscape with Blue Trees* appears behind the sitter in the *Pl. 138*
Gauguin, as if this picture were hanging on the back wall of
the room. In representing this section, Gauguin made certain
simplifications of colour, contour and texture, and he also
slightly widened the dimensions of the landscape. The result is
that there is a set of clear-cut rhythmic and geometric relation-
ships between sitter and background. Where Gauguin used a
painting of his own, van Gogh correspondingly used a view
through a window, with pots and plants on the sill outside and
a section of garden path beyond. The tilting up of this path
towards the picture plane and its geometric rhythms indicate,
once more, a carry-over from the lesson which Gauguin had
imparted during the creation of the *Garden at Etten*. The fact *Pl. 127*
that Gauguin was working alongside van Gogh in the same
studio on this occasion too may well have been the concrete
reason for van Gogh's introduction of this feature into his com-
position. The bulbs springing up in profusion, however, were
distinctly an invention of van Gogh's own, with their sugges-
tion of the latent life of plants during the winter season.

There is one other case where the two men appear to have
painted the same model simultaneously. The model here was a
man in a coat and stock whose identity is unknown. Gauguin *Pls. 157,158*
did only a rapid study in oils, but even so the same sort of
simplifications are found as in his *Portrait of Mme Roulin*. He *Pl. 150*
used dark blue for the hair and suit, blue for the floor to the

154

Pl. 126

Pl. 60

Pl. 160

Pls. V, 143
Pl. 159

Pls. 134, 135

Pl. 164

right and put a circular yellow shape behind the sitter's head, which is rather like the one in van Gogh's *Novel Reader*. He also used a darkish green, as van Gogh did there, for the wall beneath. Van Gogh, for his part, reverted to the kind of angular, crackling contours found in his *Arlésienne*. He twisted the nose across and counterbalanced this with a heaviness of shadow under the right side of the double chin. The result is a straining, stiff-necked quality which makes this the most formally capricious of all van Gogh's portraits of the period. The capriciousness, however, is distilled out of the personality of the sitter. For Gauguin the same sitter was much more purely and simply a model who happened to be available.[37]

There is a self-portrait by each man which can also be assigned to the same period. Van Gogh's *Self-portrait* for Laval suggests a watchful, strained state of mind. In colour as well as in mood, it has the same quality of sobriety as his *Chair*. Gauguin's *Self-portrait* again shows a section of one of his paintings to the rear. This painting, which seems to include part of the figure of a young girl, does not correspond to any known work of the artist; it must be either lost or imaginary. The colours and shapes of this background are once more simplified to match those of the figure. The gaze is indirect here, the expression inscrutable in the Japanese manner. Gauguin emphasized the swarthiness of his features, in keeping with the fact that he was nostalgic for the tropics at the time, and was playing with the idea that he might go back to Martinique.[38] Finger-like shapes assume an even more important role than they did in the paintings of *Washerwomen*, and the rich palette of reds and blues suggests the stimulus of the paintings by Delacroix which Gauguin saw at this time, in van Gogh's company, at the Montpellier Museum.[39] These two features of the painting, which was again done on very coarse canvas, are ones which Gauguin would not take up and develop further, side by side, until after his move to Tahiti.

Van Gogh began the first of his versions of the *Woman rocking a Cradle* shortly before his breakdown, and he would later refer to this picture as another of his 'abstractions'. Presumably this was because the imagery of the cradle-rocker had been suggested by Gauguin's tales of his experiences amongst the fishermen of Iceland.[40] There is an obvious element of reference back to van Gogh's home-life in Holland. The hands hold the rope which rocks the cradle, this cradle lying by implication below the bottom edge of the canvas. The decorative background was probably the last element van Gogh added, subsequent to his breakdown, since it appears elsewhere only in

his work of early 1889. Van Gogh was really going back here to the procedure which underlay the creation of his *Poet*—both in general conception and in the fact that the background, added around the figure, acts like an abstract emanation from the personality of the sitter. The sitter in this case was Mme Roulin once more. Her figure was presumably blocked in prior to the moment of breakdown. The treatment of this figure shows for the last time, and in a rather extreme form, that heaviness of form and roundness of contour which had been provoked by the stimulus of Gauguin's example.

It is appropriate to end with Gauguin's corresponding December portrait of *Van Gogh painting Sunflowers*. This was in progress early in the month and was finished by the time of Gauguin's second letter to Theo, in which he said that he was willing to remain at Arles after all.[41] Gauguin's notebook contains two studies of van Gogh's head which are connected with the picture, and, on the same page, a study of the thumb extending through its hole in the palette. Presumably these graphic notes were made while van Gogh was working, and saved up in magpie fashion for later use. There is also, on a much later page of the notebook, a compositional study for the painting. It includes sunflowers and the idea of a picture hanging on the rear wall. In the painting itself this picture became a section of a landscape of Gauguin's. It is rather like the *Blue Trees* in character, but again no corresponding canvas survives, so that this backdrop may have been made up.

Pl. 163

Pl. 162

Pl. 161

Pl. 138

Comparison with the preliminary studies shows that, while Gauguin kept the lines of the face exactly as they were in his sketch-notes, he lowered the eyelids and made the contours more angular, so that they dovetailed in with the landscape background. He also made the balance between figure and easel more precarious and extreme than it was in his compositional drawing, so that everything now depended on the link of the outstretched arm.

The association of van Gogh and the sunflowers is quite clearly an imaginary one, introduced for its suggestive value. Van Gogh had not painted any canvases of *Sunflowers* since the previous August; and the sunflowers were, in any case, over by the end of September.[42] And in keeping with the idea that the portrait would conjure up van Gogh's whole deep involvement with the subject of sunflowers, the colour of his coat and hair and, more especially, his beard are brought into direct correlation with the colouring of the flowers themselves. As for the chair on which the sunflowers are standing, it appears to be the very chair that van Gogh was painting at this time.

Pls. V, 143

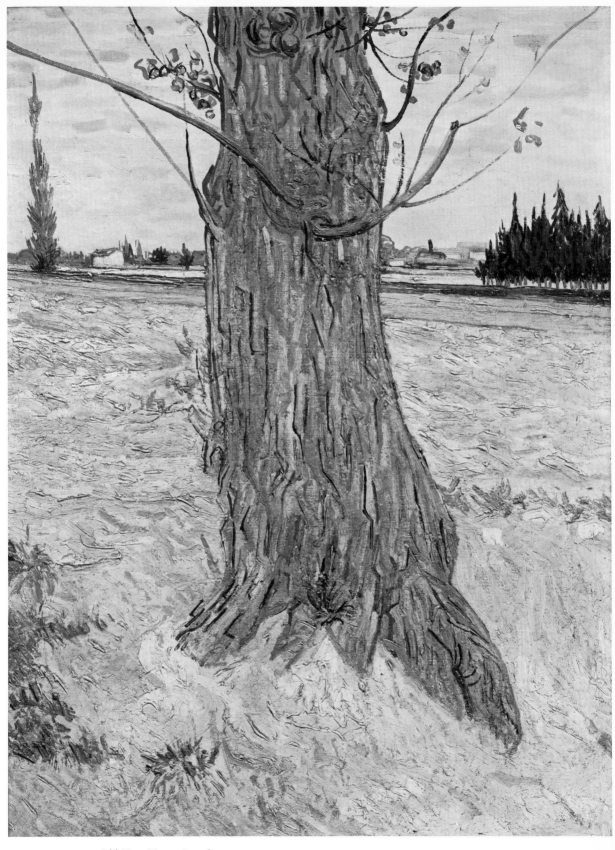

103 VAN GOGH *Old Yew Tree.* October 1888

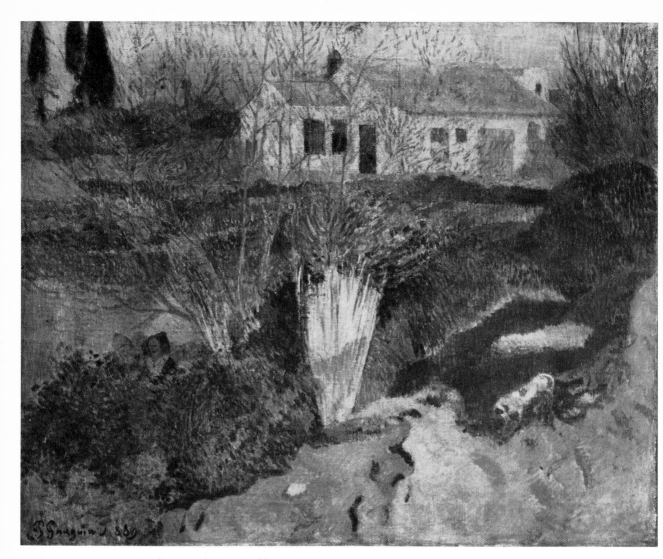

104 GAUGUIN *Landscape with Farm Buildings* 1888

105 GAUGUIN Studies for the *Landscape with Farm Buildings* (Arles notebook) 1888

106 GAUGUIN *Landscape at Pont-Aven* 1888

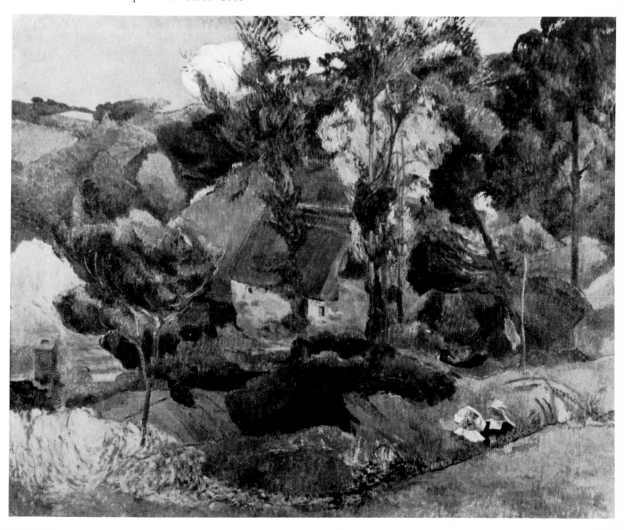

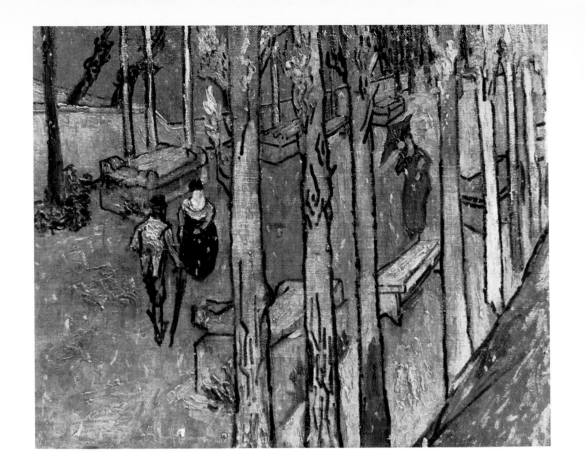

Opposite:

107, 108 VAN GOGH
Falling Leaves in the Alyscamps Avenue
(first and second versions)
November 1888

109 VAN GOGH
The Alyscamps
November 1888

110 VAN GOGH
The Alyscamps (second version)
November 1888

111 GAUGUIN
The Alyscamps
1888

112 Photograph of the
Alyscamps
(Chapel of Saint-Honorat)

113 GAUGUIN
The Alyscamps (End of the Avenue) 1888

114 VAN GOGH
Pont de Langlois
(grey version)
March 1888

115 VAN GOGH *The Red Vineyard.* November 1888

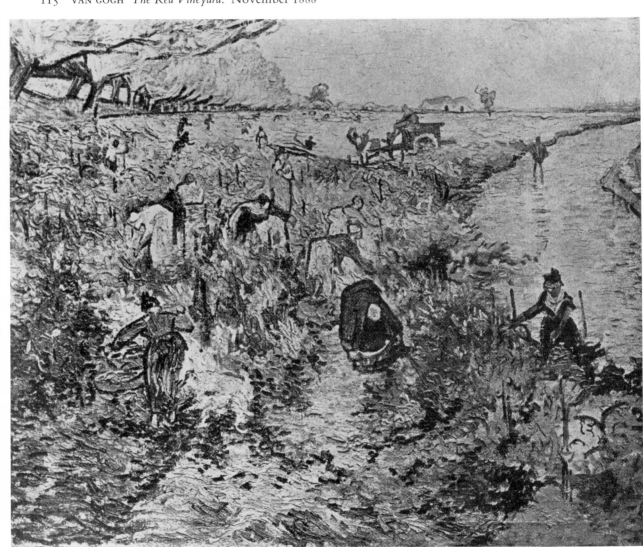

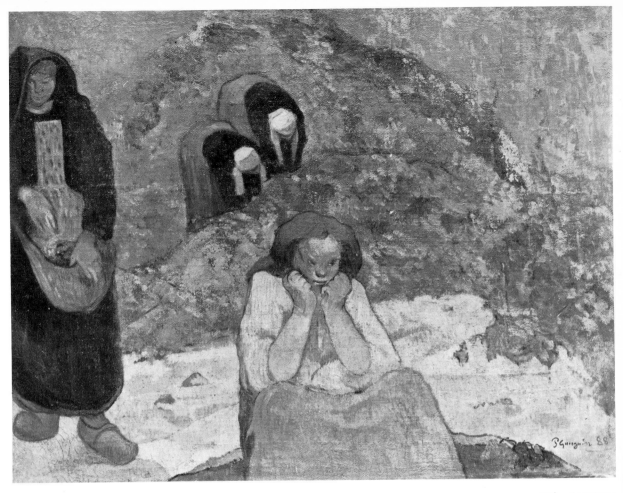

116 GAUGUIN
The Vineyard (Human Miseries)
November 1888

117 DEGAS
Seated Ballet Dancer
c. 1885

118 GAUGUIN *Arlésienne*
November 1888

119 VAN GOGH
Arlésienne, after Gauguin

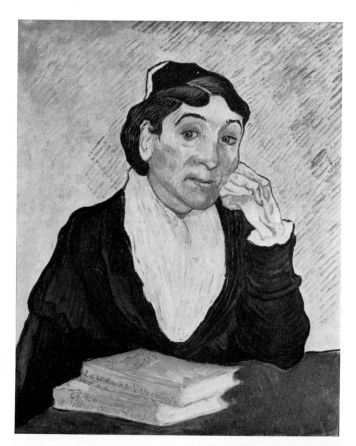

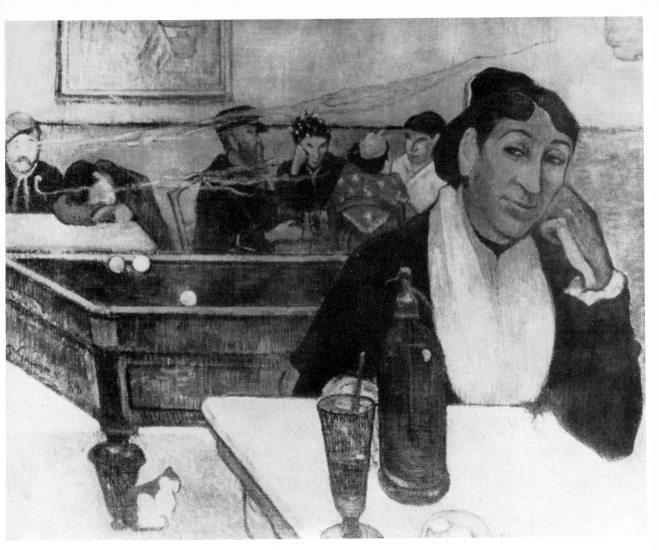

120 GAUGUIN *Night Café*. November 1888

121 GAUGUIN
Head of a Lady (Arles notebook)
1888

122 DELACROIX
Death of Sardanapalus c. 1827
(detail of central figure)

123 GAUGUIN
Woman in the Hay with Pigs
November 1888

124 GAUGUIN Sheet of studies of
Women Bathing, after Degas
February 1888

125 VAN GOGH *French Novels* (second version) 1888

126 VAN GOGH *Novel Reader in a Library*. November 1888

127 VAN GOGH *Memory of the Garden at Etten.* November 1888

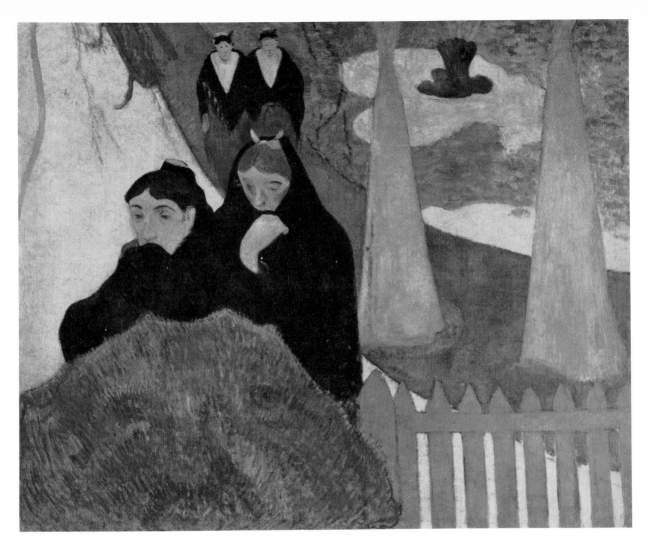

128 GAUGUIN *Women of Arles* 1888

129, 130, 131 GAUGUIN Notebook studies for the *Women of Arles* 1888. Above left, women and bush; above right, bench; below, fountain and cones

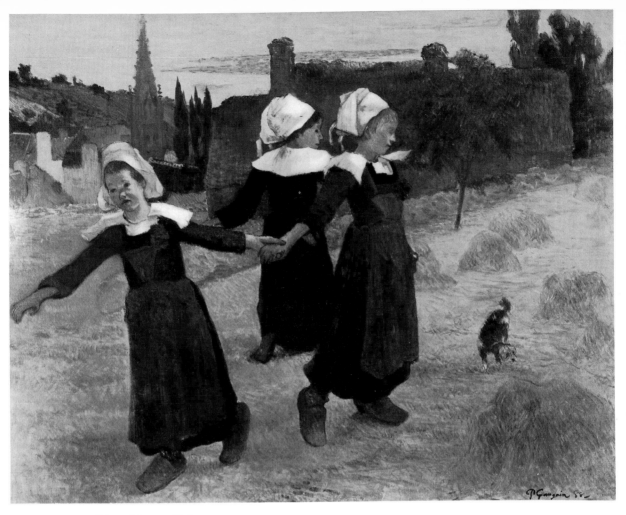

132 GAUGUIN *Ring of Breton Girls* 1888

133 GAUGUIN
A double spread
from the notebook
with studies for the
Women of Arles 1888
Headdresses and heads

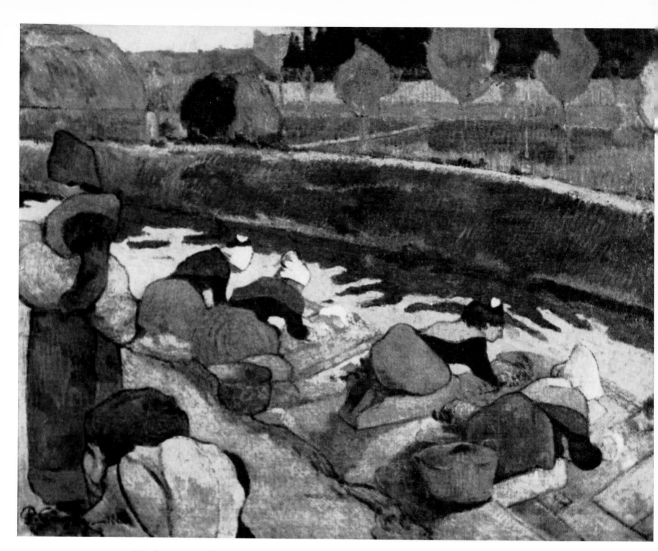

134 GAUGUIN *Washerwomen* (first version) 1888

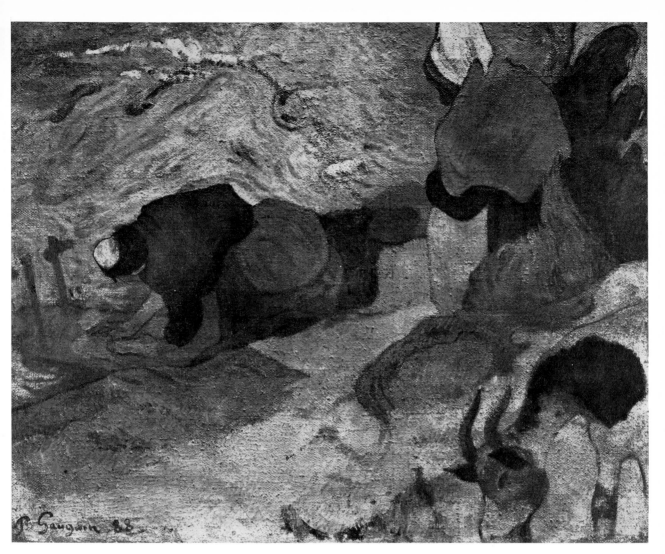

135 GAUGUIN *Washerwomen* (second version) 1888

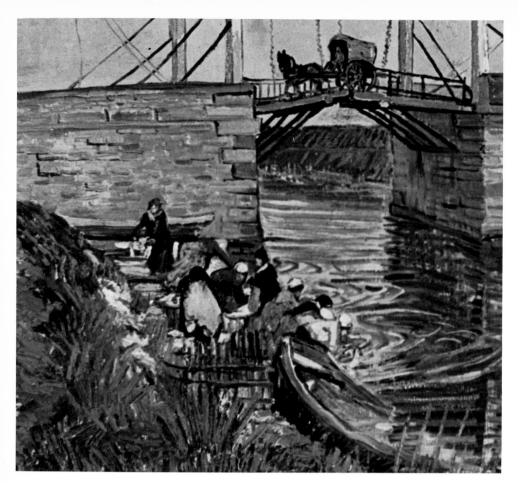

136 VAN GOGH *Pont de Langlois*
(with Washerwomen)
March–April 1888

137 GAUGUIN
Study for the *Washerwomen*
(Arles notebook)
1888

138 GAUGUIN *Landscape with Blue Trees* 1888

139　GAUGUIN　*Landscape with Farm Buildings and Cypresses*　1888

142　VAN GOGH
Study for *Small Landscape with Farmhouse
and Cypresses*. March 1888

140, 141 GAUGUIN Studies for the *Landscape with Farm Buildings and Cypresses* (Arles notebook) 1888

143 VAN GOGH *The Artist's Chair*. December 1888–January 1889

144 VAN GOGH *The Chair of Gauguin.* December 1888

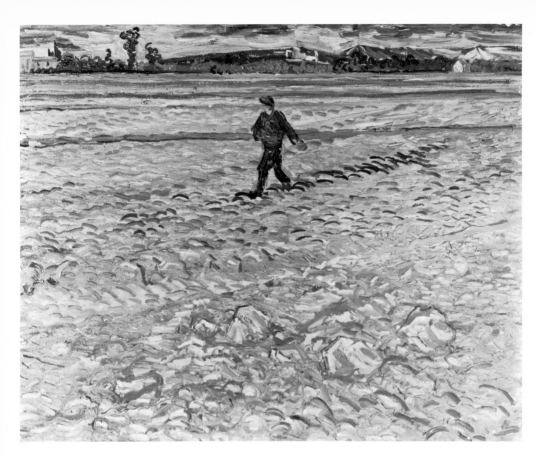

145　VAN GOGH
The Sower
October 1888

146　VAN GOGH
The Sower (study)
December 1888

147 VAN GOGH *The Sower* (final version). December 1888

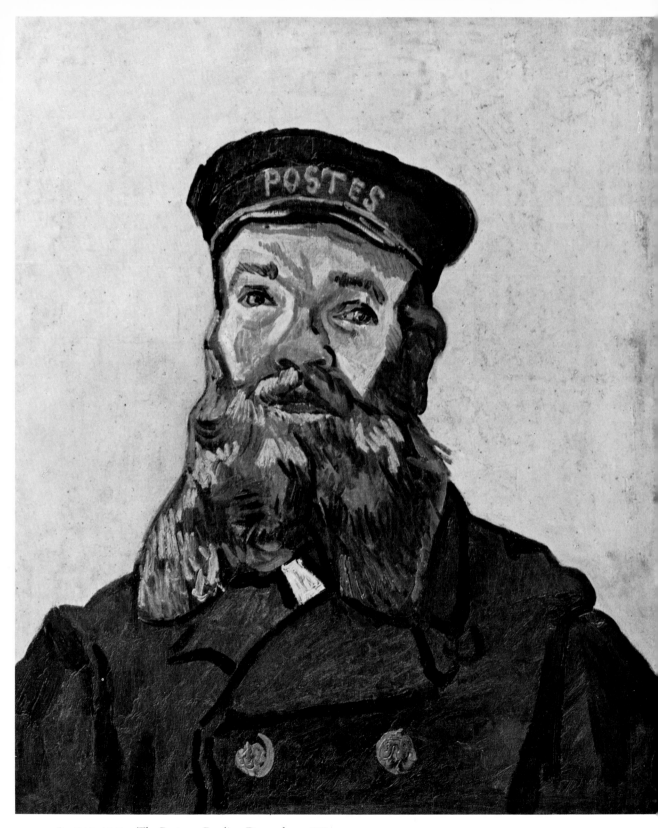

148 VAN GOGH *The Postman Roulin*. December 1888

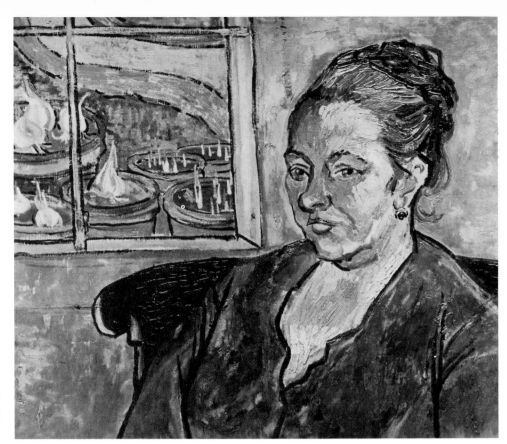

149 VAN GOGH
*Mme Roulin
(before a Window)*
December 1888

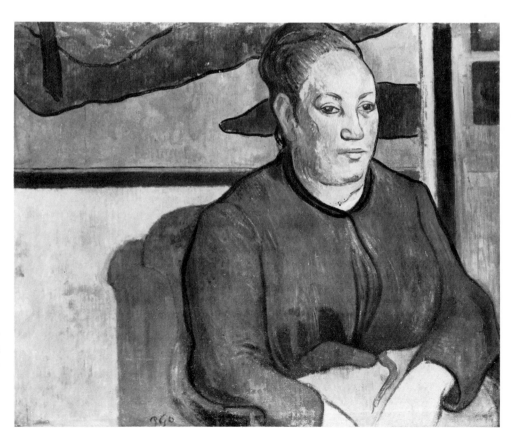

150 GAUGUIN
Portrait of Mme Roulin
1888

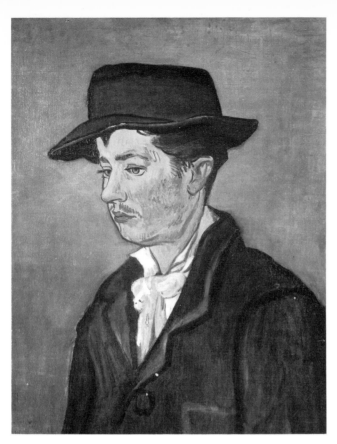

151 VAN GOGH
Armand Roulin
December 1888

152 VAN GOGH
Armand Roulin
December 1888

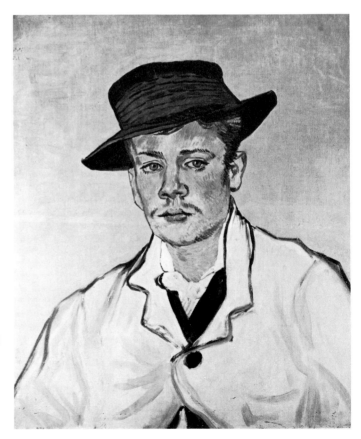

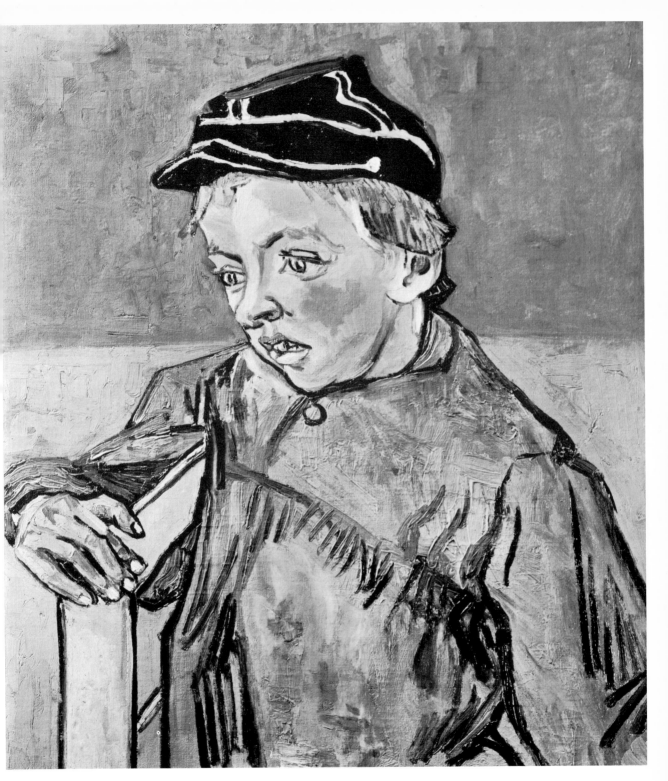

153 VAN GOGH *Camille Roulin*

154 GAUGUIN Studies of the *Roulin Baby*
(Arles notebook) 1888

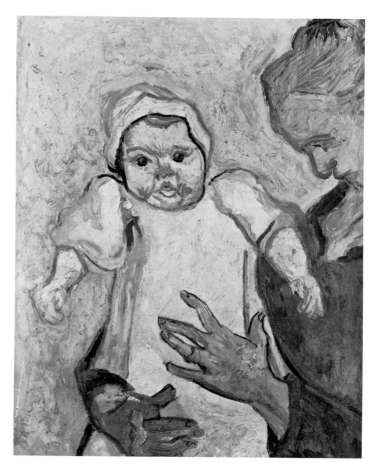

156 VAN GOGH *Mme Roulin and her Baby.* December 1888

155 GAUGUIN *Three Studies of Children*

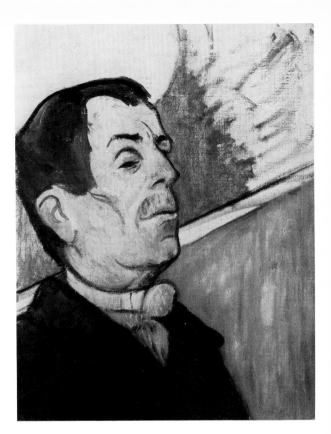

157 GAUGUIN
Portrait of a Man (in three-quarter view)

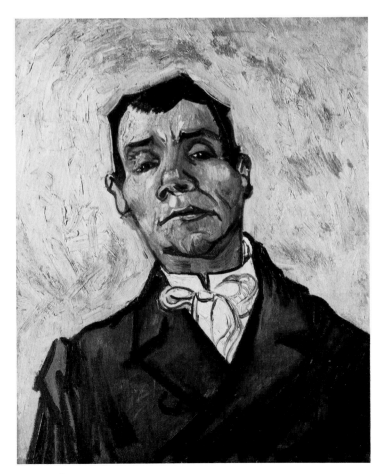

158 VAN GOGH
Portrait of a Man

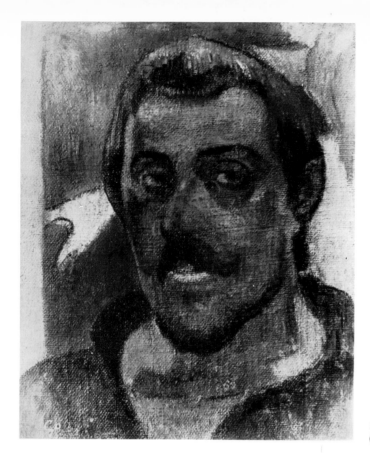

159 GAUGUIN *Self-portrait*
(with slightly open mouth)

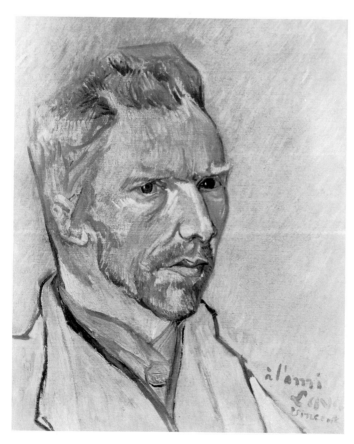

160 VAN GOGH
Self-portrait for Laval 1888

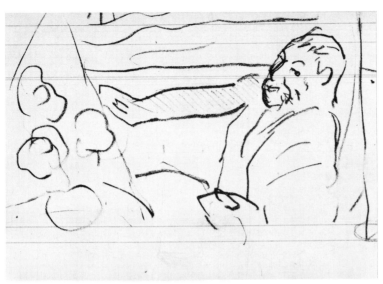

161, 162 GAUGUIN *Studies for Portrait of van Gogh painting Sunflowers*
1888. Left, composition; right, head and thumb

163 GAUGUIN *Portrait of van Gogh painting Sunflowers.* December 1888

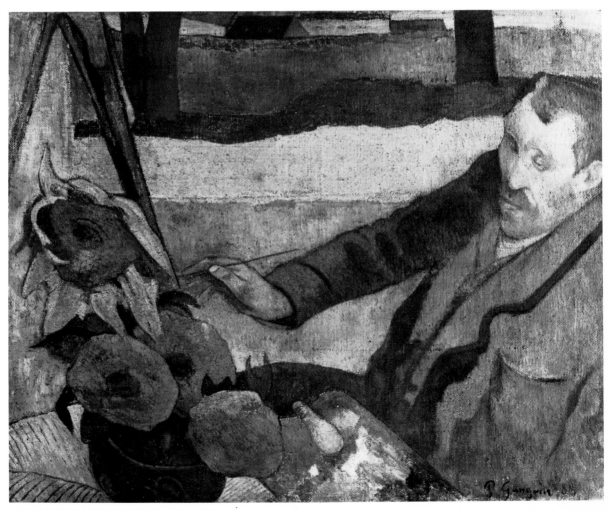

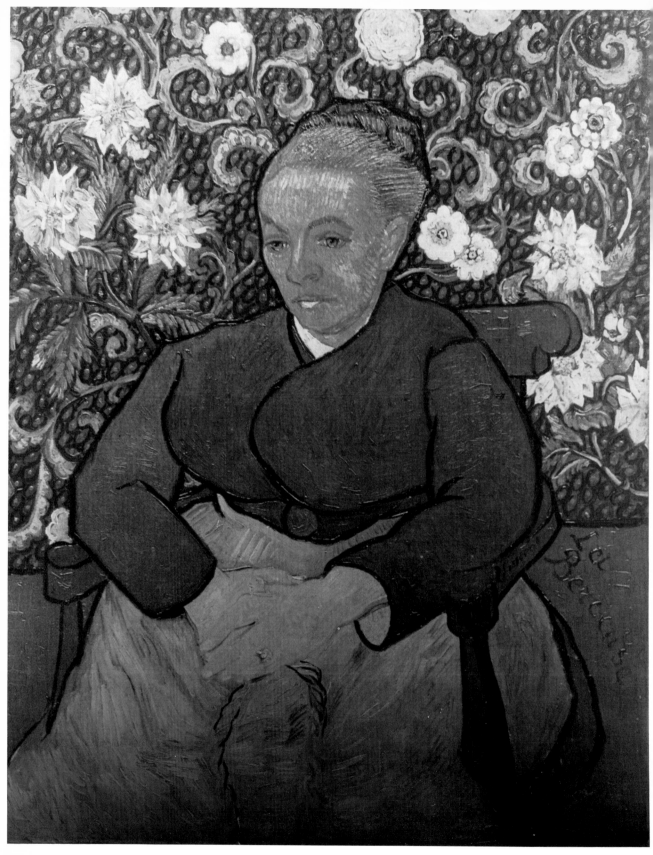

164 VAN GOGH *Woman rocking a Cradle.* December 1888–January 1889

167 VAN GOGH *Old Shoes* 1888

168 VAN GOGH *The Mousmé* 1888

This, then, is the extreme case of Gauguin's using van Gogh's imagery as a springboard for his own purpose.

The psychology communicated is one of screwed-up concentration and almost visionary intensity, as van Gogh bears down upon his subject across the full width of the canvas. In this sense there is a sympathetic understanding of the sitter's personality; but a caustic overtone also runs through the portrayal, as in the *Women of Arles* and the *Arlésienne*. Gauguin's working method is illustrated, in synthetic form, on the wall behind; van Gogh's working method is conjured up, in fictitious form, in front of this background and under the shadow of it. The distance between van Gogh and his subject, his hooded eyes and the 'open eye' of the top sunflower, become in this sense charged details. They allude to the superiority of Gauguin's conception of the need to work from memory, and to the spell which this conception had temporarily cast over van Gogh. It is implied that, even when van Gogh was working on his favourite subject, and on the one which Gauguin admired most, he was still subject to this spell. This portrait then, through its crystallization of the controversy about the use of imagination, becomes a concluding and wilful affirmation of Gauguin's aesthetic tenets.

The conclusion must be, therefore, that though Gauguin borrowed from van Gogh's imagery on occasion during his time at Arles, and though van Gogh reacted to Gauguin's presence to the extent of working from memory for a time, there was no real interaction between the two men. Certainly there was nothing approaching the relationship between master and disciple—such as had pertained, for example, between Manet and Eva Gonzalez. Nor was there anything approaching the kind of side-by-side development which Monet and Renoir had shared at certain key moments in the late sixties and early seventies.

Equally, neither man affected the art of the other in any permanent way. Van Gogh did a 'translation' of Gauguin's *Arlésienne* in the first half of 1889, and the following year made three further versions from this initial one. Gauguin, for his part, used imagery suggested by van Gogh's act of self-mutilation in a ceramic pot of the beginning of 1889 which took the form of a self-portrait. He portrayed himself there, that is, with ears missing and blood streaming down his face. Later that year, in his *Green Christ*, he used van Gogh's motif of the woman holding ropes for rocking a cradle. And in his *Old Man with a Stick*, which was perhaps painted towards the very

Pl. *119*

end of 1889, he temporarily introduced into his portraiture a van Gogh-like note of sympathetic humanism. But these are isolated works. They simply show that van Gogh had a continuing respect for Gauguin's creative powers and that Gauguin was prepared to go on borrowing motifs of van Gogh's when the occasion suggested this to him.

Gauguin did, however, produce at least one masterpiece, the *Vineyard*, during his time at Arles. And van Gogh did gain, as *Pl. 116* a result of Gauguin's presence, a more concrete sense of the relationship between nature, the art of others and his own creative spontaneity. To see the larger significance of these results, it is necessary once more to widen the framework of reference and look both forward and backward within the period of the 1880s.

Already before the two men came together there was a certain parallelism between them, as was pointed out in the preceding chapter. And their paths of development would parallel one another afresh later on, in spite of the break between them. The extent to which this is true can best be seen by putting alongside one another van Gogh's canvas of *Two Little Girls*, which was done at Auvers in the summer of 1890, *Pl. 165* and Gauguin's *Two Breton Children* which was probably painted *Pl. 166* that same year. It can be assumed that these two works were done quite independently of one another. The structural affinities between them, then, are all the more remarkable. The figures in both cases are brought up towards the picture plane and treated in terms of paired, overlapping silhouettes. The contours are strongly rhythmic in both cases, and the facial expressions have a solemn, transfixed quality. Finally, the setting serves in both cases as a sort of minimal suggestive appendage, filling out the rest of the canvas space like a decorative plate in a contemporary children's book, and amplifying both the formal rhythms and the mood of the figures themselves.

In this sense, van Gogh's and Gauguin's time together, for all its personal shortcomings, helped to keep the two artists moving, as they were already, through a common climate of pictorial development.

Coda:
The Personal Relationship between Van Gogh and Gauguin

The personal and emotional relationship between van Gogh and Gauguin continued long after their actual association was over—indeed in Gauguin's case its influence carried on after van Gogh's death, and up to the end of his own life. To examine this relationship and its influence we must take account of factors not germane to the association, but rather ones which affected the relationship subsequently. The great importance of these later factors demands that we now deal with the relationship in its totality, after consideration of the works the two men did while together. In fact rather little is positively known, or firmly to be assumed, about what happened between them at Arles.

Previous accounts of the relationship between van Gogh and Gauguin have invariably stressed the conflict between the two men, and the inherent drama of what took place. They did indeed argue and differ intensely on certain issues. There was at least one ugly incident between them;[1] and Gauguin's presence at Arles certainly played some part in precipitating van Gogh's first mental crisis. When, however, the relevant statements of the two men are put back into their original context and interpreted in this light, the extent of the conflict in artistic matters becomes considerably qualified. In this sense, then, there is another side to the story from the one which is usually told.

In personality and temperament van Gogh and Gauguin were very different indeed, so that there were almost bound to be clashes. Whereas van Gogh responded in the deepest sort of way to the sunshine and landscape of Provence, Gauguin instinctively preferred the primitivism of Brittany. Gauguin moved to Arles primarily because it was to his financial advantage to do so. He wanted to cement further the relationship between himself and Theo van Gogh, who was currently acting as his dealer. He also felt the need of a further disciple, who would discharge the same role as Bernard and Laval had discharged during the summer of 1888. He therefore looked with favour on the idea of having Vincent, who was a few years younger, working alongside him and reacting to his ideas or instruction. Vincent, for his part, nearly ruined the relationship

in advance by building up the prospect too high. Once Gauguin had initially shown an interest in coming to join him, it was quite beyond his powers simply to wait for the plan to come off. Instead, in a long series of nervous ups and downs, he interpreted every new move on Gauguin's part as a sign of treachery or scheming against him and his brother.

Gauguin was not in fact treacherous; he was simply incapable of tempering his dreams and ideals, until the pressures of reality absolutely forced him to do so. There was, however, a politicking instinct deeply ingrained in his character. And he was prone to egotistical mockery and cynicism, at the expense of those who were trying to help him. These aspects of his behaviour clashed from the first with van Gogh's stoical faith and sincerity, and would do so even more when the two men were together. In addition, Gauguin found van Gogh much too untidy and disorganized in the day-to-day conduct of practical affairs for his own comfort (he even tidied up van Gogh's messy and cluttered palette in the portrait which he did of him at work). Finally, there seems to have been—as there was almost bound to be in the given situation—an unruly homosexual element in the relationship between the two men,[2] which led Gauguin to exaggerate his prowess with women and van Gogh to feel unmanly by comparison. Van Gogh sublimated this latter feeling by transposing it into the form of an excessive veneration for Gauguin, as a man as well as an artist.

Pl. 163

However, the two men did have comparable backgrounds. Both of them had come to painting late, and had broken with previous careers in order to do so. Their respective commitments involved certain common ideas about dedication, financial sacrifice, the acceptance of physical hardship and the importance of going on painting even when it was simply a matter of painting for oneself. They also had parallel aspirations, which centred around the idea of an ideal studio where the artist could work in freedom from both human and material needs, so liberating painting for posterity. And in fact everything went well enough between them for the first five or six weeks of Gauguin's stay; that is, up until the early part of December. They made joint plans, they worked hard, and they had many topics of conversation. It was not until the first hostile incident that there were any overt signs of rupture. Up until then the only discordant note appears to have been Gauguin's nostalgia for the tropics.

A close and careful look at the topics of discussion and argument between the two men actually confirms this point. Here

it is necessary to look across at the earlier and later evidence as to what the two men thought on the leading issues. This evidence considerably qualifies each man's rationalization of the extent to which they disagreed. For example, Gauguin wrote at the end of October that, whereas van Gogh saw Daumier-like qualities in the local subject matter, he saw there a combination of Puvis de Chavannes and Japanese art.[3] No doubt, just because van Gogh was so extremely set on the importance of Daumier's example, Gauguin felt compelled to come up with a rival formulation of his own. But in fact van Gogh greatly admired certain paintings of Puvis' for the sentiment which he found in them. He also associated Puvis' work with the older culture which he envisioned as underlying the contemporary Provençal scene. And Gauguin had always admired Daumier's caricatural draughtsmanship. So the antithesis of view was certainly not an absolute one. Similarly, in a letter of December,[4] Gauguin lined up on one side the artists whom van Gogh admired as great masters, and on the other side those whom he admired, making out that his opinions were completely unacceptable to van Gogh. Van Gogh was committed, according to this well-known statement, to a line of tradition which included Daumier, Daubigny, Ziem and Théodore Rousseau, whereas Gauguin gave pride of place to Raphael, Ingres and Degas. However, van Gogh did genuinely admire all three of the latter artists, for the qualities of purity and refinement which came out in their work. The real point is, then, that Gauguin stood out for the use of line, van Gogh for the importance of colour. And here the two men were simply airing afresh an age-old controversy. It went back to the sixteenth century, and had received a fresh lease of life in the period of Ingres and Delacroix. By that time it had come to form part of the history of taste and of cultural in-warfare; and this continued to be so. By the 1880s, however, when the traditional subjects of painting and its traditional pictorial means had split wide apart from one another, it no longer had any absolute relevance. The line-colour antithesis certainly could not be applied to van Gogh's and Gauguin's actual work without a great deal of qualification.

It is significant, too, that the two lists of admired artists consisted predominantly of names belonging to the mid-nineteenth century. Correspondingly, the painters on whom van Gogh and Gauguin drew in their actual work tended almost exclusively to be nineteenth-century predecessors or contemporaries. Thus the two men actually had in common, like Monet and Pissarro, an orientation towards the past which ex-

cluded almost everything apart from one or more traditions founded in the earlier nineteenth century. Further, Gauguin's introduction of the name of Degas on his side had a political motivation behind it, in that Degas appeared an ally at the time and was interested in buying Gauguin's work.[5] And finally, it is notable that the names of other artists whom the two men both admired do not appear either in Gauguin's December statement or in his late-life memoir, where he simply added van Gogh's admiration for Meissonier and his own admiration for Cézanne.[6] Monet, for example, whose work came up for discussion on at least one occasion, is a notable omission.

Another such omission is Delacroix, and a third is Courbet. Gauguin had written enthusiastically about Delacroix in 1885 and he would borrow motifs from Courbet's art in 1889 and subsequently. Van Gogh had similarly extolled Courbet's freedom of handling back in his days in Nuenen,[7] and his admiration for Delacroix is well known, running as it does all the way from his early readings about Delacroix's colour-practice, through to the 'translations' after this artist which he did at Saint-Rémy. It is true that Gauguin admired Delacroix, and likewise Rembrandt, for different reasons from van Gogh. He responded to the power of draughtsmanship in their work, whereas van Gogh responded to their colour-schemes and the way in which these schemes conveyed symbolic values. One has here, however, simply another variant of the line-colour antithesis which has already been discussed. This point apart, there was much for the two men to respond to jointly in the art of those precursors. And when van Gogh and Gauguin visited the museum at Montpellier together in December, they certainly seem to have covered steadily and carefully, side by side, the masterpieces by Delacroix and Courbet which were to be seen there in the Bruyas Collection.[8]

The discussions of creative procedure between the two men similarly involved a certain amount of common ground. The aesthetic ideas of Bernard served as one bridge between the two men's viewpoints. Another such bridge consisted of common ideas about the importance of Japanese art, most particularly the way in which shadows were suppressed there.[9] As for the controversy about the possibility of using memory and imagination, rather than working direct from nature, it is noteworthy that van Gogh had already made several attempts at working from memory earlier in the year 1888, before Gauguin's arrival. Nor did he object in principle to producing a painting in the studio, provided that he had available some kind of direct link with the live subject itself. As early as 1885,

apropos of the *Potato Eaters*, he had told Theo how he had 'painted [the life] from memory into the picture itself', resorting to fresh visits to his subject in the intervals between his bouts of actual painting.[10] And his admiration for Delacroix had led him, in that same year, to see it as possible that an ultimate point might be reached where the practiced imagination would truly come into its own, so that the work which emerged would be a departure from the life in this imaginative sense.[11]

The issue of the use of imagination did become a crux in December 1888, when van Gogh more or less turned upon Gauguin for having driven him too far along these lines.

Pl. 163 Gauguin's *Portrait of van Gogh painting Sunflowers* seems to have been responsible for crystallizing the issue, and precipitating van Gogh into a state of hostility towards his companion. This antagonism, however, was not so much a clash of belief as a symptom of van Gogh's tense state of mind at the time and of the imminence of his first breakdown. This can be deduced from van Gogh's exactly parallel behaviour towards Gauguin in November 1889. He had just revisited Arles at the time, and his fifth crisis was to occur a month later. Significantly, in the interval he launched a violent attack on the whole nature of the most recent works of Gauguin's and Bernard's which he had seen. He told his brother that they gave him 'a painful feeling of collapse instead of progress', and in voicing his criticisms to Bernard he specifically harked back to the 'abstractions' which he had produced at Arles at Gauguin's recommendation, saying that they represented a dangerous kind of temptation.[12] He also went straight back, in his own work of the same time, to painting olive groves direct from nature. All of these points, then, imply a direct connection between van Gogh's two different outbursts against Gauguin and his awareness at the time that a mental crisis was on its way. That van Gogh turned back to the world of nature and used it as a sheet-anchor on these occasions only points up more strongly how far, in the last months of 1888, he had been willing to move experimentally along the lines advocated by Gauguin.

There was, then, no kind of absolute theoretical rift running right through the discussions between the two men. They were liable to discuss the same subject on completely different levels or planes; and there was no direct interaction between them in the realm of art-theory. But as soon as one widens the context in which their arguments are seen, leaving aside the personal and temperamental differences, one sees that there was in fact a good deal of common ground.

This ability to see the discussions which took place at Arles in a wider context was precisely what van Gogh and Gauguin lacked themselves. Even when they had gained retrospect and relative calm in their view of what had happened between them, they still defended themselves in the way they had been forced to do during their last weeks together. Each rationalized what had taken place in his own favour, and distortions or misleading emphases entered the picture in consequence.

To begin with, Gauguin claimed that he had been exploited; and van Gogh, in a state of remorse, tried altogether too hard to put things back on to a friendly basis.[13] There was, then, a long period of moderate amicability between the two men. Van Gogh much regretted during this time the fact that there was no longer any kind of alliance between himself, Gauguin and Bernard. Gauguin, for his part, when things went badly between himself and Theo, used Vincent to pull his relationship with the dealer back into line. By the beginning of 1890 van Gogh was quite prepared to emphasize what he owed to Gauguin.[14] There were plans for further exchanges of work between the two men. And Gauguin was correspondingly affected in a sincere and quite genuine way when van Gogh died.

Inevitably, however, Gauguin's feelings of guilt clashed with his ambitiousness and his desire to be recognized as a great artistic leader. Already at the beginning of 1890 the critic Aurier had dedicated a long article to van Gogh's work and had mistakenly credited van Gogh with the concept of the 'studio of the tropics', on the basis of a letter of van Gogh's to Bernard to which he had access.[15] Gauguin believed, as van Gogh did also, that Aurier should have dedicated an article to his work first. And he actually seems to have schemed to this effect, though he did not in the end get an article from Aurier until March 1891—that is, fourteen months later. His invention (for such it seems to be) of a final letter from van Gogh containing the words 'Dear Master'[16] relates back in all probability to this dissatisfaction with Aurier.

Again, in the autumn of 1890 Gauguin tried to dissuade Bernard from helping Theo van Gogh to arrange a memorial exhibition of Vincent's work.[17] The immediate reason for his taking this stand was that, since Vincent's death, Theo himself had begun to develop signs of insanity, and Gauguin was afraid that, in the eyes of the public, some of the madness of the van Gogh brothers would rub off on to himself.

These two feelings of Gauguin's—the feeling that van Gogh had received critical acclaim which was really due to him, and

the feeling that he might be held responsible for having sent van Gogh mad—underlie everything that he subsequently wrote about van Gogh, and explain the various rationalizations and distortions which run through and through those texts of his. In January 1894 he published a brief article in which he endeavoured to show that van Gogh was fundamentally mad.[18] He also put an exactly similar sketch of van Gogh's character into his text *Diverses Choses*,[19] which consists of a variety of personal records and notes put together in 1896-7. It is here that he first seems to have embarked on the distortion of chronology to suit his brief. For he used a painting of van Gogh's of *Old Shoes*, which he remembered as hanging in his room at Arles, as an illustration in this case as well; and he now implied that it had been painted during his time at Arles— whereas in fact it had almost certainly been done in August of that year.

Pl. 167

Similarly, in March 1897, Gauguin was freshly provoked by the critical contention that van Gogh, along with Cézanne, was one of the founders of the 'modern movement'.[20] Two years later his feelings on this score came to a head, when he read the article which the critic André Fontainas had devoted to his work in the *Mercure de France*.[21] He now felt that there was a concerted movement among the Parisian intelligentsia to belittle his achievement, by comparison with that of his chief contemporaries. He opened a correspondence with Fontainas and then, in September 1902, after Fontainas had become a useful contact who might get his newly completed *Racontars de Rapin* published in the *Mercure*, he compensated for this by writing a letter in which he took Fontainas directly to task for the various statements about van Gogh in the critic's earlier article.[22] It should be borne in mind that the manuscript which he was submitting was itself an open attack on men of letters who set themselves up as critics of painting. Gauguin corrected Fontainas in two ways: first by citing the *Sunflowers* (again, painted well before his arrival at Arles) in proof of what van Gogh had learnt from him; and secondly by referring to letters of van Gogh's which suggested van Gogh's attitude of reverence towards him.

Gauguin told Fontainas that these corrections of his would remain strictly between themselves. But in fact he used exactly the same material afresh in his *Avant et Après*, simply omitting any mention of Fontainas by name. In the section there devoted to his stay at Arles, that is, he again falsified chronology in order to establish his influence on van Gogh. He also amplified afresh his earlier picture of van Gogh's basic insanity. The order

of events at Arles became shuffled or confused in the process, and Gauguin also seems to have added completely spurious details.

The memoir in *Avant et Après*, therefore, cannot be accepted as a reliable account of what happened between van Gogh and Gauguin, unless the details happen to be confirmed by the documentation which belongs to the year 1888 itself. Far from presenting a true picture of the relationship between the two men, it simply reflects Gauguin's sense of grievance and his self-protective attitude between 1890 and the end of his life.

In fact Gauguin had, underlying all this, a continuing respect for what the relationship with van Gogh had given him and meant for him. He pasted into the manuscript of his *Diverses Choses* a drawing which van Gogh had given him, captioning it at the top '. . . by the late Vincent van Gogh'. In *Avant et Après* itself, there are several sympathetic touches to the portrait of van Gogh.[23] And in 1901 Gauguin painted still-lifes which included sunflowers that he had specially cultivated in Tahiti. Van Gogh had used the imagery of Gauguin's *Arlésienne* as a source for variants of his own, and Gauguin was now, as it were, finally returning the compliment—so that the sunflowers of Arles bloomed again in the tropics.

Pl. 168

Pls. 118,119

6　Towards Symbolistic Art 1880-90

The theme of this chapter is the emergence and crystallization, between 1880 and 1890, of a type of art whose characteristics can best be signalized by the use of the adjective 'symbolistic'. To give a preliminary idea of what is distinctive about this art, and of the development leading towards it, two pairs of comparisons can be used.

The first pair consists of two works by a Swiss artist, Hodler, who did not in fact have any contact with French painting until 1890. It is therefore all the more interesting that his development prior to that date should, in certain key ways, provide a parallel to what happens in France itself.

Pl. 169　　Hodler's *Shoemaker*, from about 1882, shows its subject actively absorbed in his work. He is looking down with bent head and shoulders, and dealing with both hands with the shoe in his lap. The room itself is filled with a whole profusion of objects—lying on the floor and on the work-bench, or hanging on the further wall. These objects give a homely air to the setting, painted as they are with a great deal of descriptive detail. They make the setting, in fact, of the kind associated with the tradition of genre painting. The shoemaker is at the centre of the composition, but in scale with the setting and set well back into it. His figure accords with the surrounding context, not only in terms of space, but also in terms of atmosphere and the play of light and shadow.

Pl. 170　　Hodler's *Working Philosopher* of 1884, for all the thematic continuity between the two works, is different in each of these respects. The figure there is larger in size in relation to the rest of the picture, and a flat, even background, which is entirely lacking in distinctive detail, brings the mass of the figure forward towards the picture-plane. The silhouette of the figure detaches itself against this background. And there is an equal elimination of detail in the lower half of the painting. There are fewer props, that is, and they are of a simpler kind. The figure is also more of a type, in build and physiognomy. There is a pensive character to the man's behaviour here, which overlies and qualifies the force of the action itself. The facial expression, equally, has an introverted character. The gaze is strong and direct, but it does not focus on anything—or at least

not on anything shown within the limits of the painting. And this quality of the gaze implicitly suggests the mind at work within. There is also a more explicit focus on the interrelationship between the man and the tool he is using. These two key components of the imagery, that is, are brought more explicitly into alliance with one another.

A comparison of exactly the same kind can be made between two works by a French artist, Eugène Carrière. Between his *Seamstress*, which probably dates from around 1880, and his *Big Sister*, which was shown in the Salon of 1889, all the same comparisons apply. There is an elimination of descriptive detail in the surroundings in the later work, and a greater generalization in the treatment of the human figure. The figures are larger and closer to the picture plane. The setting in the second case is of a token kind, consisting as it does of a single crock on the table to the rear. And there is a greater concentration and inwardness of expression, with stronger psychological overtones.

Pl. 171
Pl. 172

Two more points can be added in this Carrière comparison. There is, in the *Big Sister*, the misty rendering of the context in which the figures are shown, which introduces a suggestive and even mystical note, just because of the inexplicitness. And there is the greater emphasis there on the total mood which emanates from the figures' behaviour, and on those parts of the body which are particularly instrumental in conveying this mood, namely faces and hands. These elements are highlighted, while the other parts of the body are dark or melt back into darkness and shadow, only partially emerging from it as clear-cut, recognizable shapes. They assume, accordingly, a secondary and accessory importance, compared to the organs of expression which directly convey an inner state of mind.

The role of mood becomes, in this way, both more positive and more compelling. In the earlier Carrière, concentration and reverie are simply a specially emphasized aspect of the central figure's action and behaviour. The arrangement of objects in the room and the play of light and shadow there are attuned to this depiction of reverie; they play a supporting role, of a contextual kind. In the later work, on the other hand, the mood of devotion and almost religious rapture is, one may say, established and put across by the imagery as a whole. It is hard to make a clear-cut distinction in this case between the role of the figures and the role of the setting. For it is as if the behaviour of the figures sent out an aura into the surrounding context, and this context picked up and amplified the special effect.

In dealing, therefore, with the development illustrated by

these two comparisons, two interlocking kinds of analysis are involved. One has to consider the imagery which the artist uses, and the way in which this imagery changes in its character and its components. One also has to consider the way in which the imagery is presented and organized—with particular attention to the special devices which the artist uses in order that the whole tenor and mood of his imagery shall communicate itself effectively to the spectator.

Pl. 195

What exactly the term 'symbolistic' means as it will be used here[1]—what it comes to mean by 1890—is best suggested by the motto found on Gauguin's 1890-1 *Portrait of Jean Moréas*: '*Soyez Symboliste*'. This motto is not an encouragement to use symbols of an explicit kind, or to re-use in some modified or modernized way the symbols of an earlier period. For the images found in that work are not related together in any specific way, nor have they a traditional meaning. Nor was Gauguin advocating the obvious and artificial kind of symbolism that one finds in Emile Bernard's *Madeleine at the Bois*

Pl. 82

d'Amour, discussed in an earlier chapter.[2] Gauguin was certainly saying there, on behalf of Moréas—poet and author of the 1886 manifesto of Symbolism[3]—'join the ranks of the Symbolist movement' (which included writers, poets and theoreticians). But he was also saying at the same time, on his own behalf, 'be spiritual, enigmatic, mysterious and suggestive'—as he himself was in this drawing.

The subject of this chapter, in short, is the emergence in the 1880s of a pictorial imagery and a language of an allusive or suggestive kind. And while the definition of theme just provided excludes from consideration works like Bernard's *Madeleine* and the later paintings of Böcklin,[4] it lets in works of the 1880s which are not overtly symbolic, like Theo van Rysselberghe's

Pl. 173

Self-portrait of about 1889. For the hooded quality of the expression there introduces a suggestive note, which is reinforced by the texturing of the rear wall, treated as if it were cornerless. And there is also the curious motif of the metal bracket at the upper left, balancing the window pane which refracts the flowers and has the artist's signature on it.

Pl. 174

The starting point of symbolistic art in the 1880s can be labelled 'late Romanticism'. Munch's *Spring* of 1889, another non-French work, serves as a useful point of reference here. It provides an apt introduction, that is, to the meaning of 'late Romanticism' as a defining label. And it also shows very clearly what lies behind that starting point. Because Munch was work-

ing in a semi-provincial milieu in Norway, without having as yet spent any length of time in Paris, the work in fact corresponds to French developments of the early to mid 1880s. And there are altogether three different senses in which Romantic elements enter into *Spring*.

First, the treatment of the domestic interior here, with its genre objects on the table and its figures sitting pensively or concentrating on a domestic task, can be traced back through Scandinavian and German antecedents to the example of Millet and Daumier in France. These two artists, along with Courbet, who did similar interiors early on, can be grouped together under the heading of late Romantic French painters, in the sense that they made their foremost contributions between 1848 and 1865. Their vocabulary of colour and form, their way of handling light and space, their focus on the peasant, the working populace and the family, had made a very vital and fundamental contribution to the origins of impressionism, in the years when the individual artists of that movement were getting under way. Those same aspects of their art, furthermore, never lost their authority in France during the next quarter of a century. In the 1880s they still stood out as a relevant example to French painters; and in the meantime there had been a steady process of diffusion across the rest of Europe. Late Romanticism in this sense, then, has clear-cut connotations. There is a thread, or series of threads, leading back to a well-defined period in earlier French painting. And whether one speaks of a return to Romanticism, a resuscitation of it, or simply of its continuance, depends on the country and life-span of the artists one is considering, or the particular stage they had reached.

Secondly, there is a counterpoint in the Munch between the closed, shadowed interior on the one hand, and on the other the window with the bright daylight outside, the plants growing on its sill and the wind stirring the curtains. This counterpoint offers, purely in terms of imagery, the suggestion of an antithesis —an antithesis between the confined state and the outside world of nature. The light which allows the plants to grow only touches the two figures in black; the breeze which moves the curtains does not interfere with their static, almost listless demeanour; and so on. Now if one traces the line of descent of this implicit antithesis of Munch's, it goes all the way back to the imagery of high Romanticism. This time the term 'Romanticism' is used in a wider, more international sense; and the period in question is roughly 1810-50. Specifically, the motif or theme of the open window had been used by several German artists of that period. Particularly relevant is Menzel's portrayal

of a plain interior, with bright light outside the window and a breeze moving the curtain.[5] The real point is, however, that the general pattern of antithesis which is implied in this case and others like it—freedom as opposed to confinement, life as opposed to death, hope as opposed to hopelessness—is one of the staple features of high Romantic imagery, French as well as German, and indeed one of the hallmarks of that imagery. The painters of the late nineteenth century had available, in this connection, a tradition of imaginative values which was both flexible and readily accessible. In their case, then, one can often pinpoint a continuing survival of these values. It is also characteristic that the subject matter through which these values are re-enacted should now be a personal subject matter: one deriving from the artist's own intimate life and experience. The figures in the *Spring* are individuals partially turned into types, rather than types arrived at by an imaginative process of generalization. They are in fact Munch's foster-mother and sister. In painting of the 1880s personalization of this kind is an almost inherent accompaniment of the second kind of Romanticism.

Finally, there is the way in which the whole appearance of the younger woman in *Spring* implies unhappiness and depression. The pale face, the gaunt frame, the hands together in the lap holding a handkerchief, the position of the body and head in relation to the chair all add up to this suggestion. The Romantic novel is literally haunted by this kind of idea of the invalid—by the idea that in a sick person, especially a young one, there is a correlation between physical frailty and withdrawal from the active world which exercises a peculiar spell.[6] It is unlikely that Munch derived his idea from painting. Much more probably, he simply picked it up without being aware of any specific precedent, because it had been used and re-used until by his day it had filtered down to the level of popular awareness. In other words, another way in which the stock ideas and images of Romanticism lived on was through their diffusion and gradual popularization in literary form. The medium of graphic illustration with its inherent literary bias helped the process along. And here again the factor of personalization applies to Munch's re-use of the stock image in question.

To turn back now to the impressionists in the early 1880s, there are certain indications that they too were affected by the intellectual climate in France which encouraged and stimulated the emergence of symbolistic art. There are also certain

parallels in the paths which they took at this time. Although these parallels are indirect in the sense that the impressionists never consciously reoriented their interests so that they fell into line with those of the Symbolist movement, they are none the less relevant in their own distinctive terms.

In the first place, the mood of doubt and self-questioning referred to in the first chapter was not simply a response to the factionalism and new quarrelsome politicking among the members of the impressionist group, or to the grave economic crisis of 1883-4. It had deeper roots. The loss of a sense of direction is one symptom, bringing with it as it did, as early as 1881, feelings of frustration and personal ineptitude.[7] It is clear from their paintings that the leading artists were forced, at this period, into reassessing everything which impressionism, as a movement, had stood for up to that time.

The letters of Pissaro, the most articulate of the group on general issues and the most sensitive to external pressures, show him worrying in the early eighties about the kind of reception which was being accorded to their work. Fifteen to ten years earlier, when the impressionists had been united by a common radicalism of outlook, by a sense of friendship and common life, and by an emerging agreement in principle as to the qualities which were to be sought for in outdoor painting, such worries had been strictly irrelevant. Now, however, the situation had become both more open and more competitive, so that each artist increasingly had to find his own salvation, in terms of holding a place on the art scene as well as economic survival. In keeping with this, Pissarro was specifically concerned about the gap between the appreciation and understanding of the lone kindred spirit, and the attention of some kind of a general public.[8] He critized Manet for having all his life sought Salon honours and recognition at that level of authority. He equally criticized Renoir for doing drawings for a popular illustrated weekly, *La Vie Moderne*.[9] And his resolute turning of his back on any immediate hope of widespread acclaim much resembles the stress, in symbolist theory, on the response of the isolated individual to the new in poetry and on the ultimate importance of this response as the most that the poet can hope for. As the young Valéry once put it in conversation with Mallarmé, it was enough that there should be some young man in each French town who responded with understanding to one's work.[10]

Pissarro also brought under scrutiny in the early eighties, in a somewhat ambivalent way, the assumptions of the impressionists concerning creative procedure. If there was to be a

169 HODLER *The Shoemaker c.* 1882

170 HODLER *The Working Philosopher* 1884

171 CARRIÈRE
The Seamstress c. 1880

172 CARRIÈRE *The Big Sister c.* 1889

173 VAN RYSSELBERGHE
Self-portrait c. 1889

174 MUNCH *Spring* 1889

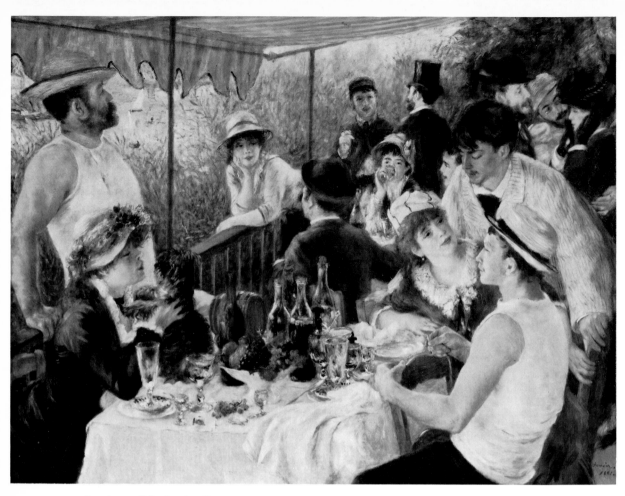

175 RENOIR *Luncheon of the Boating Party* 1881

176 DEGAS *Pagans and the Artist's Father* 1882

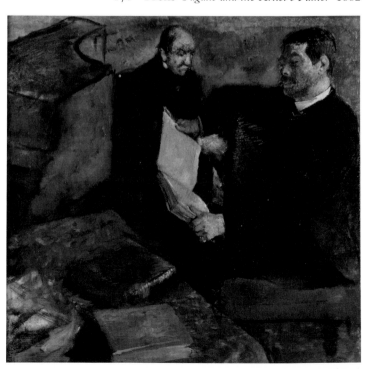

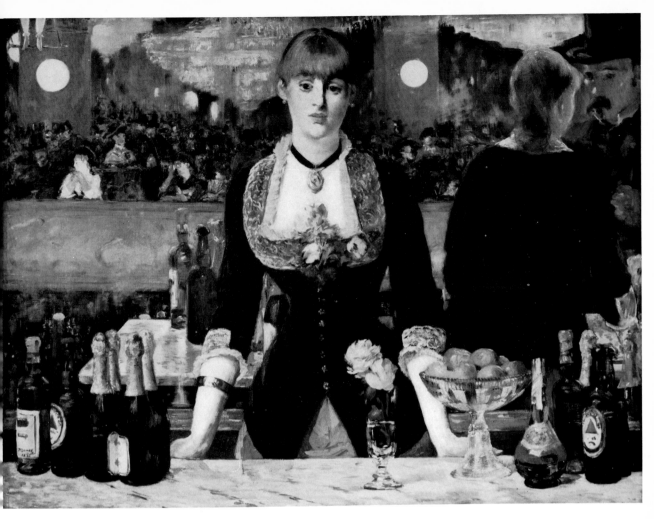

177 MANET *Bar at the Folies-Bergère* 1881-2

178 DEGAS *Melancholy* c. 1880–83

179 CÉZANNE *Reclining Boy* c. 1882–87

180 MONET *Woman with a Parasol* 1886

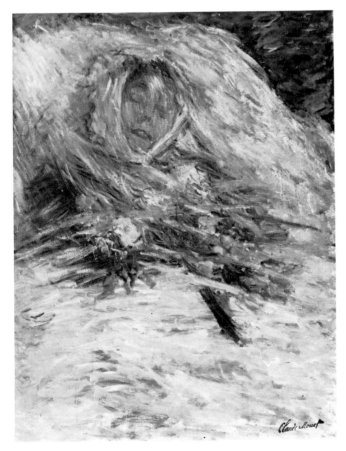

181 MONET *Camille on her Deathbed* 1879

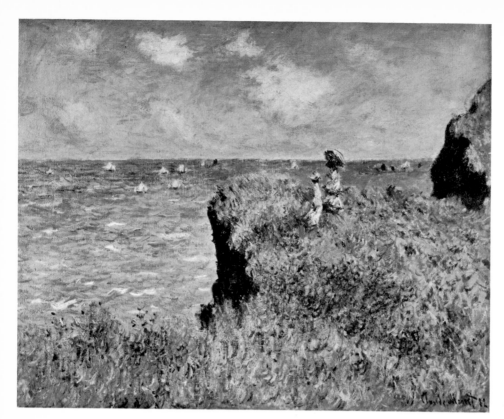

182 MONET
The Cliff Walk 1882

183 MONET
The Pink Boat 1887-88

184 VAN GOGH
Four Birds' Nests 1885

185 VAN GOGH
Pair of Boots c. 1885

186 GAUGUIN *Still-life in an Interior* 1885

187 DAUMIER
At the Art Gallery
c. 1860–65

188 GAUGUIN *Sleeping Child* 1881

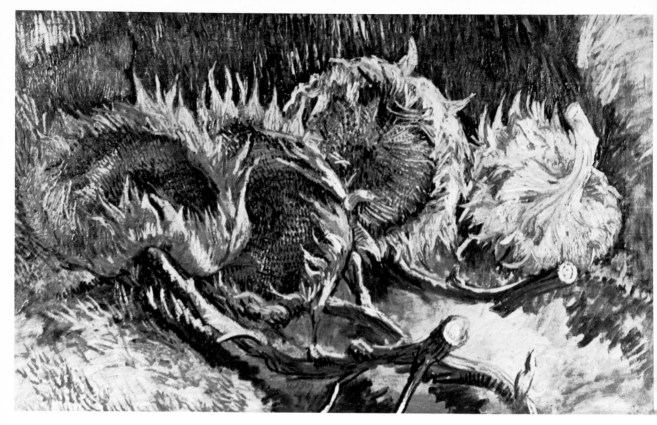

189 VAN GOGH *Sunflowers c.* 1887

190 DELACROIX
Blooms c. 1849

191 REDON Frontispiece to
Les Origines 1883

192 SEURAT
Woman powdering Herself c. 1889

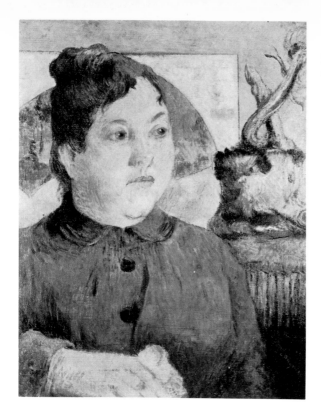

193 GAUGUIN
Portrait of Mme Kohler c. 1887

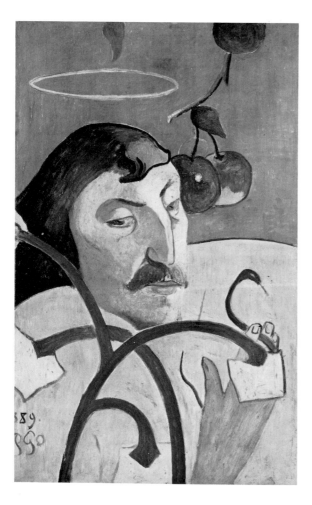

194 GAUGUIN
Self-portrait with a Halo 1889

195 GAUGUIN
Portrait of Jean Moréas c. 1890-91

196 GAUGUIN *Be Mysterious* 1890

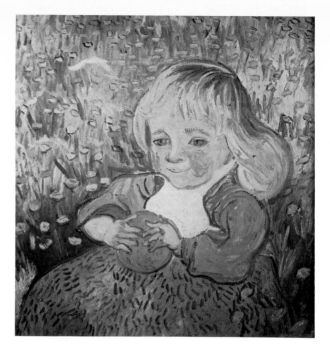

197 VAN GOGH *Child with an Orange* 1890

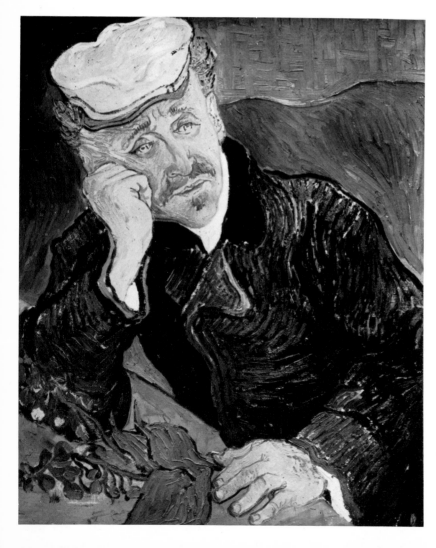

198 VAN GOGH
Portrait of Dr Gachet
(second version) 1890

reliance on direct observation and experience, he did not want this to entail any loss of imaginative power or freedom. And he observed that the use of memory could in fact produce a greater power and originality.[11] This ambivalence can be compared with the idea of the symbolists that the picture of experience given by memory can be truer to one's feelings than any descriptive record based on direct confrontation, and capture the nuances of those feelings more fully. And though the impressionists never switched over to a planned and programmatic use of memory, both Renoir and Degas indirectly used it or relied upon it in a major painting of the early eighties.

Pl. 175

The works themselves show this, rather than anything that the artists said. Renoir's *Luncheon of the Boating Party* of 1881, that is, was clearly intended as a final summation, on a monumental scale, of those hedonistic outdoor pleasures which he had so often celebrated in his paintings of the seventies: sunlight, the hot afternoon on the river, good food and the companionship of young women. He was summing up, furthermore, the whole impressionist way of life which was bound up with those pleasures. And since, by 1881, the youthfulness of spirit and fellow-feeling which had prevailed amongst the artists then had passed away beyond recall, Renoir was in the position of recreating that spirit. He seems to have done this not only in terms of mood, but also in terms of the way in which he portrayed his friends. For Caillebotte, astride a chair on the right, looks considerably younger than his thirty-three years in 1881. The figure leaning against the rail at the left appears to be Monet, but Monet as he was in the early to mid seventies (there is a comparable portrait of him by Renoir dating from 1875). Aline Charigot, the future Mme Renoir, who appears holding a dog, was much younger than Renoir anyway. And the girl with her hands up to her hat is probably Margot, Renoir's favourite model of the seventies, who had died in 1879. At least, she has very much the same kind of face as Margot, and wears Margot's sort of hat and dress.

Pl. 176

Memory was also involved, in a curious but rather moving way, in the portrait which Degas painted in 1882 of *Pagans and the Artist's Father*. In the late sixties Degas had painted Pagans plucking his guitar and his father behind, sitting beside the piano and listening. The open book of music on the piano forms the connecting link between the figures there. In August 1882 Pagans came to Degas' studio for the purposes of a fresh sitting, and there is good reason to think that the later double portrait was the direct result of this encounter. Drawings show that the first idea was to depict Pagans playing the

piano. In the painting, however, this idea was abandoned. Instead, Degas' father, dead now for eight years, appears once again to the rear, in the same pose as in the original double portrait and with the same expression of concentrated attention. The flesh on his face, however, is that of an older and sicker man and, though no music is being played, the piano is carried over from the earlier version. In these two cases, then, Renoir's and Degas' subjects were such that, because of feelings and memories, recollection entered into their presentation.

If the impressionists had difficulty in coming to terms with their position in the early eighties, their response in this situation to Manet's *Bar at the Folies Bergère* should be considered. It can be presumed that this final masterpiece of Manet's had an unsettling effect. Painted in 1881-2, shortly before Manet's death, and shown in the 1882 Salon and in the Manet retrospective of January 1884, it must have caused the impressionists to reassess their whole relationship with Manet. The *Bar* makes much the same kind of provocative challenge to the spectator as Manet's works of the early sixties, like the *Olympia*. Here too, the barmaid stares out directly at the spectator, in his imagined role of a customer standing at the bar. And the cool aloofness and enigmatic quality of her expression similarly embodies a reference to past art (in this case High Renaissance portraits such as the *Mona Lisa*). But the painting also sums up and epitomizes the whole technique which Manet had evolved in the seventies for the depiction of urban subject-matter. By sheer brilliance and bravura in the combination and rearrangement of the different constituents of the painting, each part of it and each item on the bar itself has its visual richness and lustre and optical shimmer raised to a higher power—with a strong effect of paradox, yet without any detriment to the convincingness of the continuity between objects, atmosphere and space.

During the seventies Manet's technique and special interests had put him distinctly to one side of the *plein air* impressionist painters. Whilst his work of the early sixties had mattered to them a great deal at the time, in terms of succulent paintwork, colour contrasts and the treatment of light and atmosphere, his concerns since then had been in no sense equally relevant. Now, however, in his way of dealing with visual impressions and sensations, he had again asserted his commanding position. He had gone beyond the sophistication of means which the *plein air* impressionists had attained in the seventies and their preoccupation with capturing transitory optical effects, without essentially offering any different leads from the ones which he had already provided fifteen to twenty years earlier. The

Pl. 177

Bar, then, simultaneously trumped impressionism and sent it back to its starting point. Without influencing the impressionists in any way direct way, it compounded the problem which they already faced of rethinking their premises.

In going back to the 1860s, the impressionists were going back not only to Manet's work of that time, but also to the Romantic sources which had underlain the first beginnings of their art. Quite apart, therefore, from the bending back towards those sources in terms of structure and colour practice,[12] something of the mood and spirit of Romanticism which had entered into the earliest work of the impressionists filtered back into their art in the early 1880s. A leading example of this is Degas' *Melancholy*, which can be dated from a notebook drawing between 1880 and 1883. Whether or not this was the work's original title, the qualities of introspection and wistfulness which are found in Degas' portraits of the early sixties are even more strongly apparent here, where the pose itself works in concert with them.

Pl. 178

These qualities belong, of course, to the general Romantic tradition of portraiture. While, therefore, Degas was in no sense putting himself under the aegis of Romanticism at this point, the character of his *Melancholy* belongs, like late Romanticism though within a different framework of interests, to the context of the beginnings of symbolistic art. The same applies to Cézanne's *Reclining Boy* of the mid eighties. The young boy there lies full length on the river bank with one arm supporting his head and a pensive expression on his face. This motif of the human being meditative in the world of nature is a specifically Romantic one. And the pose in this case can be compared specifically with that of the left-hand figure in Seurat's *Baignade*, while the facial expression and quality of isolation have much in common with those of the central figure there.

Pl. 179

The structural changes found in impressionism at this time parallel the changes which were noted above in the contemporary or slightly later development of Hodler and Carrière. It is not simply that, with the impressionists too, the main image characteristically becomes larger and is brought up towards the picture plane, where it enforces itself strongly upon the spectator. There are also comparable changes of an organizational kind, or ones which have to do with the very way in which the figure is presented.

Pl. 175

In Renoir's *Boating Party* the individual figures are not, in physical terms, fully incorporated into the total atmosphere of warmth and suffused light. The plasticity of each figure is stronger, its physical presence more assertive, than it needs to

be in terms of the figure's position in space and its relation to
the others nearby. Each figure, therefore, seems to displace
more of the environment than is compatible with a complete,
harmonious accord between figure and context. Again, each
individual personality separates itself off more or less strongly
from the collective mood of the company. Each expression
and action has an edge of its own, whether the figure in question
is playing with a dog, caught in a moment of thought or in-
dulging in a mild flirtation. In a gouache of Pissarro's from 1882,
Three Hoers, the shapes of the peasants are flattened, they are
linked together strongly by overlap and the continuity of
contour, and the surrounding field is treated as if it were
shrouded in mist, with a consequent loss of detail. In the later
Degas portrait of *Pagans and the Artist's Father* there is no Pl. 176
communication or link of any kind between the two figures,
and the table and chair-arm in the foreground act as barriers
intervening between them and the observer. The setting is
almost devoid of concrete detail and the books themselves are
treated more as shapes than as specific still-life objects. The
upper halves of the figures detach themselves strongly from the
back wall, the father seems squeezed in between Pagans and the
piano, and the paintwork itself has a sketchy and almost
floating quality.

Two further illustrations from the slightly later work of
Renoir and Degas show how their work continues in step, in
its own manner, with the development towards symbolistic
art. In Renoir's *Bathers* of the mid eighties one is aware that the Pl. 3
figures are models posing as nymphs, much as one is aware in
Hodler's *Working Philosopher* that a model has been called Pl. 170
upon to act a role—again one which refers back to the world
of classical antiquity. And in Degas' *Six Friends at Dieppe*, a
pastel of 1885, there is an explicit emphasis on the degrees of
non-communication between the different figures, and on the
different, personal ways in which each of them reacts to the
situation of being with the others. The figures are stacked up,
almost literally, on top of one another, and the setting is merely
a token representation of the seashore.

Finally there is the case of Monet, who had always been the
leader among the *plein air* impressionist painters and whose
path of development was uniquely linear in its progression.
Just because of this linearity, it is all the more interesting that
Monet's figure-paintings of the period should likewise have
points in common with the development towards symbolistic
art. Already in September 1879 when he set himself to do a
final, obituary study of his first wife, *Camille on her Deathbed*, Pl. 181

Monet used the same technique that he was currently using in his canvases of the snow and ice at Vétheuil. This technique has, in the painting of Camille, the force of a suggestive metaphor: it is as if Camille were physically melting away, like the winter snow. The structure of the picture works in concert here, for the whole upper half of Camille's body, in its slope away from the picture plane, seems to slide away from one's eye, and the body and edges of the face seem hardly there at all. The colours, furthermore, mainly mauve, blue and grey, produce a melancholy atmosphere. And the whole tradition of painting death-bed scenes, which Monet's subject belongs to while at the same time being absolutely personal to himself, has a long ancestry running back through the Romantic period, with an older tradition behind that.

When Monet turned back to rough sea subjects in the early eighties, he sometimes combined the choppy waves with the *Pl. 182* Romantic motif of one or two lonely figures, up on a cliff looking out to sea. And in 1886 he did a pair of paintings of *Pl. 180* *Women with Parasols* which isolate this motif and deal with it in its own right. The figure on top of a grassy ridge is now completely exposed to the forces of nature. The movement of the troubled sky and the scarf, the lines of the grasses and the curve of the body all suggest a strong buffeting by the wind. The woman's gaze is turned directly towards the spectator, but the face is blank to the point of anonymity.

Even more interesting, from the same point of view, is *Pl. 183* Monet's 1887 painting of *The Pink Boat*, one of a number of versions of this theme. The figures here match the drift of the river in that the poised, flat-lying oar and the slight tilt of the boat suggest that they are simply floating by. The colours, mainly intense reds and greens, are so consistently heightened that they have a synthetic, almost acid quality, and the youth and whiteness of the girls is seen against a background of thick overhanging foliage and deep shadow which extends to the water surface itself. There is a strong element of surprise to the appearance of the boat in this cut-off pocket of river, so closely woven and internally consistent in its qualities of colour and texture. And the whole image has, for this reason, an almost hallucinatory effect. Like the *Women with Parasols* the figures themselves seem, in a strange way, dematerialized almost to the point of ghostliness. The large size of these paintings contributes to the way in which one sees them. It is as if Monet, in his return to the subject of sunlight and water, were now coming out on the further side of reality, where imagination takes over.

One can understand, then, why artistically as well as politically Monet's example remained relevant to the younger generation of artists during the later eighties. The suspension of the boat on the river surface in *The Pink Boat*, like a floating wedge within the space of the picture, is in its way akin to the treatment of the vision in Gauguin's *Jacob and the Angel*. And van Gogh extolled Monet in 1888 for having gone further in landscape than anyone else at that time.[13]

Pl. 84

The starting points of van Gogh's and Gauguin's own developments towards symbolistic art are found, in fact, in the early 1880s. And the first clear-cut stage belongs, in each case, to the year 1885.

Van Gogh in the early eighties, like Munch in 1889, had not yet made any contact with Paris and impressionism. The French artists he admired most at this time were, appropriately, Millet and Daumier.[14] In the summer of 1885, while still based in the north, he did a series of about seventy black-chalk drawings of *Peasants at Work* in the fields. The whole project was at one and the same time a homage to Millet, and an attempt on van Gogh's part to create, out of his own personal experience, an equivalent of Millet's imagery. It is characteristic of these drawings that the figure, in each case, is large in size and set close up to the picture plane. The landscape setting, furthermore, is treated as secondary and almost incidental; not much is done beyond simply intimating the character of the field in which the work takes place.

All of this, then, can be compared with the structural changes which take place in impressionist painting during the early eighties. And there are three paintings of 1885 which plot van Gogh's position at that time in relation to Romanticism.

His major creation of that year was the *Potato Eaters*, for the final version of which, significantly, he used memory in combination with studies from the life. The final painting owes an obvious debt to Millet's and Daumier's treatment of the peasant—both directly and through the intermediary of Josef Israels' *The Frugal Meal*. This is apparent not only in the colour and handling, but also in the stockiness of build given to the figures, the emphasis on physiognomic peculiarities in the treatment of the heads, and the attention paid to the details of costume. The whole rendering of the scene was quite evidently based on personal observation; yet despite this (or perhaps just because of it) the *Potato Eaters* has an incipiently symbolistic character. There is the Rembrandtesque lighting which, in combination with the simplicity of the room and the little

picture of the Crucifixion on the left-hand wall, gives the communal meal a quasi-religious character. The subjects' gazes are harsh yet alive with feeling; and the awkward, heavy movements of the arms and hands all relate inwards to the supper itself. The little girl, furthermore, has an aura of light around her head. But as with the image of the wild duck in Ibsen's contemporary play of that name, touches such as this and the movement of the hands over the potato dish do not add up in any precise way. They are too firmly attached to the particular characters and situation for there to be any clear line of meaning running through from them to the presentation as a whole.

Pl. 181 While the *Potato Eaters* and the harvest drawings have the example of Millet behind them, the *Four Birds' Nests*, also of 1885, suggests a life-and-death antithesis of a high Romantic kind. Against a setting which merely hints, in a few sketchy strokes, at an outdoor setting of grass and trees, three nests stand upright. The one nearest has eggs in it and is couched on a base of sticks, as it would be in an actual tree; the fourth, on the other hand, is overturned and empty. The pieces of wood in that case suggest the workings of a destructive force.

Pl. 185 Still another painting which is probably of 1885, the *Pair of Boots,* is Romantic in the third sense discussed earlier (p. 211). The English graphic illustrations which van Gogh knew so well often dealt in the idea that some article of use closely associated with a man's life became, when he had gone, something to be preserved and venerated—as a key to the man's personality and the character of his daily existence. This idea, originally a Romantic one, had filtered down to the level of popular acceptance and become part of the nineteenth-century mythology of death. There was, for example an English illustration, which van Gogh knew, of the chair vacated by Dickens;[15] and when his father died in March 1885, van Gogh did a still-life of his pipe and tobacco pouch on a table. The boots here are specifically isolated, like cult-objects, worn, unlaced and empty. And van Gogh was of course personalizing the Romantic idea, since the boots are clearly those of a miner or peasant, and he knew from the inside what the life of these people entailed.

Seurat's drawings of the early eighties provide a comparison at this point: for example, the drawing of his Mother sewing which he did around 1883. The imagery there, the roundness of form, the depth of concentration again relate back to Millet. The way in which light and shadow are built up equally involves a debt to Millet, this time a technical one. And there is a

235

similar debt to Daumier's drawings in the way in which con-
tour is handled. The figure is brought forward in the sense that
its bulk occupies most of the sheet; the setting is reduced to a
token indication; the hands are intimately observed. And
once more the subject was personal, a vignette of Seurat's
home life.

The works of Gauguin's from the early eighties which are
relevant to the emergence of symbolistic art reflect a very
different pattern of interests from van Gogh's.

Gauguin's *Nude* of 1880 does indeed demonstrate attention
to Courbet; this is evident in the roundness and heaviness of
the model and the way in which the head and shoulders are
painted. The structure of this painting has a good many points
in common with the general structural trend of impressionist
and post-impressionist painting in the early eighties. The
mandolin hanging to the rear at the same time provides a
Romantic flavour. Gauguin was also aware of the example
of Millet in the early eighties, on the evidence of the build
and dress of certain figures in his landscapes of that time.
And the *Still-life with Mandolin* of 1885 has areas of red-blue
colouring which reflect the current importance of Delacroix
in Gauguin's eyes.[16]

These factors, however, are by no means the most crucial
ones when it comes to the ways in which Gauguin established
suggestive interrelationships between the different com-
ponents of his imagery prior to 1885. It is important to recog-
nize, in this connection, that Gauguin had, almost from the
first, a penchant for witty improvisation and the kind of effect
which introduces a vein of fantasy. Already in a painting of
1881 of a *Sleeping Child* (his daughter Aline) he put a bar of *Pl. 188*
music on the wall above the girl's head. The wallpaper pattern,
which may have been entirely imaginary, consists of an en-
livened combination of leaves and birds, with one of the birds
flying across, and the doll hanging from the bedrail swings
with outstretched arms. Together, these different touches
suggest the character of the little girl's dreams. There is a pastel
portrait of a young woman, *Mlle Flensborg*, dating from about *Pl. 14*
1882, in which musical notes are again included, superimposed
on the background as if they were floating above the sitter, like
an emanation from her personality.[17] And in an oil painting of a
Head of a Young Girl in the nude, from about the same date,
the face of a man is to be discerned in the surrounding darkness,
menacing her like some frightening apparition.

Two of Gauguin's early enthusiasms chime with this pre-
dilection of his for improvisation. There is his interest in

V VAN GOGH *The Artist's Chair*. December 1888

VI GAUGUIN *Still-life in an Interior* 1885

Pl. 187

Daumier's caricatural draughtsmanship. He owned prints of Daumier's and a relevant Daumier drawing; and though no early caricatures of his survive, there are some dating from 1886 and 1888-9, and also, in the same notebooks, what might be called fantasy-sketches of a more serious kind.[18] There is also Gauguin's known interest in the work of the English illustrator Randolph Caldecott—who had drawn, for example, trees with peering faces, and portraits hanging on walls with their subjects reacting to what was going on in the room.[19] And here it is worth looking across to van Gogh's comparable enthusiasm for Daumier and English illustrations. However different the shape of that enthusiasm may have been, both men were paying attention to the kind of art which was beamed towards a public at large. Popular artistic currents, then, contributed to the origins of symbolistic art, just as they had contributed to the art of Courbet.

Pls. VI, 186

The *Still-life* which Gauguin painted in Copenhagen in the first half of 1885 introduces an entirely new feature, and one which would be of great consequence subsequently. The imagery here falls into two parts. A still-life of dead game occupies the foreground. Then, to the rear, there is a domestic interior with women round a table. This interior might be understood as a second room opening off the first. Probably, however, it represents a mirror reflection, since it is framed along two sides and the colouring of the wall and window has an atmospheric blue-grey tonality. The women are elegantly dressed, but motionless and devoid of animation. As in Munch's

Pl. 174

Spring there is an implicit contrast between their shadowed existence and the bright light outside the window. The whole composition of the framed scene, furthermore, reads like a pastiche of the interior scenes painted by the mid-century Danish artist P. C. Skovgaard, and by his son Joakim as a young man a generation later. One finds there figures grouped round a table in exactly this way. When all these features are put together, then, it becomes evident that there is a schematic counterpoint here between the deadness of the game and the death-in-life quality of Danish bourgeois existence. The train of association and suggestion runs both ways, from still-life to interior scene and back in the opposite direction. The dead birds show up the deadness of the elegant women; and again, contrariwise, Gauguin's way of painting still-life paradoxically has life compared with the Danish way of painting interior scenes.

Now what Gauguin did here is extremely akin, structurally,

Pl. 43

to what Manet had done in his 1864 *Portrait of Zacharie Astruc.*

There the vertical strip to the left adds to the imagery a framed interior scene. This scene has the tonality of a mirror reflection, and it embodies a reference to the work of art which Manet had implicitly challenged in his *Olympia*. Titian's *Venus of Urbino*. There is, further, an elaborate counterpoint between the two halves of the imagery. This counterpoint is both pictorial and associative (it involves Venetian art, Japanese art, and the bridge across to Manet's work afforded by Astruc's literary and aesthetic interests). The *Portrait of Astruc* remained in Manet's studio after the artist's death in April 1883, and was subsequently acquired by Faure; and the probability is that Gauguin saw it either at the very beginning of 1884—at which time he lent an oil painting which he owned to the Manet retrospective in Paris—or later that year in the collection of Faure, whom he knew at this time.[20] It would appear, then, that the example of Manet was of paramount importance to Gauguin in 1884-5, as far as the approach to symbolistic art is concerned. The *Portrait of Astruc* imparted to him a structural and associative idea which he would exploit in a picture of his own early in 1885, and develop further subsequently. The *Bar* *Pl. 177* itself—included in the 1884 exhibition, which Gauguin surely visited—is also relevant here, with its elaborate foreground still-life and mirror reflection to the rear. In short, just as the impressionists had gone back in the very early eighties to the original sources and premises of their art, which included Manet's work of 1862-5, so Gauguin found guidance in Manet's work of that time, two to three years later.[21]

To pass more rapidly now over van Gogh's and Gauguin's relevant works of the later eighties, noting both continuity and change. In van Gogh's *Sunflowers* of 1887 four cut blooms are *Pl. 189* grouped against a plain blue matrix. Two of the stalks curl up, drawing attention to the places where they are cut through; the fourth bloom is turned over. There is no need to elaborate how what was said about the *Birds' Nests* (p. 235) continues to apply here as well—and also to some extent to the famous *Sunflowers* of 1888. While there is certainly not an explicit symbolism in any of these sunflower paintings, the arrangement of the flowers against a light background re-creates some of the overtones present in a flower-piece by Delacroix. In that Delacroix, *Blooms*, flowers on their stalks are aligned against a *Pl. 190* background of a studio wall which is coloured, like van Gogh's sunflower backgrounds, to suggest the outdoors.

Gauguin's *Portrait of Mme Kohler*, which probably dates from *Pl. 193* the winter of 1887-8, can be compared with Manet's 1868

Portrait of Zola. The gaze of Olympia is directed out towards Zola, while from a pot by Gauguin on the right, decorated with rats' heads, a rat fastens its beady eyes on the sitter. The *Zola* was included in the 1884 Manet exhibition, so it can be presumed that Gauguin knew this painting as well. Again, therefore, it looks as if a suggestive organizational device in Manet's work of the sixties was transmitted to Gauguin. There is certainly an important continuity between these two artists, which cuts right across the time-gap between the sixties and the eighties.

Pls. 79, VII, 102 The self-portraits which Gauguin and van Gogh painted for one another in the autumn of 1888 have already been discussed in an earlier chapter. Though the reservation made in the case of the *Potato Eaters* continues to apply to this van Gogh as well, namely that the suggestive elements do not fully add up, the two works nevertheless show that there was a certain parallelism between the two men at this particular moment, before Gauguin moved to Arles.

Pls. 116, 147 Gauguin's *Vineyard* and van Gogh's *Sower*, both painted while the two men were together, show a continuation of this parallelism, and in certain ways a strengthening of it. In both cases, that is, the element of mood plays a more emphatic part. Colour and texture pick up and amplify the mood which is established by the key figure and diffused outwards from it. In both cases, too, the geometry of structure now becomes more important. One sees this in the relation of shape between Gauguin's seated woman and the mound behind; and in the way in which van Gogh himself now uses the device of a tree-trunk cutting diagonally across the forefront of the picture.

The last two symbolistic works of 1888, on the other hand, *Pl. 163* Gauguin's *Portrait of van Gogh painting Sunflowers* and van *Pl. 144* Gogh's painting of *Gauguin's Chair*, conveniently sum up the parting of the ways which now occurred between the two men. In the Gauguin, three pressures upon van Gogh are simultaneously implied: the pressure of Gauguin's example, referred to in the shape of a Gauguin landscape hanging on the rear wall; the pressure of creating on the canvas itself; and the spell of the sunflowers as a subject. The treatment of van Gogh's features suggests his difficulty in reconciling these different pressures. The implications of the imagery here are, then, almost too elaborate and sophistical. In contrast, the van Gogh has a combination of two of the stock images of Romanticism: the empty chair, and the candle which is lighted to guide a missing person home. Here, as far as association is concerned, one is at the opposite pole of straightforwardness and simplicity.

In fact the only overtly symbolistic works which van Gogh did at Saint-Rémy are based, quite specifically, on ideas and images of the year 1888. The *Starry Night* was first attempted, as a subject, in September 1888; the solitary *Reaper* in a great wheatfield was created as a pendant to one of the *Sowers* of the previous year. There is no van Gogh of this period which has anything in common with, for example, Gauguin's 1889 *Self-portrait as Christ in the Garden of Olives*. An impressionistic technique is consistently used for the landscape there, in contrast to the use of Gauguin's own personal technique for the figure of Christ with his own features, so that the implication—again a highly sophistical one—is that the world of impressionism has lagged behind Gauguin's example, putting him in a position of sad isolation, and ultimately betraying him.

There are, however, certain other points to be noted about van Gogh's development at this time. When he did fresh versions of his earlier paintings, the rendering of the human form and of decorative elements is invariably more schematic; this is particularly apparent in his later versions of the *Woman rocking a Cradle*. In his 'translations' of prints after Millet, Delacroix and others there is a constant intensification of the quality and force of key details. And lastly there are a small number of Saint-Rémy works, and two more from the very beginning of van Gogh's stay at Auvers, in which each of the key components of the imagery now takes on a more specific associative value. Already in the *Starry Night,* for example, the cypress and the church spire serve as twin links between the realms of earth and sky. In the *Ravine* of October 1889, which *Pl. 2* Gauguin greatly admired and wanted to acquire—justly, because it is one of van Gogh's most inspired paintings, with its strokes crackling like fire on a heath, and also perhaps the most subtle in its allusive qualities—the two figures are engaged in an upward climb which has the implications of danger and difficulty; and the flame-like cypresses in the *Road with Cypress and Star* of the following May are again an explicit bridge. Similarly, the *Church at Auvers* of June 1890 seems to quiver and shake, against a disturbed sky, as if it were about to collapse—thereby suggesting the precariousness of man's monuments to his religious faith. And in the second *Portrait of Dr Gachet*, *Pl. 198* presumably painted that same month, the foxglove—an allusion to Dr Gachet's profession, since it was used to cure heart diseases—is no longer in a vase, as it was in the first version, but now lies withering on the table. The doctor's pose, with one hand up to his face, is the traditional one of melancholia, and the rhythms of the coat and face are picked up and amplified

in the undulating line of hillside to the rear. The general implication is then, clearly enough, that Gachet is a kind of Christ-figure. He saved others, himself he cannot save; Gachet cures other men in the exercise of his profession, but his own sufferings, those of the mind, remain.

These three developments pave the way for what happens in a small number of Auvers canvases where van Gogh, at the very end of his life, returned, so to speak, to the mainstream of symbolistic art. Before coming to these works, however, it is appropriate to turn across to Gauguin's work of 1889-90.

First, when Gauguin re-uses images of his at this time, they take on, in his case too, an increasingly schematic character. A good illustration of this is the image of the *Woman in the Waves*. It can be traced back to the 1888 image of the *Woman* *Pl. 123* in the *Hay* with pigs around her. There is, then, in 1889, a transference from farmyard to sea. And when the image is re-used in the painting on silk, *Nirvana*, which probably dates from 1890, one can see exactly what happens to the character of the contour-lines. Furthermore, when a major motif of this kind is re-used, it tends to have a more specific associative value *Pls. VIII, 38* attached to it. In the *Self-portrait with the 'Yellow Christ'*, *Pl. 4* probably from the last months of 1889, the *Yellow Christ* becomes even more concretely an image of suffering and with-drawal from the world.

Pl. 194 Finally, in such a work as the *Self-portrait with a Halo*, probably also from the very end of 1889, there is a yoking to-gether of heterogeneous images—the halo, apples on a branch, a single leaf, the head of Gauguin, lily fronds and one hand. With this there goes a new hardening of contour, each image being cut off from its neighbours by its outline, and the use of an even, plain-coloured background, in this case half red and half yellow.

The stimulus of Odilon Redon's prints of the earlier eighties seems to have played a key part in Gauguin's arrival at this yoking together of images against an undefined matrix. A typical example of a relevant print of Redon's is the plate which *Pl. 191* formed the frontispiece to his *Origines*, published in 1883. It *Pl. 195* can be put alongside Gauguin's *Portrait of Moréas* of 1890-1. Redon combines a skull, an eye, an ogreish head and an adumbration of a female figure, and Gauguin similarly com-bines the top half of a cherub, peacocks' tails, a scroll and the head of his subject. The process of combination, furthermore, brings with it spatial and material ambiguities of the same general kind as are found in the Redon.

In the light of this development by Gauguin, towards 1890, his wood relief of that year, *Be Mysterious*, can be characterized as a woven combination of images. The elements consist of a full figure, a head and a head and shoulders, and fronds which might be water or seaweed, pulled together by the force of contour and by the uniformity of the coloured background. A *Pl. 196* comparable schematization of form and contour is found in Seurat's *Woman Powdering Herself* of 1889-90. And it is very *Pl. 192* relevant that, where the wall-mirror is now in this painting, there was originally the head of Seurat himself looking in, but staring straight ahead. The two images, that of Seurat and that of his mistress, were, it seems, simply juxtaposed, without any interrelationship of scale between them, and without any psychological cohesion either. And then there are the canvases of van Gogh's from the summer of 1890 in which he used a background of meadow or wheat. As noted in an earlier chapter,[22] there are independent paintings which came first and deal simply and solely in this imagery. The wheat there *Pl. 67* occupies the whole of the canvas space, with ears, stalks and leaves woven into a kind of tapestried unity. Van Gogh then superimposed figures of young girls and children without any *Pl. 68* complete reconciliation as regards the angle of vision.

In the *Child with an Orange* there is not only a background of *Pl. 197* this kind, but also a discrepancy of scale in the size of the child's head and the size of the orange. The child, rather than sitting in the field, seems to be supported by it, and her hold on the orange appears expressive of appreciation while at the same time none too secure. The colours are light and fresh, yet pungent. It is in fact impossible to be precise about the way in which this painting works as a portrayal of the character of childhood. But one might say that just because there is no completely rational continuity between the different parts of the image, everything therefore turns on the painting's total evocative power. In the same way, in Gauguin's wood relief, the evocation of feminine mystery works with an extraordinary powerfulness, without it being possible to say piece by piece how this comes to be so.

Both artists therefore arrived, in or around 1890, at a kind of image and structure equivalent to Carrière's *Big Sister* in its *Pl. 172* power of suggestiveness, although of course far superior in quality. They evolved for this purpose a new kind of pictorial organization which had a full maturity of artistic experience behind it, yet was at the same time basically experimental. And the parallel between them lies in the fact that both of them used for this purpose a weaving together of elements.

Though it is appropriate to end here with this second stage of symbolistic art, there would in fact be two further stages. The third stage, around 1895, would bring a spreading out of the composition sideways, in the manner of Puvis de Chavannes' mural paintings. The figures would now be all essentially alike, or at least belong recognizably to a single basic family. The space would now consist of a broad corridor running across parallel to the picture plane, and the figures would be disposed like poles within this space, so that form and interval counted equally in the lateral orchestration of the picture. The structure as a whole equally tended to be stiff, static and hieratic, with a strong assertion of geometric or decorative symmetry about an axis.[23]

As for the fourth stage, around 1900, this reflects the other side of Puvis' art: his view of civilization. A world beyond time is conjured up by the way in which the figures pose and interact with one another; and the artistic past is recollected in and through the figures' stature and physique. This past is really a whole tradition, with its roots in antiquity, the Renaissance or ancient Indian and Far Eastern art. The quintessential temper and mood of that tradition of rendering the human form are conjured up, by association, in a modern recreation.[24] In these terms, then, there is an associative synthesis of the old and the new.

The year 1890, however, marks a convenient break. At the time of the *Child with an Orange*, van Gogh's suicide was only a few weeks away; and Gauguin's departure for Tahiti was equally on the immediate horizon at the time when he did his

Pls. 196, 195

wood relief *Be Mysterious* and his *Portrait of Moréas*. By 1890, furthermore, parallels begin to appear between symbolistic art and the later poetry of Mallarmé. There is Mallarmé's complexity of syntax; there is the increasing emphasis on the individual image, at the expense of the rational continuity of the poem as a whole; there is the counterpoint between phrases in the different parts of the poem; there is the role of allusion and suggestion; and the result that, as Mallarmé put it, 'the memory of the object named is bathed in a new atmosphere'.[25] Mallarmé, who had originally been a friend and associate of Manet's, was one of those who said a warm farewell to Gauguin when he left for Tahiti in 1891.[26] French painting of the new generation had turned by then in the same general direction as Mallarmé's own poetry.[27]

Postscript

To turn from the 1880s to the first fifteen years of this century, when van Gogh and Gauguin began to be rediscovered, and to consider what their example meant then, is to find that it had both a specific and a wider importance.

On the one hand, that is, certain works by the Fauves and the artists of the Brücke have features which can be compared, in a precise sense, with those of a particular phase in van Gogh's or Gauguin's art. Exhibition records and early reproductions provide a supporting framework for the making of such comparisons. These, accordingly, are cases where one can speak of a direct debt, in imagery, technique or structure. There are not, however, many such works; and they come typically in rather scattered, and even isolated, positions within the development of the artists in question. On this basis, then, one would have to conclude that van Gogh's and Gauguin's influence was relatively limited. It may have played a key role at certain junctures; but whenever a concrete assimilation occurred, the artist immediately branched out from it on his own.

The wider importance, on the other hand, has to be differently defined. The point here is not what van Gogh and Gauguin had done, in any one work or group of works, but the way they had shown of doing things. And it was not only their canvases or graphics which counted in this connection. More generally, there was the whole shape which their creativity had taken, and its dynamically appealing character. The legends of their lives, and the early texts which built up and enshrined these legends, were at least as important here as the works themselves. And the study of the latter typically involved a reading into them of what the legend already suggested.

When van Gogh's and Gauguin's example is looked at in this more general aspect, there are three main points about the nature of their contribution which stand out. First, they had shown how artists of the same generation, while maintaining their independence, could have temporary and fruitful contacts with one another and with the contemporary literary scene. These contacts could serve as a guarantee against isolation; they could enhance and clarify one's sense of purpose, without being a source of influence; and they could keep one abreast of

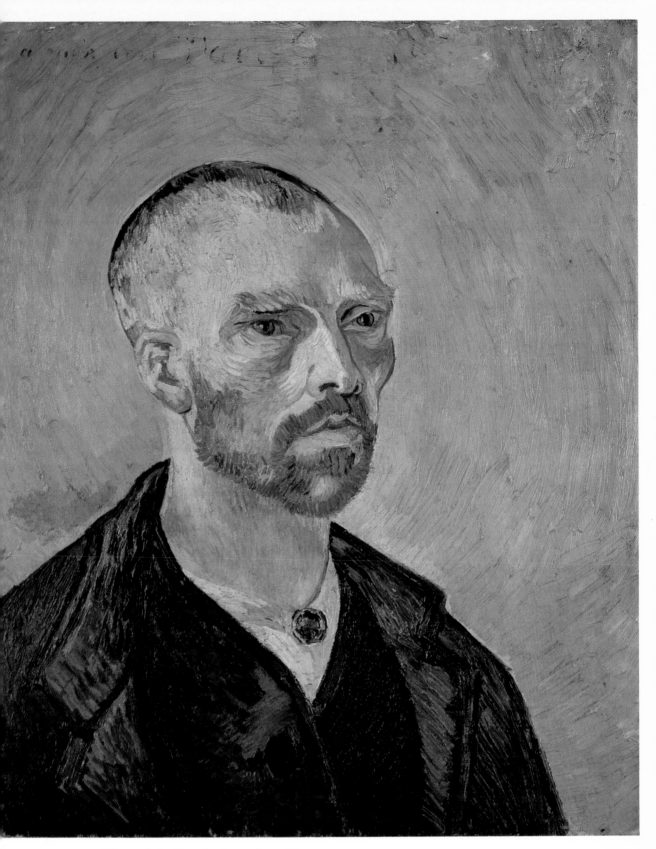

VII VAN GOGH *Self-portrait for Gauguin*. September 1888

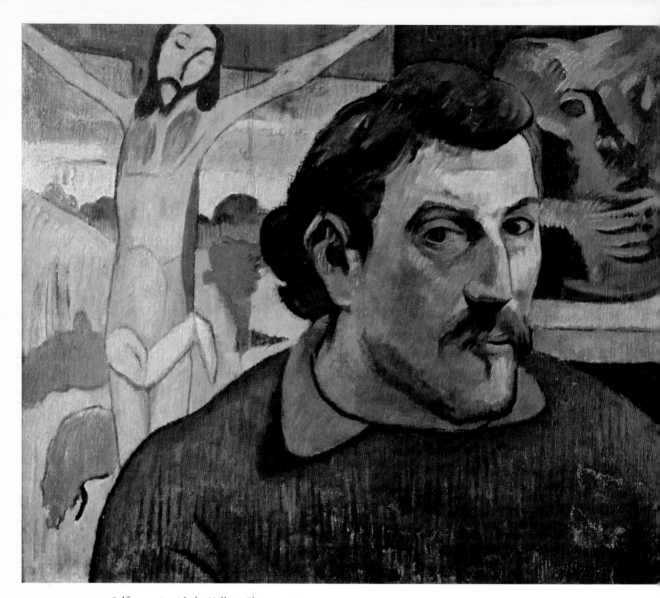

VIII GAUGUIN *Self-portrait with the Yellow Christ c.* 1889

the developments and ideas of others which paralleled those one was reaching towards oneself. The formation of loose groups and associations, which fell short of constituting a movement, but were based on like-minded premises, appeared as a natural answer to these desires, and indeed to the whole situation of the modern artist during the years in question.

Then, secondly, van Gogh and Gauguin had traced out certain ways of building upon existing art, which involved no mere imitation or direct dependence, but rather inherently stressed one's own individuality. They had shown how the art of one's immediate predecessors could serve as a springboard in terms of imagery, or be invoked in one's work in a purely referential way. And they had equally shown how, in drawing on the art of a remote, exotic culture, one could pass naturally and logically on from an associative use of that art to the forging of a structural equivalent of one's own.

Finally, van Gogh and Gauguin had shown how a modern pictorial image could work as a suggestive entity—without being literary, or requiring that the artist provide his own exegesis. Through the very way in which it was organized and presented, that is, the image could take on certain broad and emotive connotations, which emanated from its presence and its key components and communicated themselves to the spectator. Like the other two contributions, this last one too summed up and crystallized, in the clearest of forms, what had been set well on foot by Delacroix, Courbet and Manet.

All the major artists of the early twentieth century—Picasso, Matisse, Kirchner, Klee—went through corresponding stages in their own early work, between 1900 and 1914.

The groups to which the last three belonged, or led, are part of history: the Fauves, the Brücke, the Blaue Reiter—brief alliances in the longer perspective of these men's art, but crucial at the time in terms of the sharing of principles; and Picasso's association with Braque in the creation of cubism is a special case of a give-and-take relationship, amounting to a virtual partnership.

Points of reference and departure for these four in the art immediately preceding include the work of Cézanne and van Gogh and Gauguin themselves, as it became accessible. Fauve art was used in a similar way by Kirchner; Parisian Cubism by Klee. And primitive art (African in the case of Picasso and Matisse's sculpture, Oceanic with Kirchner, folk art in the case of Klee) was for them what the Japanese print was for the artists of the 1880s, with a like progression of attitude and assimilation.

And again, each had a 'symbolistic' stage, or more than one, in his early development: Picasso in his Blue and Rose periods (with surviving elements thereafter up to 1908), Matisse in his idyllic subjects of 1905-6, Kirchner in his 1911 paintings of women who are like fertility goddesses in their pure emanation of sexuality, and Klee in his drawings of just before World War I, in which he moved away from both the overweighted literariness of his early satirical etchings, and from descriptive naturalism.

These were phases which, once passed through, left each man free as both a completely formed and a fully independent artist. And in passing through such phases and associations before attaining to that full freedom, these artists were recapitulating the patterns of development which have been traced in this book.

Notes on the Text

To avoid a vast number of notes dealing with questions of dating and documentation, I have confined myself here to sources for quotations and points of fact, cross-references and a few supplementary or explanatory comments. Secondary sources will be found in the Bibliography.

Letters of Vincent van Gogh

Numbers without prefix: letters to the artist's brother Theo

Numbers preceded by	B:	letters to Bernard
	R:	letters to van Rappard
	T:	letters from Theo
	W:	letters to the artist's sister Wil

VB — *Verzamelde Brieven van Vincent van Gogh* 4 vols. in 2, Amsterdam-Antwerp, 1955.

CL — *The Complete Letters of Vincent van Gogh* 3 vols., London-New York, 1958.

Letter-numbers are cited in accordance with the numbering in those standard editions.

Letters and other writings of Gauguin

A & A — *Avant et Après*, Paris, 1923 ed.

M (followed by a number) — Letters to his wife and friends, as collected and numbered in *Lettres de Gauguin à sa femme et ses amis,* ed. M. Malingue, Paris, 2nd ed., 1949.

Mon. (followed by a number) — Letters to De Monfried as collected and numbered in *Lettres de Gauguin à Daniel de Monfried,* ed. A. Joly-Segalen, Paris, 1950.

Texts by Rewald

Imp. — *The History of Impressionism,* New York, 2nd ed., 1961.

P-I — *Post-Impressionism from Van Gogh to Gauguin.* New York, 2nd ed., 1962.

Fuller bibliographical details in all of these cases will be found in the opening section of the Bibliography. Further abbreviations, used in the

appendices, are given there, in the entries for each individual artist. All other references in the footnotes are given in full, the first time they are cited in each chapter.

Translations are my own throughout.

1 Impressionism

1 I mean that the main colours (e.g. pink, purple and orange) are not ones that one normally thinks of as governing a large section of landscape, so that they have a collective element of artificiality, when used to this extent.

2 See *Imp.* p. 456.

3 E.g. the *Entrance to a Village* in the Boston Museum.

4 See 563.

5 See 459a, W4. A passage in 371 shows that van Gogh had heard about impressionism from his brother by June 1884, but could not quite grasp its character; and one in R57, written from Nuenen in Sept. 1885, shows that he first heard of Monet then, from what his brother told him on a visit.

6 C. Chassé, *Gauguin et Le Groupe de Pont-Aven*, 1921, p. 72, recording what Sérusier had told him.

7 I have in mind a kind of parody which—in contradistinction to the usual use of the term—is serious rather than humorous in intention. A rough analogy would be the relationship of the Black Mass to the Mass proper. And it is interesting in this connection that the descriptions that one has of services involving such an element of parody are themselves a late nineteenth-century phenomenon —owed to imaginative writers of that time; see H. T. F. Rhodes, *The Satanic Mass*, 1954, pp. 76, 153, 160f., 168f.

8 The course of Gauguin's personal relationship with Degas is discussed in Appendix A.

9 See 462 (as noted in *CL*, this letter is to be dated to the late summer or autumn of 1886, rather than 1887; the reference to Cormon's studio implies that van Gogh had left it only recently).

10 552.

11 See 497.

12 See 635.

13 See 623.

14 M65.

15 A notable later use of the same idea is seen in Matisse's interiors of the 1920s.

2 The Japanese Print and French Painting in the 1880s

1 Both terms were already used, with the meanings they are given here, in the late 1870s and 1880s. For Japonaiserie, see the de Goncourts' *Journal* for 23 Feb., 1878 and cf. van Gogh's quotation in 437, written from Antwerp at the end of 1885, of the de Goncourts' saying 'Japonaiserie for ever'. For Japonisme, see the entry in the *Journal* for 19 Apr. 1884, and cf. van Gogh's letter 500 (June 1888). E. Littré, *Dictionnaire de la Langue Française*, supplément, 1883, labels Japonisme a neologism and cites a use of it by E. Bergerat in Dec. 1876.

2 See L. Bénédite, 'Whistler', *Gazette des Beaux Arts*, Aug. 1905, pp. 142f., and W. L. Schwartz, 'The Priority of the de Goncourts' Discovery of Japanese Art', *Publications of the Modern Language Association of America*, 42, 1927, pp. 798ff.

3 Philippe Burty, Ernest Chesneau. I draw in what follows on the summary by Thirion (1961; see Bibl.).

4 An excellent account of this whole development is given by Théodore Duret (who was involved in it), in his introduction to the exhibition catalogue, *Livres et Albums Illustrés de Japon*, Bibliothèque Nationale, Paris, pp. i–ix. The names of the leading researchers—Louis Gonse, Duret himself, William Anderson in London, along with the dealers Hayashi and Bing—are all given there. In their *Journal* for 28 Dec. 1885 the de Goncourts reported that they had been shown by Hayashi the first real Hokusai drawings that they had seen.

5 Felix Buhot's title-page etching of 1883, *Japonisme,* is also paradoxically revealing in this connection. The title here refers to the fact that the nine etchings which follow reproduce Japanese objects in the collection of Philippe Burty; but at the same time the front page itself, with its crane and Japanese characters and vase with a kind of salamander round it, is a pure piece of Japonaiserie.

6 See for this exhibition Louis Gonse's two-volume publication of 1883, *L'Art Japonais*, which was put together and issued in connection with it; it goes through to Hokusai and his contemporaries.

7 M66.

8 See T16.

9 Toulouse-Lautrec's *At the Cirque Fernando,* of about 1888, is another work which has corresponding features.

10 See 351a (to Furnée, Jan. 1884) and 437.

11 See 510 and W3. A large number of prints (as yet unsorted) from the holdings of the two brothers are preserved in the collection of the Engineer van Gogh, Laren. But since their collection here was a joint one, there is no way of knowing which prints were acquired while Vincent was in Paris; nor which ones were taken by him to Arles (see 480, W4) or sent to him later by Theo (540).

12 Cf. 540, B18 for van Gogh's idea that the Japanese artists lived this way.

13 E.g. the *Hillside near Vichy* of about 1866 in the César de Hauke bequest.

14 See Appendix B, where specific passages are compared.

15 See especially 509. He read this book in June 1888 (B7, W4), and his use of the terms *mousmé* (514) and *bonze* (544a, 545) came from there.

16 See M75.

17 See 540.

18 590.

19 542, B18; 590.

20 643.

21 The two sides of the interest in Japan are also interestingly combined in G. H. Breitner's Japanese pieces of the nineties—for example, *The Earring*, a work of very high quality.

3 The Importance of Seurat and his Theory

1 539.

2 The quoted phrase here is from M68; and cf. 528. Gauguin was characteristically derogatory about Signac and the other followers, rather than about Seurat himself (cf. M74, 127); and van Gogh, while he liked Signac's work well enough (B1, 539), had no doubt that Seurat was the leader (see 500).

3 *Lettres à Son Fils Lucien,* ed. J. Rewald, 1950, p. 51.

4 W4.

5 Félix Fénéon, Gustave Kahn, Emile Verhaeren.

6 See *Imp.* p. 541 and *P-I*, p. 477.

7 See 544a, 553. According to a letter from Seurat to Beauborg of Aug.

1890 (R. Rey, La *Renaissance du Sentiment Classique*, 1931, opp. p. 132) he and van Gogh had first spoken together at the exhibition organized by van Gogh in 1887 in a hall on the Avenue de Clichy (cf. for this exhibition and its date Chapter 4, n.33).

8 See 543 (on the *Starry Night over the Rhône*).

9 'Georges Seurat', *L'Art Dans Les Deux Mondes*, 18 Apr. 1891. The quotation that follows is from p. 263.

10 The details that follow are taken from Homer (see Bibl.), who cites the full evidence in each case.

11 429.

12 See 401, R58 and 428, where van Gogh said that he would send Blanc's book on to his brother. He had bought it in August 1884 (R47). Silvestre's *Eugène Delacroix, Documents Nouveaux* had first appeared, under the pseudonym 'Th. Rambler', in three separate issues of the *Figaro* (14, 21, 25 Feb. 1864). This explains why van Gogh referred twice over to Silvestre's 'article' (R58, B13). In 558a, however, he referred unequivocally to a 'book'; so evidently he had in fact read the publication in book form.

13 531, 539, 554-5; cf. also W7 (second part) and W9 of late November.

In 539 van Gogh stated that the colour-music question had interested him previously, at Nuenen; this is implied by the phraseology in 429, and cf. the second-hand report of D. Gestel, 435b.

14 571a, 576 (on the *Woman rocking a Cradle*); W15 (on the *Bedroom*).

15 633.

16 584a. The publication in question was Henry's *Rapporteur Esthétique* (1888-9).

17 See 474.

18 B14 (written in August, before Bernard joined Gauguin).

19 See W3, 494, 542.

20 605, 607, 613.

21 T29.

22 595, 605.

23 595, 607, 613. Cf. in this connection the passage in W9, written when Gauguin was at Arles, about 'bizarre lines, sought and multiplied, meandering through the picture' (the *Memory of the Garden at Etten*, discussed in Chapter 5).

24 See 614-5, B21.

25 See Appendix D for a review of the questions concerning this text, which appears at *A & A* pp. 55ff.

26 J. Rewald, *Gauguin*, 1938, Appendix; *Paul Gauguin, Carnet de Croquis*, ed. R. Cogniat-J. Rewald, Hammer Galleries, New York, 1962 (facsimile of ms.), pp. 2-12. The date of this text and the indications there that Gauguin had studied Blanc are discussed in Appendix C.

27 Rewald, introdn. to *Paul Gauguin, Carnet de Croquis*, 1962, pp. 44ff. (extracts, the second of which appears in trans. at *Imp.* pp. 494ff.); M11 (the text of which is to be compared, for purposes of reliability, with the one printed in A. Alexandre, *Paul Gauguin*, 1930, pp. 46ff.).

28 M22.

29 This date is deduced from the fact that they fell out early in the summer of 1886—at which time they were expecting to show at the Indépendants together; see Gauguin's letter to Signac, *P-I* p. 41, and Pissarro's to his son of June and of 3 Dec. that year (ed. Rewald, English trans., 1943, pp. 77, 82).

30 *A & A* p. 31; Fénéon, 'VIIIe Exposition Impressioniste', *La Vogue*, 15 June 1886 (reprinted in *Au-Delà de L'Impressionisme*, ed, F. Cachin, 1966, p. 67).

31 'La Vie Artistique', *La Vie Moderne,* 9, 9 Apr. 1887, p. 229 (cited in R. Herbert, *Seurat's Drawing,* 1962, p. 228). Cf. also Fénéon's use of the corresponding verb 'to synthetize' the next month. ('Le Néo-impressionisme', *L'Art Moderne,* 1 May, 1887; Cachin p. 92).

32 In his essay 'Le Peintre de la Vie Moderne'; *Œuvres Complètes,* Pleiade ed., 1963, p. 1166. See also p. 1033 ('Salon de 1859').

33 He referred to them in his article 'Notes sur L'Art à L'Exposition Universelle', *Le Moderniste,* 4 June 1889, p. 86 (the passage is cited in M. Bodelsen, *Gauguin's Ceramics,* 1964, p. 186).

34 See n. 29 above.

35 See n. 2 above.

36 'Un Autre Groupe Impressioniste', *La Cravache,* 6 July, 1889; Cachin pp. 109f.

37 See 564. De Musset had actually written (*La Nuit de Décembre,* stanza 18) 'sat in my way' and 'resembled me like a brother'.

38 Extract from a letter, published by Alexandre, *Paul Gauguin,* 1930, p. 48; see Appendix F.

39 See especially here his remarks on *The Spirit of the Dead Watches* of 1892 (cited in J. de Rotonchamp, *Paul Gauguin,* 1925 ed., p. 253); his article on Armand Séguin, *Mercure de France,* 13, Feb. 1895, p. 222; and the passage about the music of colour in M170 of March 1899. A clear case of Gauguin's adopting the language of the Symbolist poets is his letter to Degas of June 1896 (published in *Conferencia,* 29, 1934-35, pp. 375ff.).

4 Van Gogh, Gauguin and Emile Bernard

1 See Appendix E for this date; and for the other facts mentioned in this paragraph, *P-I* pp. 39, 191f.

2 See Bibl. for this chapter.

3 See *P-I* pp. 476f.

4 See again the Bibl. for these writings and the later ones of Bernard's mentioned below.

5 M171; see also Mon. 55.

6 M176. Gauguin's behaviour towards Fontainas is discussed in detail in Appendix G.

7 See Bibl.

8 This point has never been set out in print, but it has been generally recognized by students of the period since about 1956, when Rewald published, in the first ed. of *P-I*, a small anthology of Bernard's paintings of the late eighties and nineties. There have been Bernard exhibitions since that date which have made the point even clearer.

9 Technical examination of the *Portrait of his Grandmother* in the Boston Museum, dated 1887, strongly suggests that this is the case there; extensive overpainting was detected in the dress collar, left shoulder and cap.

10 B21.

11 Writing to Schuffenecker from Arles in Nov. 1888, Gauguin asked that his Degas etchings be sent to him from Paris: C. Roger-Marx, 'Lettres inédites de Vincent van Gogh et de Paul Gauguin', *Europe,* 15 Feb. 1939, p. 171.

12 See especially *Mlle Fiocre in the Ballet 'La Source'* (1866-7).

13 545, B19.

14 Gauguin himself, in describing this work of his, wrote of the 'chamber of a pure young girl' and the 'delicately maidenly background with its childlike flowers' (see M71 and his letter to van Gogh partially published in trans., *P-I* p. 211).

15 See 538-9, 544.

16 557, 558a, W16; B21.

17 *Mercure de France,* Dec. 1903, pp. 679f.

18 B14.

19 In B12.

20 Letter partially published in trans., *P-I* p. 202.

21 Chapter 2, p. 79.

22 *A & A* p. 117 (section dated 20 Jan. 1903).

23 See van Gogh's report in B14 of early August that Bernard was 'currently examining the methods of the Italian and German primitives.' The label 'primitive' was applied at that time to fifteenth-century art, both Italian and Northern.

24 See Chapter 5, p. 140.

25 See E. Bernard, 'Vincent van Gogh', *Mercure de France*, Apr. 1893, p. 338, and B1.

26 'Louis Anquetin', *Gazette des Beaux Arts*, 11, 1934, pp. 113f.

27 500, 510.

28 'Aux XX et aux Indépendants—Le Cloisonisme', *Revue Indépendante*, 6, Mar. 1888, pp. 487ff.

29 500.

30 *A & A* pp. 49ff.

31 B10, 528.

32 B7.

33 See 498, 511, B19; for the exhibition see Bernard's account of 1889, *P-I* pp. 67f. It was in a large hall, used as a restaurant, close to La Fourche, the junction of the Boulevard de Clichy with the Avenue de Saint-Ouen. The assumption that van Gogh had previously organized a group exhibition at the Café Tambourin, with Bernard and Anquetin participating, appears mistaken. After showing Japanese prints there some time in the first half of 1887, and then works of his own, he evidently had such a plan. But a quarrel followed between him and the proprietress, La Segatori (see 461-2, from the summer), and this presumably led on to his choosing the hall subsequently as an alternative place. As to when the exhibition there took place, the reference in 510 to how an exchange with Gauguin had come out of 'the second exhibition in the hall (*salle*) on the Boulevard de Clichy'—clearly this exhibition—is to be taken as meaning, not that Gauguin participated, but rather that he paid it a visit; and the exchange was almost certainly the one referred to retrospectively in 571, two Paris *Sunflowers* of van Gogh's for a Martinique landscape of Gauguin's, so that this would then mean that the exhibition came on towards the end of 1887, with Gauguin visiting it after his return from Martinique in November. B1, with its reference to what had been started in the *salle*, is to be re-dated correspondingly to late 1887.

34 F. Fénéon, 'Un Autre Groupe Impressioniste', *La Cravache*, 6 July 1889 (reprinted in *Au-Dèlà de l' Impressionisme*, ed. F. Cachin, 1966, p. 110). For Gauguin's reaction see M91 (of Dec. rather than Nov. 1889. His responses to what Fénéon wrote about him are discussed further in Appendix G.

35 Cf. here Chapter I, p. 45.

36 B14, W16.

37 W16.

38 B14, 478.

39 See B3 and 480 (dated by Hulsker around May 1).

40 See 511 and B10 (mid July); B11 (late July).

41 The Engineer van Gogh, who inherited them from his mother, handed them over to the Print Dept. of the Stedelijk Museum a few years ago. I saw them there in the summer of 1963 and recognized that they were in fact the various drawings recorded as sent on to Theo. A number of them were then included, at my suggestion, in the 1966 Tate Gallery Exhibition, Gauguin and the Pont-Aven Group.

42 B5, postscript.

43 See Appendix E.

44 500.

45 474, B3.

46 B3 also.

47 See 502, B8-9; B12, 514.

48 B12.

49 539.

50 B17.

51 B19. See B16 for his earlier, more amicable denial to the same effect.

52 *Ibid.*

53 See Chapter 5, p. 145.

54 See Appendix E for this date.

55 What he wrote in this connection has in fact to be seen in context. It was only after the arrival of Gauguin's account of his self-portrait that van Gogh elaborated a similar interpretation of his own.

56 The last works he had seen were some of the Martinique paintings of 1887—in particular the *Mango-Pickers (Negresses)* purchased by Theo. See in this connection his recollective praise for that work in W5 and B5, and his anxious desire to find out what Gauguin had been doing in Brittany, as expressed in 550 of Oct.

5 Van Gogh and Gauguin at Arles

1 In *The Fire Dance*, 1891.

2 In Chapter IX (*Œuvres Complètes*, 13, Paris, 1928, p. 267); the metaphor of 'rebel painting', against which the artist has to battle, is similarly used in Chapters VI and VIII (pp. 160, 226).

3 Van Gogh produced about 25 paintings during this time, which closely matches his average production during the first ten months of the year; Gauguin about 17, as compared to upwards of 40 during his preceding 8 months in Brittany.

4 558b. The chronology of all the letters of this period is discussed in Appendix F.

5 543.

6 See the discussion of this in my article, 'Van Gogh's "Blue Cart" and his Creative Process', *Oud Holland*, 81, 1, 1966, pp. 7ff.

7 *A & A* p. 15. In an unpublished section of his first letter to Theo from Arles (known to me through the kindness of John Rewald; cf. Appendix F). Gauguin similarly wrote that it would take some time for him to get acquainted with the character of the countryside.

8 558b.

9 73×92 cm. (about 28×36 ins).

10 Cf. here van Gogh's comments on the suppression of shadow in 554 of Oct. and 559 of Nov.; and Gauguin's corresponding comment in M75 to Bernard, of the end of Oct.

11 It is interesting that, in connection with Gauguin's coming, van Gogh turned towards the 'older culture' of Provence, 'sleeping underneath all the modernity' (544a to Gauguin; cf. also 539, 542). True, however, to his earlier reaction to the portico of Sainte-Trophime—'so cruel, so monstrous, like a Chinese nightmare', though he was beginning to find it admirable in its way (470 of March)—he did not paint the older monuments of Arles, apart from the one case of the Alyscamps.

12 B19.

13 559.

14 Letter B23 in *Vincent van Gogh— Letters to Emile Bernard*, ed. D. Lord, 1938.

15 559.

16 558.

17 Chapter 2, pp. 82-3.

18 B14. The female portrait was that of *Mme Puvis* (the Princesse Cantacuzène).

19 See M75.

20 Van Gogh later remembered how, in discussing Degas with Gauguin, he had quoted Degas as having said

'I am saving myself up for the Arlesian women' (570).

21 559.

22 See Chapter 4, p. 127. Bernard had supposed, from the description of the *Night Café* which van Gogh sent him soon after it was completed, that the painting represented a brothel; presumably this was because of his own interest in brothel subjects at the time (B16; cf. also 502, B9 of June). In B16 and 19 van Gogh had denied this, first amicably and then with increasing indignation; as he put it elsewhere, his subject had simply been 'a low public house' where night prowlers took refuge (518, 534). Firm as he might be on this point, however, he was also conscious of having failed to produce any treatment of a real brothel to rival those of Bernard. As described in Chapter 4, he had actually gone on to attempt, from memory, a little canvas of a scene in a brothel— but only in order to have something of the kind to send to Bernard; he wrote that he would have preferred not to paint it (at least this way) (B19, 548). All of this Gauguin was privy to, since Bernard was with him at the time. Furthermore, at the very time when Gauguin was completing his *Night Café*, van Gogh was stimulated to attempt another oil sketch of a brothel himself (see below) and hoped that this would develop into a corresponding painting of a finished kind (561). He was also very sensitive to Gauguin's immediate success with the Arlesian women (558, 560).

23 W9.

24 See 561–2 and B21.

25 In W9.

26 W9.

27 See M68 and 74.

28 *A & A* p. 17.

29 558a, 560.

30 *A & A* p.18.

31 F454, H468.

32 558a, 560.

33 *Le Carnet de Paul Gauguin*, ed R. Huyghe, 1952 (facsimile), p. 72.

34 560.

35 555.

36 See 560. For the date of Dec. 23 for van Gogh's breakdown, see Appendix E.

37 Two other works to be mentioned here are a drawing of children (*Pl. 155*) which has a distinct claim to being by Gauguin, and if so, was most probably done at this time; and van Gogh's *Boy with a Cap* which may well represent still another December portrait of his.

38 This comes out in an unpublished section of Gauguin's second December letter to Theo van Gogh (known to me through the kindness of John Rewald), and also in his contemporary letter to Schuffenecker (A. Alexandre, *Paul Gauguin*, 1930, p. 92); see Appendix F for these letters.

39 See 564. Gauguin made a little sketch of Delacroix's *Portrait of Bruyas* in his notebook (p. 57). Cf. also *A & A* pp. 220ff: Gauguin's account of what he had seen on an earlier visit to the museum (probably in 1883) presumably also involves memories of the 1888 visit— which is contrasted—in terms of the major paintings mentioned.

40 See 574 (and cf. 558b).

41 See Appendix F for this letter.

42 See 543.

Coda

1 What happened in December is gone over in Appendix E.

2 I have adapted here a phrase used by Freud in discussing retrospectively his own relationship with Wilhelm Fleiss (Ernest Jones, *The Life and Work of Sigmund Freud*, abridged

ed., London, 1961, p. 202). I am grateful to Professor George Goethals of Harvard for directing my attention to this relationship; as described by Jones (ch. 13) it contains a number of remarkable parallels.

3 M75.

4 M78.

5 In support of this interpretation, there is an equally strong correlation at other periods between Gauguin's view of Degas' art and the state of the relationship between the two men; see Appendix A on this point.

6 *A & A* p. 16.

7 429 (and cf. 519 of Aug. 1888).

8 See Chapter 5, n. 39.

9 See Chapter 5, n. 10, and also 510.

10 403.

11 403, R58.

12 615, B21. See 614 for the visit to Arles.

13 A letter from van Gogh to Gauguin, which is not in *CL*, is to be added to the record here. Kept by Gauguin, it was published by J. de Rotonchamp (*Paul Gauguin*, 1906, pp. 57ff.); it is to be dated from its content around 23 Jan. 1889. See also, at *A & A* p. 13, what purports to be an extract from a letter of van Gogh's, advising Gauguin to consult a mental specialist. This is probably from a genuine letter which Gauguin had similarly kept —but one written from Arles early in 1889, rather than from Saint-Rémy, as Gauguin stated, since there is an exactly similar comment in 571.

14 626a.

15 See *P-I* p. 386, n. 67.

16 *A & A* p. 24.

17 M113.

18 'Natures Mortes', *Essais d'Art Libre*, 4, pp. 273 ff.

19 Louvre MS. RF 7259, pp. 261f.; published by Rotonchamp, 1906, pp. 48f.

20 Mon. 30.

21 The details of Gauguin's relationship with Fontainas, the arguments which he used in correspondence with the critic, and the background here of his reactions to earlier critical comment on his work, are gone over in Appendix G. They show a side of Gauguin's character which has not previously been brought out.

22 M176.

23 See especially the section 'Les crevettes roses' (pp. 42ff.).

6 Towards Symbolistic Art

1 The German word *symbolistiche*, as used by K. Badt in *Die Kunst Cézannes*, 1956, has a somewhat different meaning.

2 Chapter 4, p. 100.

3 'Le Symbolisme', *Figaro Littéraire*, 18 Sept. 1886 (partially published in trans., *P-I* pp. 147f.)

4 It also excludes cases where the allusion, if it exists, is of a purely private character. A good example of this is van Gogh's *Two Crabs* of early 1889. It has been suggested that the crab on his back there represents van Gogh after his breakdown, and the one sidling away Gauguin. It was, on the other hand, noted in an earlier chapter (2, p. 83) that the subject of crabs was probably suggested by a Hokusai reproduction. One could not deduce the other reading from the work itself, without outside information.

5 *The Balcony Room* (1845).

6 The description of Catherine Linton in Chapter xv of *Wuthering Heights* (published in 1847) is strikingly a propos here. It represents a characterization of illness of exactly the kind in question. It also includes the

elements of window and breeze from outside.

7 The evidence suggesting this is brought together and discussed in Appendix H.

8 See especially his letter to his son of 20 Nov. 1883 (*Lettres à Son Fils Lucien*, ed. J. Rewald, 1950, p. 68).

9 Letters of 28 Dec. 1883 and 10 Feb. 1884 (*ibid.* pp. 73, 78). Renoir did drawings for the weekly in question from 1879 to 1884 (see J. Rewald, 'Auguste Renoir and his Brother', *Gazette des Beaux Arts*, 27, 1945, pp. 171ff).

10 P. Valery, 'Je Disais Quelquefois à Stephane Mallarmé' (1932), *Variété III*, 1936, p. 9. I owe my knowledge of this passage to the late Professor Renato Poggioli.

11 See his letters of 28 Feb. and 13 June 1883 (*Lettres*, pp. 33, 50).

12 Discussed in Chapter I (pp. 11ff.).

13 482, 525 (May and Aug. 1888). For Monet's admiration for Gauguin's *Vision*, see Octave Mirbeau's letter to him of Jan. 1891 ('Lettres à Claude Monet', *Cahiers D'Aujourd'hui*, no. 9, 1922; cited in trans., *P-I*, p. 472).

14 In 1882 he chose subjects for lithographs which expressed the basic human emotions of grief and weariness—calling them respectively *Sorrow* and *At Eternity's Gate*. And this choice brings out another, complementary side of the background here: namely the strong appeal to van Gogh of the language used by the popular illustrators for portraying such emotions, especially on the part of the poor and underprivileged. Van Gogh's comments in his letters represent a reading in on this basis. In other words he was already thinking symbolistically at that time; but there are not as yet any corresponding features in the works themselves.

15 See 220 and 252, of 1882.

16 Gauguin had earlier copied Delacroix's *Aline the Mulatto Woman* at the Montpellier Museum —most probably in 1883.

17 She was apparently a music teacher.

18 *Carnet de Croquis*, ed. R. Cogniat-J. Rewald, Hammer Galleries, 1962 (facsimile), pp. 56, 58, 77, 94; *Carnet*, ed. R. Huyghe, 1952 (facsimile), pp. 12 (bottom), 22ff., 157, 171.

19 See especially—for early examples here—*The Three Jovial Huntsmen*, 1880, p. 10; '*Graphic*' *Pictures*, 1883, p. 64 ('Mr Carlyon's Christmas', published in Dec. 1881); and *The Hey Diddle Diddle Picture Book*, 1883, p. 23 ('The Fox Jumps Over the Parson's Gate'). All these books were published by Routledge of London. I was conveniently able to consult the collection of first editions in the Houghton Library, Harvard University. Gauguin's admiration for Caldecott's work is recorded in the memoirs of the English artist A. S. Hartrick (who met Gauguin in 1886): *A Painter's Pilgrimage Through Fifty Years*, 1939, p. 33. In letters to van Rappard of 1882-3 van Gogh expressed a similar admiration for Caldecott's illustrations (R15-16, 21, 37-8; and cf. 267).

20 He dedicated a still-life to him.

21 It is interesting to compare here the admiration which Vincent expressed in August 1888 for an early Manet of *Peonies* which he had seen in Paris—evidently the painting of this subject now in the Louvre; and his memory a month later of paintings of gardens by Manet—evidently those of 1880-2 (528-9, 539). Theo owned a great many Manet prints (now incorporated into the Theo van Gogh colln. at the Stedelijk Museum, Amsterdam).

22 Chapter 2, p. 84.

23 See especially Gauguin's *Day of the God* (1894) and *Delightful Day* (1896); Hodler's *Eurythmia* (1894-5); and Munch's *Dance of Life* (1899-1900). The time-lag of some five years in Munch's case continues to apply after 1890 as well; between 1892 and 1908 this artist lived mainly in Germany.

24 See especially Gauguin's *Two Tahitian Women* (1899) and *The Gold of Their Bodies* (1901); Hodler's *Day* (1898-1901); and Munch's so-called *Death of Marat* (1907; cf. the preceding note).

25 Foreword to René Ghil's *Traité du Verbe*, 1886; re-used subsequently in the chapter in Mallarmé's *Divagations* of 1897 entitled *Crise de Vers* (*Œuvres Complètes*, Pleiade ed., 1956, pp. 368, 858; see p. 1574 there for the dating of the various earlier pieces and articles used in the assembling of that chapter).

26 See Mallarmé's speech at the farewell banquet of 23 Mar. (*Mercure de France*, May 1891, p. 318), and the letter of his to Gauguin published by de Rotonchamp, *Paul Gauguin*, 1906, p. 80.

27 A summarizing definition of what is meant by symbolistic art may seem called for here, and I would suggest the following: A gathering of images which, by virtue of association and/or organization, collectively carry suggestive power.

Clearly this definition has points in common with what was said by contemporary theorists and critics about Symbolism (with a capital **S**) in painting. But at the same time their formulations, and ones based on them since, apply much more directly and concretely to the art of Denis, Sérusier and Bernard in the early 1890s than to the works considered here (as is brought out by the article of A. A. Wallis, 'The Symbolist Painters of 1890', *Marsyas*, 1, 1941, pp. 117ff.). The esoteric, mystical and overweighted symbolism practised by those three forms, in fact, a minor and chronologically limited episode—a conceptual dead-end—within the total development of symbolistic art. That type of Symbolism was taken up by others outside France (e.g. in Belgium) in the 1890s, but there too it was short-lived and proved to have no lasting validity. (Cf. on this point the close of the review by Fénéon, 'Rose + Croix, *Le Chat Noir*', Mar. 18, 1892; Cachin, p. 131.) Symbolistic art, on the other hand, is relevant in rather obvious ways—actually stage by stage—to the young Picasso between 1901 and 1905; and in other ways too it forms a background to early twentieth-century art. That is one reason why a definition has to be general, and the discussion chronologically oriented.

Appendices

A. Gauguin and Degas: the personal relationship

In 1880 or early 1881 Degas acquired his first painting by Gauguin, the still-life *On the Chair*. This was by exchange—Gauguin probably received his Degas pastel of a *Dancer* in return. It was Degas, along with Pissarro, who had first invited Gauguin to show with the impressionists in 1879 (see *Imp.* p. 423); and it was an affirmation of his support for Gauguin's inclusion in the fifth and sixth exhibitions of 1880 and 1881 that the still-life was catalogued on the latter occasion as belonging to him (Venturi, *Archives*, II, p. 366, no. 34). Correspondingly, Gauguin's address appears in Degas' notebook of this period (Bibl. Nat. Dc. 327d réserve, Carnet 5, p. 1 bis; see Reff, *Burl. Mag.*, 1965, p. 615). By the end of 1881, however, Gauguin was ready to tender his resignation from the group to Pissarro, on the grounds that Degas had brought in more and more protégés of his—Raffaelli in particular—and had thereby, by stages, driven out the true impressionists (letter to Pissarro of 14 Dec. published in trans., *Imp.* p. 465). And Degas for his part, according to Eugène Manet (undated letter, *Correspondance de Berthe Morisot*, ed. D. Rouart, 1950, p. 111), refrained from participating in the seventh Impressionist exhibition, which opened in March 1882, because of this ill-will of Gauguin's towards him.

In the spring of 1885 Gauguin was equally sour towards Degas, accusing him of having 'greatly harmed our movement' by his continuing behaviour (letter to Pissarro published in trans., *Imp.* p. 493). And he appears to have deliberately made himself unpleasant to the older artist when the two of them met at Dieppe in September of that year (see M25 for the date of Gauguin's presence there). In the following year, after a quarrel with Seurat and Signac early in the summer, it was to Degas and his personal circle that Gauguin turned. He now saw Degas 'all the time' (see Pissarro's letter to his son of Nov. 1886, where the incident at Dieppe is referred to; *Letters*, ed. Rewald, 1943, pp. 81f.).

It was at about this time that Theo van Gogh began acting as Degas' dealer whenever he could manage it; and by 1888 he had evidently established a firm position for himself (see 483, T57). He held an exhibition of Degas' work at his gallery in February 1888, and at least one painting of Gauguin's was on view simultaneously. That summer Gauguin developed the idea of setting Theo up as a dealer in impressionist pictures (M65); and he moved to Arles largely in order to further his commercial relationship with Theo (see M73). When a one-man exhibition of his opened at Theo's gallery that November, and Degas expressed interest in buying a picture, and was said to be spreading the word enthusiastically about the exhibition as a whole (T3a), Gauguin wrote that he had 'the greatest confidence in Degas' judgement' (M68).

Then in the second half of 1889 the situation was reversed, with more or less simultaneous changes on both fronts. When Gauguin wrote to Bernard in September of that year: 'You know how I esteem what Degas does, and yet I sometimes feel that he lacks a sense of the beyond, a heart that stirs' (M87), his relationship with Theo van Gogh was entering a bad phase (see T16, M91, 95). The connection becomes clear two months later, when one finds Gauguin blaming Degas alongside the dealer for 'the whole collapse', and at the same time

saying that Degas did not like his paintings because he failed to find in them 'what he sees himself (the foul smell of the model)'. He also commented adversely to Schuffenecker at that time on Degas' slow rate of work (M92, 94).

Subsequently, at the auction-sale which Gauguin held in February 1891, Degas bought a painting, *La Belle Angèle* (W-C 315). He bought another from the Durand-Ruel exhibition of November 1893 (W-C 499), and he apparently defended Gauguin's art stoutly on that occasion (see M170, Mon. 82 and *A & A* p. 116). At the second auction-sale of February 1895 he went further and bought at least three more paintings (W-C 413, 440, 449). The breach in the relationship was thereby healed, and in June 1896 Gauguin wrote Degas a wildly fulsome letter of praise and gratitude. 'For the rest', he said there, 'you have understood that my art does not have a scientific character . . . and profoundly wise as you are, you are extremely indulgent on this subject. For, great artist that you are, you know that emotions and suffering are involved in art, that is to say passion' (a complete reversal of Gauguin's 1889 opinion). 'You understand what nobility means. In my isolation . . . I hold very much in mind your instruction, the instruction of your words, the noble and silent instruction which your art, so noble and lofty, carries; and also your example, *so unique* at this moment . . . You buy at the Hotel [Drouot auction-sales] whatever you find beautiful.' (Letter of June 10, *Conferencia*, 29, 1934-5, pp. 375f.)

Throughout all this, furthermore, Gauguin's respect for Degas as a person seems to have remained reasonably constant (see Mon. 46). The connection between his shifting view of Degas' art and the changing winds of the political situation is therefore all the more evident. And it is understandable in this light that at the end of 1888 there should have been a certain rivalry between Gauguin and Vincent for Degas' friendly esteem (cf. 564, where Vincent asked his brother to pass on a message to Degas).

B. Van Gogh's sources on Japanese art

In his first letter to his brother from Arles, giving his impressions of the countryside there, van Gogh wrote:

> And the landscapes in the snow, with the peaks white against a sky as luminous as the snow, were just like the winter landscapes that the Japanese have done (463, which carries the bracketed date 21 Feb.).

and again, in his first letter to Bernard from there:

> I want to begin by telling you that the country seems to be as beautiful as Japan in terms of the limpidity of atmosphere and the gay colour-effects (B2, of March).

and in describing retrospectively, in September 1889, the reasons why he had gone south, he wrote:

> Wanting to see a different light, believing that looking at nature under a brighter sky can give us a closer idea of the Japanese way of feeling and drawing (605).

These sentences are to be compared, as a group, with a passage in Théodore Duret's essay of 1884, 'L'Art Japonais', which was reprinted in his 1885 book *Critique d'Avant Garde* (p. 166):

Living under a luminous sky, in an atmosphere of an extraordinary transparency, the Japanese seem to possess a sharpness and delicacy of vision superior to those of Europeans. For them, to let the eye wander over beautiful colours is a pleasure. In their art, too, the brilliance and harmony of the colouring, more than in any other art, are an essential condition of beauty.

Van Gogh must quite evidently have read Duret's book during his time in Paris.

In September 1888 he received from his brother the first two numbers of Bing's *Le Japon Artistique*. and, after reading the text, he reported that he found it 'a bit dry' and that it 'left something to be desired' (540).

Later that month, in the course of a well-known statement about Japanese art (inspired by the reproduction of the *Study of Grasses*), he wrote:

I envy the Japanese the extreme clearness *(netteté)* that everything has in their art. Never is it tedious and never does it appear done in too much of a hurry. Their work is as simple as breathing, and they do a figure in a few sure strokes with the same ease as if it were as simple as doing up one's waistcoat.

and this is to be put alongside the editorial comment in the periodical on the Hokusai prints reproduced there (no. 2, pp. 20f.):

It is done with such a frank clearness *(netteté)* of perception, the note is so *natural* and yet at the same time so personal, life is expressed in so intense a way, the brush-work so sure of itself that the draughtsman's name comes over instantly . . . [there then follows a comparison with the Kaigetsudo print].

Van Gogh was clearly drawing on these interpretative remarks in the passage cited, but at the same time—in keeping with what he said in 540—expressing the same ideas more dynamically and in a more personal way.

C. Gauguin's *Notes Synthétiques:* date and sources

This text of Gauguin's was first published by Henri Mahaut, who owned the notebook containing it (*Vers et Prose*, 22, Jul.-Sept. 1910, pp. 51ff.). It was then re-published by Rewald in his 1938 book on Gauguin (pp. 161ff.; in trans. in the English ed.), and dated around 1890. When, however, the notebook itself was published in facsimile in 1962 (Hammer Galleries, New York, ed. R. Cogniat, J. Rewald), it became clear that these notes (pp. 2-12 in the notebook itself, transcribed in the introdn., pp. 57ff., and given in fresh trans. in the accompanying English version) were in fact of considerably earlier date.

Rewald in his introduction (pp. 51ff.) now suggested that they were composed in Rouen in 1884 or in Copenhagen in 1885. A label on the inside cover of the notebook, facing the page on which the notes begin, shows that it was purchased in Rouen, in 1884, and jottings on pp. 15 and 119 have to do with Gauguin's return journey from Copenhagen to Paris, with his son Clovis, in the summer of 1885. Rewald also pointed out (pp. 48ff.) that the attack in the text (pp. 58ff.) on literary men who set themselves up as art-critics almost certainly refers, most particularly, to the criticism of J. K. Huysmans. He published in this connection a section of an 1883 letter to Pissarro, in which Gauguin

criticized Huysmans's *L'Art Moderne*, which he had just read, in exactly similar terms. Bodelsen agreed on the dating of the text to 1884 or 1885 (*Gauguin's Ceramics*, 1964, pp. 190, 199). She also indicated that the sketches of children and of Gauguin himself on pp. 79-87 of the notebook—which are in the same sort of ink as the text—must also have been done in Rouen or Copenhagen (cf. Cogniat's introdn., p. 28, where no date was suggested). At the same time she corrected Cogniat's dating of the Breton sketches in the notebook—convincingly arguing that they are all of 1886.

The colour-wheel and accompanying notes on pp. 75-6 of the notebook, which are in the same ink and script as the *Notes* themselves, are taken from Charles Blanc's *Grammaire des Arts du Dessin*, Paris, 1867 ed., p. 599 (with colour wheel opposite). I am grateful to William Homer for tracing this source for me. The passage on p. 532 there:

> Straight or curved, horizontal or vertical, parallel or diverging, all lines have a secret relationship with feeling. In the sights of the world as in the human figure, in painting as in architecture, straight lines correspond to a feeling of austerity and strength, and can give a composition in which they are repeated a grave, imposing, rigid appearance. Horizontals, which express, in nature, the calm of the sea, the majesty of horizons almost lost from sight, the vegetal tranquillity of resistant and strong trees, the settling-down of the globe after the catastrophes which have previously shaken it, immobile, eternal duration . . . horizontals express analogous feelings in painting, the same quality of solemn repose, peace and duration.

is to be compared with the paragraph in M11 of January 1885 beginning 'Le triangle équilatéral . . .' (the version of the text here given by A. Alexandre, *Paul Gauguin*, 1930, p. 51, is clearly a more accurate transcription). And the discussion of architecture and music on p. 63 of the *Grammaire* similarly bears some relationship to the discussion of music in the *Notes* (pp. 61ff.).

D. Gauguin's Turkish treatise

What is known here is as follows:

Gauguin was in possession of a text, on the principles of painting, which he said was by 'Vehbi-Zunbul-Zadi, the painter and giver of precepts'. He included two passages from it in his *Cahier pour Aline* of 1893 (ed. S. Damiron, 1963, no paging). He then copied these and further extracts into his *Diverses Choses* of 1896-7 (Louvre ms. RF 7259, pp. 209-212) and also into his *Avant et Après* of Jan.-Feb. 1903 (1923 ed., pp. 55ff.; the quotation above is from there).

Seurat also had a copy of the text, certain passages of which he underlined. The central section of this version, now in the Signac Archives, was published by Herbert (*Burl. Mag.*, 1958, p. 151—with the underlinings reproduced). A statement of Gustave Kahn's much later, to the effect that Seurat was concerned about the so-called 'papier de Gauguin' of which he had a copy, since Gauguin was not one to conceal 'the truth' (*Mercure de France*, Apr. 1924, p. 16), suggests —though there is no proof of this—that it was Gauguin who gave the text to Seurat, rather than the other way round. And Herbert convincingly proposed that this happened in the winter of 1885-6, before the quarrel between the two artists. This date was accepted by Løvgren, and he further suggested that

Gauguin and Seurat had discussed the text in relation to Seurat's theoretical ideas of the time (*The Genesis of Modernism*, 1959, pp. 93f.).

The source of the text is something of a puzzle and a mystery. According to Kahn, it was an extract from an Oriental treatise on the colouring of carpets, but this may not be right. There is a Turkish poet Sunbul-Záde, who died in 1809 (E. J. W. Gibb, *A History of Ottoman Poetry*, IV, 1905, pp. 242ff.). Mme Cachin-Signac told Herbert that there was an unpublished manuscript by this poet in the Bibliothèque Nationale in Paris, containing the text in question, and Herbert, after checking the opening invocation of that 'testament' against Seurat's copy and finding that it corresponded, assumed this to be the source. However, a subsequent and further check by Samuel Wagstaff revealed that the B.N. manuscript—while similar in its general content—does not in fact correspond after the invocation (I am grateful to Wagstaff and Herbert for telling me that this had happened).

Rookmaaker (*Synthetist Art Theories*, 1959, *Notes*, pp. 36f.) suggested that Gauguin had written the text himself—simply attaching to it a Turkish name which he knew. But, as Homer pointed out (*Seurat and the Science of Painting*, 1964, p. 289, n.27), he gave no evidence in support of this hypothesis. The best supposition, if the B.N. manuscript really was the source, is that Gauguin created a free variant after notes supplied by someone who knew Arabic. At the same time, there is in the National Library in Ankara, a handwritten *mesnevi* by Sunbul-Záde ('Luftiyye-i Vehbi'). Sixty pages of a larger text here deal with calligraphy, orthography, geometry, poetry, literature and music (information from the library). It is equally possible, therefore, that someone who had travelled in the East had brought back a translation and given it to Gauguin—for example, Charles Blanc's friend Adalbert de Beaumont, who had gone out to make a study of Oriental art (see Blanc, *Les Artistes de Mon Temps*, 1876, p. 72) and had published, with E. Cottilon, a folio on Turkish decoration in 1883.

Since there would appear, in any case, to be different versions or manuscript copies of Sunbul-Záde's 'testament', further checking now would require an Arabic specialist.

E. Events and movements in 1888

GAUGUIN'S MOVE TO BRITTANY

The letter which Gauguin wrote to Vincent from Brittany, asking him to find out from his brother if any work of his had been sold (*CL*, I, pp. xliii f.; placed later there) corresponds in its content to the one referred to in 466 of early March (dated by Hulsker around 3 Mar.); and Vincent reported there that Gauguin had been in bed for two weeks. In M61 to his wife, Gauguin said that he would be leaving for Pont-Aven 'on Thursday'. His departure date must therefore have been either 9 February (as suggested by H. Perruchot, *La Vie de Gauguin*, 1961, p. 153) or 16 February. Vincent himself left for Arles around 20 February (see 463, which carries the bracketed date of 21 Feb.).

BERNARD'S DEPARTURE FROM PARIS

Theo van Gogh visited Bernard in Paris early in April (see 474 for this). Vincent wished him a good journey at the end of B3, a letter which is to be dated to

the end of April—after B4, for Vincent referred there to the arrival of sketches from Bernard, as in 480, whereas in B3 he referred to the arrival of sonnets, as in 477. Correspondingly, there are references in 480 (dated by Hulsker to around 1 May) to the house that Bernard had taken, and in 484 to Bernard's presence in Brittany. Bernard must therefore have left Paris around the very end of April.

BERNARD'S MOVE TO PONT-AVEN

This is mentioned in M67 of 14 August, and in Vincent's letter 523, which was re-positioned by Hulsker and dated by him to around 18 August. The date of B15, which also refers to the move, can be narrowed down accordingly to mid-August.

GAUGUIN'S ARRIVAL AT ARLES

Vincent recalled this wrongly in 561 as having occurred on 20 October. His mistake here was first noticed by Nordenfalk and Meyerson (*Konthistorisk Tidskrift*, 1946, p. 131, n.1), who indicated that Gauguin must actually have arrived between 23 and 27 October (see T2-3, which together put Theo's receipt of the telegram announcing the arrival in between those two dates). Bodelsen subsequently narrowed the date to 23, or possibly 24 October (*Burl. Mag.*, 1957, p. 200, n.9) and Nordenfalk independently, in a note on this question (*Museumjournaal*, 1958, pp. 164ff.), now gave the date as most probably the 23 October. In fact Gauguin's first letter to Schuffenecker from Arles, postmarked 25 October, in which he said that he had had to travel from Sunday noon to Tuesday morning (C. Roger-Marx, 'Lettres inédites de Vincent van Gogh et de Paul Gauguin', *Europe*, Feb. 15, 1939, p. 170) puts it beyond doubt that he left Brittany on 21 October and arrived at Arles early on 23 October. Perruchot (1961, p. 167) was the first to give this arrival date absolutely correctly; and cf. *P-I*, 1962 ed., p. 243.

WHAT HAPPENED AT ARLES

As was pointed out by Rewald (*P-I* p. 270, n.35), the sequence of events given by Gauguin in *Avant et Après* (pp. 19ff.) is not to be taken as reliable in its details or its chronology; what actually took place would appear to have been as follows. (See Appendix F for the dating of the relevant letters.)

First, towards mid-December there was some kind of ugly incident between the two men (not on the eve of Van Gogh's breakdown, as stated in *A & A*, though it may have been as described there), and it must have been as a direct result of this that Gauguin wrote to Theo saying that he must leave (*CL*, I, p. xlv). The disagreement was patched up soon after, however; in token of their reconciliation the two men visited the Montpellier Museum together, as described in 564; and Gauguin now wrote to Theo and Schuffenecker to say that he was not leaving after all (*CL*, I, p. xlv; Roger-Marx, 1939, p. 171). Vincent, for his part, remained in a tense and nervous state for a few days after this, waiting for Gauguin to decide whether he would really stay (see 565). And there followed the events of the critical evening on which Vincent cut off his ear, as described by Bernard to Aurier on 1 January, on the basis of what Gauguin had told him when he got back to Paris. This letter of Bernard's, published by Rewald (*P-I* pp. 267f.), is quite clearly more dependable on points of fact than Gauguin's narrative of fifteen years later.

It is to be noted here that Vincent and Gauguin, on the evidence of the *Letters,* remained on good—or at least fairly amicable—terms throughout November and on into December (see B19a, W9, 562, and 563, 558a, 560, as dated in Appendix F). It is not until M78 of December (see again Appendix F) that one finds Gauguin complaining that he and Vincent could not get along together.

Vincent's self-mutilation has always been placed on 24 December—this being the date that Mme van Gogh-Bonger gave in her original edition of the *Letters* (see *CL*, I, pp. xlvf.). At the same time she also stated that it was on the 24 December that Theo received Gauguin's telegram of notification (*CL*, III, p. 110); and this would seem to imply that the breakdown had occurred the previous evening. For Gauguin found out what had happened only on the morning after. There is no reason to doubt his statement to this effect in *Avant et Après* (pp. 21f.); it is upheld by the report of Bernard's referred to above. It is a further complication that in both of those cases Gauguin said or implied that the breakdown took place the day before his departure from Arles, when in fact he only left after Christmas (see below). But the date of the breakdown is, in any case, put beyond doubt by the report which a local, weekly newspaper, *Le Forum Républicain*, carried on its front page on 30 December. This report, re-produced by Tralbaut (*Van Gogh,* 1960, p. 100) tells how Vincent had given his ear to a brothel-girl the previous Sunday—i.e. 23 December.

THE DATE OF GAUGUIN'S DEPARTURE FROM ARLES

As already mentioned, Gauguin, in telling Bernard what had happened, appar-ently pushed the date of his departure as far back as possible; and he did the same by implication in *Avant et Après*—saying there (p. 23) that he had instructed the police commissioner to tell Vincent, when the latter recovered consciousness, that he had already left for Paris. The assumption must be that, in both these cases, Gauguin wanted to dissociate himself as far as possible from the catastrophe. For the indications are that he actually stayed on at Arles for several days after 23 December. According to Mme van Gogh-Bonger (*CL*, I p. xlvi), he and Theo returned to Paris together after Christmas was over. And Bernard in his report of 1 January—without noticing the inconsistency—similarly said that Gauguin had arrived four days earlier (*P-I* p. 270, n.47). Finally, Gauguin was present at the execution in Paris of a man called Prado (*A&A* pp. 178ff.), which took place at dawn on the 28 December (Perruchot, 1961, p. 182, n.1); as noted by Bodelsen (*Gauguin's Ceramics*, 1964, p. 204) he made sketches of the guillotine in his notebook (*Carnet*, ed. R. Huyghe, 1952, p. 209). He must therefore have returned either on the 26 December, as suggested by Perruchot, or more probably—in the light of Bernard's statement—on the 27 December, just in time for the execution.

F. The chronology of van Gogh's and Gauguin's letters from Arles

The letters of each man, from the time they were together, are here arranged in the order in which they are held to have been written. T3a from Theo to Gauguin, which clarifies several points of chronology, was first published with comments by Bodelsen (*Burl. Mag.*, 1957, pp. 199ff.), and was subsequently included in *CL*. The French texts of the letters of Vincent's which are not in *VB*, but were added in *CL*, are to be found in the corresponding French edition of the complete

correspondence. It is assumed that it took one or two days at this time for a letter to get from Arles to Paris or from Paris to Arles—on the basis of the fact that Vincent replied in 557 to T2 of 23 October, and 557 was then answered in its turn by T3 of 27 October. For Hulsker's scheme of dating for the van Gogh letters, see Bibl. Dates given to letters to Theo in brackets in *VB* go back to Mme van Gogh-Bonger's original editorial work.

LETTERS FROM GAUGUIN

1 Letter to Schuffenecker, announcing his arrival at Arles (partially published by A. Alexandre, *Paul Gauguin*, 1930, p. 88; further sentences added by C. Roger-Marx, *Europe*, 15 Feb., 1939, p. 170, and by M. Bodelsen, *Gauguin's Ceramics*, 1964, p. 213, n.12). Postmarked on the envelope 25 Oct., Gare d'Arles.

2 Letter to Theo van Gogh (referred to at *CL*, I, p. xliv, where one sentence from it is cited). In 557 Vincent wrote 'Gauguin will certainly write to you today,' but towards the end of the letter this became 'Soon, when Gauguin writes to you, I will add another letter to his.' This, then, implies contemporaneity with one or another of Vincent's next two letters, 558b and 558 of the last days of October (q.v.). Further, unpublished sentences from this letter of Gauguin's (known to me through the kindness of John Rewald) refer to his arrival the previous Tuesday, and to his having only just received Theo's letter. What had happened was that, on or just before 23 October (cf. T2 of that date), Theo had written to tell Gauguin that he had sold a painting and to send him the proceeds (500 frs.). Gauguin knew of this sale by 25 October, from T2; it is mentioned in an unpublished section of his letter to Schuffenecker of that date (see above; Mrs Bodelsen kindly showed me her transcript of this letter). But he had not then received Theo's letter to him, because Theo had mistakenly sent it to Pont-Aven, thinking that Gauguin was still there (see T3). It can be assumed, on the basis of Gauguin's reference to the previous Tuesday, that Theo's letter, forwarded from Brittany, took between four and six days to reach Arles. So this dates Gauguin's reply to around 27-9 October.

3 Letter to Bernard, M75. Gauguin enclosed the money he owed to the Pension Gloannec, and an unpublished passage from his letter to Schuffenecker of 25 October shows that he used for this purpose the 500 frs. he had received from Theo around 27-9 October (see above). There is also a reference to discussion with the Zouave Milliet, and he left for Africa on or around 1 November (see 558b). This letter must therefore date from the last days of October, rather than November as suggested by Malingue.

4 Letter to Schuffenecker, partially published by Roger-Marx (*Europe*, 15 Feb. 1939, p. 171), and assigned there to November. Gauguin announced that he would go to Martinique if he sold anything, and this implies that his one-man exhibition at Theo's gallery—referred to as having opened in T3a of 13 November —was already organized at this point. Cf. also the postscript to B19a (paraphrased at *CL*, III, p. 519) in which Gauguin similarly said that he intended to move to the tropics as soon as he got the chance. These two points together place the letter early in November.

5 Letter to Bernard, M68. Captioned by Malingue as written from Pont-Aven in October. But the references to Vincent clearly indicate that it was written from Arles; and Bodelsen re-dated it to after 13 November (*Burl. Mag.*,

1957, p. 201) on the basis of the mention of Degas' intended purchase of a painting out of the one-man exhibition—a piece of news which Gauguin was given in T3a of 13 November. The letter also discusses what Gauguin interpreted as a 'campaign' organized by Seurat and Signac, with the collaboration of the *Revue Indépendante,* and in his letter to Schuffenecker of 23 November (see below) Gauguin correspondingly mentioned that he had been invited to exhibit by the *Revue* and had refused. These two points, then, place the letter in the region of 15-23 November.

6 Letter to Schuffenecker, partially published by Alexandre (1930, pp. 89f.). Dated 23 November. Besides mentioning here the invitation he had had from the *Revue Indépendante,* Gauguin also wrote that as soon as he had received money from Theo he would send some to his wife; this evidently refers back to the news of sales he had received in T3a.

7 Letter to Bernard, published as B23 in *Vincent van Gogh—Letters to Emile Bernard,* 1938 (see pls. 31-2 there for the French text in facsimile), and dated there to November. The references to Gauguin's *Night Café* and *Vineyard* place it after 559, and between 561 and 563—in other words, towards the end of November.

8 Letter to Schuffenecker, M74. First published by Alexandre (1930, pp. 82ff.), and said there to have been written before Gauguin's departure for Arles. Dated 13 November, according to Malingue; but this cannot be right. The two canvases which Gauguin told Schuffenecker to go and see here are clearly the ones which Vincent reported were about to go off to Paris in 563 (q.v.). Cf. also the fact that Schuffenecker wrote back on 11 December (*P-I* pp. 259f.) reporting that he had seen the canvases in question the previous Saturday—8 December. That letter of Schuffenecker's evidently provided the answer to Gauguin's concern that these canvases of his would not arrive in time to be included in his exhibition before it closed; and so it must have been written very soon after the receipt of M74. Finally, in bringing up how Schuffenecker had been refused a place in the *Revue Indépendante* exhibition, Gauguin now mentioned that he had been invited to exhibit with the *Vingtistes* in Brussels. At the time of his 23 November letter to Schuffenecker Gauguin had evidently not yet received that invitation; for he simply said there that he had declined to exhibit with the *Revue* himself—whereas he now said that the Brussels exhibition would be 'in opposition to the little dot'. Correspondingly, the opening sentence here implies a gap after Gauguin's 'last letter'—that of the 23 November—while he waited for a package to arrive (containing, it can be assumed, the linen and etchings he had asked for in his early November letter to Schuffenecker). It follows, therefore, from these different points that M74 cannot be earlier than the very end of November, and is most probably of early December.

9 Letter to Bernard, M78. Assigned there to December. The opening sentences here refer to a commission to obtain colours from Tanguy's that Gauguin had given to Bernard, in M68, and to the receipt of an intermediate letter from Bernard. A later passage mentions the refusal of the *Revue Indépendante* to exhibit Schuffenecker's work—which means, by analogy with M74, that the letter cannot be earlier than the very end of November. The final sentence conveys Vincent's thanks for 'the study that you sent him in exchange', and this work

must clearly be the 'marine' of Bernard's mentioned in 562 as having arrived. Lastly, and most crucially, the question raised here of two drawings which Theo van Gogh should have received, but which Bernard's mother had inconsiderately appropriated, is referred to equally in 560. A December date—most probably in the first or second week of that month—is therefore clearly indicated.

10 Letter to Theo, published in its entirety in trans., *CL*, I, p. xlv. Gauguin announced here that he must leave Arles. He asked Theo to send him some of the money due to him, from the sales made during his one-man exhibition. Schuffenecker visited that exhibition on 8 December (see his letter of 11 Dec., *P-I* pp. 259f.), and it must have been about to close then, or have closed very soon after. This point, and the probable sequence of events in December, as discussed in Appendix E, together push the date of this letter down towards mid-December (Mme van Gogh-Bonger assigned it to the second half of that month, but time must be allowed after this for the visit to the Montpellier Museum, for Gauguin's second letter and for a pause of a few days before the events of 23 December).

11 A lost letter to Schuffenecker, asking to be put up in Paris. That Gauguin wrote to Schuffenecker now with this request is implied by his subsequent letter to him (see below). It is possible that a section of this letter does in fact survive, in the shape of a passage discussing Gauguin's *Vineyard*. This passage, published by Alexandre (1930, pp. 48f.), but mistakenly incorporated there into the text of a much earlier letter to Schuffenecker, M11 of January 1885, was first recognized for what it is by H. Dorra (*The Style of Paul Gauguin from 1871 to 1891*, Harvard Ph.D. thesis, 1954, p. 121, n.24). If it does represent part of an otherwise missing letter, this would then explain how Alexandre came to make that mistake. And it is appropriate that Gauguin should have written now on these lines, after receiving Schuffenecker's letter of praise of December 11 (*P-I* pp. 259f.); cf. the remarks in the two cases about 'the absolute' and 'the beyond'.

12 Letter to his wife, M76. Assigned by Malingue to November, but re-dated by Bodelsen after 11 December (*Burl. Mag.*, 1957, p. 201), on the basis of the fact that Gauguin enclosed here Schuffenecker's letter of that date (*P-I* pp. 259f.; that this was the letter in question is made clear by Gauguin's remark that it showed what was currently thought of his painting). The sum of 200 frs. enclosed here clearly represents money received from Theo, in accordance with Gauguin's request in the letter to the dealer discussed above (cf. Gauguin's remark in his 23 November letter to Schuffenecker, cited earlier, concerning the sending of money to his wife). So this places M76 a little later, around 20 December.

Gauguin's reference here to how he was working 'to bursting point' is to be compared with his remark in M74 that he was 'moving at full speed [in his production], like a locomotive' (though the mood is in this case less optimistic than there); and he mentioned also—as Vincent had done in 563 (speaking there of 'liver or stomach trouble')—how he was gradually recovering his health. These two points, an increased sense of well-being on Gauguin's part and a current run on his creative energies, clearly lie behind his decision at this time that he would stay on.

13 Letter to Theo, in which Gauguin said that he would not be leaving Arles after all. The opening sentence of this letter was given in paraphrase by Mme van Gogh-Bonger (see *CL*, I, p. xlv, and cf. *P-I* p. 264 for reference to another

passage in it). In a further, unpublished passage (known to me through the kindness of John Rewald) Gauguin mentioned the visit to the Montpellier Museum, and said that Vincent would be sending his impressions—which he did in 564. This reference, the content of M76 discussed above, and the date of Vincent's breakdown (see Appendix E) together place the letter around 21 December.

14 Letter to Schuffenecker, communicating the same decision (partially published by Alexandre, 1930, p. 92ff; further sentences added by Roger-Marx, *Europe*, 15 Feb., 1939, p. 171). This letter, assigned by both Alexandre and Roger-Marx to December, was clearly written at the same time as the one to Theo. The opening words 'You await me with open arms, I thank you . . .' imply that Gauguin had written to Schuffenecker earlier to ask if he could stay with him; and a welcoming reply from Schuffenecker must have reached him in the meantime.

LETTERS FROM VAN GOGH

1 557. Given the bracketed date of 20 October in *VB*, as a result of the belief that that was Gauguin's arrival date. Vincent wrote here 'As you learnt from my telegram, Gauguin has arrived in good health,' and this puts the letter after 23 October (see Appendix E). He also referred to Gauguin's sale of a painting, which he knew of from T2 of 23 October; and T3 of 27 October represent Theo's reply (cf. Vincent's words here 'To do a thousand pictures at 100 francs . . . is very, very, very hard,' and Theo's comment there 'I don't understand the calculation of so many pictures at 100 francs.'). Hulsker justly re-dated the letter 25 or 26 October on this basis; I had reached the same conclusion independently.

2 558b. Not in *VB*, but in *CL* in translation; dated there to the end of October. Hulsker placed it before 558 and dated it around 28 October—and that indeed seems like the likeliest date. As soon as Theo returned from Brussels, that is, he sent off a money-order to keep Vincent and Gauguin going (see T3 of 27 Oct.). This dispatch clearly corresponds to the sum of 50 frs. acknowledged here; and since Theo chose to send the money that way in order that the two artists should have it as quickly as possible, it seems likely that it arrived first—before T3 itself—and prompted this letter of Vincent's. This would then explain the inquiry here as to whether Theo had achieved anything in Brussels—the point being that it was appropriate for Vincent to ask this before T3 had arrived, with its comments on this subject, but not after it had come. Certainly the letter dates from before 1 November, since Vincent mentioned that Milliet would be leaving on that date; and the fact that he gave the day as '1 November', rather than 'tomorrow' or 'the day after tomorrow', equally suggests 28 October.

3 558. Given the bracketed date of 22 October in *VB*, probably because the postscript implies that Gauguin had arrived only recently. Hulsker redated it around 28 October; and the very end of October seems clearly right, since Vincent dealt here with two points brought up in T3 of 27 October—his state of health and his worries about money. If 558b was in fact written earlier, before receipt of T3 (see above), then this letter could have been written either later the same day—after T3 had arrived—or a day or two later.

4 B19a, to Bernard (with a postscript of Gauguin's, paraphrased at *CL*, III, p. 519, and partially published in trans., *P-I* p. 252). Assigned in *VB* to the end of

October. It should in fact be dated early November, since Vincent mentioned here that Milliet had gone off to Africa, and the lieutenant left, according to 558b, on 1 November. Cf. also the corresponding report in 559 as to works completed or in progress.

5 559. Headed November (in brackets) in *VB*. The report here: 'Gauguin is very happy at your liking his dispatch [of paintings] from Brittany,' shows that Theo had now sent word that the consignment of Gauguin's paintings that he was expecting had arrived; and this puts the letter at least a few days after 27 October, since Theo mentioned in T3 of that date that he had not as yet received those canvases. At the same time, a more exact indication of the date of the letter is perhaps provided by the opening acknowledgement of 100 frs. received. According to Hulsker's reconstruction, that is (*Maatstaf*, 1960, pp. 326ff.), the standing arrangement for Vincent's support at Arles, between February and October 1888, was that he received 200 frs. from his brother per month, in the form of weekly dispatches of 50 frs., which normally reached him on Friday or Saturday of each week. With the coming of Gauguin, on the other hand, the rate became 300 frs. per month for the two of them (see 558, where Vincent proposed this, and also his corresponding suggestion in 568 that, now Gauguin had left, his own support should be reduced to 150 frs. per month); and Theo now switched to sending 100 frs. per installment (see 562, 558a, 560, and also 565, with its separate mention of an extra 50 frs. received). This must mean—to make up the new monthly total—that Theo now sent money about once every ten days, rather than once a week. The 50 frs. acknowledged in 557 would then represent Vincent's allowance for the week ending 27 October, sent a little early (25 October was a Thursday) because Theo was leaving for Brussels; the 50 frs. sent by money-order on 27 October (T3; see above) is to be discounted as a special and supplementary payment, designed to help out in the situation caused by Gauguin's arrival; and the first of the 100 frs. payment would then have fallen due in the week ending 3 November. 559 is therefore likely on this basis to have been written around 4 November. Hulsker himself assigned it to mid-November; but he took there to be an intermediate letter—558a (see the discussion of its date below)—acknowledging receipt of 100 frs.

6 A missing letter, of around 11 November, in which Vincent gave Theo a message from Gauguin about the stretchers which he wanted used. That there was a letter, of approximately that date, in which Vincent said something on this score is implied by Theo's words in T3a to Gauguin (of 13 November) 'Even before receiving my brother's letter I had [your pictures] mounted on adjustable stretchers.' Subsequently, in the postscript to 561, Vincent passed on a further message on the same subject—having to do now with the way in which Theo was to reimburse himself for the money spent on those stretchers.

7 561. The references here to works now completed, or almost completed, place this letter after 559, and therefore well into the month of November. Cf. also the reference to Gauguin's arrival date, given as '20 October', and the words 'I believe I have not yet told you that Milliet has left for Africa', which imply that Vincent thought he might have told Theo this in an earlier November letter. Hulsker suggested the beginning of December here. Cf. however M68, dated above around 15-23 November, for the commission given to Bernard—to buy colours from Tanguy—which is referred to in the postscript here in exactly

corresponding terms. These two letters must therefore be closely contem-
poraneous in date, so that 561 is to be dated on this basis to mid-November or a
little later.

Another point which supports this same dating is Vincent's statement that
he had been invited to exhibit by Dujardin, of the *Revue Indépendante*, and had
refused. He added in this connection 'I boldly venture to believe that Gauguin
takes the same view. In any case he does not press me at all to do this.' The
background here appears to be that, until he had made up his mind whether or
not he would exhibit with the *Revue* himself, Gauguin did not want either of
the van Gogh brothers to gain any inkling of his feelings on the subject. For in
discussing in M68 what he took to be the *Revue*'s 'campaign', he specifically told
Bernard to say nothing about this to Theo, since otherwise he would appear
'indiscreet'. Once he had decided that he would not exhibit, on the other hand,
he no longer had any reason to conceal his feelings; and he communicated that
decision to Schuffenecker on 23 November (see above).

8 562. The order of paints, which Theo had said in T3 of 27 October that he
would have Tasset send shortly, is reported here as having arrived (two days
earlier). Otherwise the letter can only be dated in relation to 563—from the
references in the two cases to Gauguin's *Woman in the Hay with Pigs*. Hulsker
assigned 562 to the first half of December on this basis—but he put 563 too late
(see below). Most probably the 100 frs. acknowledged here represents Theo's
third payment of this amount since Gauguin's arrival—made some time late in
November.

9 W9, to his sister. Dated 'second half of November' in *VB*. This is clearly
right. The same paintings of Vincent's are referred to as in 562, and one of them
is in this case said to be just finished, which brings the date of the letter down
towards the end of November.

10 563. Captioned December (in brackets) in *VB*. As noted above in the
discussion of M74, the two canvases of Gauguin's mentioned here as having just
gone off to Paris were seen by Schuffenecker on 8 December—so that Hulsker's
date of mid-December is too late. Further, Theo had written in T3a of 13
November that Gauguin's *Ring of Breton Girls* needed to be retouched; and
time must be allowed after that date for Gauguin's communication of his agree-
ment to doing this, for the dispatch of the painting to Arles, and for the retouch-
ing itself, referred to here as completed. These two points, then, together, indicate
a date around 1 December.

11 558a. Not in *VB*, but in *CL* in translation, and dated there to the end of
October. Hulsker moved down the date, but only to the beginning of November.
In fact this letter, and 560 along with it, should be dated rather to early December,
for the following reasons. First, Vincent wrote in 560 'Of course it is winter here
too, though it still continues to be very fine from time to time'—and the warm
weather normally lasts into December in the South of France. And secondly,
and more crucially, the reference in 558a to Gauguin's continuing success in
achieving sales must date from some time after 13 November, at which date
(in T3a) Theo sent word that Gauguin had definitely sold two canvases and all
but sold a third. As of early November, that is, (see T2, 557), Gauguin had as
yet sold only one of his recent canvases through Theo. After 13 November, on

the other hand, Gauguin had money to play with—as is implied by Vincent's further remarks in 558a about Gauguin's financial plans, and how in this connection Theo should remember to pay Gauguin back for sheets, etc. contributed to the Arles ménage.

Cf. also 563, for a parallel remark of Vincent's to the one here about what he hoped to be capable of when he was forty; and M74 (assigned above to the very end of November, or more probably early December) for Gauguin's receipt of his invitation to exhibit with the *Vingtistes*, which is similarly referred to in 560.

12 560. Captioned November (in brackets) in *VB*; assigned by Hulsker to the end of that month. This letter goes very closely with 558a, in terms of the paintings referred to, and is therefore equally to be dated early December. The fact that additional works of the two artists are mentioned here as in progress is perhaps an indication of a slightly later date in this case; at the same time, the sum of 100 frs. acknowledged is probably the same in both cases.

13 564 (discussing the visit to the Montpellier Museum). Assigned by Hulsker to mid-December. This is certainly right. The reconstruction in Appendix E of the events of December, and the discussion above of Gauguin's December letters together indicate a date in this case just a few days before 23 December. On the question of Gauguin's improving health, cf. Vincent's comment here that Gauguin had told him that morning 'that he felt his old self was coming back'.

Vincent's state of tension and alarm, once things went wrong between him and Gauguin, is probably the reason why, between early December and now, he did not apparently write to Theo at all.

14 565. Given the bracketed date of 23 December in *VB*, and assigned to that day by Hulsker also—on the evident assumption, in both cases, that Vincent's breakdown took place on 24 December. It actually occurred the previous evening (see Appendix E), but the letter could still have been written that day. It is evident from the opening remarks here that Theo had written asking why exactly Gauguin had written to him announcing that he must leave; and the ensuing sentences—which testify, in their short and jerky character, to an intensely troubled state of mind—show that the question of whether or not Gauguin would stay had now come up afresh. So the letter quite clearly belongs last in the present sequence, and it is best dated on this basis around 23 December.

G. Gauguin's behaviour towards two critics: Fénéon and Fontainas

In his first notice of Gauguin's work, which formed part of a larger review of the Impressionist Exhibition of 1886 (*La Vogue*, 7 and 15 June; reprinted in F. Fénéon, *Au-Delà de l'Impressionisme*, ed. F. Cachin, 1966, p. 62), Félix Fénéon referred back to the two sculptures which Gauguin had shown in the 1881 Impressionist Exhibition (Gray nos 3-4), and mentioned in this connection how Degas had shown that year his wax of the *Little Ballet Dancer*. He implied thereby, quite correctly, that there was a relationship—at least of parallelism—between the subject matter of those two sculptures and Degas' imagery. It is doubtful, however, if Gauguin was pleased by this comment. He never liked the bringing in of any other artist's name in connection with his work (see below)—however

this was done. Also, at the time of that review, Gauguin's political relationship with Degas had not yet entered its friendly phase (see Appendix A). And finally it was in this year, and specifically with this review, that Fénéon began serving as the main spokesman for, and supporter of, neo-impressionist art and theory. That June Gauguin had just quarrelled with Seurat and Signac (see *P-I* p. 41). Thereafter he would take up an attitude of categorical opposition and hostility to the neo-impressionist camp (cf. Chapter 3); and he would correspondingly label Fénéon, in a letter of January 1890, 'Signac's man' (A. Alexandre, *Paul Gauguin*, 1930, p. 102; the passage goes on to refer to Fénéon's piece on Signac in the *Hommes d'Aujourd'hui* series, which had just come out).

In January 1888 Fénéon reviewed the exhibition which Gauguin shared with two other artists at the Boussod Valadon gallery (*Revue Indépendante*, Jan., pp. 189f.; reprinted in F. Fénéon, *Œuvres*, ed. J. Paulhan, 1948, pp. 116ff.). Speaking of a Breton landscape and one from Martinique, he wrote that 'these bold paintings would sum up the work of M. Paul Gauguin, if this troublesome (*grièche*) artist were not above all a potter'. The next month, writing of the *Two Bathers* of 1887 (W-C 215) which was now to be seen at Boussod Valadon, he brought up for the first time the relevance of Cézanne's example: 'a slender, rectilinear and smooth trunk, already seen in Cézanne' (*Revue Indépendante*, Feb., pp. 307f.; Cachin p. 109). When Gauguin saw the January piece, he commented that it was 'passable as far as the artist goes, but curious as to his character . . .' (M63). And the word 'troublesome' seems indeed to have irked him intensely. In November of that year, in telling Schuffenecker how he had declined to exhibit under the auspices of the *Revue Indépendante*, he wrote 'At least I shall earn the label of troublesome' (Alexandre, 1930, p. 89).

Then the next year, in reviewing the Café Volpini exhibition, Fénéon wrote, as mentioned in my text: 'It is probable that M. Anquetin's manner . . . has not been without some influence on M. Paul Gauguin'. He went on immediately to qualify this by saying—again quite correctly—that if this was so, the influence was 'purely formal' (*La Cravache*, 6 July, 1889; Cachin p. 110). But Gauguin did not like this linking of Anquetin's art with his. Misrepresenting what the critic had said, he observed sourly in a letter to Bernard later that year 'Fénéon has nicely written that I was imitating Anquetin, whom I do not know' (M91). Nevertheless, he would copy the opening sentences of that review into his *Cahier pour Aline* in 1893 (ed. S. Damiron, 1963, n.p.); anything complimentary that a critic of stature had said he wanted written into the record.

Lastly, in May 1891, Fénéon wrote a longer piece on Gauguin (*Le Chat Noir*, 23 May; Cachin pp. 112f.). He did not like the more recent work nearly as much, and this strengthened the view he had already put forward in 1888 that Gauguin was more of a sculptor than a painter. Building up to this conclusion, he wrote that 'Bernard, who is today perhaps [Gauguin's] pupil, appears to have been his initiator,' and that, in the paintings shown in the auction-sale of February that year, there were 'trees of Cézanne's and [the] Arles canvases were van Goghs'. It was here that Fénéon really went off the rails for the first time in his view of Gauguin's art. Yet these remarks of his set a pattern for critical comment during the next eight to ten years. Thus—in parallelism with the propaganda of Bernard and his adherents—one finds Camille Mauclair writing in 1896 that 'Gauguin has come entirely out of Cézanne' (*Mercure de France*, Jan. 1896, p. 130); Thadée Natanson saying in 1898 that 'Gauguin has sought his path . . . according to the ideal renewed by Cézanne and the impressionists, out of whom he comes'

(*Revue Blanche*, Dec. 1898, p. 544); and André Fontainas in 1899 relating Gauguin's drawing to that of van Gogh and Cézanne (see below). And it is clearly this conformity of viewpoint (along, of course, with resentment against Bernard) which lies behind Gauguin's bitter observation to De Monfried, in July 1899, that many writers affirmed that he was 'born of Cézanne, van Gogh, Bernard. What a skilful pasticher that makes me!' (Mon. 56; cf. also Mon. 82 of Aug. 1902).

Aurier's article on Gauguin had appeared in the *Mercure de France* in 1891, and Charles Morice's in December 1893. During the artist's stay in France in 1893-5 Julien Leclerq gave him support in the periodical's pages, reviewing the exhibition which he held at the end of 1894 (Jan. 1895, pp. 121f.); and a drawing of Gauguin's and also his piece on Séguin were included in the issue of February 1895. At that time, however, the regular art-critic of the *Mercure* was the young Camille Mauclair, who had taken over this position in January 1894 at the age of only twenty-two. Mauclair was intensely critical from the first of Gauguin's Tahitian paintings (as compared to his Breton ones). He called them 'colonial' art (July 1894, p. 274). After Leclerq had answered this charge (Nov. 1894, pp. 264ff.), Mauclair did more than simply stand his ground (Nov. 1894, p. 285). He spoke out further in a succession of articles, now calling the Tahitian works carpet-like, and charging Gauguin with having detrimentally imported philosophy into his painting, and spoilt in this way what he had got from Cézanne (Mar. 1895, pp. 358f.; June 1895, pp. 358f.; Jan. 1896, p. 130).

When, therefore, Mauclair gave up his post as reviewer in September 1896, feeling that he had said his say, and a new critic, André Fontainas, succeeded him in December of that year, it was natural for Gauguin to hope that his art would now receive more sympathetic attention in the *Mercure*. A month later, however, in a piece dealing with works of van Gogh's on exhibition at Vollard's, Fontainas wrote that van Gogh's role in the modern movement, alongside that of Cézanne, appeared 'as important as that of Paul Gauguin' (Jan. 1897, p. 222). This must have seemed to Gauguin to represent no change. Hence his angry comment to De Monfried in March that he would not exhibit with Bernard, Denis and others, as Schuffenecker wanted him to, because it would 'provide an opportunity for the *Mercure* critic to say that it is Cézanne and van Gogh who are really the promoters of the modern movement' (Mon. 30).

Two years later Fontainas began his review of the recent paintings of Gauguin's shown at Vollard's in November-December 1898 with the words 'I do not like Paul Gauguin's art' (*Mercure*, Jan. 1899, p. 235). This was too much for Gauguin when he read the piece (see Mon. 52). He composed a letter on the subject—addressed to Fontainas himself, rather than to the *Mercure*, on the grounds that, as he put it to De Monfried, the critic was well-intentioned, even if he understood nothing—but limited himself there to a very general statement of his theoretical position (M170). When the critic wrote back in an effort to clear up misunderstandings, Gauguin continued to hold back his feelings. His letter of reply was less polite and more off-hand, but still argued in rather general terms (M172). He was quite evidently resorting opportunistically here—and against the drift of his anger—to the strategy of seeing how far he could win the critic over to his side.

Left unassuaged in this way, Gauguin's resentment against what he called 'critico-literary lucubrations' (Mon. 78) grew even stronger over the next two to three years. It ultimately found relief in the preparation of a text, *Racontars de*

Rapin (ed. A. Joly-Segalen, 1951), in which he sought to demonstrate that men of letters were utterly useless and ineffective when they set themselves up as critics of painting. And when the text was completed, he chose to send it to Fontainas. He hoped that Fontainas, out of continuing interest in him, would intercede on his behalf with the *Mercure's* editor, and so assure publication there. Here, in other words, he was putting back to profit the effort he had expended two years earlier on increasing rather than alienating the critic's respect for him. But at the same time the text that he was submitting amounted to a whole-hearted attack on the pretensions to art-criticism of men like Fontainas. It was at this point, therefore, that—to set himself straight with the critic—Gauguin now took Fontainas to task in his covering letter (M176) for the remarks made in the article of two years earlier.

In order to understand the factitious nature of Gauguin's argument here, it is necessary to go into detail. He cited Fontainas, in the first place, as having said 'Although Gauguin's way of drawing recalls van Gogh's a little bit'. The critic had actually written (p. 236 of his article): 'Gauguin has invented his way of drawing, even though it is perhaps close to van Gogh's, or even to Cézanne's.' So this paraphrase, with its omission of the accent on Gauguin's originality, was hardly a fair one.

Gauguin then invited Fontainas to consult some of the letters of van Gogh's to his brother which had appeared in the *Mercure*, claiming that he would find there the words: 'Gauguin's arrival at Arles will change my painting a great deal . . .' He was referring here to the extracts which had appeared in the periodical, through the offices of Bernard, between August 1893 and February 1895. They were mainly from letters of 1888 predating Gauguin's arrival at Arles. But since no dates were given, different parts of one or another letter were freely redistributed on no particular principle, and Gauguin's name appeared as 'G', for reasons of anonymity, almost throughout, no ordinary reader of the time could be expected to derive from that source the information about van Gogh's attitude towards him that Gauguin suggested could be found there. Furthermore, the particular sentence that Gauguin quoted is not to be found amongst the extracts. The closest matching comment in the 1888 letters to Theo as they are known today is in 544: 'His [Gauguin's] coming will change my way of painting.' In the extracts, where 544 was not used, the nearest comment (Jan. 1894, p. 34) is from 515 of late July: 'I think that it would be an enormous change for me if Gauguin were here . . .'; but this passage has to do with Vincent's sense of isolation rather than his painting.

Gauguin would similarly refer in *Avant et Après* (p. 13) to a letter of Vincent's published in the *Mercure* which, he claimed, showed how Vincent had insisted on his coming to Arles, to act as director of the studio which Vincent planned to establish there. Again there is no such passage mentioning the intended directorship, either in the extracts from the letters to Theo, or in those published earlier (April–July 1893) from the letters to Bernard. The sections containing major references to Gauguin (e.g. Sept. 1893, p. 69; Nov. 1893, p. 272; Jan. 1894, pp. 28f., 36; Jul. 1894, p. 258) are all from letters of earlier date than the emergence of this idea in Vincent's mind. So the question arises of Gauguin's real sources in these two cases.

Gauguin went on to mention to Fontainas how, in his letter to Aurier (626a), Vincent had written 'I owe a lot to Gauguin.' In this case his citation was perfectly correct (cf. the words there: 'I owe a lot to Paul Gauguin'); and the reason

for this is clearly that he had been sent a copy of that letter (see 626). This suggests, then, that in the other two cases he was actually drawing on letters to himself which he remembered or had kept (cf. on the latter point p. 26 n. 13). 544a to him—which seems to have been kept by Schuffenecker, to whom it was sent on, though Gauguin asked for it back (see M71, 73)—correspondingly contains a discussion of the studio project and a sentence beginning 'I believe that if from now on you start to think of yourself as the head of this studio . . .'. And there was probably, by the same tokens, another, lost letter to Gauguin of around the same date in which Vincent alluded, as in 544, to the effect that Gauguin's coming would have upon his painting. On this hypothesis, then, Gauguin's quotation on the latter subject was real—at least in an approximate sense—but fiction entered in through his wanting to be able to suggest that Fontainas might have consulted, to his benefit, already published documentation.

Gauguin told Fontainas that these corrections of his were 'between ourselves'. He simply wanted to claim his 'tiny little share' of credit, without detracting from what was due to van Gogh, and to show how criticism was subject to error, even when it was made in good faith. He even spoke in the same letter of a general resolve to keep silent about the development of his art, in that 'truth does not emerge from polemic, but from the works that one has done'. Nevertheless within the next few months, as brought out in my text, he would go against all such professions by presenting the same arguments over again in his memoir *Avant et Après*; and without mentioning the author now—the only concession to his promise—he would include there (p. 19) the same incorrectly quoted statement of Fontainas', saying that it made him smile. The professions in question, therefore, were really, from the point of view of intention, a convenient way of assuring Fontainas that his errors would not be put on view as such. Exactly in conformity, furthermore, with his behaviour over the *Racontars* (which had been refused by the *Mercure*), when the new manuscript was completed in February 1903, Gauguin, just three months before his death, designated Fontainas as its recipient. He desperately wanted the work to be published, he wrote, in the hope that a few might then read it. And he again gave a strategic explanation of why he was sending it to the critic: 'my bizarre nature, my instinct . . . although I am far away confidence [in you] comes to me, without reasoning. So it is a large matter with which I am charging you, a labour, a responsibility' (M177).

Fontainas had in fact given up his art-reviewing for the *Mercure* in July 1902; and Charles Morice had taken his place that November. It was Morice, therefore, who would ultimately write the obituary article on Gauguin for the *Mercure*; it appeared in October 1903 (pp. 100ff.). He would quote there from the manuscript of *Avant et Après*, which he had from Fontainas (see p. 108, n.1). And in particular he would publish—for the first time (pp. 126ff.), and presumably with Fontainas' altruistic consent—the sections in it dealing with van Gogh.

H. Doubts and difficulties of the impressionists in the early 1880s

The so-called 'crisis' of impressionism (not perhaps the best word for what took place in the works themselves), has usually been dated 1883-5, on three main grounds. First, there is the well-known retrospective statement that Renoir made to Vollard in 1918: 'Around 1883 . . . I had gone absolutely to the limit of

"impressionism" and I came to the conclusion that I did not know either how to paint or how to draw. In a word, I was in an impasse' (A. Vollard, *En Ecoutant Cézanne, Degas, Renoir*, 1938, p. 213). Then, secondly, the economic crash of 1882 and its aftermath threw the Impressionists back during those years into a state of financial distress, so that they were inevitably looking around desperately for support wherever they could find it (cf. *Imp.* p. 486). And finally there are the letters of this period in which the artists gave vent to intense feelings of doubt and dissatisfaction with their work (Pissarro to his son, 20 Nov, 1883, *Lettres*, ed. Rewald, 1950, p. 68; Monet to Durand-Ruel, 1 Dec., 1883, Venturi, *Archives*, I, p. 264; Degas to Lerolle, 21 Aug., 1884, *Lettres*, ed. Guérin, 1945, no. 54).

There are, however, a number of separate indications that the artists in question were already assailed by a loss of self-confidence and spontaneity, or felt the need for a change of direction, as early as 1880-2.

Monet, after suffering the rejection of his *Floating Ice* by the Salon of 1880, organized a one-man exhibition of his work at the *Vie Moderne* that June (*Imp.* pp. 443, 447); and when asked by an interviewer at that time if he was still an impressionist, he replied 'The little sanctuary has become a banal school, which opens its doors to the first dauber who comes along' (E. Taboureux, *La Vie Moderne*, 12 June, 1880; cited by G. Bazin, *L'Epoque Impressioniste*, 2nd ed., 1958, p. 82). After the exhibition closed without his selling anything, he accepted Mme Charpentier's offer of 1,500 frs. for one of the paintings of *Floating Ice*, even though he had priced it at 2,000 frs. (M. Robida, *Le Salon Charpentier et les Impressionistes*, 1958, p. 82). In September of the following year, at Vétheuil, he was already extremely discouraged by the bad weather, and in the autumn of 1882, at Pourville, his self-criticism became acute. He now destroyed at least four or five canvases, and saw nothing good in others which he had begun (Letters to Durand-Ruel of 13 Sept., 1881 and 18, 19 and 26 Sept., 1882, Venturi, *Archives*, I, pp. 223f, 236, 237f.) His feelings in 1883-4—years during which he was obsessed with the need to retouch his paintings—are in fact in a direct line of continuity.

Pissarro's letters to his son do not begin until 1883, but in February of that year he reported having changed his *Market* (P-V 615) completely, and in July he spoke of two paintings—one of them the *Apple Eaters* (P-V 695)—that he had meditated on for two years, without being able to finish them (*Lettres*, ed. Rewald, pp. 30, 56). Also in February 1882 he told Théodore Duret that, while he was doing quite well, he dreaded 'a repetition of the past' (letter of 24 Feb. A. Tabarant, *Pissarro*, 1924, p. 46).

Degas' *Little Ballet Dancer* of 1880, shown in the Impressionist exhibition of 1881, clearly represents a summing-up—now in a different medium—of this artist's ballet subjects of the seventies. And the change to sculpture at this point is significant.

Lastly, there is the case of Renoir's *Les Parapluies* (Nat. Gall., London). According to the most recent view of the matter (see the findings of S. Pearce, as reported by M. Davies, *National Gallery Catalogues, French School*, 1957 ed., pp. 196ff.), the two stages of work on this painting are to be dated, on the basis of costume, 1881-2 and 1885-6. And the evidence of style chimes with that conclusion, since the first stage, as represented by the three figures on the right, compares very closely with the *Girl's Head* painted at Naples in 1881 (Masterpieces of Art, Seattle World's Fair, Apr.-Sept. 1962, cat. no. 48), and the second stage (as seen in the figure of the girl with the bandbox) with the 1885 and 1886 paint-

ings of *Mme Renoir Feeding her Child* (W. Gaunt, *Renoir*, 1952, p. 57; J. Meier-Graefe, *Renoir*, 1929, p. 247). Furthermore, the tacking edges indicate (see Davies) that the painting was almost certainly laid out in its entirety at the first stage, and subsequently recast and revised. It looks very much, then, as if Renoir left this large canvas of his blocked in but unfinished—because he was unable to go further with it—when he went off to Italy in the autumn of 1881. And it was from Naples, on 21 November, that he wrote to Durand-Ruel: 'I am still in the toils of research. I am not content, and I paint out, paint out again. I hope that this madness will come to an end . . . I am like the children at school. The white page must be well covered with writing, and bang! . . . a blot. I am still at the blotting stage, and I am forty years old' (Venturi, *Archives*, I, p. 116). By mid-1885 Renoir felt that he was coming out on the other side of his difficulties, for he wrote to Durand-Ruel that August '. . . now, I no longer have to search. I have trouble only in beginning' (Venturi, *Archives*, I, pp. 130ff). This suggests, then, that the year 1883, which he would use only as an approximate demarcation in his statement to Vollard, is to be understood as the median date of the difficulties, rather than their starting-point.

Bibliography

Since the second edition of each of Rewald's volumes provides an extremely full and complete bibliography on impressionism (up to 1961) and on post-impressionism (up to 1962), there is no point in citing afresh here all the publications in those lists which are relevant to the 1880s. I have therefore confined myself, very selectively, to those publications which have served as handbooks in the preparation of my study; and to those which stand in the immediate background to my work, because of the special material or points of interpretation which they contain. Further sources, which have to do simply with points of detail, are given in my footnotes (and the supporting catalogue to be published separately, see page 4).

I Basic Sources

ON THE 1880S AS A PERIOD

J. REWALD, *The History of Impressionism*, New York, Museum of Modern Art, 1946, 2nd ed., 1961, chs. 12–15.
J. REWALD, *Post-Impressionism from van Gogh to Gauguin*, New York, Museum of Modern Art, 1956, 2nd ed., 1962.

The second edition of each of these monumental volumes displaces the first, for scholarly purposes. For the first volume was completely revised and enlarged, with the addition of numerous plates and a thoroughgoing improvement in the quality of the illustrations; and the second incorporates, in its revised form, a number of additions and corrections. These two books are invaluable as guides to research; as richly documented repositories of factual information; and for the anthologies of plates which they contain, chapter by chapter. Interpretation does not normally go beyond a linking together of the artist's words and the work itself; but certain suggestive comparisons are made through the juxtaposition of illustrations.

S. LØVGREN, *The Genesis of Modernism—Seurat, Gauguin, Van Gogh and French Symbolism in the 1880s,* Stockholm, 1959. A University of Uppsala thesis.
The only previous interpretative survey of the development of post-impressionism. It pursues certain valuable and important lines of inquiry, having to do with Symbolism in literature and in painting; and there are good, illuminating analyses in it of key works by van Gogh and Gauguin. See below for further comments on individual chapters.

LETTERS OF VAN GOGH

Verzamelde Brieven van Vincent van Gogh, 4 vols. in 2, vols. 1–3 ed. J. van Gogh-Bonger, vol. 4 ed. V. W. van Gogh, Amsterdam-Antwerp, 1955.
Contains the letters in the languages in which they were originally written. A few important errors of transcription. The footnotes are a weak aspect of the publication, being too few in number and not detailed enough.

English translation: *The Complete Letters of Vincent van Gogh,* 3 vols., London-New York, 1958.

Contains a few additional letters. The translation, which represents for the most part a revision and smoothing out of the original English translation of 1927-9, sometimes leaves the meaning of a passage unclear, and there are certain definite errors.

This publication—though its completeness may not, for a variety of reasons, be absolutely final—displaces all previous editions of the artist's letters in terms of the texts which it offers. The letters to Theo are numbered continuously without any prefix. Those to Bernard and the artist's sister Wil are numbered with the prefixes B and W; those to van Rappard and from Theo with the prefixes R and T.

Vincent van Gogh—Letters to Emile Bernard, ed. and tr. D. Lord (pseud. for D. Cooper), London-New York, 1938. Not always textually reliable, but still useful for its footnotes and discussions of the date of each letter.

The Letters of Vincent van Gogh, ed. and introd. by M. Roskill, London-New York, 1963. A paperback selection of the letters to Theo. Independently revised translations, additional footnotes; a date or approximate date is given at the head of each letter.

On the chronology of the letters to Theo, there is a series of articles by J. Hulsker: 'Van Gogh's dramatische jaren in den Haag', *Maatstaaf*, 6, 1958, pp. 401-23; 'Van Gogh's opstandige jaren in Nuenen', *ibid.*, 7, 1959, pp. 77-98; 'Van Gogh's extatische maanden in Arles', *ibid.*, 8, 1960-1, pp. 315-35; 'Van Gogh's bedreigde leven in St. Rémy en Auvers', *ibid.*, pp. 639-64. Chronological tables are given at the end in each case. The first two tables were reprinted by Hulsker in English, along with an article, 'Van Gogh's Dutch Years', in *Delta* (The Netherlands), 3, 1960, pp. 31-45. See also the reports by M. de Sablonière, summarizing Hulsker's findings: 'En nogmaals Vincent van Gogh', *Museumjournaal*, 5, 1959, pp. 55-6; 'De volgorde van de brieven van Vincent van Gogh', *ibid.*, 6, 1960-1, pp. 134-6 and p. 230 (English versions at the back of each number).

Hulsker argues cogently for a number of revisions in the order of the letters, and goes into the problems of dating very thoroughly. As for his own schemes of dating, it would be a mistake to regard these as absolutely definitive; and he goes too far in trying to pin each letter down to a particular day or the neighbourhood of a particular day. But his tables serve (in default of contrary evidence) as a fair and accurate guide to the part of each month in which the letters were written; and I have consistently used them in this sense (abbreviation: Hulsker).

LETTERS AND WRITINGS OF GAUGUIN

Lettres de Gauguin à sa femme et ses amis, ed. M. Malingue, Paris, 1946, 2nd ed. 1949.
The French texts here seem to be—so far as can be currently judged—thoroughly inaccurate transcriptions. This applies particularly to details of punctuation and orthography. The letters are quite often wrongly dated, and corrections of dating have since been made by Rewald, Bodelsen, Daniellson and others. Only a few sparse footnotes. The 2nd ed. contains further letters at the end. The English translation, *Gauguin—Letters to his Wife and Friends*, London, 1949, cannot be treated as reliable.

Lettres de Gauguin à Daniel de Monfried, ed. A. Joly-Segalen, Paris, 1950.
Differs in the numbering of the letters from the original ed. of 1919. It completely
supercedes that ed., because the names are no longer disguised as there, and also
because of its notes and documentation.

P. GAUGUIN, *Avant et Après*. Memoir written in Atuana and the Marquesas, in
1903. First published in full, in facsimile, Leipzig 1918. Very revealing about
Gauguin's life and character, though not to be taken as factually reliable. I have
used the regular Paris ed. of 1923.

All other sources for Gauguin's letters and writings are cited individually in
the notes on the text.

CATALOGUES OF PAINTINGS AND WORKS IN OTHER MEDIA (ARRANGED
ALPHABETICALLY BY ARTIST)

Cézanne

L. VENTURI, *Cézanne, son art, son œuvre*, 2 vols., Paris, 1936.
Covers paintings, watercolours, drawings and prints. Very few works of
Cézanne's are dated or reliably dateable, and the scheme of dating used by
Venturi is, for the most part, only a very broad and approximate one. Many
of the dates have since been revised or disputed, by Rewald, Gowing, Cooper
and others: Rewald, Novotny and Chappuis are now preparing a revised ed.

Degas

P. A. LEMOISNE, *Degas et son œuvre*, 4 vols., Paris, 1946-9.
Vols II-III cover paintings and pastels. For revisions of dating, see especially
J. Boggs, *Portraits by Degas*, University of California Press, 1962, p. 106.

Gauguin

G. WILDENSTEIN, R. COGNIAT, *Paul Gauguin*, Vol. 1, Catalogue, Paris, 1964
(abbreviated W-C).
This volume deals with the paintings and other 'definitive works'. Valuable in
terms of the localization of pictures and the documentation assembled. Un-
fortunately the size and quality of the illustrations are absolutely inadequate.
Also quite unreliable on the chronology of undated works, and on questions of
authenticity. An unhelpful arrangement of pictures by year and subject matter.
See further the anon. review in the *Times Literary Supplement*, Aug. 19, 1965,
p. 712; and the review by M. Bodelsen, *Burlington Magazine*, 108, 1966, pp.
27-38. A second volume, which will cover drawings, has been announced.

C. GRAY, *Sculpture and Ceramics of Paul Gauguin*, Baltimore, 1963 (abbreviated
Gray).
A useful compilation. The plates, especially the colour ones, are poor.

M. BODELSEN, *Gauguin's Ceramics*, London, 1964.
Much more reliable and clearcut than Gray on the order and dating of the
ceramics. Also notable for its chapter on Gauguin's stylistic development. Good
plates, some in colour.

Van Gogh

J. B. DE LA FAILLE, *L'Œuvre de Vincent van Gogh,* 4 vols., Paris-Brussels, 1928 (abbreviated F).
This publication, covering paintings and drawings, remains the basic van Gogh catalogue. De La Faille's arrangement of the works according to period has been consistently re-used ever since. Works mentioned in the artist's correspondence were separated off, period by period, from those not so mentioned and arranged in approximate chronological order; and summary references to the correspondence, as then known, were given at the end of each entry. Small plates, a few missing. Then and subsequently, De la Faille entangled himself very deeply and unsuccessfully in the problem of forgeries.

J. B. DE LA FAILLE, *Vincent van Gogh,* Paris-London-New York (Hyperion), 1939 (abbreviated H).
Covers paintings only. These were now arranged, within each period, in a looser and less systematic way. Individual entries include a number of cogent revisions, and also additional references. Larger plates, some in colour.

W. SCHERJON, J. DE GRUYTER, *Vincent van Gogh's Great Period—Arles, Saint-Rémy and Auvers-sur-Oise,* Amsterdam, 1937.
Covers only the paintings of 1888-90. Good black-and-white plates. Attaches to each painting, in the main body of the catalogue, the relevant passages in the correspondence, citing these in full in English. The paintings unmentioned in the *Letters* are grouped in separate sections. More reliable than De La Faille in its exclusions.

These three publications provide, between them, a good foundation. But five points are to be noted in qualification of their value today: (1) the further letters which have since appeared mean that there are a considerable number of documentary references to be added; (2) before these further letters appeared, some revisions had already been made as regards the works referred to in particular passages (see especially, in this connection, D. Sutton, 'Vincent van Gogh et les annotations de Douglas Cooper', *Arts,* 2 Jan., 1948, p. 3, with its summary of the changes proposed by Cooper); and there are now additional, and sometimes very solid, grounds for making more changes of this kind; (3) careful study of the letters and other sources can sometimes supply missing evidence as to original ownership; (4) there has been no systematic study of the internal chronology of any one period; (5) there are many completely unsettled questions concerning authenticity, variant versions, and the period to which a work belongs.

Mrs. A. Tellegen-Hoogendorn is currently preparing, for the Rijksbureau voor Kunsthistorische Documentatie in the Hague, a revised and updated ed. of De La Faille's catalogue. In the interim, the following two publications are of considerable supplementary value:

J. LEYMARIE, *Van Gogh,* Paris-New York, 1951.
Though written before the additional letters of the artist became available, it contains good analytical notes on 160 major paintings, all of them well reproduced.

Detailed catalogue . . . of 272 works by Vincent van Gogh belonging to the collection

of the State Museum Kröller-Müller, 1959 ed., L. Gans; new and revised ed., 1966, ed. F. Gribling.
This is the only publication on a large group of van Gogh's works which amounts to a complete catalogue raisonné. The newest ed. incorporates corrections and suggestions of other researchers, including myself.

Manet

P. JAMOT, G. WILDENSTEIN, *Manet*, 2 vols., Paris, 1932.
Covers paintings and pastels. Very detailed and full information in each catalogue entry—a certain proportion of which need serious re-study. The plates are unfortunately not arranged in chronological sequence.

Pissarro

L. PISSARRO, L. VENTURI, *Camille Pissarro, son art, son œuvre*, 2 vols., Paris, 1939 (abbreviated P-V).
Covers all works except watercolours and drawings.

Seurat

H. DORRA, J. REWALD, *Seurat, L'œuvre peint, biographie et catalogue critique*, Paris, 1959.

C. M. DE HAUKE, *Seurat et son Œuvre*, 2 vols., Paris, 1961.

The entries for the paintings in these two catalogues differ from one another, for the most part, only over points of detail. The second includes more drawings.

There are no catalogues at present for the work of Monet, Renoir, and Toulouse-Lautrec. Here the larger volumes of reproductions have to serve in lieu.

II Bibliography for the chapters

I IMPRESSIONISM

L. VENTURI, *Les Archives de l'Impressionisme,* Paris-New York, 1939, I, pp. 56ff.
Remarks on the individual artists' changes of direction at this time.

H. ROSTRUP, 'Impressionist-Problemer: Claude Monet og hans billeder i danske samlinger', in *Festkrift til Frederik Poulsen*, Copenhagen, 1941, pp. 55-66.
His discussion of Monet's development includes three works of the early eighties.

C. GREENBERG, 'The Later Monet' (1957), reprinted in this author's *Art and Culture*, Boston, 1961, pp. 37-45.
Contains remarks of a general, but highly perceptive kind about Monet's work of this time.

F. FÉNÉON, review of the Degas exhibition of 1886, reprinted in Fénéon, *Œuvres*, ed. J. Paulhan, Paris, 1948, p. 73.
A brilliant and exploratory characterization of the Degas *Nudes* of 1884-5.

J. BOGGS, '*Danseuses à la barre* by Degas', *National Gallery of Canada Bulletin*, 1964, pp. 1-9.
Contains a perceptive section on the character of Degas' draughtsmanship in the early eighties.

There is no systematic study of Gauguin's early development or of van Gogh's Parisian period; nor of the early work of Lautrec. On Seurat and impressionism, see W. Homer, 'Seurat's Formative Period—1880-1885', *The Connoisseur*, 142, 1958, pp. 58-62.

On the general principles involved in van Gogh's and Gauguin's 'translations', see F. Novotny, 'Die Bilder van Goghs nach fremden Vorbildern', in *Festschrift Kurt Badt zum siebzigsten Geburstage,* Berlin, 1961. pp. 213-30; R. Field, 'Gauguin plagiaire ou créateur', in *Gauguin* (essays by various hands), ed. R. Huyghe, Paris, 1960, pp. 139-69.

On paintings within paintings in the later nineteenth century, see now A. Chastel, 'Le Tableau dans le Tableau', in *Stil und Überlieferung in der Kunst des Abendlandes, Akten des 21 International Kongresses für Kunstgeschichte in Bonn 1964,* Berlin, 1967, I, p. 26; and T. Reff, 'The Pictures within Degas' Pictures', *Metropolitan Museum Journal*, I, 1968, pp. 125ff. (both published since my text was completed).

2 THE JAPANESE PRINT AND FRENCH PAINTING

F. SCHEYER, 'Far Eastern Art and French Impressionism', *Art Quarterly*, 6, 1943, pp. 116-143.
The best treatment of its kind. Particularly good on van Gogh's later development.

M. TRALBAUT, 'Van Gogh's Japonisme', in *Mededelingen van de Dienst voor Schone Kunsten der gemeente's Gravenhage*, nos. 1-2, 1954, pp. 16-40.
Summary in French. Includes a detailed study of van Gogh's 1887 copies of Japanese prints.

Y. THIRION, 'L'Influence de l'Estampe Japonaise dans l'Œuvre de Gauguin', in *Gauguin, sa vie, son œuvre*, ed. G. Wildenstein, special no. of the *Gazette des Beaux Arts*, 1958, pp. 95-114.
The long section on Gauguin's work of 1888-9 contains a carefully formulated series of comparisons.

Y. THIRION, 'Le Japonisme en France dans la seconde moitié du XIXe siècle, à la faveur de la diffusion de l'estampe Japonaise', *Cahiers de l'Association Internationale des Etudes Françaises*, 13, 1961, pp. 117-130.
A general cultural survey, well documented. Traces the changes of situation and attitude between the 1860s and the 1880s.

J. SANDBERG, 'Japonisme and Whistler', *Burlington Magazine*, 106, 1964, pp. 500-7.
Sets out very well and clearly the distinction, in Whistler's early work, between Japonaiserie and Japonisme.

L. REIDEMEISTER, introdn. to exhibition. cat., 'Der Japonismus in der Malerei

und Graphik des 19 Jahrhunderts', Haus am Waldsee, Berlin, Sept.-Oct. 1955. *Bibliography*
Contains some very intelligent observations on individual works.

3 THE IMPORTANCE OF SEURAT

M. SCHAPIRO, 'Seurat and 'La Grande Jatte',' *Columbia Review*, 17, 1935, pp. 9-16.
Excellent analysis of the painting's different aspects.

A. CHASTEL, 'Seurat et Gauguin', *Art de France*, 2, 1962, pp. 297-304.
A general essay which stresses the importance of Puvis de Chavannes' example.

R. HERBERT, *Seurat's Drawings*, New York, 1962.
A lively text, with some good observations about Seurat and Gauguin.

W. HOMER, *Seurat and the Science of Painting*, Cambridge, Mass., 1964.
Publication of a Harvard University thesis. A very detailed and thorough examination of Seurat's theoretical sources.

4 VAN GOGH, GAUGUIN AND EMILE BERNARD

Gauguin and Bernard

(a) The original controversy:

F. FÉNÉON, 'M. Gauguin, M. Dujardin', *Le Chat Noir,* May 23, 1891. Reprinted in Fénéon, *Au-Delà de l'Impressionisme* (collection of articles), ed. F. Cachin, Paris, 1966, pp. 112f.
Discussing Gauguin's development, on the basis of the 1891 auction-sale, Fénéon wrote of Gauguin's derivations from Bernard, whom he called the 'initiator'. Important as the very first statement by a critic on the subject.

BERNARD, 'Lettre ouverte à M. Camille Mauclair', *Mercure de France*, 14 June 1895, pp. 332ff.

GAUGUIN, 'Notes sur Bernard' (Ms. in the colln. of Pola Gauguin), pub. by H. Dorra, 'Emile Bernard and Paul Gauguin', *Gazette des Beaux Arts*, 45, 1955, p. 260.

(b) Bernard's later returns to the subject:

BERNARD, 'Notes sur l'Ecole dite de "Pont-Aven",' *Mercure de France*, 47, Dec. 1903, pp. 675ff. Reply by M. Denis, *ibid.*, 49, Jan. 1904, pp. 286f. (letter dated 10 Dec., 1903); reply by C. Morice, *ibid.*, Feb. 1904, pp. 393-5 (part of an article entitled 'Les Gauguins du Petit Palais et de la Rue Lafitte'). Bernard responded briefly, in turn, to each of these replies: *Mercure*, Feb. 1904, p. 574; Mar. 1904, p. 856.

———, 'Souvenirs', *La Renovation Esthétique,* Nov. 1907 and Apr. 1909.

———, 'Gauguin et Emile Bernard', *Le Point*, Oct. 1937.

———, 'Mémoire pour l'histoire . . .', (dated 1919), *Maintenant*, 2, 1946, pp. 204ff.

————, 'L'aventure de ma vie', pub. in *Lettres de Paul Gauguin à Emile Bernard*, Geneva, 1954, pp. 11-46.

————, Ms. (post 1936) in the colln. of Bernard's widow, cited by Dorra (see above).

(c) Early participation by art historians in the dispute:

C. CHASSÉ, *Gauguin et le Groupe de Pont-Aven*, Paris, 1921, pp. 67-70.
Minimizes Bernard's role.

H. FOCILLION, *La Peinture au XIXe et XXe, Siècles,* Paris, 1928, pp. 290f.
Maintains that Bernard was a significant artist in his own right.

(d) Leading treatments of more recent date:

B. DORIVAL, *Les Etapes de la Peinture Française Contemporaine,* I, Paris, 1943, pp. 74ff, 94f.

A. MEYERSON, 'Van Gogh and the School of Pont-Aven', in *Swedish Van Gogh Studies, Konsthistorisk Tidskrift,* 15, 1946, pp. 135-49. See also below.

M. MALINGUE, *Gauguin, le peintre et son œuvre,* Paris, 1948, pp. 34-7.

R. HUYGHE, introdn. to *Le Carnet de Paul Gauguin,* Paris, 1952, pp. 36-50.

H. HOFSTÄTTER, *Die Enstehung des Neuen Stils in der französischen Malerei um 1890,* mimeographed thesis, Freiburg, 1954. See also the same author's 'Emile Bernard—Schüler oder Lehrer Gauguins', *Kunstwerk,* 11, 1957, pp. 3ff. and his *Geschichte der Europäischen Jugendstilmalerei,* Cologne, 1963, pp. 63-8.

DORRA, *Gazette des Beaux Arts,* 1955, pp. 227-46.
Adds fresh material on Bernard's side.

REWALD, *P-I,* 1956, Chapter 4.

H. ROOKMAAKER, *Synthetist Art Theories,* Amsterdam, 1959, Chapter 6.
Deals mainly, as the title implies, with theory. Not well organized, but its special focus nonetheless gives it a definite value.

LØVGREN, *The Genesis of Modernism,* 1959, Chapter 3.

M. DE SABLONIÈRE, *Paul Gauguin,* Amsterdam, 1960, pp. 27-31.

BODELSEN, *Gauguin's Ceramics,* 1964, pp. 182-5.

W. JAWORSKA, 'Ze Studiów nad Szkołą Pont-Aven', *Rocznik Historii Sztuki,* 6, 1966, pp. 230ff., with summary in French, pp. 282-5.
Extracts from her book in Polish, *Wkregu Gauguina.* The first section deals with Gauguin and Bernard.

The most valuable of these treatments are those of Løvgren and Bodelsen: first, because, though they do not refer to Bernard's backdating, they implicitly take account of it; and secondly because, leaving aside the whole controversy, they concentrate on the evidence provided by the works themselves, and go into this in depth.

MEYERSON, *Konsthistorisk Tidskrift*, 1946, pp. 140-2.

REWALD, *P-I*, 1956, Chapter 4.

THIRION, *Gazette des Beaux Arts*, 1958, pp. 98-100.

L. GANS, 'Vincent van Gogh en de schilders van de "Petit Boulevard",' *Museum-journaal*, 4, 1958, pp. 85-93.

The first three of these writers progressively published relevant works by Bernard and Anquetin; Gans added further comparisons with works by van Gogh.

'Gauguin and the School of Pont-Aven', exhbn. cat., Tate Gallery, London, Jan.-Feb., 1966; cat. by R. Pickvance.
Included, on my suggestion, some of the drawings which Bernard sent to van Gogh, with cat. information supplied by me.

JAWORSKA, *Rocznik Historii Sztuki*, 1966, pp. 282-5. Includes a summary in French of the section of her article/book (see above) dealing with van Gogh and the Pont-Aven school.

5 VAN GOGH AND GAUGUIN AT ARLES

(a) Early contributions on this subject:

FÉNÉON, *Le Chat Noir*, 1891.
Fénéon also suggested here that Gauguin's work showed derivations 'from van Gogh (at Arles)'. Again the first critical statement on the subject.

Mercure de France, 7-13, Apr. 1893-Feb. 1895.
A series of extracts from van Gogh's letters to Bernard and Theo, published by Bernard. Those passages which concern Gauguin come mainly from letters of 1888 predating Gauguin's arrival at Arles. His name appears as 'G' almost throughout.

A. FONTAINAS, 'Art Moderne. Expositions Gauguin . . .', *Mercure de France*, 29, Jan. 1899, pp. 235ff. Fontainas suggested incidentally here that there might be some kinship between Gauguin's draughtsmanship and Van Gogh's.

GAUGUIN, *Avant et Après* (1903), 1923 ed., pp. 13-24.
Gauguin's memoir of what happened at Arles. Often used as a reliable primary source; but it was inspired by prejudicial motives, and contains statements which are verifiably false or erroneous.

J. VAN GOGH-BONGER, Introdn. to the *Letters* (first pub. 1914), *CL*, I, pp. xlivff.
An attempt at an impartial and judicious account of what happened. Gauguin's account is labelled 'a mixture of truth and fiction', and extracts from letters of Gauguin's are published or given in paraphrase.

(b) More recent treatments:

Any number of books make some passing analysis of a work of this period by van

Gogh or Gauguin, and posit cross-influence from one artist to the other. But there has not been any sustained treatment of the order of the paintings and the relationship between them. The following contributions stand out for one reason or another:

C. MORICE, *Paul Gauguin*, Paris, 1919, pp. 159–63.
Suggests that van Gogh's love of nature held Gauguin back from the dangers of abstraction.

C. STERNHEIM, *Gauguin und van Gogh*, Berlin, 1924.
The only book on the subject. Sensationalized, and justly classified by Rewald under the heading of 'fiction'. Heads a long line of writings on the subject which are of the same essential genre.

D. C. RICH, 'Gauguin in Arles', *Bulletin of Art Institute of Chicago*, 29, 3, March 1935, pp. 34ff.
A first attempt at the problem, based on the bold but loosely argued suggestion that, contrary to Gauguin's claim, he was influenced by van Gogh.

MEYERSON, *Konsthistorisk Tidskrift*, 1946, pp. 142–9.
The first treatment at any length of artistic relations between the two men.

W. WEISBACH, *Vincent van Gogh—Kunst und Schicksal*, Basel, 1949–51, II, Chapter 3.
Handles the material sensibly and thoroughly from a biographical point of view, emphasizing psychological considerations.

HUYGHE, *Carnet de Gauguin,* 1952, Introdn., pp. 50ff.
Adopts a direct approach to the subject. Rather general in its remarks, but quite subtle and controlled in its treatment.

REWALD, *P-I*, 1956, Chapter 5.
Places its stress on the primary documentation, which had now become greatly expanded. Interweaves contemporary statements of the artists with earlier and later ones. Additional documents were incorporated into the 1962 ed. of this chapter.

M. TRALBAUT, *Van Gogh—A Pictorial Biography*, London, 1960 (also in Dutch and French).
Useful for its map and photographs of sites at Arles.

(c) Additional writings relevant to the Coda to Chapter 5.

On the earlier and later relationship between the two men:
REWALD, *P-I*, Chapters 4, 7, 8, for Gauguin's behaviour.
LØVGREN, *The Genesis of Modernism*, 1959, Chapters 3–4.
They contain some cogent points of interpretation.

On the character and psychology of van Gogh and Gauguin:
G. KRAUS, *The Relationship between Theo and Vincent van Gogh* (lecture), Otterlo, 1953.
R. GOLDWATER, *Gauguin*, New York, 1957, introdn., pp. 9–44.
These both contain very perceptive analyses.

See also now F. CACHIN, *Gauguin,* Paris, 1968, Chapter 3 (1888), which is perceptive about Gauguin's behaviour that year.

I add here two items missing from Rewald's bibliography:

H. BLUM, 'Les Chaises de Van Gogh', *Revue Française de Psychanalyse,* 12, 1958, pp. 83-93.
C. MAURON, *Van Gogh au Seuil de la Provence,* (pamphlet), Marseilles, 1959.

6 TOWARDS SYMBOLISTIC ART

LØVGREN, *The Genesis of Modernism,* 1959, Chapter 1.
Through its treatment of the intellectual currents leading up to Symbolism, and of key literary events of the mid 1880s, this chapter can be said to have opened up a new way of looking at the period.

R. GOLDWATER, 'Symbolic Form: Symbolic Content', in *Problems of the 19th and 20th Centuries, Acts of the XX International Congress of the History of Art,* IV, Princeton, 1963, pp. 111-21.
A brief but extremely suggestive interpretation of what was involved in French painting of the 1880s. I was also helped by Goldwater's Trask Lectures on symbolism, first given at Princeton University and repeated at the Institute of Fine Arts, New York in 1959.

POSTSCRIPT

On the Fauves in relation to van Gogh and Gauguin, see G. DUTHUIT, *Les Fauves,* Geneva, 1949; tr. R. MANNHEIM, *The Fauvist Painters,* New York, 1950, pp. 35-51.

For the works by KIRCHNER and other Brücke artists which show the direct influence of van Gogh and Gauguin, see D. GORDON, 'Kirchner in Dresden', *Art Bulletin,* 48, 1966, pp. 336ff. This article is most valuable for its concrete documentation and analysis of individual works; it contains contributory suggestions of mine.

III Notable papers presented in my seminar on van Gogh and Gauguin, Harvard University, spring 1962, by graduate students of the Dept. of Fine Arts

K. CHAMPA, 'The Breakdown of Impressionism'.
M. BENNETT, 'Van Gogh, Gauguin and Monet'.
S. LEONARD, 'Van Gogh, Gauguin and Cézanne'.
C. ACKLEY, 'The portrait background, 1870-1890'.
R. HATFIELD, 'The still-life background, 1870-1890'.
E. PARRY JANIS, 'Van Gogh, Gauguin and the Japanese Print'.
R. CALKINS, 'Van Gogh, Gauguin and Seurat'.

List of Illustrations

Dimensions are given in inches, height preceding width. All works are oil on canvas unless otherwise stated.

COLOUR PLATES

I Vincent van Gogh, *Mme Roulin and her Baby,* December 1888. $25\frac{5}{8} \times 20$. Courtesy of Robert Lehman Foundation Inc., New York.

II Paul Gauguin, *Ham,* c. 1880. $19\frac{3}{4} \times 22\frac{3}{4}$. Phillips Gallery, Washington.

III Vincent van Gogh, *Portrait of Père Tanguy,* c. 1887. $36\frac{1}{4} \times 28\frac{3}{4}$. Musée Rodin, Paris.

IV Paul Gauguin, *Portrait of Marie Lagadu,* 1890. $25\frac{1}{2} \times 21\frac{1}{2}$. Art Institute of Chicago, Joseph Winterbotham colln.

V Vincent van Gogh, *The Artist's Chair,* December 1888 – January 1889. $36\frac{3}{8} \times 28\frac{7}{8}$. Tate Gallery, London.

VI Paul Gauguin, *Still-life in an Interior,* 1885. $23\frac{1}{2} \times 29\frac{1}{4}$. Private colln., U.S.A.

VII Vincent van Gogh, *Self-portrait for Gauguin,* September 1888. $24\frac{3}{8} \times 20\frac{1}{2}$. Fogg Art Museum, Harvard University, Maurice Wertheim colln.

VIII Paul Gauguin, *Self-portrait with the Yellow Christ,* c. 1889. $15 \times 18\frac{1}{8}$. Colln. of family of Maurice Denis, Paris.

MONOCHROME PLATES

1 Claude Monet, *Rocks at Belle-Isle,* 1886. 24×29. Colln. Mr and Mrs Erik Meyer, Copenhagen.

2 Vincent van Gogh, *The Ravine,* October 1889. $28\frac{3}{4} \times 36\frac{1}{4}$. Boston Museum of Fine Arts, Bequest of Keith Macleod.

3 Pierre-Auguste Renoir, *Bathers,* 1884-7. $45\frac{1}{2} \times 67$. Philadelphia Museum of Art, Carroll S. Tyson colln.

4 Paul Gauguin, *The Yellow Christ,* 1889. $36\frac{1}{4} \times 28\frac{1}{4}$. Albright-Knox Art Gallery, Buffalo.

5 Paul Gauguin, *Market Gardens of Vaugirard,* 1879. $26 \times 39\frac{1}{2}$. Smith College Museum of Art, Northampton, Mass.

6 Paul Cézanne, *The Harvest,* c. 1876. $18 \times 21\frac{3}{4}$. Colln. Paul Mellon, Upperville, Virginia.

7 Paul Gauguin, *Seated Model,* c. 1882. Pastel, $18\frac{1}{4} \times 12$. Present whereabouts unknown.

8 Edgar Degas, *Dancer adjusting her Shoe,* c. 1880-2. Pastel, $23\frac{1}{2} \times 18$. Ordrupgaard colln., Copenhagen.

9 Claude Monet, *Sunflowers,* 1881. $39\frac{3}{4} \times 32\frac{1}{2}$. Metropolitan Museum, New York, Havermeyer colln.

10 Paul Gauguin, *Basket of Flowers,* c. 1884. 19×24. Colln. Mr and Mrs William Coxe Wright, Philadelphia.

11 Vincent van Gogh, *Quarry at Montmartre,* c. 1886. $22 \times 24\frac{1}{2}$. Stedelijk Museum, Amsterdam, Vincent van Gogh Foundation.

12 Vincent van Gogh, *Moulin de la Galette,* c. 1887. $17 \times 14\frac{3}{4}$. Glasgow Art Gallery and Museum, McInnes bequest.

13 Vincent van Gogh, *Lady at the Cradle,* c. 1887. $21\frac{3}{4} \times 18\frac{1}{4}$. Stedelijk Museum, Amsterdam, Vincent van Gogh Foundation.

14 Paul Gauguin, *Mlle Charlotte Flensborg, c.* 1882. Pastel, 13 × 10¼. Ny Carlsberg Glyptotek, Copenhagen.

15 Paul Signac, *Still-life,* 1883. 12¾ × 18¼. Nationalgalerie, Berlin-Dahlem.

16 Paul Gauguin, *Breton Coast,* 1886. 29½ × 44. Private collection, New York.

17 Paul Gauguin, *Farmyard Scene, c.* 1889. 36 × 28½. John Herron Art Museum, Indianapolis.

18 Paul Gauguin, *Still-life with a Portrait of Laval,* 1886. 18⅛ × 15. Colln. Mrs Walter B. Ford II, Detroit.

19 Paul Cézanne, *Still-life with Fruit Dish, c.* 1880. 18½ × 22⅛. Colln. René Lecomte, Paris.

20 Paul Gauguin, *Portrait of the Schuffenecker Family,* 1889. 28¾ × 36¼. Musée du Louvre, Jeu de Paume.

21 Edgar Degas, *The Bellelli Family,* 1858-60. 78¾ × 99½. Musée du Louvre, Jeu de Paume.

22 Vincent van Gogh, *Fishing in the Spring, c.* 1887. 19¼ × 22⅞. Colln. Chauncey McCormick, Chicago.

23 Claude Monet, *Two Men Fishing,* 1882. 15 × 20½. Private colln., Paris.

24 Vincent van Gogh, *Boats at Saintes-Maries,* June 1888. 25⅜ × 28. Stedelijk Museum, Amsterdam, Vincent van Gogh Foundation.

25 Claude Monet, *Boats at Etretat,* 1884. 28½ × 36¼. Colln. John Hay Whitney, New York.

26 Vincent van Gogh, *Harvest in the Crau,* June 1888. 28½ × 36¼. Stedelijk Museum, Amsterdam, Vincent van Gogh Foundation.

27 Paul Gauguin, *Fan-design after Cézanne,* 1885. Watercolour, 11 × 21¾. Ny Carlsberg Glyptotek, Copenhagen.

28 Paul Cézanne, *View of L'Estaque, c.* 1882. 21¼ × 28¾. National Museum of Wales, Cardiff, Gwendolin E. Davies bequest.

29 Paul Gauguin, *Portrait of Marie Lagadu,* 1890. 25½ × 21½. Art Institute of Chicago, Joseph Winterbotham colln.

30 Paul Gauguin, copy of Manet's *Olympia,* 1891. 34¾ × 50¾. Present whereabouts unknown.

31 Camille Pissarro, *Still-life, Basket of Pears,* 1872. 18 × 22. Private colln., U.S.A. (on loan to Boston Museum of Fine Arts).

32 Claude Monet, *Chrysanthemums,* 1878. 21½ × 25½. Musée du Louvre, Jeu de Paume.

33 Camille Pissarro, *Self-portrait,* 1873. 21½ × 18. Musée du Louvre, Jeu de Paume.

34 Paul Cézanne, *Portrait of Chocquet, c.* 1877-80. 17¾ × 14½. Columbus Gallery of Fine Arts, Ohio.

35 Vincent van Gogh, *The Postman Roulin, c.* 1889. 25½ × 21¼. Kröller-Müller Museum, Otterlo.

36 Vincent van Gogh, *Portrait of a Young Girl, c.* 1890. 20 × 19¼. Kröller-Müller Museum, Otterlo.

37 Paul Gauguin, *Ham, c.* 1889. 19¾ × 22¾. Phillips Gallery, Washington.

38 Paul Gauguin, *Self-portrait with the Yellow Christ, c.* 1889. 15 × 18⅛. Colln. of family of Maurice Denis, Paris.

39 Pierre-Auguste Renoir, *Portrait of Chocquet, c.* 1875. 18 × 14¼. Fogg Art Museum, Harvard University, Greville L. Winthrop colln.

40 Paul Gauguin, *Self-portrait with Delacroix Reproduction, c.* 1890. 17¾ × 14½. Present whereabouts unknown.

297

Photographic Acknowledgments

Victor Amato, Washington 175, Archives Photographiques 87, 171, Bernheim Jeune 179, Brenwasser, New York 82, 160; Rudolf Burckhardt 103; Bulloz, Paris 38, 90, 165; Galerie Charpentier, Paris 23; Daniel, Liège 47; Durand-Ruel, Paris 30, 114, 176; Fogg Museum Archives 19, 40, 53, 92, 120, 159; A. Frequin, The Hague 151; Giraudon, Paris 44, 45, 51, 119, 171, 180; Knoedler, New York 25; R. G. Lock, Southampton 52; Marlborough Fine Art, London 126; Museum of Modern Art, New York 1; Musées Nationaux, Versailles 20, 21, 32, 33, 42, 54, 56, 88, 91, 100, 109, 111, 132, 135, 168, 181, 186, 196, 198; Princeton University Archives 122, 127; Renger, Essen 152; Reportaz, Athens 107; S.E.P.T, Nice 112; Michael Speich, Winterthur 145; Stickleman, Bremen 43; Studio Piccardy, Grenoble 80; Adolph Studly, New York 98; K. Teigen, Oslo 174; Marc Vaux, Paris 104; Wildenstein, New York 10, 16, 18, 49, 153, 183; Witt Library, Courtauld Institute 7; H. Wullschleger, Winterthur 197.

The following illustrations were made after reproductions in books, catalogues etc.: 41, 50, 61, 62, 65, 66, 83, 85 (after C. Kunstler, *Gauguin,* 1947; courtesy of Mrs Bodelsen) 115, 117, 195; 105, 121, 129, 130, 131, 133, 140, 141, 154, 161, 162 (from Gauguin's notebook),
All other illustrations were supplied by the museums or private owners to whom the works belong, and are reproduced with their kind permission.

Index

Plate numbers are given in parenthesis